Worlds of Art

WORLDS OF ART

Painters in Victorian Society

Paula Gillett

RUTGERS UNIVERSITY PRESS • NEW BRUNSWICK, NEW JERSEY

Library of Congress Cataloging-in-Publication Data

Gillett, Paula, 1934-
Worlds of art/Paula Gillett.
p. cm.
Bibliography: p.
Includes index.
ISBN 0-8135-1459-2
1. Painting, British. 2. Painting, Victorian—Great Britain.
3. Feminism and art—Great Britain. 4. Art and society—Great Britain.
5. Great Britain—Civilization—19th century. I. Title.
ND467.5.V52G55 1990
759.2—dc19 89-30373

To my husband, Eric,
and to our children, Walter, Nadia, and Noel,
with love

Contents

List of Illustrations

Preface

This book had its origins in a sense of puzzlement. As a student of the social and cultural history of Victorian England, I was impressed by a jarring imbalance in the role accorded to the art world by nineteenth-century writers and by later scholars. Artists and their activities clearly had a prominent place in the image that contemporaries presented of their times; but that same art world received scant notice—if, indeed, it received any at all—in the writings of social and cultural historians. Why was this so?

Further study led me to believe that two related reasons (or sets of reasons) accounted for this anomaly. First—and perhaps foremost—were the major changes in taste and aesthetic philosophy that, beginning in the late nineteenth century, called into question the value of much of Victorian painting, particularly its emphasis upon anecdote and edification. Second was the fact that Victorian art (with the notable exception of the work of Turner) has been retrospectively overshadowed by the great achievements of English writers and scientists during the same period as well as by the dazzling accomplishments of nineteenth-century French painters.

In recent years, however, important studies by art historians and notable painting exhibitions in Britain and the United States have stimulated a new interest in Victorian art and have made it clear that the image of nineteenth-century English art that prevailed for such a long time was prejudiced and inaccurate. In any case, we now see that a richer understanding of the Victorian period must give art a more prominent place, for there can be no doubt that contemporary paintings and art exhibitions were central to the experience of many Victorians.

This study therefore has as its principal goal the broadening of our understanding of English social and cultural history to include the role of contemporary art and its creators. It does not attempt to be comprehensive in its inclusion of artists and deals especially with painters whose names are unfamiliar even to many people knowledgeable about art history: George Frederic Watts, Hubert Herkomer, and Elizabeth Thompson, for example, appear in these pages far more often than the Pre-Raphaelites Dante Gabriel Rossetti and William Holman Hunt. Finally, the book concentrates its attention on oil painters rather than watercolorists. Almost all of the artists who enjoyed great public prestige and high income during

this period exhibited oil paintings at the annual exhibitions of the Royal Academy of Arts, and most were or aspired to be members of that institution; separate societies of watercolor painters were founded during the nineteenth century in response to the Academy's policy of favoring oils in their hanging arrangements and excluding watercolor artists (unless they worked in oils as well) from membership.

The book's seven chapters explore, from a variety of perspectives, the distinct worlds that together comprised the Victorian art scene. An introductory chapter is followed by an overview (chapter 2) that charts the rise of painting to professional status, a change that came about largely as the result of the greatly increased demand that began in the late 1840s for pictures by living painters. The key role that the Royal Academy played in bringing about and protecting that status change is emphasized in chapter 2; and since the Academy, the institution that symbolized artists' claim to genteel status, was, by the decision of the majority of its members throughout the Victorian period, exclusively male, this chapter is entitled "Gentlemen of the Brush."

Chapters 3 and 4 present biographical portraits of four important painters, all of them Academy members—the popular artist William Powell Frith and the social realists Frank Holl, Luke Fildes, and Hubert Herkomer; the discussion of their rise to prominence shows how their careers exemplified developments discussed in the first and second chapters. Chapters 5 and 6 explore the very different character of the world of female painters and their efforts to respond to and reshape the special combination of opportunities and obstacles that their social and occupational environment provided. The concluding chapter is a study of Victorian art publics, particularly as these were affected by the development of the Aesthetic movement and the establishment of the Grosvenor Gallery during the later 1870s.

This book would never have been written without the assistance and encouragement of several remarkable people, and it is a very special pleasure to take this opportunity to thank them. Professor Sheldon Rothblatt of the University of California, Berkeley, Department of History, has encouraged this project from its earliest stages. I am deeply grateful for his imaginative teaching, his incisive criticism, and his unfailing and generous kindness. It has been a privilege, as well as a delight, to study history with the benefit of his guidance and support.

The encouragement, patience, and persistence of Leslie Mitchner, senior editor at Rutgers University Press, provided a large part of the impetus that is necessary to an author who faces the seemingly interminable process of revising a manuscript that began its life as a doctoral disserta-

tion. I was fortunate indeed to have the benefit of Professor Richard Altick's readings of the manuscript; his critical comments and suggestions were enormously helpful in the task of improving the book's overall structure and in the recasting of individual chapters. Gene Tanke provided skillful assistance to the process of reorganization; and Gregory Suriano, the book's copy editor, patiently helped me to clarify my ideas and their presentation with infinite good will and a wonderful spirit. I am deeply grateful for the interest of both these editors in the book and for their expertise and kindness. And, finally, my thanks to Nick Humez, an intelligent, perceptive indexer, and to Marie-Anne Seabury, who pulled me through the final proofreading.

My debt is great indeed to the staff of several branches and offices of the libraries of the University of California, Berkeley, including Doe Library, the Bancroft Library, and the Northern Regional Library Facility. I especially appreciate the resourcefulness and patience of the staff of the Interlibrary Borrowing Service. The fine work of the Doe Library's Photographic Services Office can be seen in the illustrations reproduced in this book from nineteenth-century journals.

The long genesis of this study made it an integral part of my family's life. I thank my husband, Eric, our daughter, Nadia, and our sons Walter and Noel for understanding—and even encouraging—my longstanding preoccupation with other times and people.

Worlds of Art

If we are to make some attempt to define the problems which con-
fronted artists in Britain during 1969, we must say that, on the
evidence, the chief problem is one of professional status. We are aware
that this problem is generally held to have been solved in the nine-
teenth century, when painters and sculptors, like actors, established
their status as professional men, on a level with doctors, parsons and
lawyers. But this position, painfully built up, has now been under-
mined again.

—Edward Lucie-Smith and Patricia White, *Art in Britain: 1969–1970* (London, 1970), 20.

THE DAYS WHICH WE SOLD PICTURES IN

Oh, the days which we sold pictures in
 Are still to mem'ry dear.
Though they have vanished into space
 For many a weary year.

We ne'er shall see their like again,
 Nor prices get like those
With which the eager buyer would
 Incontinently close.
Now feel we hardness of the times,
 Our debts still daily grow;
Ah, the days which we sold pictures in,
 A long time ago!
. .
Now tens of thousands of young moths
 Are flutt'ring round the Art;
They'll burn their little wings, I fear,
 And feel, like us, the smart.
"Anch'io son pittore," then
 They won't so gladly crow;
Ah, the days which we sold pictures in,
 A long time ago.

—Henry Stacy Marks, *Pen and Pencil Sketches*, 2 vols. (London, 1894), 2:225–226.

1. *Introduction*

The tone of writings on English art tends to differ noticeably from that found in histories of other aspects of English life and culture. We are familiar with chronicles of great achievements in philosophy and political theory, of the growth of political institutions of wide and enduring influence, of the inexhaustible richness of English literature, and of the momentous contributions to science and technology. In comparison, English painting appears as a poor relation, its growth stunted by lack of nurture in a stubbornly inhospitable environment. A few painters of true genius can be named, but over the centuries, and especially during the Victorian period, the story of English art seems characterized by talents incompletely developed or somehow misled.[1]

No one who reads the memoirs of nineteenth-century English painters can fail to be impressed by their acute sense of peripheral status within English culture and by their belief that British painting had no authoritative tradition comparable to the great legacy of European art. In the words of the twentieth-century British painter and critic Eric Newton,

> It is difficult to realize that while England had, for over a hundred and fifty years, created little but charming decorations, Italy had produced Leonardo, Michelangelo, Raphael, Titian, Tintoretto, Veronese, and was already treading the steep downward path of artistic decline. As far as English painting up to the seventeenth century is concerned, the High Renaissance might have occurred on some distant planet.[2]

Victorian painters would have nodded their heads in sad assent to this judgment. To what causes did they attribute the late and (as they considered it) limited development of painting in England?

While few would have accepted even a greatly weakened version of Hippolyte Taine's querulous suggestion that there might be some inherent defect in the English retina,[3] many painters and art lovers would have agreed that the dismal nature of the English climate had a detrimental effect upon artistic creativity. It was no accident, they thought, that the rich glories of Renaissance painting had developed under Italy's brilliantly blue skies. It seemed evident that in that favored country, nature herself provided a visual education, the lack of which in England could never be

overcome by calculated human efforts. Many artists, having left (tempo-
rarily or, as some did, permanently) the grays and fogs of England, would
have shared the sentiments expressed by a fictional representation of
Frederic Leighton, one of the most eminent Victorian painters, in a story
written by his friend Adelaide Sartoris: "I know nothing like the emotion
that the first Italian town gives one after an absence—the well-remembered
yet always new aspect of men and things! The faded frescoes on the old
palaces—the balconies teeming with crowded flowers; the shops, half in,
half out of doors—the barber with the striped curtain drawn back, that the
patient may flâner with his eyes while his chin is in jeopardy, . . . the ill-
shaven priests and slippered women. . . . How noisy—how sunny—how
fascinating it all is."[4] The painter George Frederic Watts (who dressed in
the style of the Italian Renaissance and encouraged his admirers to ad-
dress him as "Signor") said that only lands of sun and leisure are natural
places for art; art exists in England not as a native, but as a guest.[5]

Cultural factors, however, rather than the natural landscape, were seen
as the primary force hampering English artistic development. "The eye,"
wrote Taine in 1889, "is epicurean like the palate, and painting is an ex-
quisite feast served up to it."[6] Late in the century, the ideas of Whistler
and his followers accustomed segments of public opinion to the possibility
that painting's visual appeal was central to its nature and not merely sec-
ondary and instrumental. Until then, the visual delights English painters
provided had to be handmaidens to offerings far more elevated than epi-
curean feasts if they were to be well received by art lovers. This low rank-
ing, by patrons and public, of aesthetic values that painting alone can
offer, frequently encouraged artists to be excessively concerned with nar-
rative and with morally didactic subject matter. Taine, a lecturer at the
Ecole des Beaux-Arts and a philosopher who interpreted cultural phenom-
ena as reflections of the interrelationships of race, milieu, and the con-
cerns and outlook of the historical moment, attributed the English bias
in art largely to the influence of national character, intensified by the hec-
tic pressures of modern industrial society. "Temperament in this country
is too militant, the will too stern, the mind too utilitarian, man too case-
hardened, too absorbed and too overtasked to linger over and revel in the
beautiful and delicate gradations of contours and colors."[7] Kenneth Clark,
who in his role of public educator served as successor to John Ruskin and
Roger Fry, agreed with this judgment. "In England," he wrote, "the ma-
jority is not merely apathetic, but hostile to art."[8] The idea, often repeated
during the nineteenth century, that English culture is essentially an-
tagonistic to art, is still by no means dead.

This does not mean that the Victorians who incorporated moral themes in their paintings were doing so only in response to the public's anti-aesthetic bias. Many English artists of the mid-nineteenth century were deeply religious, and the evangelical faith that stressed the importance of individual responsibility, good works, and moral self-restraint was fittingly expressed in famous paintings such as William Holman Hunt's *Awakening Conscience* and in a multitude of lesser-known pictures. Still, there was a distinct feeling of uneasiness among the more thoughtful and self-conscious painters (and probably among the more gifted); they worried that their success was more the result of the congruity of the sentiments expressed in their paintings with society's religious and moral aspirations than it was of excellence of artistic conception and execution. For a large proportion of the growing numbers of exhibition visitors new to art, the subject—preferably narrative—was all that really mattered. Even as late as 1863, Lady Eastlake, a noted writer on art and the wife of the president of the Royal Academy, complained that the British public "had scarcely advanced beyond the lowest step of the aesthetic ladder, the estimate of a subject."[9]

Frustrated as English artists were by this distance between their artistic aims and the untutored response of most of their viewers, they were harshly critical as well of their own shortcomings as painters. Again and again, visits by English artists to the Continent confirmed their belief that their European counterparts commonly attained a level of professional mastery seldom found in England. "My belief is that we in London are the smallest and most wretched set of snivellers that ever took pencil in hand," wrote the Royal Academician Daniel Maclise from Paris in 1844, "and I feel that I could not mention a single name with full confidence, were I called upon to name one of our artists in comparison with one of theirs." "If people only knew as much about painting as I do," said Edwin Landseer at the height of his fame, "they would never buy my pictures."[10]

It was repeatedly urged in conversations, letters, memoirs, biographies, and in testimony elicited by parliamentary committees and royal commissions that the cause of this low state of competence lay with the stinginess and improper direction of English patronage. History painting—the creation of the large works with idealized figures that had sole right to be called "high art"—was widely believed to be the most honored sphere for the great painter. Yet Reynolds, who had preached this doctrine, had "taken another course, one more suited to my abilities, and to the taste of the times in which I live," and had become wealthy by painting portraits.[11] With idealized subjects and neoclassical motifs, these pictures were painted in the

image of high art. It was generally held that Reynolds had thus "elevated" this branch of painting by providing it with a timeless, universal quality that allowed it to transcend the limits of the realistic and the transitory. Yet Reynolds himself knew that the "course" he had taken was, essentially, a compromise. Portrait painting could be brought *closer* to high art, but it could never occupy the same high plane. Benjamin Robert Haydon, the major proponent of the cause of high art in England during the first half of the nineteenth century, was less willing to accept the limitations suggested by his own abilities and by the taste of the times. His dogged and, as some felt, fanatical upholding of the preeminent status of history painting contributed to the despair that ultimately led him to suicide.

Knowledge of the contrasting fortunes of these two painters provided an important part of the intellectual frame of reference for nineteenth-century English painters, few of whom wished to be led, as Reynolds's pupil Northcote had put it, "down the garden path" of producing a kind of art which held high official esteem but was expensive to produce and essential unmarketable. A measure of confusion and inconsistency was thus an integral part of the English painter's education, particularly if he had studied in the Academy schools, where the regimen of drawing from casts of antique statues and then from the nude model was ostensibly preparation for the history painter. But if landscape and genre art were (as the popular painter William Powell Frith told a parliamentary committee in 1866) the only kinds of art that existed in England,[12] because there was appreciation of and demand for them, then it is hardly surprising to find that many art students cut short their period of neoclassical training and began their professional lives with a grounding which they often knew to be inadequate.

How very different was the situation in France where, despite the increasing privatization of the market, paintings were still regularly commissioned by church and state, and medals awarded at the annual Salons were accompanied by substantial cash payments.[13] In England, pictures were not wanted in churches, and (with the notable exception of commissions given at the time of the building of the new Houses of Parliament in the early 1840s) government patronage was rare. The new middle-class patrons who, by the 1840s, had come to dominate the contemporary art market—the notebook of the painter, commented Lady Eastlake, began to show higher prices even as it exhibited lowlier names[14]—generally preferred small pictures of domestic incident and local scenery. Nevertheless, English painters were blamed for not producing large-scale, ideal art even

by observers thoroughly familiar with the discouraging patronage situa-
tion. Artists reacted with understandable anger to the frequently con-
descending comments of members of Parliament and of critics like this
one from the *Times*:

Those lofty aspirations which have made the great artists of all ages important per-
sonages in the history of human civilization are not to be sought, save as rare ex-
ceptions, among the artistical motives in this country. Should such proficiency be
attained in one or two departments as continental schools would assign to the sec-
ond rank, the visitor to an English gallery must be satisfied, flattering himself, if he
is patriotic, that lack of encouragement is the only cause that native artists lack
ambition, and laying stress on the oft-repeated argument that great works are be-
yond the reach of the generality of private purchasers, and that to private pur-
chasers alone the English artist owes his existence.[15]

Some painters agreed with the implication of the *Times* article that the
lack of patronage for high art was not the sole reason for its failure to de-
velop in England, but held that the predominance of genre and landscape
was not to be lamented, as it directly and fittingly reflected English values
and the national temperament. Could not illustrations of domestic virtues
and of the beauties of the countryside provide as refining and inspiring an
influence upon sensibility and character as depictions of mythological and
historical events, the significance of which was often lost upon the major-
ity of viewers who had no knowledge of their symbolic language? The
argument that genre art, even with its "vulgar," "low," and "confined" sub-
jects,[16] could carry the moral weight of high historical painting had been
forcefully made in the eighteenth century by Hogarth, "Whose pictured
morals charm the mind, / And through the eye correct the heart,"[17] and
was often and variously restated during the nineteenth. The print-sellers
firm of Agnew, for example, was praised in 1878 by the *Art Journal,* in a
typical piece of Victorian art commentary, for periodically issuing engrav-
ings of paintings of the British school that are "of great worth as teachers
of many of the lessons to be derived from Art." One of the *Journal*'s favor-
ites that year was a picture by G. D. Leslie ("worthy son of a good father")
called *School Revisited,* which showed a young woman on a visit to the
school she had attended in girlhood. The cottage that housed the school
was "a very model of neatness, order, and loving lessons that prepared for
life." The print was declared to be one of the most agreeable works with
which to decorate "our English homes."[18] Ruskin frequently gave high
rank to genre pictures that effectively conveyed ideas of moral worth and
inspiration, while the Pre-Raphaelites, during the first decade of their

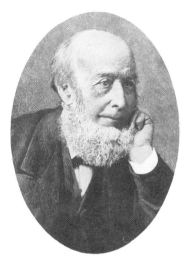

1. Richard Redgrave, a painter of contemporary social subjects and landscapes, was a prominent Victorian art administrator and coauthor (with his brother) of an important historical survey of the work of British artists. Redgrave is best remembered for moving portrayals of the social injustices suffered by women, painted during the 1840s. (As published in the *Magazine of Art*, vol. 15, 1892.)

movement, sought to influence the public with the "modern moral subject," and thoughtfully named their newly established meeting place for artists and patrons the Hogarth Club.[19]

One of the most eminent defenders of the moral worth of genre art was Richard Redgrave (1804–1888), whose productivity as a painter was curtailed by the varied and time-consuming duties that came with his appointments to important posts in the growing field of art administration—he was a teacher and then headmaster in the Government School of Design, art superintendent in the Department of Practical Art, inspector general for art in the new Department of Science and Art, and surveyor of the royal collection of pictures. Redgrave, whose pictures (especially those painted during the "hungry forties") were meant to stimulate compassion for the victims of social injustice, held that the sentimental bent and moral content of English genre art set it on a far higher plane than that occupied by the seventeenth-century Dutch tradition from which it derived.

The subjects of British artists . . . almost always appeal to the higher sentiments, and embody the deep feelings and affections of mankind. Our poets and writers, as well as those of other countries, find in them loving illustrators. Even when the painter chooses for his subject our rough sports, our native games, our feasts and merry-makings, he contrives so that some touching incident, some tender episode, or some sweet expression, shall be introduced to link them to our higher humanity: and those offensive accompaniments which the Dutch artist seemed instinctively to revel in are judiciously passed over, or hinted at rather than prominently displayed.[20]

By the last two decades of the century, Redgrave's defense of English painters and their work would have seemed old-fashioned. Concern was still being expressed about the failure of England to develop excellence in the highest branch of painting, the historical. "Whether this arises," conjectured the *Quarterly Review* in 1886, "from the national temperament, from the want of opportunities for its exercise, from the deficiency of adequate training and instruction, or from what other causes, we cannot here enquire. The attempts hitherto made to foster and develop this branch have failed."[21] The *Art Journal* was still praising pictures that set examples of decorous behavior. "They are beautiful types of humanity, . . . undisturbed by any sordid emotions," its critic wrote of the figures in a Marcus Stone painting reviewed in 1896. "Their lovers' quarrels and reconciliations, their partings and welcomes, and all the other small events of their placid lives, are presented with a gentle suggestion of properly ordered passion which recognizes the importance of obeying the laws of self-repression laid down by good society."[22] But discussions like these, their terms long familiar to several generations of art lovers, were by then beginning to seem obsolete to members of the social elite. Their orientation to art matters was, since the 1870s, increasingly marked by the influence of the Aesthetic movement, which denigrated the native tradition of genre art not because of its "low" subjects, but because of its emphasis on narrative content and moral suasion and its accompanying lack of concern for purely visual criteria. The only proper "message" a picture should convey, wrote Walter Pater in one of the classic formulations of Aesthetic movement ideology, is sensuous delight.

In its primary aspect, a great picture has no more definite message for us than an accidental play of sunlight and shadow for a few moments on the wall or floor is itself, in truth, a space of such fallen light, caught as the colors are in an Eastern carpet, but refined upon, and dealt with more subtly and exquisitely than by nature itself.[23]

The Aesthetic movement's basic tenets and its assaults upon traditional Victorian morality were popularized during the 1870s and 1880s by James McNeill Whistler, whose witty ridicule of the dominant anecdotal strain in English art was spread abroad in accounts of the famous lawsuit he brought against Ruskin in 1878, his response to the great critic's attacks on paintings exhibited in the opening show of the Grosvenor Gallery during the previous year. Although mention of the name of the outrageous Mr. Whistler was avoided in some polite circles during the eighties, the phenomenal success of his major exhibition, "Nocturnes, Marines, and

Chevalet Pieces," held at the Goupil Gallery in 1892, signified that an important change in the cultural climate had taken place.[24]

"What did our fathers of the nineteenth century do," asked Virginia Woolf in an essay on Ruskin, "to deserve so much scolding?"[25] By the 1890s, the most advanced segments of the art public had tired of Victorian earnestness and were glad to turn away from sentimental moralizing in art and even to enjoy Whistler's studied iconoclasm. The English tradition in painting, then as always subject to anxious examination, was found shockingly deficient by the new art critics who came to prominence in the nineties—R.A.M. Stevenson, D. S. MacColl, Roger Fry. Their criteria were derived neither from the high art of Reynolds's ambitions nor from the didactic anecdotes of the Hogarthian mode, but from an ideology that stressed the importance of purely visual elements of design and technique. Just as the proponents of high art had once berated the inadequate ambitions and provincialism of native painters, the new critics now compared the celebrated names in English art—Leighton, Burne-Jones, Poynter, Alma-Tadema—with the French Impressionists and Post-Impressionists, to find their native tradition, once again, wanting.

The cultural role of the English painter of the second half of the nineteenth century thus had at its very center elements of troubling uncertainty. Perhaps the reason for this peripheral status within the culture as a whole was intrinsic, and therefore not temporary. Perhaps the strange, antisocial eccentricity of England's greatest painter, Joseph Mallord William Turner, could be seen as symbolic of the artist's place "outside the center." This specifically English insecurity existed in combination with the more general questions faced by all nineteenth-century European artists: How should one paint for new groups of art patrons and for greatly enlarged and heterogeneous art publics? Where should one search for new visual symbols to replace the formalized and lifeless ones of past ages? How could one meet the expectations, engendered by the Romantic movement, for sincerity, intensity, spontaneity, and originality? How could a painter overcome a sense of marginality in industrializing societies in which utilitarian values left little space (and sometimes even denied the need) for the experience of art? No wonder, then, that many artists took spiritual shelter in what one art historian has termed an "earthly paradise"—a vision of a society (most often modeled on classical antiquity, the Middle Ages, or the early Renaissance) in which the painter's role is central and secure and art's language universally understood and appreciated.[26]

But the spiritual gratifications afforded by ideal visions of the distant

past could not solve the problem of finding a suitable role for the artist who had to paint his pictures in the very different context of Victorian England. The lack of consensus as to the artist's proper role and mission, the constant need for canvases that would cause sensations at exhibitions and thus keep the artist's name prominently before the public, and the burdensome expectation of originality all worked against fostering the gifts of painters of second rank (and below), whose works covered the walls at the annual art shows. An artist who created light, popular pictures might enjoy his success with a relatively untroubled soul, although he too had a psychological penalty to pay, having to face the charge—a very grave one for a Victorian in the public eye—of descending to popular taste rather than elevating it. For the truly ambitious painter who aspired to take his place among the world-historical figures in art (for artists shared the general belief in the Great Man), a moderate level of achievement might be as unsatisfying as complete failure. George Frederic Watts and Frederic Leighton, for example, who wished so desperately to combine in themselves the power of the painters of the Renaissance and the Romantic era's image of the divinely inspired artist, seem to have been almost overwhelmed by their own unlimited aspirations; their biographies and letters communicate a sense of acutely painful frustration, even real tragedy. The frequently ebullient Burne-Jones, who enjoyed not only ready sales and high prices, but also the adulation due the symbolic leader of a cult (see chap. 7 on the Grosvenor Gallery exhibitions), shared—although perhaps less intensely—in these feelings. "I don't want to copy objects," he once told his assistant, in an aside that suggests dissatisfaction with his ability to communicate to the public his highest artistic aims. "I want to show people something." He considered himself as no more than a small master, a "fourth-rate Florentine painter in a large commercial city."[27]

Nineteenth-century painters, especially the most serious and ambitious among them, could not help but respond to the high expectations, held by the art public and by themselves, concerning their personalities and creative powers. Some degree of disappointment, it would seem, was inevitable. A metaphor used by Hugo von Hofmannsthal aptly characterizes this special combination of disillusionment accompanied by the pose of genius; his image of the artist caught in this sociohistorical dilemma was that that of the "sick eagle."[28] The lasting effects of Romanticism, still present in our own day, left little room for the role Burne-Jones thought would have been his in Renaissance Florence, that of the small master, able to express his modest but admirable gifts without having to bear the

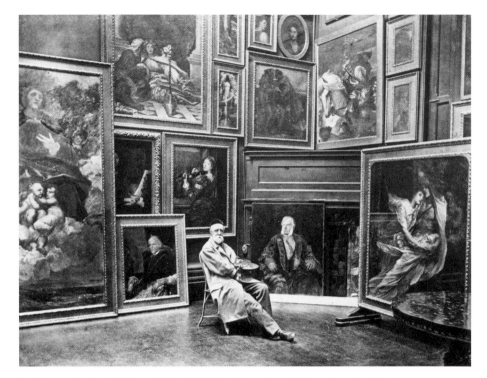

2. George Frederic Watts (1817–1904) in his studio. Dedicated to the idea that art should be an instrument of moral elevation, Watts is now most highly regarded for his portraits. Showing the painter surrounded by a selection of his works in a room Watts built especially to display them, this photograph conveys his wish to pass on an enduring legacy to his countrymen. (After the photograph by J. P. Mayall, as published in Frederic George Stephens, *Artists at Home*, New York, 1884.)

burden of comparison (whether inflated or invidious) with the greatest geniuses of art.

IN RECENT YEARS, painting exhibitions (both in Britain and the United States) and publications by art historians and biographers have stimulated renewed interest in Victorian art.[29] Even so, many (if not most) artists of the time—even figures of considerable prominence—remain unknown to students of Victorian social and cultural history, for this new interest in nineteenth-century English art has not yet been reflected in broader works of historical interpretation. The goal of the following chapters will

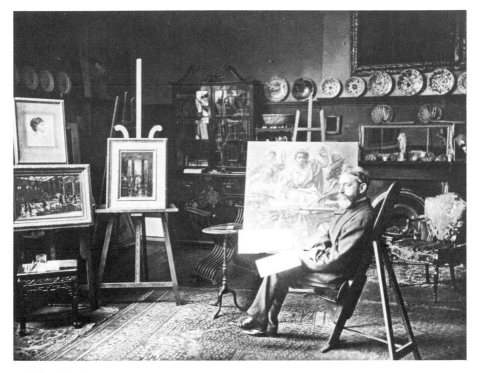

3. Edward John Poynter (1836–1919) was, like his contemporary Frederic
Leighton, a distinguished neoclassical painter and a prominent leader in the
official art world. First professor at the Slade School of Art in London, and later
director of art at the South Kensington Museum and at the National Gallery,
Poynter succeeded Leighton as president of the Royal Academy in 1896 and
held that post until 1918. (After the photograph by J. P. Mayall, as published in
Frederic George Stephens, *Artists at Home*, New York, 1884.)

be to provide a detailed picture of important aspects of the Victorian art
world, drawn from a wide variety of contemporary sources, and to show
how this knowledge enriches and deepens our understanding of social
history.

Whatever art historians may think of the quality of the work of Victorian
painters—until recently their judgments tended to be strongly nega-
tive[30]—many of these artists emerge from the pages of their writings and
from the observations of contemporaries as remarkable, often fascinat-
ing personalities. Their high degree of individuality no doubt confirmed
the belief, widespread at the time, in the uniqueness of those born with

artistic gifts. This strongly marked individuality does not, however, make generalization impossible for one who would study them as a social and economic group, for all necessarily shared certain preoccupations and practices. Anyone whose livelihood derived from the production and sale of pictures had, necessarily, to care about the state of the market for contemporary art and was therefore concerned about factors that influenced its vitality. Such factors included the general economic situation of the country; the presence of old masters (whether authentic or fraudulent) on the market at prices many patrons could afford; the prejudices of art critics; and the fairness with which painting exhibitions were run. And almost all artists were acutely and often painfully sensitive to issues that were in any way linked with their own social status and with the standing of the profession in the eyes of contemporaries.

This status anxiety, a pervasive feature in a society that was continually creating new wealth and redefining criteria of gentility, was particularly strong among painters. As recently as the preceding century, English painters had lived and worked as artisans, and the degrading memory of this low status could never be entirely forgotten by those who, however different were their spacious new studios from the old and cramped workshops of their predecessors, still labored with their hands and sold the goods they produced. Photographs taken of painters in their studios during the last three decades of the century show how enduring was the concern to erase residual memories of their artisan-tradesman past: impeccably dressed, they stare imperiously into the distance, their high-backed chairs and easels standing on oriental rugs, their palettes and brushes almost out of place amidst such opulence.[31] One is reminded of the remark made by Carlyle's niece when she accompanied her famous uncle to a portrait sitting at Millais's new Genoese palazzo in Palace Gate in the early 1880s. Overwhelmed by the grandeur of the hall with its white marble staircase and columns and doors of dark polished mahogany, and by the studio forty feet long by twenty-five feet wide by twenty feet high (a room that the artist, who loved space, found "none too large"), she turned to Millais and asked if "all this" could really have come "from a paint-pot."[32]

Although the scale of Millais's surroundings was unusual, wealthy and high-living artists were a numerous and highly visible group by this time. It seems paradoxical that many of the painters who repeatedly expressed the conviction that contemporary England had little room for art were in fact working in what one art historian has characterized as the "golden age of the living painter."[33] The use of this phrase is appropriate. The level of public interest in art that began at mid-century and continued well into the eighties was unprecedented. Fabulously high prices were paid for pic-

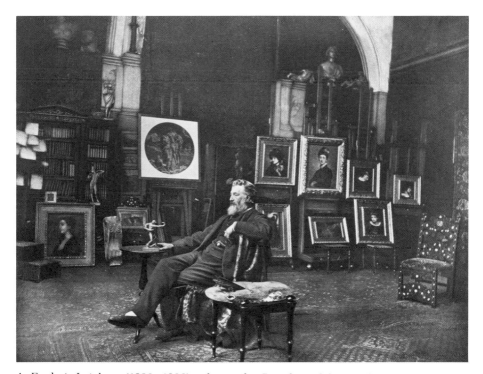

4. Frederic Leighton (1830–1896) in his studio. President of the Royal Academy from 1878 until his death, Leighton was widely considered the most distinguished president of the Royal Academy since Sir Joshua Reynolds. He was the only painter to be elevated to the peerage, as Baron Leighton of Stretton, but died just a day after receiving that honor. (After the photograph by J. P. Mayall, as published in Frederic George Stephens, *Artists at Home,* New York, 1884.)

tures, periodicals exclusively devoted to art were founded, and England's major exhibition of contemporary art, that of the Royal Academy, caused tremendous interest and excitement each year. The social events that began the season for London's elite were planned around the show's opening. Numerous issues of the *Times* and other periodicals devoted long columns to descriptions of the paintings and to critical commentaries. In 1879, the peak year of attendance, 391,197 visitors paid to view the exhibition.[34] The attorney general who, in the course of the sensational Whistler-Ruskin trial that took place the preceding year, had spoken of the "present mania" for art, was calling attention to a familiar social fact.[35]

Why did so many artists, even in the midst of all this fame and adula-

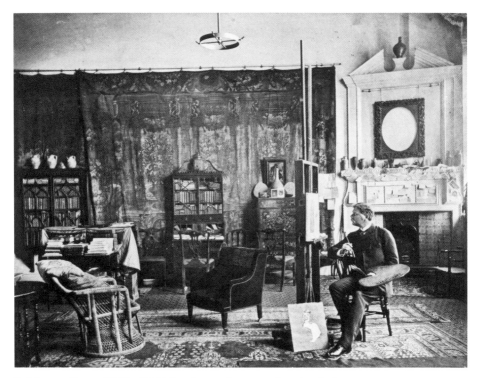

5. Marcus Stone (1840–1921) first learned to paint from his father, a genre artist who was an Associate of the Royal Academy. Stone's frequently sentimental pictures commanded a ready market and prices to support an opulent style of living. (After the photograph by J. P. Mayall, as published in Frederic George Stephens, *Artists at Home,* New York, 1884.)

tion, continue to feel oppressed by an overpowering sense of marginality? A number of answers to this question are suggested in the following chapters. Close attention to the careers of several prominent Victorian painters show that, however varied their artistic goals and practices, all had to respond to the basic uncertainty, the continuing lack of consensus concerning the role of the artist in society, and the legitimate functions served by the painter's work. Success and fame, however delightful, could not resolve this dilemma.

Even in the short run, public approbation seldom proved an unmixed blessing. The conditions that created success often bore no relationship to a painting's merits. Artists knew very well that stunning popular and criti-

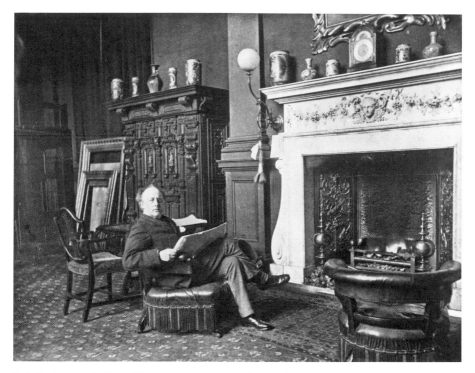

6. John Everett Millais (1829–1896) in his studio. With the signs of his profession discreetly placed in the background, the rich and famous Millais chose to be photographed in the pose of a gentleman in his private club. (After the photograph by J. P. Mayall, as published in Frederic George Stephens, *Artists at Home*, New York, 1884.)

cal acclaim might result from the depiction of a theme of high current interest, but success of this kind often proved ephemeral. A portrait's success was often due more to the social prominence of the sitter than it was to any recognition of the painter's abilities; many commissions were accepted with just this thought in mind. Good placement in the Academy exhibition was an important precondition for success, for the finest painting might go unnoticed if hung too high for viewing or in a dark corner. But the painter who was able to have pictures (particularly mediocre ones) hung too often at eye level in the best rooms was potentially suspect; the advantageous hanging might signify the abuse of his power as an Academician or the illicit use of personal connections with members of the

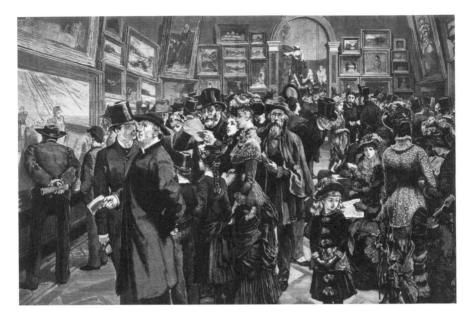

7. William Small, "At the Royal Academy" (*Graphic*, 26 June 1880). An illustrator of a number of books and periodicals, William Small was also a painter. Like other depictions of the Academy exhibition, this one shows that the annual show was at least as much of a society outing as it was an artistic event.

Hanging Committee. Even when success was merited, it signified little for the future, and many painters were embittered by the senseless changes in favor that they attributed to fashion. A painter who changed style or subject matter after enjoying success with one kind of picture was often berated for trying what he could not hope to do as well, while if he remained consistent to past practice, he risked losing the public's interest. Although painters struggled ardently for success, they knew that it was an ambiguous reward.

Another problem of far deeper significance resulted from the high incomes that artists enjoyed during the third quarter of the century. The impressive rise in status this new wealth helped to cause came close to fulfilling long-cherished ambitions for the social elevation of the artist. The Romantic movement had not weakened these ambitions but presented an altogether different ideal, that of the artist as a spirit mystically driven to create, one who was little understood—perhaps even scorned—by contemporaries. Nineteenth-century painters lived with uneasy combinations of these two conceptions, that of the painter-professional and

that of the painter-genius. The upper-class income level that was enjoyed by many painters during the "golden age" helped to establish painting as a profession, but it upset this uneasy balance, creating a profound sense of disloyalty to Romantic ideals. Originality and spontaneity were qualities alien to the polished professional image that many artists cultivated. The professional painter of the 1850s and 1860s was someone whose high degree of social integration made it possible to represent and serve common aims and ideals rather than the uncertainties of individual inspiration. Monetary rewards and elevated status had been achieved in substantial measure, but the psychic costs they incurred—especially among the most serious and reflective artists—were hardly negligible.

The new generation of painters who began their careers in the late 1880s and 1890s, when the days of high prices were clearly over, were far less concerned about social status than about selling their work. The gains that had been made in the social acceptance of painters did not appear to be in immediate jeopardy and, in any case, many of these young artists came from "good families." Their anger and frustration at the difficulty of finding adequate remuneration, now that the demand for contemporary art was so weak, were intensified by their conviction that society had broken an implicit promise. Had they not been led to believe, when they were young art students, that they would be as generously rewarded as the preceding generation of painters?

Herein lies some of the appeal that Whistler held for this group. This American-born, West Point–educated celebrity, who socialized with the "advanced" segment of the elite, was unquestionably genteel, in accordance with the assertive manner of the dandy. His message, however, was not that of the socially-integrated gentleman, but of one type of romantic artist—the lonely figure who scorned the public as he knew it would scorn him, the aristocrat of aristocrats. Endowed with a colorful and attention-getting personality and with great gifts as a publicist, Whistler strangely united in himself divergent images of genius and gentility.

Emulating the attitudes and social posture of their master, Whistler's disciples of the nineties represented a new spirit on the English art scene, which soon took on a very different character from that of the preceding years. Even as "art-for-art's sake" became the creed of the avant-garde of the nineties, the wider public interest in art that had prevailed since mid-century began rapidly to weaken. Equally rapid was the decline in the reputations of many of the painters whose careers will be discussed in the following pages. The congruence between prevailing social ideals and the form and content of painting that had been such a remarkable feature of Victorian life was at an end.

2. Gentlemen of the Brush

In 1839, young Queen Victoria commissioned the Scottish artist Francis Grant to paint her in an equestrian group portrait. The picture was shown at the following year's Royal Academy exhibition, with the title *The Queen Riding at Windsor with Her Gentlemen.*[1] Fourth son of the laird of Kilgraston and husband of a niece of the duke of Rutland, Grant was fully at ease in this high company. His education had included two years at Harrow and two at Edinburgh High School. He is said to have studied for the bar, but his dislike of the law and predilection for high living—fox hunting at Melton Mowbray in Leicestershire was his favorite form of recreation—led him to seek profit from his artistic gifts. By the time he was twenty-six, he had spent the whole of his inheritance of about ten thousand pounds. A group portrait Grant did of some fellow-sportsmen, *The Melton Breakfast* (1834), was the first great success that led to his becoming "the accepted portrait-painter of the upper circles of England."[2]

The response of the queen and of her prime minister and most trusted adviser, Lord Melbourne, to this gentleman-turned-professional-painter reveals a great deal about attitudes towards painters at the topmost levels of the social pyramid. Melbourne found Grant "deucedly difficult to understand," a comment made in response to the artist's offhand remark that "he was going into Leicestershire to paint three days and to hunt three days." The queen, who watched the progress of the picture with fascination, summed up her impressions of the artist unequivocally: Grant, "a very good-looking man, was a gentleman, spent all his fortune and now paints for money."[3]

Victoria's youthful reaction to the artist reflects the prevailing conviction that, although a number of painters had risen to the rank of gentleman, essential derogation followed when one born a gentleman took up painting as a career. In *The Newcomes*, a novel published a decade and a half after the queen first set down her thoughts about Francis Grant, Thackeray wrote:

The Muse of Painting is a lady, whose social position is not altogether recognized with us as yet. The polite world permits a gentleman to amuse himself with her,

8. Sir Francis Grant (1803–1878), president of the Royal Academy from 1866 until his death, was a painter of portraits and hunting scenes. His high social connection helped him gain great success as one of the most fashionable portrait painters of his time. "It is no disparagement to the President," wrote the *Magazine of Art* in 1878, "to say that we think that he obtained his post as much by his social as by his artistic qualities." (As published in the *Magazine of Art*, vol. 1, 1878.)

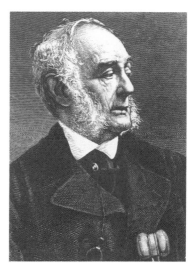

but to take her for better or for worse! forsake all other chances and cleave unto her! to assume her name! many a respectable person would be as much shocked at the notion, as if his son had married an opera-dancer.[4]

In 1866, Francis Grant was elected president of the Royal Academy. The queen's comment on this event conveys not only a greatly altered attitude towards him, but also a notable element of uncertainty in the social categorization of the artist: "The Queen will knight Mr. Grant when she is at Windsor. She cannot say she thinks his selection a good one for Art. He boasts of *never* having been in Italy or studied the Old Masters. He has decidedly much talent but it is much the talent of an Amateur."[5]

The queen recognized the error of her initial judgment. Grant, as much at home in the great houses of London as he was fox hunting at Melton Mowbray, had not, as she had thought, left his gentility behind when he became a professional painter. But his surprising ability to combine genteel status with painting for money still made her uncomfortable and led her to question his professionalism. Surely she knew that in England there were many professional painters who had neither traveled in Italy nor studied the Old Masters—and, in fact, that it was precisely gentlemen-amateurs who were most likely to have done both. Victoria's confusion was symptomatic of the fact that during the late sixties, more than at any time since the founding of the Academy in 1768, the painter's social status was undergoing a change of revolutionary proportions.

The Social Elevation of the Painter

One young man who found inspiration in Thackeray's story of Clive Newcome, who shocked his well-connected family by turning his back on social advantage and deciding to become a painter, was Edward Coley Burne Jones, the son of a Birmingham picture-frame maker. Like his friend William Morris, Ned Jones (later called Burne-Jones) had come to Oxford in 1853 to prepare for a career in the Church. In an essay on Thackeray's novel that the two young friends published in 1856 in their joint venture, the *Oxford and Cambridge Magazine*, Burne-Jones eloquently expressed the deeply personal meaning *The Newcomes* had for him. He wrote:

I refer principally to that episode in Clive's life where he makes known to his father the desire of his heart to become a painter, and dedicate his life to that end; and the good Colonel loving his son so that he would gladly die for him, cannot be brought to see it with the eyes of his son. Can understand him adopting it for amusement's sake, refined *dilettantism;* but to be a painter by profession—to live by the labour of his hands so, this he cannot comprehend, this society and immaculate respectability cannot endure. . . . Respectability? When shall we waken from this nightmare and dream of phantoms to a knowledge of the true dignity of work in any kind; to a confession of the majesty of soul in any form? I wish that the primal question at the setting out of life were not *what* is the best thing to do, and the most thought of, but rather *how* and in what manner and degree of excellence it is to be done.[6]

Burne-Jones's passionate identification with his fictional counterpart sprang directly from recent experience. Just a year earlier, he had broken the very same sort of news to his own father, who had found it necessary to move to a smaller house and take in a lodger in order to send Ned to Oxford to prepare for a career in the ministry. The sudden change of vocation could hardly have seemed, at that time, repayment for such paternal devotion. Bitter arguments must have taken place between father and son. In a letter to a cousin in 1855, Burne-Jones allowed himself the following sarcastic outburst:

I shall not grace my friends now by holding that highly respectable position of a clergyman, a sore point that, giving up so much respectability, going to be an artist too, probably poor and nameless—very probably indeed—and all because I can't think like my betters, and conform to their thinking, and read my bible, and yes, dear friends, good advice, not very profound perhaps, rather like sawdust to a hungry man.[7]

For Burne-Jones, a shopkeeper's son, the new career choice did not involve social derogation, but the denial of future prospects. Very different

was the case of William Morris, son of a successful London stockbroker, who in 1847, four years before his death, had secured a coat of arms for his family.[8] For the wealthy and elegantly dressed Morris (whose income since he came of age in 1855 had been nine hundred pounds a year), the growing of long hair and a moustache, the donning of a soft hat, and marriage (in 1859) to his model, Jane Burden, the daughter of an Oxford groom, had signified a profound change in personal identity. Yet within a short span of years, the assumptions that Burne-Jones and Morris held about the social consequences of choosing painting as a career were to become outmoded. Ironically, the respectability that would soon come to painters would lead far beyond the fulfillment of the elder Jones's fondest paternal ambitions: his son would one day become Sir Edward. In stark contrast, Morris, who became increasingly concerned with reestablishing the unity of artist and artisan and dedicated to freeing society from degrading notions of social exclusiveness, would turn away from painting altogether. He came to believe that within the structure of the modern capitalist economy, painting was an irredeemably elitist form of art that bore witness to a diseased society. Although he remained friends with Burne-Jones for many years, Morris never bought a picture after he lost interest in becoming a painter; his own house had few pictures on its walls.[9]

Like Burne-Jones and Morris, the future landscape painter and art writer Philip Gilbert Hamerton had personal experience of the profound social gulf that separated the clerical from the artistic career during the 1850s. He was motivated by a love of art, a strong dislike for "construing" classical authors, and moral scruples against signing the Thirty-Nine Articles (the basic doctrinal statement of the Anglican church, subscription to which was required for matriculation at Oxford and for graduation from Cambridge).[10] But when he decided to seek private instruction in painting, he found his efforts frustrated by his impeccable social credentials and independent means: he had been born into "one of the oldest and best-descended families in the English untitled aristocracy." So strong was the association of professional painting with low social status at this time that an aspiring artist of high social class found it difficult to escape being labeled a dilettante, which was considered the only proper role for a gentleman with a turn for art. As Hamerton wrote in his autobiography:

There was nothing more difficult in those days [1852] than for a young gentleman to become an artist, because no human being would believe that he could be serious in such an intention. As I had a fine-looking horse in the stable at the hotel, Pettitt [the Keswick artist whom Hamerton had chosen to be his teacher] of course took me for an amateur, and only attempted to communicate the superficial dexterity that amateurs usually desire.[11]

If everyone, from Pettitt the painter to Victoria the queen, knew that no gentleman would be a professional artist, then one choice open to the gentleman aspiring to be a painter was to cease to appear the gentleman. Thus, William Morris's deliberately altered demeanor, while it no doubt included an element of self-conscious posing, also served to conceal the combination of apparent high social status and artistic professionalism that was considered to be incongruous at this time.

How was it that the ascription of low status to the career of painting continued to be so natural for well over a half-century after the death of Reynolds? It was Reynolds who was again and again credited with the accomplishment of having raised the status of the artist, both by the example of his own life and by his distinguished service as first president of the Royal Academy, membership in which was regarded, in the words of Reynolds's pupil Northcote, as "equal to a patent of nobility"?[12] Of the public significance of Reynolds's high social attainments, there can be no doubt; he had shown, with real brilliance, that a painter could gracefully take his place both in intellectual circles and in aristocratic society. When he died, leaving an estate of eighty thousand pounds, this unprecedented eminence was marked by a ceremony at St. Paul's with ten pallbearers: three dukes, two marquesses, three earls, a viscount, and a baron.[13] Even so, his assimilation into the highest social stratum was less than complete. Horace Walpole, the writer, politician, and connoisseur, was deeply interested in Reynolds's work and career; during the 1760s, he collected so much information about the painter that he spoke of being "delighted in indulging his Vasarihood." Walpole met on familiar terms with both David Garrick and Reynolds, but it is the opinion of one noted scholar that he always remained aware, as a fact of social significance, that the first was an actor and the second a painter. Reynolds cultivated the society of writers, a group that the aristocratic Walpole avoided. In 1771, Walpole and Reynolds visited Paris. The records that each kept of the trip indicate that they moved in two distinct social worlds. Walpole spent most of his time in the company of aristocrats, while Reynolds, who spoke French quite poorly, socialized mostly with painters and art dealers. There must have been numerous slights and innuendos behind Frances Reynolds's otherwise surprising statement that she derived far greater respectability from being the daughter of a clergyman than the sister of a great painter.[14]

But no one demonstrated the limited extent of the gain in painters' status, even after the founding of the Academy, more clearly than did the president himself. Like his successors Sir Thomas Lawrence and Sir Charles Eastlake, Reynolds almost never offered hospitality to his fellow

painters, except on occasions of semiofficial Academy entertaining. He seems never to have proposed an artist for membership in The Club, a society (of which Dr. Johnson and Edmund Burke were members) that Reynolds had founded in 1764 for weekly conversational dinners. Even more significant is the fact that no artists were invited to the dinner party Reynolds gave on 27 April 1769 to celebrate being knighted. In the opinion of William Whitley, a collector of richly detailed information about the lives and social relationships of artists during the eighteenth and early nineteenth centuries, it is strange to find that the Royal Academy was completely unrepresented at that event.[15]

There were two major ways of acquiring gentlemanly status in eighteenth- and early nineteenth-century England, before the Victorian redefinition added a strongly moral dimension to the word *gentleman*. One needed the education of a gentleman, devoted largely to the history and literature of classical antiquity; or one needed the means by which to live like one. Before the 1860s very few artists had the first. Reynolds, the son of a clergyman and school headmaster, had a rudimentary classical education; at the local grammar school he attended, he acquired only an insecure command of Latin and no knowledge at all of Greek. It was an education he considered weak, when in later years he came to associate with men of learning and literary attainments. F. W. Hilles has characterized Reynolds's deliberate and liberal sprinkling of his writings with classical allusions and quotations as the equivalent of the unnaturally erect posture of a man of small stature.[16]

If the painter was to become a member of polite society, it was essential for him to live in gentlemanly style. With a yearly income of six thousand pounds, Reynolds was easily able to do this. The self-conscious ostentation of his adopted mode of life was a fitting counterpart to his classically decorated prose. Having used almost all his savings for the leasehold of a house in fashionable Leicester Square, he then purchased an elaborate carriage with carved wheels and painted panels that illustrated the seasons of the year. The coachman supplemented his own income by charging admission to those curious to view it. When his sister, Frances Reynolds (a painter herself), criticized its excessive showiness, the painter replied, "What, would you have one like an apothecary's carriage?"[17]

It was not for almost a century after Reynolds's acquisition of the splendid house and carriage that substantial numbers of artists were able to live like gentlemen. Some of the best-known English painters of the first half of the nineteenth century lived in houses so modest that their average purchase price could easily have been surpassed by the income from a single

picture sold at prices that became standard during the century's third quarter.[18] Like the elegant billiard-room that the Victorian painter Frank Holl made of his engraver-father's old workshop, the palatial studio-houses of the sixties, seventies, and eighties were attempts to replace and deny the earlier image of the artist—attempts altogether in the spirit of Reynolds's remarkable coach. With the instrument of the Royal Academy and by the impressive example of his own professional and social accomplishments, Reynolds had succeeded in replacing the figure of the artisan-painter—whether coach painter, sign painter, hand-and-drapery painter, or face painter, as they were known at the start of his career—with the figure of the *artist*.

How did this new persona, the English artist, live in the days when spacious north-lit studios and tapestry-hung reception rooms were as yet undreamed of? Consider the situation of Charles Robert Leslie (1794–1859), the well-loved genre painter and close friend and biographer of John Constable. He became an Associate of the Royal Academy in 1821 and a full Academician four years later. He was elected professor of painting in 1826, and received two important royal commissions in 1838 and 1841 to paint the queen's coronation and the christening of a royal princess. For all his eminence, the studio in which Leslie painted most of his works was, by the standard of later times, no studio at all, but simply a back bedroom. A contemporary wrote: "So small was this room, that it was difficult to make one's way on a floor strewn with materials ready at hand for his purpose. There was little or no space to retire from his work, to enable him to see the effect."[19]

By the 1850s and 1860s, many illustrated periodicals (notably *Punch*, *Illustrated London News*, *Household Words*, *Cornhill Magazine*, and *Once a Week*) and the "factories" that supplied them with wood-engravings were providing artists with an economic cushion during the early years of their careers. Before then, young painters lived under conditions of discomfort and deprivation that, with the added touch of gaiety present in Richard Redgrave's autobiographical memoir, suggest comparison with Henri Murger's depictions of artist-life in Paris.[20] "I and my fellow-students," wrote Redgrave of the years between 1818 and 1830, "then had little hope of selling our pictures, and those who had no independent means had to submit to many privations in the study of their profession. They eked out their incomes by designing for silversmiths, by painting an occasional portrait, or by drawing for woodcuts. They put up with hard fare with a light heart, and were a thoughtless, jovial crew."[21] It seems amazing that so many of these artists managed to survive their early years.

One cannot help being impressed by the sheer determination and inex-
haustible energy that supported their efforts to grind out enough income
to subsidize paintings they knew were unlikely to sell, but the exhibition
of which might help to establish their names. Solomon Hart, for example,
added to the meager income received from the sale of his pictures during
the 1830s by spending his evenings doing wood-drawings for *The Library
of Entertaining Knowledge,* one of Charles Knight's series of books pub-
lished for the Society for the Diffusion of Useful Knowledge. This promise
of steady income gave Hart the courage to undertake the ambitious pic-
ture that gained him entry into the Academy.

This employment was a turning-point in my pecuniary affairs. For I was so fully
occupied during the winter evenings, that I hardly ever went to bed without having
earned a guinea, and sometimes two. Thus I was able, during daylight, to bestow
all my time and pains on my pictures, and pay the expenses incurred in their pro-
duction. I also was not under pressure to send them to the Exhibitions, until I had
completed them to my mind. . . .

The money thus earned enabled me to devote myself more earnestly to my early
pictures. Each of them took me six months to paint. The small sums I received for
them could not pay for rent, taxes, food, and clothing, for three persons—my fa-
ther, brother, and self. I was forced to decline several commissions, and take my
chance of selling more ambitious works, with a view of becoming an R.A. This I
accomplished. . . . The prices then paid scarcely enabled one to live. In order to
obtain the diploma of R.A. I had the rashness to enlarge my canvas to nearly four-
teen feet square. I devoted a year on it, and paid models during the entire time.
I could never see the whole of the effect, as I had to fold the canvas at the bottom to
get at the top, and *vice versa.* In order to view it as a whole, I hired a room in Brook
Street, at a cost of twenty pounds for a month. I exhibited it at the Royal Academy,
and had no offer for its purchase. The following spring I was elected an Academi-
cian. When I called upon Chantrey he scolded me for painting so large a picture,
and choosing so painful a subject as the "Execution of Lady Jane Grey." I asked
him whether his vote for me had been influenced by the picture. He answered
in the affirmative. Thereupon I rejoined that I had made a good investment of
my time.[22]

In addition to work illustrating books and periodicals, a major source of
income for artists during the first half of the nineteenth century was their
employment as drawing masters, both privately and by schools. Richard
Redgrave and his friend George Smith personally delivered prospectuses,
in which their qualifications as teachers of drawing were persuasively set
forth, to about a hundred schools. This method proved unproductive, but
the drawing-mastership Redgrave did eventually find was held by him al-
most until he became an Associate of the Royal Academy, in 1840. William
Mulready (1786–1863), one of the most eminent genre painters of the

period, depended for almost his entire career on income from teaching, supplemented by earnings from book illustration. Mulready once commented that he "had passed through life as a drawing master, giving a little of his superfluous time to painting." P. G. Hamerton recalled that when flush times came in the fifties, it became a matter of pride for painters to refuse to give lessons; they sought thereby to declare their social superiority to the humble drawing master upon whose path they themselves had probably once expected to tread.[23]

During the first half of the century, parental opposition to a career in painting was usually based not upon disapproval of the presumably immoral ways of artists but upon an understandable concern for the venture's economic precariousness. An early or imprudent marriage, for example, could doom a painter's career at the very start. "I remember the time," Mulready said, "when I had a wife, four children, nothing to do, and was six hundred pounds in debt."[24] Others had undergone similar deprivations, to the detriment of family life and careers. The bachelor Joshua Reynolds told John Flaxman, the sculptor and future illustrator of Homer, "I am told you are married; if so, sir, I tell you you are ruined for an artist."[25] Although this proved a false prophecy in Flaxman's case, words like these must have given pause to several generations of young men who had to weigh love for art against the desire for a secure family life.

This situation underwent a remarkable change during the 1850s. The dramatic upturn in the financial fortunes of Charles Robert Leslie was typical. As his son, George Dunlop Leslie, wrote: "My father earned more by his paintings during the last ten or twelve years of his life [from the late 1840s until his death in 1859] than he had earned throughout almost the whole of the rest of his career; it was, indeed, the only period of his life in which he was enabled to put by money at all."[26] The progression from modest living to riches, described again and again in biographies of British artists active during the third quarter of the century, is remarkably congruent with the Victorian image of the self-made man, who by talent, strength of character, and unremitting effort made his contribution to society and was rewarded with wealth and honors. It is not surprising to find that Samuel Smiles included, in the famous book first published in 1859, *Self-Help; with Illustrations of Character, Conduct, and Perseverance*, along with chapters on businessmen, scientists, inventors, and leaders of industry, a chapter called "Workers in Art," in which he wrote of the inspiring example of artists of "humble origin," who by "patient labours" and "indefatigable industry" were able to rise above privation to make full and valuable use of their natural gifts. No doubt there was some degree of

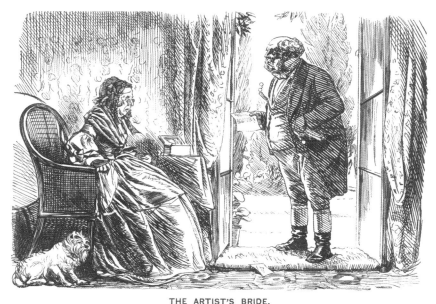

THE ARTIST'S BRIDE.

FATHER (reading letter from lately married daughter in London). "*And, dear Father, if you could send us any old worn-out smock-frocks, or corduroys and ankle-boots—Mother could get them from the farm-men for a trifle, it does not matter how shabby they are—they would be very useful to my dear Edward—*"

MOTHER (with a shriek). "*Mercy on us! my poor child! There, Sam, I told you how it would be!*" (Faints.)

But it turned out from the sequel, that dear E. only wanted those garments to paint from, for his great picture of the "Statute Fair," that was the chef d'œuvre of the Season, and for which he got, say 4000 pounds, exclusive of Copyright.

9. "The Artist's Bride" (*Punch*, 31 August 1861). The *Punch* cartoonist invites his readers to smile at the lack of sophistication of a contemporary painter's rustic in-laws. Living outside the London art world into which their daughter has recently married, this country couple do not yet know that the image of the starving artist has become old-fashioned and outmoded.

exaggeration in these stories, but the essential elements were based on the experience of real life. Smiles's account of William Etty's career shows how these patterns could be transformed into the belief system that we know as the Victorian gospel of work.

William Etty was another notable instance of unflagging industry and indomitable perseverance in art. His father was a gingerbread and spice maker at York, and his mother . . . was the daughter of a rope-maker. The boy early displayed a love of drawing, covering walls, floors, and tables with specimens of his skill; his first crayon being a farthing's worth of chalk, and this giving place to a piece of coal or a bit of charred stick. His mother, knowing nothing of art, put the boy apprenticed to a trade—that of a printer. But in his leisure hours he went on with the practice of drawing; and when his time was out he determined to follow his bent—he would be a painter and nothing else. Fortunately his uncle and elder brother were able

and willing to help him on in his new career, and they provided him with the means of entering as pupil at the Royal Academy. We observe, from Leslie's Autobiography, that Etty was looked upon by his fellow-students as a worthy but dull, plodding person, who would never distinguish himself. But he had in him the divine faculty of work, and diligently plodded his way upward to eminence in the highest walks of art.

Many artists have had to encounter privations which have tried their courage and endurance to the utmost before they succeeded. . . .

Martin encountered difficulties in the course of his career such as perhaps fall to the lot of few. More than once he found himself on the verge of starvation while engaged on his first great picture. . . . Upheld throughout by the victorious power of enthusiasm, he pursued his design with unsubdued energy. He had the courage to work on and to wait; and when. . . he found an opportunity to exhibit his picture, he was from that time famous. Like many other great artists, his life proves that, in despite of outward circumstances, genius, aided by industry, will be its own protector, and that fame, though she comes late, will never ultimately refuse her favors to real merit.[27]

"Genius, aided by industry," "the divine faculty of work"—one should add to Smiles's account of Etty's life Frith's recollection of that artist who, even when old and sick, would trudge up the stairs to the life class held at the top of the Academy's quarters in Trafalgar Square, stopping occasionally to recover his breath, rather than miss one night of study and self-improvement.[28] This exemplification by painters of one belief central to the Victorian ethos, that a person's moral worth is shown in unswerving and unremitting industry in his chosen field of work, is a clue to the relatively easy integration of artists into respectable society that followed upon the improvement in their earning power. Carlyle and Ruskin, the two great proponents of the gospel of work, were both sources of inspiration to artists.

Carlyle, his "scarcely suppressed contempt for painters" notwithstanding,[29] was a source of inspiration to Ford Madox Brown, who included a portrait of the philosopher in his famous 1863 painting, *Work*. Carlyle and the Christian Socialist F. D. Maurice are portrayed as "brainworkers, who, seeming to be idle, work, and are the cause of well-ordained work and happiness in others."[30] Brown's biographer, his grandson Ford Madox Ford, noted that the painter's copy of *Past and Present* showed clear signs of frequent use, with pencil-markings underlining the passages that elaborated the gospel of work.[31]

Ruskin, for many years a disciple of Carlyle, placed high value upon the amount of labor expended upon a painting, both as meritorious in itself and as a determinant of its artistic worth.[32] This belief in the importance of

the visible presence of hard work in a painting was a crucial element in Ruskin's famous attack on Whistler, and it is significant that the charge was made in *Fors Clavigera*, a series of letters to the workers of England.[33] Inspired by his vision of an ideal society in which the artist would be a worker uniting the labor of hand with the devotion of heart and mind (as the critic presumed him to have been in medieval times), Ruskin charged Whistler not with lack of ability, but with its misuse, with the moral failings of flippancy of attitude and shoddiness of work. According to Whistler's account of the 1878 libel suit he brought against Ruskin, the great critic indicated (in the words of the attorney general who repre-sented Ruskin at the trial) that he had the highest appreciation for *com-pleted* pictures, but required from the artist more than "a few flashes of genius."[34] Ruskin, in his statement of the case, wrote that Whistler should have been aware of "what good artists gave, habitually, of labour to their works, or received, contentedly, of pay for them." An artist should know "his true position with respect to his fellow workmen, and ask from the public only a just price for his work." Two hundred guineas, said Burne-Jones, testifying for Ruskin, was too high a price "when you think of the amount of earnest work done for a smaller sum."[35]

For this image of moral respectability (which was based not only upon regular habits of hard work, but also upon the piety shared by many early Victorian painters) to become social respectability required economic im-provement as well as gains in social polish and presence, gains that could be both confirmed and accelerated by the recruitment of painters from higher social strata. The movement of the painting profession towards so-cial respectability was slow and gradual. Members of the 1863 Royal Com-mission on Royal Academy in Relation to the Fine Arts investigating the position and practices of the Academy made clear, as did many of the wit-nesses they interviewed, that they looked upon painters as crude and un-educated people. Ruskin agreed with his questioner's suggestion that the "want of refinement" of many Academy pictures was directly attributable "to the want of education among artists," while Tom Taylor, art critic, play-wright, and kind friend to many painters, urged the commission that the next president of the Royal Academy (to succeed the socially polished Eastlake) be a layman and not a painter at all. It was his forcefully stated opinion that the dignity of the position would be lowered if the office were filled by an Academician, for no painter since Reynolds had culture wide enough to bring to it.[36]

"Artists are dull dogs . . . an uneducated lot." Such was the authori-tative opinion of Benjamin Jowett, master of Balliol College, Oxford, as

reported to A. S. Hartrick, an Oxford student during the late 1870s, in response to the young man's tentative proposal of painting as his life career. Hartrick later became a successful painter and art teacher: "Nevertheless, that dismissal of all artists as 'dull dogs' rankled with me at the time and still does."[37] Yet, the relative ease with which this army officer's son was able to proceed in opposition to the sage advice of his elders, enrolling at the Slade School of Art soon after he had passed the matriculation examination for medicine at Edinburgh University, may be taken as an indication that the painter's career, although not always looked upon as desirable for a young man of good family, was not now, as it had been in the student days of Burne-Jones and Morris, altogether unthinkable. The attitude expressed by Jowett reflected the standard judgment of an earlier time and was long out of date by the late seventies. Conceptions of the social position of the painter had undergone great change, and while the essential preconditions for this change were to be found in the fifties, in the boom market for contemporary art and in the writings of Ruskin and Thackeray, the actual metamorphosis seems to have taken place during the later sixties.

In 1862, P. G. Hamerton included, in a book called *Thoughts about Art,* an essay with the title, "The Painter in His Relation to Society." In it, the author expanded upon the contemporary relevance of Plutarch's observation that excellence in "servile or mechanic employments" was a sign of the neglect of nobler studies; thus, even the greatest admiration for works of art could coexist with low social status for their creators. Hamerton observed that most people agree with Plutarch's judgment. Men respect power. The class in England which holds power is blind to the value of art, whose power is too subtle for them to understand; thus, artists are regarded by polite society with contempt. Reconsidering this essay in 1873 for inclusion in a new edition of his book, Hamerton found it necessary to add a note in which he stated that the entire essay could now be considerably abridged, "because the rapid progress of liberal ideas makes it no longer necessary to occupy many pages in fighting against one of the most stupid and narrow-minded prejudices of our barbarian and Philistine classes." Hamerton ascribed the change to the general easing of class barriers. "It has always been one of the characteristics of classes to be able to perceive truth and poetry quite accurately and delicately in the forms which the class approves, and to be at the same time entirely blind to them in forms not consecrated or accepted by the class."[38] The argument is not worked out in close detail, but the implications are clear. Since significant numbers of people without the polish provided by a classical education

were now being allowed into the gentlemanly class, artists similarly lacking in social finish no longer appeared to be pariahs. The widening of the upper classes in its turn entailed a consequent expansion of the "truth and poetry" their members were able to perceive and accept.

The admission of painters of undistinguished social origin into fashionable society was accompanied by a dramatic alteration in the social recruitment of professional artists. Critics of the Academy's supposed neglect of high art had commonly attributed this neglect to the fact that painters almost always originated in the lowest and least-educated social strata. Not having acquired the vocabulary of gentlemen, that is, a familiarity with classical history and mythology, how could they paint pictures that would speak the language of the upper classes and at the same time provide "elevating" influences to the masses? Addressing himself to the same problem in a different national context, the French art critic Ernest Chesneau suggested that the solution was obvious. One must, he said, give literary and scientific training to "the illiterate classes," while at the same time improving the artistic training of the cultured classes.[39] In England, the solutions proposed were similar, although not identical. Ruskin's founding of an art school at Oxford while he was Slade professor in the early seventies was not intended to make artists of gentlemen, but to create a more informed and appreciative class of patrons. Although Ruskin did propound a new system of art education, it was not by this proposal but by the noble image of the artist presented in his writings that he was able to make the profession appear acceptable and even highly desirable to those of privileged birth and education. The great critic emphasized the subservience of all purely technical and mechanical aspects of painting to the intellectual nature of the endeavor.[40] A gentleman who was persuaded by Ruskin's analysis need have no fear for the future status of a son who aspired to a career in art.

In theory, this was all very well—one could even accept the scarcely articulate Turner as a divinely gifted intellectual with a confusingly rough exterior—but uneducated Royal Academicians with far more modest talents could hardly be taken seriously as "brain-workers." Other professions were upgrading themselves by means of qualifying examinations; would not the profession of painting experience similar improvement if the undeserving were filtered out by a test of general education which might be made a prerequisite for admission to the Academy schools? Such a suggestion had been made by an Academician during the 1840s. His proposal had been that candidates to the schools present along with their drawings a certificate of university matriculation or proof "at least of having had a

first-class education at some good school." It was pointed out, however, that such a requirement would have excluded from the schools, among many others, Turner, Landseer, Millais, and Constable. "I need scarcely say," wrote G. D. Leslie, who had heard of the proposal from his father, "that this innovation found little support."[41]

The idea received renewed public discussion by the 1863 commission on the Royal Academy, but the initially favorable reception was once again tempered by the fear of closing the door upon some future Turner. Holman Hunt, for example, dedicated to a genre of art laden with symbolic and philosophical content, testified that while a requirement for general education sounded fine in the abstract, he would be against adopting any regulation that, had it existed in the past, would have kept Turner out of the Academy schools. The wealthy baronet and art amateur Sir Coutts Lindsay was among the strongest proponents of the proposed test; Turner, he said, would have been "an infinitely greater man if he had been compelled into a better education." The didactic painter George Frederic Watts, who, like Ruskin, held that the quality of a painter's thoughts and insights were more important than his mastery of technique, was one of the few artists to support the proposal. He responded to the Turner question with subtlety. "Such a man as Turner," said Watts, "would have probably set to work to gain the necessary acquirements, if he desired to enter the Academy, and would have acquired an amount of education which would have been valuable to him." Ruskin's own testimony went to what he identified as the heart of the matter. Instead of supporting a test that would have excluded Turner, he advocated a completely restructured system of art education. Schools for all social classes should teach the elements of art as part of their curriculum. The future painter would proceed, at about the age of fifteen, to a "university of art," where he would receive a broad and liberal education that would enable him "not only to work nobly, but to conceive nobly." Like several of his fellow witnesses, Ruskin was concerned "to attract to the profession a superior class of men to that which is often to be found in it."[42]

THERE ARE numerous examples of individual social mobility among painters prior to the 1860s, but these did not alter the occupation's unambiguous placement outside the gates of respectability. For example, a long list could be compiled of artists who repeatedly enjoyed aristocratic hospitality, but the very form in which it was offered was indicative of limited social acceptance. Rather than signifying social integration, the invitation to an artist expressed the desire to enliven a country weekend with a talented and "interesting" guest.

An American novelist of manners pointed to one aspect of such invitations that artists found particularly galling: they were often the only guests present without their families. The novelist's observation that English hosts never invited the wives and daughters of artists to their lavish parties and country-house weekends is confirmed by many letters (frequently published in memoirs and biographies) from painters to their left-at-home wives.[43] The American artist Chester Harding, reminiscing during the 1860s about his periods of residence in England in the twenties and again in the forties, cited the socially ambiguous position of the painter as the main cause of his decision to return to the United States. The decision had been an especially difficult one because of his close relationships with highly placed patrons and a deep emotional attachment to London, "the fountainhead of everything that is excellent in my profession, as well as every means of attaining excellence in it." While Harding's decision to leave was, in both cases, influenced by the unpropitious state of the economy and consequent lack of demand for the work of painters, other factors were also involved.

I was influenced in my decision even more by another consideration. I had three daughters, nine, seven, and three years old. They were very pretty. Should they, when they grew up, fulfil the promise of their childhood, I felt they would be exposed to dangers growing out of the state of society in England which they would be free from at home. My profession entitled me to move in the highest circles, in which, at the same time, my wife and children would not be recognized. This is one of the cruel customs of the aristocracy of Great Britain.

Harding was acutely aware that even his own welcome to high social circles was not without its note of humbling ambivalence. The artist, he wrote, although he may be privileged to take "Lady So-or-So" down to dinner, has often to face the unmistakable signs of her disgust at being escorted by "that vulgar man."[44]

It is hardly surprising that, as society moved towards awarding greater status to wealth (until by the end of the century the "wrong people" were said to be everywhere), it was money that made the difference. The high earning power of painters, sustained for a quarter of a century, gave impetus to the social rise not just of individual artists but of the profession itself. Money was not a sufficient cause—time was needed for the establishment and recognition of the new gentlemanly image of the painter; the grand houses had to be built, the sons sent to the great public schools— but it was essential. High remuneration, as Carr-Saunders and Wilson observed in their book on the professions, implies public recognition of status; thus, the best way to gain status is to procure high income.[45] Squire

and Marie Bancroft, the famous Victorian actor-manager couple, under-stood this well and applied their insight effectively to their sector of the art world. The Bancrofts took great pride in their contribution to the elevation of the status of actors, a change in status they had consciously sought by means of the enormously increased salaries they paid.

Salaries were lamentably small, and the rewards to which even eminent actors could aspire in former times were pitiful indeed. . . . We may claim without ar-rogance to have been the first to effect a reform which should secure a proper re-ward for the laborious life and special gifts demanded of the actor, and make the stage a worthy career for refined and talented people. The pay was small enough, and on the old lines, when we began; in a few years things were very different. . . . The advance came soon by leaps and bounds: . . . We gave George Honey sixty pounds a week to take the part in *Caste* which he had previously acted for eigh-teen, while Mrs. Stirling, when she played the Marquise in our final revival of that comedy, received eight times the salary we had paid to the original representative of the character. To Charles Coghlan, who only received nine pounds a week with us when he replaced Montague, we paid, on later occasions, fifty, and then sixty pounds; and without multiplying examples, I may say that such rates were main-tained proportionately throughout the company.[46]

The status reward connected with high remuneration for the work of artists was not, of course, newly born in the nineteenth century. Francis Haskell has observed that the high prices paid to artists in seventeenth-century Rome, after the decline of the High Renaissance had set in mo-tion a downturn in the social standing of the profession, had the effect of again raising "the whole status of art in the eyes of the world."[47] In seventeenth-century Amsterdam, it was said that Rembrandt's extremely high bids at auctions of drawings and paintings—so high that there never was a second bidder—were deliberately made "in order to emphasize the prestige of his profession."[48]

"Among the contemporary masters of the brush who adorn the true En-glish School," wrote T.H.S. Escott in 1898 in a book called *Personal Forces of the Period,* "Mr. Marcus Stone, Mr. Orchardson, Mr. Leslie are each of them finished and prosperous men of the world in social request every-where. Each of these, with the polished manner the outcome of prosperity as well as breeding (and better specimens of the intellectual gentlemen of England could not be found), impresses the popular mind with a feeling that art can be an exceedingly paying business; each thus, apart from his work, materially improves the status of his profession." It had been ob-vious, long before Escott delivered this pompous judgment, that painting could, indeed, be a paying business and that the artist could take his place as a gentleman with no sense of incongruity.[49] It was this combination of

the possibility of material gain with the promise of gentility that made painting a serious and acceptable vocational choice for painters from respectable families. Francis Davenant's inclusion of art as a career to be considered by ambitious parents along with law and medicine (each with its attendant attractions and disadvantages) in his 1870 manual *What Shall My Son Be?* confirms Hamerton's observation that major status change had taken place by the early seventies.[50] Davenant's point in a similar book of 1881 was that bohemian habits and frequent carelessness of appearance among artists tended to perpetuate the idea that, although art was a "respectable" career, artists themselves were "not quite *comme il faut* persons." In fact, Davenant urged, the reputation was no more deserved by artists than by law students or university undergraduates, and not so much deserved as by medical students. In any case, such residual uneasiness was present mostly in the "popular mind"; the profession, far from being despised, Davenant adds, was "rather affected by those whose education and associations are likely to help greatly towards taking away altogether the erroneous notion I have referred to."[51]

In 1878, the *Magazine of Art* provided its readers with an outline of the preparatory stages of a career in painting that was altogether congruent in tone with any other vocational description. The route counseled is through the Academy schools, entrance into which is characterized as easy, with "none of the provoking limitations of age which hedge in the examinations preliminarily necessary to so many of the professions." The applicant had to send in a drawing of given dimensions from an antique statue, with testimony to its genuineness written by "a person of known respectability." The usual stages of study are then described—three months as a probationer doing anatomical drawings from statues, successful performance there giving the privilege of seven years' attendance in the schools, in the requisite order: antique room, preliminary painting room, and life drawing, first in night classes and later at the life school during the day.[52] The article conveys no sense of concern that either bohemian leanings or irrepressibly individualistic talents might feel cramped by such a rigidly ordered regimen.

In 1879, Watts, in an article published in the *Nineteenth Century* magazine, wrote wonderingly of the prevailing fashion for youth of good education and family to take up art as a profession, a thing, he said, unknown until now. "Plutarch," he wrote, "looking at the incomparable work of Pheidias, and rightly estimating these most perfect productions, then to be seen in all their perfection, and speaking of them in the highest terms and praising the effect as it deserved to be praised, goes on to say that,

beautiful and noble as they were, it was not desirable that ingenuous youth should devote its time to such occupation." The situation, as Watts saw it, was paradoxical: in classical antiquity, beauty was loved and valued, while the artist was despised; in late nineteenth-century England, ugliness abounds and there is little regard for beauty, yet in no time in known history has art been regarded as a pursuit with so much approval.[53]

In view of the frequent reiterations by English painters of the far higher status of art and artists in France (one succinct comment on the contrast between French aesthetic sensitivity and English philistinism held that "the French have *goût* and we have gout"), it is surprising to find Ernest Chesneau observing, in 1886, that most French painters continued to come from the lower classes: "We still find in the middle and cultivated classes, and among the wealthy, the same invincible prejudice against the profession of art. . . . No tendency is more resolutely opposed in middle-class society than that which leads a son of the family to adopt art as a profession." Chesneau added that in England or America, the narrow-minded timidity that causes French parents of artistically talented youths to push them into "safe" business or government posts would seem incomprehensible.[54] One wonders if Chesneau was acquainted with William Morris's unambiguous statement on the social recruitment and status of the English painter, included in his 1883 speech, "A Socialist's Protest against Capitalist Brutality: Addressed to the Working Classes." English painters, Morris had said, are "all by virtue of their occupation conventionally of the class of gentlemen, and many of them are men of education from their youth up."[55] For Morris, of course, the social elevation of the painter, so long sought and so hard won, was no cause for celebration.

The Painter as Gentleman

W. L. Burn, in *The Age of Equipoise,* points to the 1840s, when the last duels were fought in England, as a time of major change in the redefinition of the concept of gentility. The disapproval and termination of a practice that had been, for centuries, the particular mark of a gentleman, indicated that a very different concept was in the ascendant, one which retained the old ideals of loyalty, courage, and graciousness, but which added to them attributes with a distinctly moral dimension: thoughtfulness, unselfishness, self-discipline, the ideal of service to society.[56] It was a kind of gentility to which England's new professional men could and did aspire. The professional man's devotion to the goal of serving society was held to differentiate him from the crude, crass, and socially irresponsible

businessman supposedly motivated by self-interest and greed. Artists, once they had begun as a group to earn high incomes, felt it necessary to show that they were socially responsible professionals, and not eager and self-serving beneficiaries of a sudden demand for their wares; their newly acquired ability to live like gentlemen had to be seen as due recognition of their possession of the moral qualities that attached to this status. Thus we find painters making constant assertions of the social importance of their work, of the high recognition given to art in ancient Greece, of the proba bility that their own age would be best remembered by the legacy of its artists and writers rather than by the accomplishments of business and political leaders. And when artists' expensive scale of living had begun to tarnish the image of selfless dedication celebrated by Smiles, we find Holman Hunt constrained to defend his fellow practitioners against the charge that they were "suffering from a plethora of prosperity and greed."[57]

Just as it was the man considered to be the greatest English artist who became a focus of attempts to formulate appropriate admission standards to the Royal Academy schools, so it was again Turner who, for decades after his death in 1851, was at the center of discussions of the painter's claim to gentility. Until the 1880s, when Whistler's doctrine—that all art worthy of the name served its own internal ends alone—grew rapidly in influence, the prevailing belief was set forth with biblical fervor in the writings of Ruskin: Art reflects the moral character of its creators, and its primary purpose is the development of man's spiritual self. If the highest social ideal was held to be represented in the image of the gentleman, and if the painter was in Ruskinian terms the highest among men, it followed that the painter must be a gentleman. But how could Turner—ill-kempt, penny-pinching, irascible, scarcely literate—be seen as embodying this ideal image?

The charges made against Turner's character are conveniently summa-rized in two books of reminiscence published in 1871 and 1883 by the *Art Journal*'s editor, Samuel Carter Hall, whose opinions take obvious excep-tion to Ruskin's belief in the essential linkage between works of art and the moral character of their creators.

Millions have admired his works, but none loved, the great landscape-painter. Per-haps a meaner soul was never linked to so lofty a genius. . . . He amassed a great fortune: he had no heart to spend it—he altogether forgot "to do good and to distribute." While living, he never sought to help or benefit any of his fellow-creatures, and when he died it was sorely against his will that he conferred on others advantages for which he was to receive nothing in return. . . . It is a miser-able character I thus describe. . . . Turner was essentially selfish—in youth, in

manhood, in old age. It is said, and I believe with truth, that his father was the curator of his large gallery in Queen Anne Street; but he made the old man account to him for the shillings he received from visitors, and deducted them from his weekly allowance of sixteen shillings!

But I am not to criticize either him or his immortal works; I merely describe him. He was short and thick, singularly ungraceful, with thin lips—ever the indication of a thrift-loving soul—hair gray, straggling over a big head overladen with flesh, a keen penetrating eye, a broad but not high brow, deficient in the organs of benevolence and veneration. Whenever he appeared in public—occasions chiefly limited to private views of the Royal Academy—he wore a blue coat with gilt buttons, the creases being palpable, that showed it had but recently been removed from the drawer in which it had reposed for perhaps a year; and I remember a positive sensation being created at Somerset House when an audible whisper of wonder went round—"Look at Turner: why, he has a pair of *new* gloves!"[58]

There were numerous answers given by late-Victorian artists and writers to characterizations like Hall's that held Turner to be the absolute antithesis of the gentleman. After his first meeting with the artist in 1840, Ruskin noted in his diary:

Everybody had described him to me as coarse, boorish, unintellectual, vulgar. This I knew to be impossible. I found in him a somewhat eccentric, keen-mannered, matter-of-fact, English-minded gentleman: good-humoured evidently, bad-tempered evidently, hating humbug of all sorts, shrewd, perhaps a little self-ish, highly intellectual, the powers of his mind not brought out with any delight in their manifestation, or intention of display, but flashing out occasionally in a word or look.[59]

Here is a description not, certainly, of a perfect or conventional gentleman, but of a man of intellect and depth; Ruskin's use of the word "gentleman" seems both deliberate and purposeful. "Pretty close, that," the great critic wrote, a half-century later, in a comment on this account of his initial reaction to the painter, "and full, to be seen at a first glance, and set down the same evening."[60]

Artists' anecdotes about Turner generally stressed his keen intellect, his kindness and generosity, and his selfless dedication to his art. The enigmatic character of Turner's conversation and lectures was not, in the opinion of Richard and Samuel Redgrave, due to want of intelligence, but to deficient verbal power. Their characterization is that of a benevolent eccentric, particularly kind in his readiness to offer helpful advice to young artists.[61] If Turner was secretive in his habits, it was not from want of fellow-feeling but because his great powers were nourished by solitude and lonely studies. His niggardliness was not that of the selfish miser but the result of his devotion to the general good: "The large property he had

accumulated by his art, and his generous disposal of it (though partially frustrated) for the benefit of his brother artists and his countrymen, are well known."[62]

Solomon Hart, too, in a memoir published in 1882, attested to Turner's liberal spirit, ascribing his lack of verbal coherence to "defective education." Hart contrasted the welcome given Turner at two very different social occasions. The first was a dinner attended by artists, at which he was an unexpected guest. The artists were delighted to have Turner among them: "He was placed on the right of the chairman, and was the hero of the evening." The second was a gentlemen's dinner. Turner was an invited guest at this event, which must have been held during the forties. Although the invitation was itself a sign of their admiration for the painter's works, Turner's hosts were completely put off by his ungenteel appearance.

A little gentleman in black entered the room, dressed in a coat the cuffs of which covered his knuckles, his trousers were so long that they covered his insteps, and his shoes had ties fantastically cut. Mr. Prior [author of a life of Goldsmith] asked me whether it was possible, that this Mr. Turner could be the painter. All eyes were fixed upon him. Mr. Field [a well-known solicitor] remarked to me, that our friend was making an unfavorable impression, and that something must be done to relieve him from the predicament. An observation having been made, at the moment, by some one about fishing in Yorkshire, Turner, an expert angler, rushed at once into the conversation. He displayed a great amount of knowledge of the country, enriched by poetical, antiquarian, and other references. He monopolized the talk, and the rest of the company were willing listeners, and they rose from their seats, convinced of his mastery of the subject.[63]

It was ironic—Hart does not say this but clearly implies it—that Turner's gentlemanly qualities could only be appreciated by this group when the conversation touched upon the upper-class passion for sport. Hart's use of the word "gentleman" seems as purposeful as Ruskin's in his description of Turner. His discussion of Turner's appearance at these two events conveys the strong impression that, in a groping and incomplete way, this Royal Academician who had once lived over a milk-shop where he struggled to support his family was expressing his own convictions as to the nature of true gentility.[64]

In the same year that Hart's *Reminiscences* appeared, P. G. Hamerton published his biography of Turner, a book in which the question of Turner's approximation to the ideal of the gentleman is a central preoccupation. Hamerton dismissed out of hand the possibility that Turner, rude and antisocial in manners, lower-middle class in style and family origin, could be called a gentleman in any conventional sense of the word. Had he been

born a gentleman, Hamerton pointed out, in a passage eloquently evocative of his own life's experience, it is highly unlikely that Turner would ever have become an artist. The social circumstances of Turner's birth, said Hamerton, were, in fact, highly favorable ones for a future artist.

He was born exactly in that rank of society where artistic genius had, at that time, the best chance of opening, like a safely-sheltered flower. To perceive the full truth of this, we have nothing to do but imagine him born in any other than the humbler middle class. If his father had been a little lower in the world, the boy would have been fixed down to some kind of humble labor from his childhood, and held down to it afterwards by want. . . . What is *quite* a certainty is, the stifling of his gift in any English family of that time which had the slightest pretension to aristocracy. If Turner had been what is called a gentleman, he would have been exposed to influences which are as deadly to artistic genius as an unbreathable gas is to the animal organism. Without any open discussion of the subject, without so much as one act of rebellion on his part, he would have known, by the subtle instinctive perception of youth, that the pursuit of art involved a mysterious degradation, and in some vague, undefinable way, was disapproved of with wonderful unanimity by the public opinion of his class. . . . The calm conviction of the classically educated gentleman that he knew everything compatible with the noble life, and that all studies but his own were degrading, was more deadly to artistic genius in his class than the simple stupidity of a purely animal existence.[65]

One by one, Hamerton disposed of the charges made against Turner's intellect and character. His undeniably serious incapacity for language—he had once tried unsuccessfully, with the aid of his friend Trimmer, to learn Latin and Greek—was accompanied by a lively curiosity that extended far outside the sphere of many artists; he was interested in literature, in science, and in classical antiquity. Turner had, in fact, "a mind of extraordinary refinement." The more balanced development of the faculties that is generally valued by those of the gentleman class would have hampered the channeling of energy necessary for the development of Turner's genius; to some extent, Turner the man *had* to be sacrificed to Turner the artist. His antisocial behavior—the secretiveness of his private life, his refusal to respond to invitations—was a protective screen for one who required privacy in order to work. His astonishing productivity—merely to copy all his works, commented Hamerton, would take someone a hundred years—was sufficient evidence for the wisdom of this policy; he could never have accomplished this enormous volume of work had he taken time to follow the social rules. Turner's parsimony and undeniable eagerness to acquire money were not signs of personal greed but the results of habits built up in the pursuit of artistic independence; once this was attained, "he did not, in the real and true meaning of the expression,

work for money." He gave generous sums to needy friends and took great pains to direct that a large part of his fortune be used, after his death, for the founding of a charitable institution that would assist poor artists. Hamerton took evident pride and delight in repeating stories of Turner's delicate tact and kindness.

Mr. Trimmer once happened to be fishing with Turner, who took with him Campbell's *Pleasures of Hope*. There were illustrations in the book, and he showed one of them to his companion, saying, "That is pretty." Mr. Trimmer answered, "Nothing first rate, is it?" Turner repeated his words of praise. "It is *pretty*, and he is a poor man with a large family."

Turner, like his great patron at Petworth, Lord Egremont, "had the most delicate perceptions united to the plainest manners"; both were eccentric Englishmen whose gentility was not of the conventional kind. Turner, unpolished and even boorish, was not, in the superficial sense, a gentleman, but "had a nobility of heart as much above ordinary gentlemanhood as true poetry is above mere versification."[66]

Like the Redgraves, Hart, and Hamerton, the engraver Edward Goodall (1795–1870), who knew Turner well, attested to the latter's great capacity for kindness as well as to what a recent biographer has characterized as Turner's "stern professionalism"—a single-minded devotion to work and an intolerance of anything that looked as if it might interfere with his independence.[67] In Goodall's view, Turner's insistence upon high prices was not mercenary, but was instead the expression of his uncompromising demand that the value of his art be fully respected:

Another anecdote of the immortal Turner is perhaps well known by this time, but I will tell it just as my father used to tell it. It was a short time after the Royal Academy Exhibition, where Turner had his grand picture of *The Building of Carthage*.

Sir Robert Peel called on the painter. "Mr. Turner," he said, "I admire your *Building of Carthage* so much that I should like to become the possessor of it. I am told you want 500 guineas for it."

"Yes," replied Turner, "it *was* 500 guineas, but it is 600 to-day." The fact is he was disappointed it had not been sold at the private view, and he felt very angry at the Press for criticising it so severely.

"Well," returned Sir Robert, "I did not come prepared to give 600 guineas, and I must think over it. But, at the same time, it seems a most extraordinary piece of business on your part."

"Do as you please," said Turner, "do as you please."

After a few days Sir Robert Peel called again.

"Mr. Turner," he said, "although I thought it a very extraordinary thing that you should have raised your price when I came, I shall be proud to buy that picture, and I am prepared to give you the 600 guineas you asked for it."

"Ah!" said Turner, "it *was* 600 guineas, but to-day it is 700."

Then Sir Robert Peel grew angry, whereupon Turner burst out laughing. "I am only making fun of it; I do not intend to sell the picture at all."[68]

The Building of Carthage was left by Turner to the nation, on the condition that it hang in the National Gallery between two landscapes by Claude, the great seventeenth-century painter whose achievements and influence contributed to the acceptance of landscape painting as a serious art form.

Another of Goodall's anecdotes conveys Turner's powerful sense of mission, motivation that clearly transcended the desire for financial gain. Goodall relates the incident of a later visit by his Quaker uncle to the same picture.

By and by Turner came in, and the Quaker said, "Mr. Turner, my nephew tells me that thou valuest that picture very highly."

"I have been offered a very large sum, 1500 guineas, for it, which I have refused."

"Well," said the Quaker, "I should call that picture my dead stock. It just costs 75 guineas a year to keep that picture on thy walls."

"Ah!" answered Turner, "I have never looked at it in that light; but I have only a life-interest in it."[69]

There was, and still is, a fascination in discovering, in Turner, the strange habits of an eccentric genius; but the Victorian preoccupation with the great landscapist conveys more than just this heightened curiosity. In an age given, increasingly, to celebrations of the high importance of art in the life of the individual and the nation, to continuous reformulations of the key concept of the gentleman (reformulations that stressed nobility not of birth but of character), and to an ideal that held that devotion to work was source and sign of salvation, these memories of Turner, consciously related in opposition to the well-known tales of his parsimony and rude behavior, could be taken as proof that the man generally considered to be the greatest of English artists personified certain important values of the times. By their discussions of his exemplification of the gentlemanly ideal, Turner's memorialists were also moralists, suggesting how other artists, whatever their level of talent, could aspire to the more spiritual attributes of the gentleman. Turner was, and others might be, a gentleman by virtue of his kind heart and willingness to help needy colleagues and their families. He was, and others might be, a gentleman by his devotion to work to the very limits of his powers for noble ends rather than for financial gain. In summary, Turner, the consummate artist, could be seen in many ways as a model of the professional man.

Painting as a Profession

In 1861, exactly a decade after Turner's death, painting was for the first time listed in the census report as a profession, recognition of the status change that would soon make the career acceptable to social classes that formerly would have considered it beneath them.[70] But labels often conceal as well as reveal; if painting was a profession, it never ceased to be a special case, and an analysis of the new social position must give some sense of the tensions and ambiguities that went with it.

If, as sociologists have pointed out, there is no sharp dividing line between the professions and other occupations, there have nevertheless been certain occupations that could lay undisputed claim to professional status.[71] In nineteenth-century England these were the three "liberal" or "learned" professions: divinity and the highest branches of law and of medicine.[72] Occupations aspiring to professional status would rest their claims upon the possession of at least some of the most important attributes of these three well-established groups. What were the most crucial of these attributes? First, members of a profession might be presumed to have had a broad and comprehensive general education (throughout the nineteenth century, this meant classics and mathematics), followed by the mastery of a body of knowledge directly related to occupational responsibilities; if, in practice, the latter was for the greater part of the century expendable, the former was not. Second was disinterestedness of motivation: the professional man had turned his back upon the commercial motive of working for profit; his motive was the higher one of the desire to serve humanity and his country. In keeping with this motivation was the third attribute, a gentlemanly style of refinement and restraint that differentiated him from the brash, self-interested businessman. Fourth was a close connection with the state, a connection recognized by official honors and titles to individual practitioners, and royal charters to professional societies.

The importance of the Royal Academy—which was founded with the patronage of King George III—in establishing and furthering painters' claims to genteel status was very great indeed. If it were not for the Academy, said one painter early in the century, artists would be treated like journeymen, and the opinion was shared, if reluctantly, even by that institution's harshest detractors.[73] The *Art Journal* in 1863 called the Royal Academy "the only source from which a status is obtained by its profession."[74] The Academy justified the privileges enjoyed by its members by

its frequently announced goal of dedication to serving the nation: it would pass on a body of skills in tuition-free schools and would, by its annual exhibition, allow a large public to view the work of the best artists of the kingdom, members and nonmembers alike. The ultimate service envisioned by Reynolds was the development of a British school of high art which, by refining taste, "disentangling the mind from appetite, and conducting the thoughts through successive stages of excellence," would gradually exalt human nature and lead to virtue and public benefit.[75]

Most of the criticisms made against the Academy during the nineteenth century may be subsumed under the charge that it failed to live up to its own high professional ideals by a lack of dedication in running the schools, by inequitable treatment of nonmember artists in the handling of pictures submitted for exhibition, and by the favoring of easily marketable popular art. The lack of professionalism in the Academy schools was not, however, solely the result of desultory teaching by a succession of Visitors or of the irregularly given and poorly attended lectures in perspective and anatomy.[76] These were recognized as serious problems, but at least equally serious was the Academy schools' inattention to the quality of painters' materials, a manifestation of the more widespread failure of English painters to ensure the durability of their work. At the very time that painting had gained recognition as a profession, concern was growing that few works of contemporary art would last well beyond the lifetimes of their creators.

One source of the problem lay in the increasing distance between the painter and the preparation of his materials. The movement of artists' education out of guild-run workshops, first into painters' studios (for example, Reynolds's study with the portrait painter Hudson, or Gainsborough's with Francis Hayman) and then into the Royal Academy schools, was accompanied by the development of a separate locus for the manufacture of painters' materials, which were increasingly produced by artists' colormen. It was no longer necessary for the painter to grind his own colors. While this system saved time that could be devoted to painting, it also created a dangerous dependence. No longer trained in the preparation of their materials, artists could not guard against improper preparation and the use of adulterated pigments and mediums. Complaints of fraudulent practices among the colormen were common as early as the eighteenth century and became considerably more serious with the advent of the tin tube for oil paint, which appeared on the market in 1841.[77] Catalogues of the color merchants were now filled with an array of names of new dyes, but painters had no way of knowing which products were inferior or adul-

terated. "The painters of the 60's, 70's and 80's were presented with increasingly varied, tempting and exciting color lists which, pure poetry though they be, carried no indication of the colors' relative stability. . . . No one knew for certain which of them to avoid. The color merchants' catalogues placed the most untrustworthy of the new inventions impartially alongside the standard tested pigments, and made no discrimination whatsoever among them."[78]

The conflict was essentially this: the painter, wishing to become a gentleman, had seen fit to remove himself as far as possible from his artisan origins but, in doing so, had weakened the claim that painting was truly a profession, capable, like other professions, of handing on a developing and increasingly subtle and secure body of knowledge. Like others who shared his concern about this problem, Holman Hunt pointed out that the practice of Victorian painters was greatly at variance with that of the old masters. Their careful attention to the practical skills of painting, Hunt observed, had ensured the safety of their creations: "In old days the secrets were the artist's; now, he is the first to be kept in ignorance of what he is using."[79]

Training in the preservation and application of an elaborate technique that includes both an intellectual component and the mastery of relevant skills is a crucial test of whether an occupation can truly be called a profession. Like Watts, Leighton, and other painters concerned about the important question of artists' control over their materials, Holman Hunt believed that this central weakness caused nineteenth-century English painting to fall far short of the professional ideal. Although the Academy responded to criticism of its lack of leadership in this matter by appointing a professor of chemistry—artists themselves testified at the 1863 Royal Academy commission hearings that the rapid deterioration of English paintings had become notorious—little progress was made. Hunt had scant expectations of help from that genteel body and sarcastically seconded the judgment of one long-time member that "such work is far beneath the dignity of the Royal Academy."[80] It was no coincidence that this problem in professional ethics—for this was what Hunt and others considered it to be—came increasingly to the fore at a time when the price of paintings had soared to a level that would, in earlier times (as in later) have been considered exorbitant. The *Art Journal* published, in 1857, under the heading "Painters' Morality," a report on a discussion of the question of pigment stability that had taken place at recently held hearings of the National Gallery Site Commission. The testimony discussed was given by the painter William Mulready to commission member Michael

Faraday and holds additional interest for its restrained mention of Turner, many of whose oil paintings were by then quite visibly deteriorating. The negative example set by the great painter, who had so strangely combined the wish to leave great works to posterity with the pursuit of expressiveness at the cost of durability, and who had treated the canvases kept in his own gallery with gross neglect, contributed to the troubled tone of the proceedings.[81]

The short life which is predicted . . . for many of the finest works of the modern school of painting, makes it very important that the attention of the artist should be called emphatically to the subject in question; and we are glad that Mr. Mulready has spoken on it as he has. . . . "The Commissioners," said Professor Faraday, questioning the distinguished painter then before the Commission, "have several times heard the words 'legitimate painting' and 'vicious pigments' used. Is it not understood in the profession that every painter has a right to use exactly what means he likes to produce his pictures?"—"I am not sure," says Mr. Mulready, "that that is the understanding in the profession. I am not sure that a painter has a right, except in experiments, to use pigments which he knows are short-lived. I do not think he has a right to use such pigments in a picture that he knows the purchaser expects to last."—"Have you any right," rejoins the Professor, "to expect that painters like Turner can be brought under strict regulations—or, are we obliged to get pictures of all sorts of construction according to the ideas of the painters?"—To which the painter is compelled to reply—"If you are obliged to get pictures, you can hardly avoid some risk in that respect. . . . It is a question of morality with the painter. . . . I cannot venture to define what is legitimate painting. I think an artist should be very careful to embody the means that will produce an effect that deserves to last; and he should be very careful to employ the means that are most likely to produce a picture that *will* last." . . . "Do you consider," asks the Professor, "that the injury which has happened to Turner's pictures is a change in the pigment itself?"—"I think," says Mulready, "some of Turner's pictures have suffered from that cause; and I believe that some of his pictures may have suffered from the process which he employed. . . . When he was very much pressed for time, he may, I fear, have paid too little regard to the quality of the vehicle used and the permanence of the pigment."

The subject is sufficiently indicated in these extracts; and the interests which it affects, it will be seen, are of more kinds than one. The rights concerned are both public and private—but the prosperity of the profession is involved through each of them. The question is at once a question of morality and a question of Art. It regards the claims of the individual purchaser, and the permanence of the National School. . . . In a practice so purely empirical as that of painting, of course, no code is possible;—but there are certain broad principles of morals, as well as certain broad principles of means, which are plain enough, and which art cannot overlook without suffering in her own character and in that of her professors.[82]

At the heart of matters of professional ethics is the question of whether the practitioner has been motivated primarily by the desire to perform

dedicated service to a client or to society, or whether his motives have been pecuniary in nature.[83] From this standpoint, Turner's professionalism was above reproach, as none could seriously have claimed (not even detractors like Hall, who loved to expand upon Turner's delight in acquiring and accumulating money) that his daring experiments were done out of the desire for quick profit. Leighton, too, was a fine symbol of disinterested motivation. Eulogizing him, Edward Poynter (the first Slade professor of art at University College, London) took care to remind his listeners that Leighton had had no pressing financial reasons for selling his works. The usual stimulus, Poynter noted, was wanting; Leighton had the means to live a life of ease.[84]

Both Turner and Leighton had sold their pictures at high prices, but neither was, to borrow Queen Victoria's phrase, "painting for money." Other painters were not so readily absolved; pecuniary motivation that flagrantly violated professional dedication to high standards was a charge frequently brought against artists. The requirements of professionalism were indeed demanding. The artist was to take full responsibility for the durability of his work, even as the materials he used were affected by rapidly changing technlogy. He was expected to express the best that was in him, regardless of prospects in the marketplace, and was to develop these talents, avoiding tired repetitions of earlier successes. In addition, beginning in the late 1850s, he was to avoid undue and, especially, covert use of that strange new instrument that was both a rival and a tool for artists—the camera.

Such requirements and expectations colored discussions of these and other issues in what may be seen as an emerging, albeit unofficial, code of professional ethics. Two especially prominent subjects of controversy were the "pot-boiler," an expression deprecatingly applied to a work of literature or art executed for the sole purpose of swift monetary gain ("boiling the pot"), and the replica, a repetition by the artist of a successful work. A brief discussion of contemporary concerns regarding the pot-boiler, the replica, and the use of photography will show how ideals of professionalism were applied to specific problems of practice.

The pot-boiler seems to have been accepted as a legitimate device, if used only occasionally by a painter with pressing financial needs or family responsibilities, or during the painting of a large picture, the production of which necessitated a long period of income deferral. Such was more than once the case with Ford Madox Brown, who wrote to a patron who had commissioned a large oil painting: "During the last fortnight I have had to fall back on the domestic pot-boiler from the dire necessity of keeping the establishment supplied in victuals, but in a day or two I shall be again in a

condition to give my undivided attention to the picture." But the artist who did nothing but such quickly produced pictures, with content chosen for immediate popular appeal and salability, was seen as exemplifying the ethics of business rather than professional norms. Thus Brown criticized Frederick Goodall for being "excessive in all that is low and to the public taste."[85] One expected a businessman to produce anything for which people would pay, but the artist-professional was to follow the ideal of an educational responsibility that transcended the laws of supply and demand. Professionals were to serve the welfare, not the whims, of their clients. Reynolds had set forth this ideal with great clarity and forcefulness in his fifth discourse:

> Be as select in those whom you endeavour to please, as in those whom you endeavour to imitate. Without the love of fame you can never do any thing excellent; but by an excessive and undistinguishing thirst after it, you will come to have vulgar views; you will degrade your style; and your taste will be entirely corrupted. It is certain that the lowest style will be the most popular, as it falls within the compass of ignorance itself. . . .
>
> I mention this, because our Exhibitions, while they produce such admirable effects by nourishing emulation and calling out genius, have also a mischievous tendency, by seducing the Painter to an ambition of pleasing indiscriminately the mixed multitude of people who resort to them.[86]

Art unions, annual lotteries whose winners were allowed to acquire paintings up to some authorized price, were often criticized for the encouragement they supposedly gave to the production of pot-boilers. Two parliamentary committees conducted investigations of the art unions, first in 1845 and again in 1866. The report of the earlier committee charged that the unions produced an injurious stimulus to art by encouraging the production of inferior works. More seriously still, the report suggested that shady practices had been followed in pricing the canvases eligible to be chosen by the lottery winners. The committee emphasized the art unions' responsibility to encourage high art. Its report tempered its criticisms with some praise, expressing appreciation of the encouragement the unions had given to landscape and marine painting and to *tableaux de genre* illustrating literary themes. "The more homely scenes of common life" also received the approbation of the committee, since "they are oftentimes the only intelligible mode in which Art can speak to a large portion of the community." The report carefully added that the inclusion of "moral influences" was essential for this kind of art to be "useful." Both the 1845 and 1866 committees expressed contempt for pictures cynically and shoddily turned out in anticipation of satisfying the ignorant tastes of most art

union subscribers: "Where the artist himself consents to treat his profession as a trade, it is some time before the people will be induced to treat it as Art."[87]

Not always distinct from the pot-boiler was the painting-replica, the painter's own imitation of a previously sold work. Dante Gabriel Rossetti, for example, frankly described one of his pictures as a "vile replica" that financial need had forced him to paint, "a beastly job, but lucre was the lure."[88] The sale by an artist of copies of his earlier works was a generally accepted practice that was engaged in with great frequency during the 1850s and 1860s, when demand was heavy and easily copied small works were held in special favor. Sometimes the replicas were small versions of large paintings or slightly revised versions of the originals; many salable pictures could thus (as Frith put it) be "bred from" the original subject. Richard Redgrave, for example, did four versions of *The Governess*. Millais, about 1860, did numerous watercolor copies of large works. "For these there was a constant demand, and the dealers worried him into painting no less than seven or eight watercolour replicas of *The Black Brunswicker* and *The Huguenot*."[89] Ford Madox Brown spent so much time painting replicas during the year 1868 that he had no time to devote to new subjects.[90]

But an age that placed high value on genius and originality could not be altogether comfortable with the painting-replica, the production of which came increasingly to be seen as a violation of professional practice. A note of defensiveness becomes especially evident in painters' references to this issue in the later part of the century, when the interest in realistic depictions of clever subjects had begun to shift, at least among the more advanced segments of the art public, to an art that communicated the unique expression of a painter's sometimes momentary vision. Looking back from the vantage point of the 1880s, Frith declared that Landseer had probably been the only popular painter to remain free from the "vice" of copying.[91] Frank Holl's daughter proudly insisted that her father's replicas were "never mere copies," but always repaintings with the same models posed anew; she added that they were as fine, if not finer, than the originals.[92]

Frederick Goodall's carefully worded statement, made at the century's end, that he had, with the permission of the buyer of one of his large pictures, done a small version of it for another patron, suggests an important ethical problem connected with the production of replicas.[93] When painted in the same medium and dimensions as the source-pictures, and without the knowledge of earlier patrons and later purchasers, both the paintings

and their imitated versions masqueraded as unique originals, with the existence of replicas seriously lowering the market value of the originals. A forceful denunciation of this practice as a grave breach of professional ethics was made before the 1863 commission investigating the Academy by D. R. Blaine, a barrister practicing in London who had special knowledge of artistic copyright.

Instances have come to my knowledge of the most eminent artists having made numerous copies of their own pictures. . . . I have heard a very eminent artist say, I have painted that picture nine times, and every man believes he has got the original. . . . The grievance to the public is great. For example, a gentleman goes to an artist and purchases a picture from him. Modern pictures fetch very high prices—we have instances of as much as £10,000 being paid for a modern picture. The artist sells his picture to the purchaser, who usually never thinks for a moment of asking the artist anything more than the price of the picture; he is content to purchase it, and gives a cheque for the money. There the transaction ends. Some time afterwards the gentleman finds that without his sanction, without his knowledge, from one up to eight repetitions (as in the case to which I have referred) of his picture have been made. In some instances those repetitions are made entirely by the artist himself, in others with very considerable assistance. Having paid a great deal of attention to art, I have seen repetitions of pictures by modern British artists which I feel perfectly confident have been made by their assistants, and but slightly worked upon by themselves, yet signed with their names. Now the result of such a system, so far as regards the purchaser of an original work, thus repeated, is that the pecuniary value of his picture is materially depreciated. . . . I think, as a matter of professional conduct, there can be no question that the artist, in the honourable practice of his profession, ought to state to the purchaser when he purchases the picture, if he does not acquire the copyright, "I shall be at liberty to repeat this picture."[94]

Several years earlier, the *Art Journal,* as assiduous in its desire to expose modern forgeries as it had once been in exposing fake old masters, had declared its intention "to arrest the progress of a most iniquitous but a most profitable trade," and threatened to print the names of artists who, in collusion with dealers, took advantage of the public acceptance of replicas and proceeded to the logical next step of outright forgery. The *Journal* related an incident in which a well-established artist whose pictures sold at high prices was visited by a dealer, who announced that he had in his possession a dozen or so works in the painter's style; he offered a payment of five hundred pounds if the painter would spend a half-hour touching up each canvas and sign his name. The artist was outraged, and ordered the dealer to leave his house immediately. "There is little doubt, however," concludes the *Journal,* "that the dealer did without the artist; and it is not improbable that an unscrupulous 'brother' was found to do the touching,

and to sign the name, at much less cost to the dealer."[95] Unethical professional behavior had, by its example, encouraged outright criminality.

The rapid development of photography in the final quarter of the century created a new sphere for ethical problems in painting. There was argument and uncertainty concerning its proper use by painters. Those who believed that preparatory sketches from the model or from nature were essential steps in the production of a painting felt that the short-circuiting of this process by the use of photographs was shoddy and unprofessional. "It was the custom," reflected the painter William Richmond, in a letter to the *Studio* published in 1893, "when artists travelled for their note-books to be constantly in their hands, and every *impression* was either carefully or summarily therein registered. I have been told that the kodak has taken the place of the note-book. If this be true the lamentable absence of interest in our annual exhibitions is to be accounted for. Photography can never be an art, though it may be a valuable adjunct! Yes. But if it ever is used by an artist instead of his pencil where he could use his pencil, it will prove to be the destroyer of art instead of being, as it should be, an aid."[96] In the same article, which included thoughts on the subject expressed in letters from a number of painters, Walter Sickert expressed the view that painters and draughtsmen who worked from photographs were mapping rather than drawing, and were thereby weakening their powers of observation and of expression. He added that, to avoid misrepresentation, paintings done from photographs should be described as such in art catalogues.[97]

The question of the use of the camera in preparatory sketches left room for honest disagreement; such could not be the case where outright deceit was concerned. Richmond said that he had heard of portrait painters who were painting over photographic images on their canvases, thus substituting a mechanical for a creative process. Many artists of repute, wrote George Moore in *Modern Painting,* used photographs "to save themselves trouble, expense, and, in some cases, to supplant defective education." He thought that the "cheap realism" of Herkomer's portraits was probably the result of his use of the method described by Richmond.[98]

A more serious charge of unethical practice brought against Herkomer was said to have resulted in that artist's loss of his position as Slade professor at Oxford. Herkomer had published a book illustrated with pen-and-ink drawings, reproduced by the photographic process known as photogravure, and had allowed them to be described and sold as "proof etchings." The charge of misrepresentation was repeatedly pressed by Joseph Pennell, graphic artist and disciple of Whistler, in a series of articles in the *National Observer* that appeared during 1891. According to

Pennell, a work could be described as an etching only if two criteria were met: the artist must have drawn the design on a metal plate and must then have bitten or engraved it himself; photographs of drawings done on paper (even if the negatives had been scratched in places with the etching needle) could not be called etchings. Sickert, in a letter contributed to the paper, stated that while it was often difficult for anyone not a specialist to tell the difference between etchings and drawings reproduced by photogravure, "this makes fraud in these matters commercially all the more criminal."[99] The existence of the camera had, indeed, added a new dimension to questions of professional ethics for artists.

By about 1860, when the compilers of the following year's census report were making the decision to include painting in their professional category, the elements of professional standing had become clear; foremost among the requisites was a professional association, preferably holding a royal charter, which would "focus opinion, work up a body of knowledge, and insist upon a decent standard of conduct."[100] Branches of the legal and medical professions had formed associations to carry out these functions. Reform within the legal profession (still incomplete in the 1860s) dated back to 1825, with the founding of the Law Society, while reform of the lower branches of medicine had begun in 1815 with the passing of the Apothecaries Act. Another of the key acts in the regulation of nineteenth-century professions was the Medical Act of 1858, which brought unity to that profession, setting up a central authority with disciplinary power and confirming the idea that "professional men should be responsible for their own behaviour, with the power of visiting heavy displeasure on offenders."[101] The Royal Academy was frequently spoken of as a professional association similar to those in the fields of law and medicine. If, however, it was so considered, it had to be found wanting by all but its most uncritical members and friends: in focusing opinion, it was inequitable and one-sided; in working up a body of knowledge, it was either inefficient or insufficiently motivated; and it had not made efforts towards the development and enforcement of a code of ethics. "No rules," the barrister Roberton Blaine said to the 1863 commission, "have been passed by the Academy as regards the honourable practice of the profession. . . .

[QUESTION] You mean that as the bar, very imperfectly at the present time, but in a certain way, has laid down certain rules for the professional guidance of its members, so the Royal Academy, as representing the arts in England, should lay down certain rules for the guidance not only of its own members, but of all artists, in their transactions with the persons to whom they sell their pictures?

BLAINE: That is my conviction, and it would tend enormously to advance the tone of feeling prevailing in the profession.

[QUESTION] You think that in that way the Royal Academy might perform a useful function which would touch a class of cases which can never be touched by any positive enactment?

BLAINE: Decidedly.

[QUESTION] Do you think that the Royal Academy, if properly constituted and invested with functions of that sort, by its own choice, could act as a sort of court of honour in individual cases where such questions arose?

BLAINE: Unquestionably.

[QUESTION] So that doubtful cases of conflict between the rights of the buyer of the picture and the artist himself might be settled by arbitration, as it were, by reference to the Academy?

BLAINE: Undoubtedly that might be so, and I think with the greatest possible advantage to the proprietors and to the artists.

[QUESTION] In such a case the sanction to the rules or to the ruling of the Royal Academy would be, would it not, the only sort of stigma which would attach to the artist who refused to abide by them?

BLAINE: Yes.

[QUESTION] You would not attach any more positive penalty?

BLAINE: No; I would leave that to the law, excepting that the Royal Academy ought, decidedly, to have the power of excluding any member from its ranks who acted in an unprofessional manner.[102]

Blaine considered the broadening of the Academy's membership to be an essential precondition to the enforcement of an ethical code in the world of painting, for how could that body perform this important professional function while it included only a minute fraction of practicing artists? Blaine advised that the Academy be completely reshaped by a new constitution to be established by act of Parliament that would enlarge its membership, making it coterminous with almost all artists practicing in England; women painters were to be included both as Associates and as full Academicians. The women were not, however, to be allowed to dilute male dominance in the running of the institution: "I would allow them to vote," Blaine stated, "but it would be unfitting that they should be members of the council."[103] There were many professional women artists by this time, and the Academy schools had recently been opened to female students. (See chaps. 5 and 6 for a discussion of women's status in the Victorian art world.)

The Rewards of Professionalism

Two last factors must be considered to complete this discussion of art as a profession: first, the system of rewards that marks society's recognition of professionals; and second, the very important matter of professional autonomy. The subjects are closely related, for the rewards system and the

assertion of independence from the marketplace were seen as separating the professional person from both the artisan and the businessman. The most worthy painters, according to the ideal widely accepted until late-Victorian times, worked under the direction of their own inspiration and self-imposed high standards; their true reward was in the knowledge that they had contributed to social progress through the elevation of taste and, some thought, through the more direct moral education to be found in didactic painting. Honors bestowed by society were a recognition of the congruence of artistic autonomy with common values. This idea of congruence had to be reexamined after the attacks made upon it by Whistler and by later artists and critics. It is a testament to the strength of the idea that it was not discarded but reformulated—that the artist, even when claiming to be concerned only with the aims of art and not with the goals of society, continued to be highly valued for his unique contributions to the national life.

High remuneration was regarded as the professional person's due, an essential contributing factor to a style of life that included comfort, grace, and outward dignity. Commercial motivation was implicitly denied, in that these financial rewards were understood to be recognition *of* service rather than payment *for* service, and particular pride was taken in the belief that the profession's official leader from 1878 to 1896, Royal Academy president Leighton, painted by choice, a motive unsullied by the need for income.

Although high prices for the works of prominent artists were accepted as the norm, there was a prevailing although ill-defined sense of appropriate upper limits that made some prices appear excessive. Astronomical prices for paintings created uneasiness; it was suspected that they had resulted from unprofessional motivation and from tactics far more appropriate to the business world. The *Art Journal*'s discussion of the sum Frith received for *The Marriage of the Prince of Wales* as "the most munificent recompense ever accorded to an artist since Art became a profession" implied as much.[104] And one finds in passing comments late in the century more than one suggestion that a feeling of collective guilt accompanied the knowledge that many artists had asked ridiculously high prices while the getting was good, and were thus to a great extent to be blamed for undermining their own market.[105]

Some degree of naiveté in financial affairs could serve as a badge of honor, a sign to the world that the painter was preoccupied with higher things. Dante Gabriel Rossetti, addressing Edward Burne-Jones's financial helplessness, wrote to his friend: "My dear fellow, you'll always need someone to look after you—you're no better than a child." Rossetti, too,

needed looking after in this part of his life, as he suffered the continuous loss of large sums by his habit of leaving cash in bureau drawers in a house he frequently left to the care of a variety of acquaintances, models, and servants.[106]

It seems fitting now, as it must have then, that the painter who officially headed the profession of art in late-Victorian times enjoyed the greatest possible distance from the marketplace. Few painters could aspire to the degree of indirectness that Leighton employed in his commercial transactions. His enormous prestige made it possible for him to leave a price list with a servant on the days set aside for dealer visits to his studio, thus placing two intermediaries between himself and the ultimate purchasers of his paintings. But even painters of more modest reputation who had to take a more direct role in marketing their pictures could follow Leighton's principle of holding to prices once set. "It is not," wrote Francis Davenant in 1881 (in a book of vocational guidance entitled *Starting in Life*), "the custom to haggle over pictures when the purchase is made direct from the artist, but to give the price asked or to decline the sale." Burne-Jones, whose advice on pricing was requested by Mr. and Mrs. Barrington, then acting as financial advisers to the unworldly painter Watts, gave this reply: "You must never let Watts alter his price. Whatever price he asks for a picture that he must stick to."[107]

In order for this advice to prove sound, intelligence and foresight (and a good measure of luck) were critically important in the initial pricing decision. "Don't make yourself cheap, or others will take you at your own valuation" was the advice given one young artist at the turn of the century. "You can always knock something off a price, but you can never put anything on."[108] Many artists would have disagreed (although the coming of bad times must have led to many compromises with principle) as to the propriety of "knocking something off," and there are numerous stories, particularly from pre- and post-boom times, concerning the danger of pricing oneself too high. William Collins, for example, in the late 1840s, encouraged by a five-hundred-guinea commission given him by Sir Robert Peel, put a similarly high price on his next major painting. Lower offers were made for it, but the painter considered himself bound to stand by his initial valuation; the picture finally did sell, but the artist had had to keep it for twelve long years.[109] "For years," wrote Solomon Hart in 1882, "do I remember seeing the picture hanging over a pianoforte in his drawing-room. He used to caution me to be warned by his example, and not to ask too large prices."[110] Millais, too, wrote of the dangers of overpricing. High prices, he said, angered the dealers, who felt "entirely shut out" by the

WHAT OUR ARTIST HAS TO PUT UP WITH.
"IT 'S VERY ODD—BUT I CAN'T GET RID OF MY PICTURES. THE HOUSE IS FULL OF THEM!"
"CAN'T YOU GET YOUR GROCER TO GIVE 'EM AWAY WITH A POUND OF TEA, OR SOMETHING?"

10. George Du Maurier, "What Our Artist Has to Put Up With" (*Punch,* 25 January 1890). The elderly artist, whose career has seen far better days, is represented in a pose of utter dejection. Perhaps too old to adapt to the contracted art market by turning to portraiture or teaching, he has continued to turn out canvases and is unprepared for his friend's blunt declaration that contemporary paintings are now a glut on the market.

artist's preemption of what they saw as their rightful bargaining space. Even during times of heavy demand for contemporary painting, the fact that a work had remained unsold for a long time could act as a deterrent to purchase; buyers become skeptical, Millais observed during the late 1850s, about the value of something that no one wants.[111] Laura Knight turned down an offer of three hundred pounds for a picture that she had priced, at the Royal Academy exhibition, at six hundred. The offer, she thought, was "too big a come-down to accept." The painting, damaged in storage during World War I, ended its days by being cut into small scraps and put into the studio ash-can. "It is no use saying I was not grieved at its loss."[112]

For a long time the Royal Academy had helped painters maintain the stance of holding aloof from the marketplace. The list of pictures for sale and their prices were given to the secretary, but no differentiation was made in the catalogue between works that were for sale and those already purchased. The initiative had, therefore, to be with the buyer. An example of the highly respectable indirect process to which this system gave rise was Queen Victoria's purchase, in 1855, of Leighton's *Cimabue's Madonna Carried through the Streets of Florence.* The queen asked Royal Academy president Eastlake to inquire about the price from the secretary; the pur-

11. Frederic Leighton, from a portrait by George Frederic Watts. The two artists met in 1855 and remained lifelong friends. (As published in the *Magazine of Art*, vol. 1, 1878.)

chase once made, Leighton was informed and congratulated, having had no direct part at all in the transaction.[113] This highly professional, indirect system of information-leading-to-sales was considerably eroded by the contracted art market that prevailed during the final quarter of the century. "The most curious thing, to notice in this Exhibition," commented Ford Madox Brown, expressing his shocked reaction to a visit to the show in the early 1880s, "is how *all* the works are for sale—some for large prices, like Herkomer's, some for modest ones, as are *Frith's!*—but all, whether R.A.'s or others, for sale, and prices, of course, pitilessly gibbeted in the catalogue. Alas the day!"[114]

The rewards that evoke the highest esteem among members of the professions were not monetary but symbolic. The ritual awarding of titles, medals, prizes, and offices underscored a profession's orientation towards the community interest, rather than the combined self-interest of its members. Here, for example, is Mrs. Barrington's list of the "dignities and honours" conferred upon Frederic Leighton:

Knighted, 1878; created a Baronet, 1886; created Baron Leighton of Stretton, 1896; elected Associate of the Royal Academy, 1864; Royal Academician, 1869; President of the Royal Academy, 1878; Hon. Member, Royal Scottish Academy, and Royal Hibernian Academy, Associate of the Institute of France, President of the Inter-

national Jury of Painting, Paris, Exhibition, 1878; Hon. Member, Berlin Academy, 1886; also Member of the Royal Academy of Vienna, 1888; Belgium, 1886; of the Academy of St. Luke, Rome, and the Academies of Florence (1882), Turin, Genoa, Perugia, and Antwerp (1885); Hon. D.C.L., Oxford, 1879; Hon. LL.D., Cambridge, 1879; Hon. LL.D., Edinburgh, 1884; Hon. D.Lit., Dublin, 1892; Hon. D.C.L., Durham, 1894; Hon. Fellow of Trinity College, London, 1876; Lieut.-Colonel of the 20th Middlesex (Artist's) Rifle Volunteers, 1876 to 1883 (resigned); then Hon. Colonel and Holder of the Volunteer Decoration; Commander of the Legion of Honour, 1889; Commander of the Order of Leopold; Knight of the Prussian Order "pour le Mérite," and of the Coburg Order Dem Verdienste.[115]

"Roughly," wrote T. H. S. Escott about 1880, "it may be said professions in England are valued according to their stability, their remunerativeness, their influence, and their recognition by the State."[116] Britain today is one of the few Western countries that have not abolished titles, and writings by and about artists from the eighteenth century onwards attest to the great significance of these honors. The inspiration Hogarth found in the career of his father-in-law, Sir James Thornhill, is said to have been less in his works than in the fame he had achieved as a history painter, his position as king's painter, and his knighthood.[117] Reynolds was very pleased by his receipt of knighthood in 1769. "I acknowledge," he wrote, in a memorandum written during the last year of his life, "that I do not feel myself possessed of that grandeur of soul sufficient to give me any pretension of looking down with such philosophical contempt upon titles. Distinction is what we all seek after, and the world does set a value on them, and I go with the great stream of life."[118] Turner, who was "quite aware of the greatness of his own powers, and jealous of their proper recognition," was observed to be deeply hurt at being left out of the official awards, especially when his friend David Wilkie and his disciple Augustus Wall Callcott were given knighthoods.[119] It was one of the penalties he paid for not being, in the conventional sense, a gentleman.

The reactions of three famous Victorian painters—Richard Redgrave, George Frederic Watts, and Edward Burne-Jones—to offers of titles reveal both the importance of these honors and the uneasy feelings to which they gave rise. It was difficult to completely dispel the suspicion that the acceptance of a title might signify a measure of worldliness inappropriate to the artist's calling. Thus Richard Redgrave, who used his talents to paint works that would evoke compassion for the plight of the poor, refused an offer of knighthood (made in recognition of his services as the queen's inspector of pictures and for his development of the prince consort's plans for the museum at South Kensington), and he did so in terms that bring to mind the image of the prosperous yeoman who would not be a gentle-

12. Richard Redgrave in his studio. In his eighties (and almost completely blind) when this photograph was taken, Redgrave conveys a presence at once workmanlike and meditative, as if pondering his long and eventful career. (After the photograph by J. P. Mayall, as published in Frederic George Stephens, *Artists at Home*, New York, 1884.)

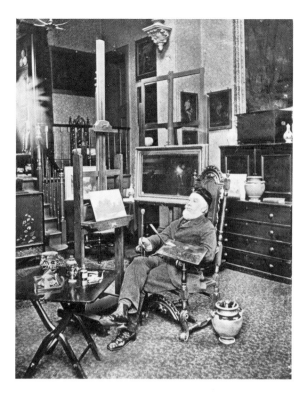

man.[120] In an understated way, Redgrave's words convey a juxtaposition of humility concerning his own origins and social identity and pride in the worthiness of the artist's profession. "My mode of life," he wrote, in his first letter of refusal to the queen's agent, General Grey (17 April 1869), "is very simple, and I am quite contented with the honours Her Majesty has sanctioned to me as an artist, and beyond all with the permission still to serve her." "I trust," he added in a letter to Prime Minister Gladstone written a week later, "you will convey to Her Majesty and will yourself be assured of the sincere gratification this approval of my services has given me, and my deep sense of the honour intended for me, but, as inconsistent with my mode of life, I would humbly ask the Queen's gracious permission to decline it." "Blundering letters!" Redgrave later commented on looking over these responses, but he never changed his mind. "Some of my family regret my decision, but I am much happier as I am, than I could be as 'Sir Richard.'"[121]

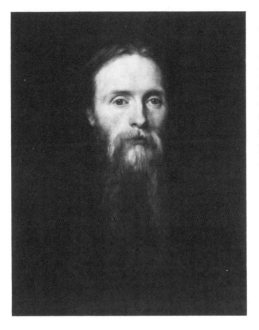

13. This portrait of Edward Coley Burne-Jones (1833–1898) was painted when the sitter was thirty-seven by George Frederic Watts as a gift to Georgiana Burne-Jones, the artist's wife. The portrait conveys the otherworldly, visionary character of both artists. (By permission of the Birmingham Museum and Art Gallery.)

Watts and Burne-Jones showed not only an uneasy concern for titles but were obsessively preoccupied with the lack of dignity they perceived in their inherited family names. Watts was distressed by the sound of his name (which he thought unaesthetic) and by its lack of social distinction. "He had," wrote his second wife in her adulatory biography, "a curious dislike to the sound of his surname, and habitually took trouble to avoid using it. . . . He had fancies about the inheritance of a name, and used to say when he heard of one that pleased his ear, 'Ah, if I had a name such as that, I should have done my work better.'" Watts often spoke with his friend Mrs. Barrington of his distress at not having a great name to sustain. He would have been proud, he told her, to keep up the position of great ancestors and would have striven to emulate them. Watts never visited Hereford, where a grandfather lived, preferring to indulge the fantasy that he was of noble Celtic blood: "I belong to a family that has gone down in the world," he said. [122]

Burne-Jones's dislike of his name was strong enough to cause him, at the advanced age of fifty-two, to alter it; the son of Mr. Jones of Birmingham, the painter had been known, until then, as Edward or, to close friends, Ned Jones. The name seemed to emphasize the unpoetic nature

of the artist's origins. ("We all know how," wrote the *Art Journal* in its 1898 obituary tribute to the artist, "from the dreariest and most prosaic surroundings, out of the most unpropitious circumstances, his passion for beauty and poetry fought its way upwards into the light.") The precipitating cause of the name change was the ambition of the artist's son Philip, whose participation in the Prince of Wales's social circles meant that he needed, "above all, not to be called Jones," but the painter's own distress long predated his son's. To carry the name Jones, he had said, is to face "annihilation." It was after years of great success at the Grosvenor Gallery and shortly before his election to the Royal Academy that the painter made the decision to add to the surname; the change contributed to his growing estrangement from Morris, who was disgusted by the action and seldom referred to it.[123]

Twice, in 1885 and again in 1894, Watts was offered the hereditary title of baronet; he was the first painter to be honored in this way.[124] Both times, he declined the honor. The reasons for his first refusal (privately stated) were the ugliness of his name, the fear that the award would expose him to appeals for financial aid that he could not satisfy, his inability to support the mode of life he considered to be appropriate to such a title, and one reason that "will not so well bear the light," no doubt the fear that, as Ellen Terry had been his legal wife until 1877, her son by E. W. Godwin, who was born in 1872, might claim succession to the title. "Mr. Watts," commented Millais's son and biographer, "for reasons highly honourable to himself, declined the offer."[125]

The letter Watts wrote to Gladstone on the occasion of his second refusal of the title gives another dimension of his feelings, a sense of a certain unsuitability of the award to creators in the world of art and letters. It has been suggested, however, that the grandiose tone of the refusal belies disappointment that the proffered award was not a peerage.

In addition to my natural shrinking from the publicity which must and should accompany all social distinctions honorably carried, I feel strongly that the proposed honour which, fittingly bestowed on the statesman, the lawyer, soldier, and the like, those whose exertions have reference to the immediate and material power of the nation, and whose services can be easily appraised, cannot as fittingly be bestowed on purely intellectual efforts in the domain of literature and art; here I think one such conventional but well-understood distinction, such as the Universities bestow in their honorary degrees, which do not imply material position, would better meet the requirements of the case.[126]

Watts did accept honorary degrees from Oxford and Cambridge and was among the first recipients of the newly established Order of Merit. The

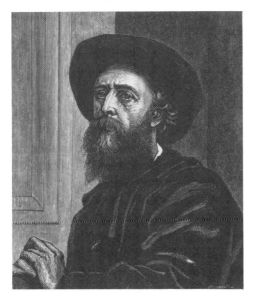

14. George Frederic Watts's self-portrait. Watts—whom Leighton called "England's Michelangelo" and others the "English Titian"—preferred to be addressed as "Signor." (As published in the *Magazine of Art*, vol. 1, 1878.)

rewards he most desired, however, could not be made by contemporaries, but only by posterity, for he held that a period of a hundred years was needed for the proper aging of a picture and that the artist therefore worked not for the present but for future centuries and millennia.[127] But the need for recognition was, inconsistently but understandably, present in this artist; he liked the grand title of "Signor," by which he was known to the elite company that frequented Little Holland House, and wrote, in 1901, to Herkomer, on the occasion of the latter's receipt of the Bavarian Verdienst Order, which allowed use of the prefix *von*, "I envy you your *von!* That is a real distinction such as I do not think Knighthood or Baronetcy is."[128]

The awarding of knighthoods to painters, an unusual event in Reynold's day, became a more frequent practice during the nineteenth century. The public became thoroughly accustomed, by mid-Victorian times, to finding *Sir* before the names of a number of prominent artists, for instance, Raeburn, Lawrence, Wilkie, Callcott, Eastlake, or Landseer. Knighthood, however, was a once-only grant made in recognition of achievement; more enduring upward mobility extending not to the painter alone, but to his family and descendants, required a hereditary title. There is reason to believe that Benjamin West's refusal of knighthood was not due (as the Redgraves reported) to the scruples of his Quaker conscience, but rather to his unwillingness to settle for a title that would die with its holder.[129]

The honor that would have been acceptable to West was the same that Watts would later refuse—the baronetcy. Thus, the offer made to Watts in 1885 was a significant milestone, and although that artist declined the honor, John Everett Millais accepted it with unmixed joy and pride, having long held that such a distinction "was not only an honour to the recipient, but to the whole body of artists, and an encouragement to the pursuit of Art in its highest and noblest form." "At last," an Academician friend wrote to Millais, "artists are baronets, and . . . doctors, lawyers, and merchants have not the monopoly of the rank."[130]

In sharp contrast, the award of baronetcy to Burne-Jones (with Gladstone, again, as agent) was accepted with ambivalence, guilt, and pain. When the documents announcing the baronetcy arrived, "Morris was downstairs and there was terror lest he should get wind of them. Almost furtively poor Ned began to design 'the necessary heraldic arrangements.'" The painter's wife Georgiana, a woman of strong socialist convictions, was scornful. "The honor," she wrote without further comment in her volume of reminiscences, "was accepted."[131]

The most coveted honor of all was, of course, a place among the *nobilitas major,* the lords of the realm. In 1859, a writer in the *Contemporary Review* rated as the higher professions the church, bar, army, and navy; medicine, solicitors, painting, and civil engineering were "lower" or "outside" because they did not lead to the peerage.[132] "I think that they should have made you a Baron instead of a baronet," George Du Maurier wrote to

15. John Everett Millais at the age of twenty-four in a 1853 pencil drawing by William Holman Hunt. At first harshly criticized in the press, Millais benefited from Ruskin's defense of the Pre-Raphaelite Brotherhood and was elected an Associate of the Royal Academy in the year of this drawing. (As published in the *Magazine of Art*, vol. 11, 1888.)

his friend Millais in 1885, "but it is a step in the right direction." [133] The transformation of Sir Frederic Leighton into Lord Leighton, Baron of Stretton, made just before his death in 1896, had been long awaited. To artists—even to those who responded coolly to the man and to his work— this was an award of exceptionally great significance, a truly momentous event, as one of their number could now take his seat in the House of Lords, an equal to the highest born. Frederick Goodall related the conversation he had with Leighton soon after the award was announced. Congratulated upon his elevation to the peerage, the Royal Academy's president replied with characteristic graciousness and tact and with a full sense of the importance of the event. "My dear Goodall," he said, "I do not look upon it as an honour to myself so much as to my brother Academicians. We are all peers now." [134]

Leighton, with his title and regal bearing, expressed in his person the professional's proud claim to autonomy. Who could challenge the fitness of such a man to rule in his own dominion? But even the grand presence of this extraordinary figure could only symbolize the freedom and respect to which all artists aspired; the ever-present preoccupation with the painter's insistence upon autonomy never diminished, for it was always more or less under threat. This constant striving for full autonomy served as the most important link between the image of the artist as a highly qualified professional, properly independent of lay direction and criticism, and the image that was a direct legacy of the Romantic era, that of the inspired genius, impelled to create out of an inner vision.

Autonomy, which had seldom existed in the pure and untarnished form in which artists liked to imagine it, was a constant concern even to the most prosperous, respected, and seemingly "free" practitioners. Of course, it was the portrait painter who suffered the greatest loss of status for working, as George Dunlop Leslie put it, "in harness." [135] But any work done on commission could arouse an almost unbearable sense of constraint: "Your letter," wrote Turner to a friend to whom he had sent a gift of two drawings, "treats them both so like a commission that I feel my pride wounded and my independence roused." [136] The greater freedom that came with the development of the dealer system, allowing the artist wider scope than when he worked for an individual patron, had its own limitations and frustrations. Millais, for example, had a great deal to say about the unreliability of dealers in changing orders with the shifting winds of demand, while Hamerton commented that poverty was liberty compared with work under a dealer's pressure to produce in accordance with a formula whose success had been proved. [137]

Again and again, in conversations and in writings, artists fought against threats and supposed threats to their autonomy, relating and retelling anecdotes of painters who had successfully (and sometimes insultingly) resisted efforts to influence their work. Herkomer, for example, when offered a commission to paint the portrait of a famous person on the condition that it be executed in his earlier, rather than his current "impressionistic" style, bluntly refused.[138] John Singer Sargent, although he accepted commissions only with the stipulation that he have absolute freedom of choice in design, costume, and setting, suffered nonetheless from his failure to please his sitters.

He himself remarked wryly that every portrait he painted made him at least one enemy, and defined a portrait as "a likeness in which there was something wrong about the mouth." To a lady who complained about the drawing of her nose, Sargent coolly replied: "Oh, you can alter a little thing like that when you get it home." His response to Sir Edgar Speyer's criticism, that his wife's neck was not green, was to paint it greener. Similarly, when Sir George Sitwell brutally pointed out that Edith's crooked nose had been painted straight, Sargent painted Sir George's own nose crooked, and left Edith's nose as it was.[139]

Cecil Rhodes, calling at the studio of the sculptor Alfred Gilbert about a commission, was infuriated when he found only the small wax figures that the sculptor used in planning his works. He was not, he said, "out to furnish a toyshop. I want something big! Big! Can't you show me anything I want?" Gilbert's response was to conduct the patron and his party to the door.[140] Such outraged responses by artists to challenges to their autonomy did not originate in the nineteenth century: for example, the seventeenth-century artist Salvator Rosa once told a client who had tried to dictate a painting's theme and treatment that he should "go to a brickmaker, as they work to order."[141] But both the legacy of Romanticism and the new wealth of Victorian painters probably made angry responses to interfering patrons a more frequent occurrence.

The success and high earnings that mid-Victorian painters achieved increased their artistic freedom by giving them the means to paint works for which there were no likely purchasers. For example, Watts's earnings from portraits allowed him to paint "a series of pictures suggesting reflections of a highly ethical and serious nature, with the view of presenting them to the nation."[142] Similarly, Herkomer wrote that "depending entirely on my portraiture for my income, I am now in a position to *give away* any important picture that I may care to paint, and this I have actually done with my last three large canvases. . . ."[143]

But with success came new threats to the painter's freedom. Success

could, for example, tempt an artist to avoid risks and stay with proven themes. Herkomer's strenuously self-conscious efforts to avoid being dubbed a painter of old men after the success of *The Last Muster* becomes entirely understandable when one looks at the instance of Marcus Stone, R.A., who became wealthy by numerous depictions of a popular formula that one writer has called the "Dorothy" picture: "a scene in which the chief figure is a young woman wearing vaguely period costume and obviously called Dorothy." Stone had an elegant house in the Melbury Road artists' colony with a garden and a tapestry-hung studio, and reproductions of his works "were to be seen in every print-seller's shop window in Europe." Yet, from the standpoint of the use he might have made of his talents, he considered himself a failure. "He often inveighed against God, the Royal Family and the Victorian prudery which caused him to paint such sentimental nonsense. 'One sells one's birthright,' he used to say."[144]

Success could also set in motion a schedule more generally associated with the driven life of the entrepreneur, a hectic pace detrimental to reflective professionalism and to the continual refinement of the painter's highest capacities. Sargent's career, as described by the French painter Jacques-Emile Blanche, provides an extreme example of the price that success and fame could exact.

Hardly ever could he paint what he himself desired except when he had rushed off to Italy, to Spain, or to the Tyrol to do water-colours—yet he was like a surgeon who leaves his cases accumulating against his return. There were sitters awaiting him in London, there were tiresome portraits and ceremonies which a Royal Academician cannot avoid. Sargent became speechless when he had to propose a toast, weighted down by the harness which his prodigious success fastened around his shoulders. . . . "The Van Dyck of Tite Street" had to make appointments six months or a year ahead with Royal Highnesses just as occupied as he. During the season, at the grill-room of the Hyde Park Hotel he devoured his meals and gulped down his wine, his watch on the table in front of him."[145]

After about 1900 Sargent returned to landscape painting, and in 1907 decided to abandon the practice of portrait painting.[146]

Increasingly, towards the end of the century, one finds a desire among artists (and not only those of the art-for-art's-sake persuasion) for the freedom to become totally absorbed in their painting, a desire to turn away from the earlier Victorian painter's sense of social mission. One manifestation of this desire was the formation of communities of artists in rural areas, such as the fishing village of Newlyn on the Cornish coast. As Kenneth Bendiner has pointed out, these artist-colonies "represent the alienation of the artist from society, a significant gap between the standards and lan-

guage of creators and the ideals and direction of established culture."[147] Painters expressed this inward-turning tendency in a variety of ways. Sargent, for example, never read newspapers and was completely uninformed about developments outside the world of art.[148] Burne-Jones, who had taken part (with Morris) in the anti-Turkish agitation following the massacre of Bulgarian Christians, was disillusioned by the public's loss of interest in that issue. Having permanently lost faith in the efficacy of political activity, he decided to return to his studio and confine himself to his true vocation. As a friend wrote in 1899, a year after the painter's death, Burne-Jones had come to feel a sense of revulsion about thinking of the injustice and cruelty in the world.[149] The impressionist landscape painter Philip Wilson Steer, one of the "advanced" artists to be championed by the critic (and future keeper of the Tate Gallery) D. S. MacColl, was described as having little time for literature and scant interest in it. "He lives," MacColl wrote admiringly, "by his eyes."[150]

MacColl and the other New Critics, observed the *Studio* in 1893, had "closed their Ruskins for ever," having chosen "their own gods—gods whom their fathers never admitted even within the gates." In an article in the same issue of the magazine, MacColl points out that painting is an unsatisfactory vehicle for the expression of ideas, adding (in an aside that almost offhandedly discards a central Ruskinian tenet) that whether an artist has ideas at all is in any case irrelevant to his work. In MacColl's view, painting is a special form of private amusement for one "who has a peculiar lust of the eye, one so trained and sophisticated as to be gratified within the limits of a frame and a flat canvas."[151]

For a few young painters, the new canons of criticism that judged paintings by their visual properties alone —MacColl said that the man with no interest in technical questions had no interest in art—entailed loss as well as gain. William Rothenstein, for example, who regarded himself as one of the "advanced" artists of the nineties, never lost his feeling of awe for the grandeur of the most eminent among his Victorian predecessors. Rothenstein always remembered his first meeting with Watts in the early years of that decade of change.

He was then a very old man, very gentle, obviously delicate in health, but of serene and dignified aspect. He wore a black velvet skull-cap and a fine cambric shirt, with delicate wristbands setting off beautiful, old, veined hands. When I spoke with admiration of one of his latest exhibited pictures—a great oak tree strangled by ivy—he said hesitatingly that he had something in his mind at the time which inspired it, though he scarcely liked to speak of this to me—the undisciplined art of the day slowly sapping the life of a centuries-old artistic inheritance. In the pres-

ence of a man of Watts' character and achievement, I realized how trivial our paint-
ing must appear in his eyes; and how misguided our lives. . . .

Watts' didactic comment had some point: compared with the giants then still
alive, Watts and Whistler, Burne-Jones and Ruskin, William Morris, Meredith,
Hardy and Swinburne, we were little men.[152]

With the withdrawal of painters from a professionalism devoted to serv-
ing the ideals of society to a professionalism equally devoted to serving the
demands of art itself, there came a rapid contraction in the size of the art
public. No more would there be great excitement to catch hints of what
might be coming in the Royal Academy show, no longer would the *Times*
fill long columns with detailed accounts of walls crowded with paintings.
Art, wrote the great admirer of the unity of mid-Victorian culture, G. M.
Young, is no longer our business in the world. Even into the 1890s, Young
observed, interest in society's culture-bearers, among them painters, was
still widespread. One small incident that occurred in the summer of 1896
symbolized to him just how great a change has taken place in later times.
Young was standing on a railway platform near a man who was "certainly
not of the aesthetic class." The man opened his newspaper and exclaimed
to a friend, "Millais is dead."[153] But even at that time, there were many
who no longer cared.

3. *William Powell Frith: The Ambiguity of Public Triumph*

William Powell Frith was born in 1819 in a West Yorkshire village. His parents, who were then employed in a large household, moved to the health resort of Harrogate in 1826. There they became proprietors of the *Dragon*, a large and fashionable inn with a ballroom and a variety of parlors and reception rooms.[1] William's artistic gifts were discovered when, at the age of eleven, he copied the drawing of a dog from an engraving. Frith's father, who had an interest in art and some degree of talent, considered this accomplishment as a clear sign of genius, and the young artist was soon looked upon as the prodigy of Harrogate. His formal education, which took place at two boarding schools near Dover, was considered unimportant in the presence of this much-admired artistic ability. In his memoirs Frith wrote:

I found copying Dutch prints much easier than geography and the use of the globes, to say nothing of Latin, for a very slight experience of that language led me to feel that life would be unendurable if I were compelled to learn it; so that beyond a little of the grammar, and the acquisition of a few quotations—which I find useful to this day when I desire to create an impression that they are but samples of a wealth of the classical knowledge that I possess—I know nothing whatever about it. . . . [At St. Margaret's] the most of my time [was] taken up with my eternal copying in chalks, or lead-pencil, with a little pen and ink for a change, from any good, bad, or indifferent print that fell in my way. . . . I remained about two years at St. Margaret's, and, except a little French, I learned nothing.[2]

In fact, the French drawing master at St. Margaret's had been given strict orders to let William do as he liked. This was just as well, wrote Frith, for he was as ignorant as his pupil.

Perhaps the most striking feature in the youth of the artist, given the early and enthusiastic encouragement of his talents, was the reluctance with which his career choice was made. One reason for this reluctance may have been Harrogate's distance from London, the country's one true art center. Had William been born in or close to that great city, he would probably have made many visits to the great paintings at the National

Gallery, first opened to the public in 1824. He would certainly have visited the annual exhibitions of contemporary art which had been held regularly in the capital since 1760, predecessors to the Royal Academy shows that began in the closing years of that decade.

The great age for the founding of provincial art galleries was not to come until the late nineteenth century; nevertheless, important beginnings were made in the early years of the century, when many art institutions and societies were founded in provincial towns.[3] For example, the Northern Society at Leeds, not far from Harrogate, had held painting exhibitions since 1809.[4] But Frith appears not to have attended them, and such pictures as he did see locally did not inspire him with enthusiasm for a career in art. He wrote, "It must be remembered that up to this time I had seen no modern pictures, but only the ancient ones in my father's collections. Those were very dark, so obscure as to cause one of our Harrogate friends to say that he 'didn't care a button for the old masters, for you have to take a sponge and wet 'em all over before you know what the subjects are about.'" Old masters—or "black masters," as Hogarth had preferred to call them—like the ones owned by the elder Frith had long been a prominent feature of the English art trade. Hogarth had hated them, and contemporary artists considered them unfair competition (because the prestigious names of their supposed creators attracted a large share of the available patronage); but demand for them remained strong until the vogue for the modern picture began in the late 1840s. It was said that many of the fake old masters received the final baking that gave them the look of cracked and darkened authenticity in secret ovens in Richmond, a town near London.

In these circumstances, young William decided that he would like to become an auctioneer, a less demanding and at that time a more profitable career than that of an artist. But this decision exasperated his father, who said, "Now look here. . . . You have your living to get; everybody says you show ability for the artist business; will you follow it? If you will, I shall take you to London, and am willing to spend some money on it." According to Frith, nothing less than the veto of a Royal Academician would satisfy his father that he was unworthy of following the arts. In due course, a compromise was reached. Father and son would travel to London, where the advice of an Academician-painter would be sought. If his opinion was favorable, then William would go to "Mr. What's-his-name in Bloomsbury and learn the business" in preparation for application to the Royal Academy schools; if it were not, an apprenticeship in auctioneering would be sought at Oxenham's in Oxford Street.[5]

What accounts for the elder Frith's determination to make an artist of his son? We know that he had a respect for art (and certainly, from Frith's account, a reverence for artists), some contact with the fashionable world, and sophistication enough to seek the advice of an R.A. in London rather than take the opinion of the local portrait painter. This being the case, there can be little doubt that he would have been familiar with the fact that Sir Thomas Lawrence, the illustrious president of the Royal Academy, was the son of an innkeeper. Lawrence had died in 1830 (the year Frith's parents discovered their son's artistic "genius") and was buried in St. Paul's after a state funeral attended by noblemen and gentlemen pall-bearers. Where public access to works of art was so limited, success stories like that of Lawrence are likely to have served as agents of recruitment into the art profession.

In 1835, Frith and his father made the momentous trip to London, one of many similar trips that launched careers in English art during the nineteenth century. Drawings done by the sixteen-year-old William were shown to two Academicians, the Chalon brothers. Their favorable verdict led to Frith's enrollment in Sass's School of Art for a two-year course of study that would prepare him for admission to the schools of the Royal Academy. Edward Lear, the limerick writer and landscape artist, was a fellow student at Sass's school, which was subsequently attended by John Everett Millais and Dante Gabriel Rossetti. Years later, when the rich and successful Frith showed the same drawings to Alfred Chalon, the elder artist could not remember having seen them or having given the crucial advice.

"Do you mean to tell me," said Chalon, "that I advised that you should be trained an artist on such evidence as that?"
"Indeed you did."
"Then," said Chalon, "I ought to be ashamed of myself."[6]

It was Frith's stated purpose in writing and publishing his memoirs during the late 1880s to be of help to young aspirants in art. Like the Chalon brothers and so many other noted artists, he was often consulted by the parents of would-be artists for his expert opinion on artistic aptitude. The reader of his autobiography senses an undertone of personal irritation over time spent with unpleasantly importunate parents. But Frith leaves no doubt of his real conviction:

Except in the rarest and most exceptional cases, judgment from early specimens is absolutely impossible. Consider the quality of mind and body requisite for a successful artistic career—long and severe study from antique statues, from five to eight hours every day; then many months' hard work from the life, with attendance at lectures, study of perspective, anatomy, etc.; general reading to be attended to

also—all this before painting is attempted, and when attempted the student may find he has no eye for color. . . . What is more fearful still, he may find that he has all the language of art at his fingers'-ends, and that he has nothing to say. . . . Composition and arrangement of the colors, and light and shadow, necessary in a group of more or less figures, cannot be taught, or if taught by line and rule the result is *nil;* the whole thing is a matter of feeling and imagination. An artist must see his picture finished in his mind's eye before he begins it, or he will never be an artist at all.[7]

Frith's memoirs, according to the *Times* obituary of 3 November 1909, pleased all those "who are content to regard art as a profession like every other, and to clear their minds of any mysterious and sacramental ideas in connexion with it." Since this charge—essentially a charge of philistinism—was typically made by Frith's detractors, an account of his career should give close attention to his attitude towards artistic creativity. While no "mysterious" or "sacramental" images of the artist and his work appear in the passage just quoted, it is important to note that it leaves considerable room for unteachable qualities of feeling and imagination. Frith is quite clear about the necessary prerequisites for success in art: physical stamina and the ability to tolerate concentrated hours of hard work, a good color sense, enough reading to suggest subjects (it is clear that this is what Frith meant by "something to say"), a feeling for good composition, and the ability to visualize. His tone seems closer to that of eighteenth-century discussions of aesthetics than to the discourse of the Romantic age into which he was born. In fact, the eighteenth century held a great attraction for Frith; again and again, he sought subjects for his pictures in novels by Goldsmith and Sterne and Richardson, in the *Spectator,* and in scenes from the lives of Dr. Johnson and his circle. He seems to have felt no instinctive sympathy with the romantic stereotype of the ardently artistic youth struggling against his parents' banal concerns for financially secure prospects: "Parents, in nearly all instances that have come within my experience, have shown marked and often angry opposition to the practice of art as a profession for their children; naturally and properly, I think, considering the precarious nature of its pursuit."[8]

Frith also discusses his first Academic successes in language characteristic of eighteenth-century writers on professional placement and advancement: "I had," he writes, "no influence to help get my first picture exhibited." And he recounts his intense delight at finding that a scene he had portrayed from *The Vicar of Wakefield* had been hung "on the line," in "that envied, coveted position which so many are destined to long for, but never to occupy. I confess I was as much astonished as I was de-

lighted, for I had no interest, not knowing a single member of the Academy."[9] Also eighteenth century in feeling is Frith's implicit definition of genius, which seems close to the spirit of Samuel Johnson's formulation: "Large general powers accidentally determined to some particular direction."[10] "As Sir Joshua Reynolds said when he commenced his profession," the young art student Frith wrote in a letter to his mother, "he *would* be a great man, and he *was* a great man. Whatever profession he had followed he would have been equally great—that's my firm opinion!" Frith's views on the psychological foundations of artistic creativity did not, however, retain this youthful certainty. He agreed with Reynolds that belief in the notion of inborn genius was usually dangerous. Thus: "How many instances have I known of men who, living in the full persuasion that they were God-gifted geniuses, have persevered from year to year, in spite of every kind of rebuff, in producing pictures destitute not only of genius, but of anything approaching to talent!" But he also came to feel that Reynolds sometimes overemphasized this point of view:

Reynolds says, "You must have no dependence on your own genius; if you have great talents, industry will improve them; if you have but moderate abilities, industry will supply the deficiency." Another writer says, "Genius means the power of taking great pains." I don't think either of those great men could have been quite serious, or could have intended their advice to be taken literally, but rather to enforce the absolute necessity of hard work. Would the severest application have produced a Raphael or a Hogarth? No. But neither Raphael nor Hogarth could have produced their immortal works without the exercise of painful industry.[11]

His temperamental affinity for the Age of Reason notwithstanding, Frith did not remain untouched by the powerful winds of change that swept through the intellectual and aesthetic climate of Europe during the first quarter of the nineteenth century. He describes himself as a "worshipper" of Shelley and proudly writes of his friendship with the poet's son. His frequent use of the expression *feu sacré* appears to be without irony. If he wrote of art as a profession like any other, it was perhaps because he felt that such a description was applicable to his own career and to those of the overwhelming majority of his fellow-practitioners. His recitation of the qualities requisite for success in art was not, after all, addressed to future immortals, who would surely have little interest in his advice; it was addressed to aspirants closer to his own level of talent. His honesty and clarity on this question are admirable: "I know very well that I never was, nor under any circumstances could have become, a great artist; but I am a very successful one."[12]

The key phrase in this frank confession is "nor under any circum-

stances." With these words, he shows himself a man born into the age of Romanticism, for he vehemently rejects the popular Enlightenment theory that the newly born human is a tabula rasa, completely malleable by educative influences. The best art training in the world, he wrote, could not develop "a faculty which Nature has failed to implant." Nature, he seems to be telling us in his unsystematic and anecdotal way, must first prepare the soil even for modest talent like his own, implanting some mysterious faculty into the souls of those few capable of greatness—although even this capacity will be stillborn without arduous and long labor.

From our twentieth-century standpoint, the charge brought against Frith by his contemporaries and echoed in the *Times* obituary—that his attitude toward art and the art-producing faculty was at worst philistine and at best narrow in the value it placed on the creative imagination— appears somewhat crude. The truth is more subtle: romantic ideas on art and the imagination did indeed influence Frith, in more ways than we have mentioned, but he objected strongly when those ideas were given extreme formulations and applied to all forms and degrees of artistic activity. Certainly, he would have objected in strong terms to these words of William Blake, which may be read as a distillation of the Romantic reaction against eighteenth-century rationalism and environmentalism: "Reynolds thinks that man learns all that he knows. I say on the contrary that man brings all that he has or can have into the world with him. Man is born like a garden ready planted and sown. This world is too poor to produce one seed." [13]

Henry Sass, in whose care young Frith was placed, was a former Academy student and a friend and contemporary of Wilkie, Mulready, and Haydon. These artists referred many pupils to Sass's school. Sass himself was noted for various eccentricities and for a hot temper (he suffered an incapacitating mental breakdown soon after Frith left the school), but Frith, one of his two boarder-pupils, wrote appreciatively of his teaching and of Mrs. Sass's motherly kindness. The school, then the only one of its kind in London, featured a gallery with replicas of antique statues and a lighting scheme that was compared with that in the Roman Pantheon. The regimen of study began with a long course of drawing "from the flat": students were to make copies of outlines Sass had prepared from the antique, "beginning with Juno's eye and ending with the Apollo—hands, feet, mouths, faces, in various positions." When sufficiently advanced in this skill, they were allowed to proceed to the next, which was the representation of a huge white plaster ball which stood on a pedestal; by a process of hatching (that is, drawing fine parallel lines), students were to learn to suggest the

qualities of light, shadow, and rotundity. Although Frith termed Sass's system "admirable," his criticisms suggest that perhaps what he found most valuable was its inculcation of the steady work habits he thought essential to success in art.

I spent six weeks over that awful ball (the drawing exists still, a wonder of line-work), the result being a certain amount of modelling knowledge very painfully acquired. Then came a gigantic bunch of plaster grapes, intended to teach differences of tone . . . in a collection of objects, with the lights and shadows and reflections peculiar to each. How I hated and despised this second and, I thought, most unnecessary trial of my patience! but it was to be done, and I did it. Then permission was given for an attempt at a fragment from the antique in the form of a hand. Thus step by step I advanced, till I was permitted to draw from the entire figure. How I regret that I did not exert myself to draw more figures and more carefully! but the severity tried me very much, and I felt very weary and indifferent. I could feel no interest in what I was about. Perspective bewildered me, and to this day I know little or nothing about that dreadful science; and anatomy and I parted after a very short and early acquaintance.[14]

After two years of working from the antique, Frith was allowed to "try for the Academy," and, to his and Sass's surprise, he was accepted. It was not until he had begun to paint (for which purpose he again attended Sass's, for Academy students had to work at drawing for some time before they were allowed to try the brush) that Frith found real enjoyment in his vocation.

Here, again, the system was admirable. A simple antique model was put up before the student, who, provided with brushes, and black and white paint only on his palette, was told to copy it in monochrome. I date my first real pleasure in my work from that moment. After the tedious manipulation of Italian chalk, the working with the brush was delightful, and the result seemed so much more satisfactorily like the object imitated than was possible by the former method. . . . I no longer regretted the easy life, or what I thought such, of the auctioneer. I felt real enjoyment in my work, a feeling which has possessed me from that day to this in ever-increasing strength.[15]

In 1837, the year the eighteen-year-old Frith began study at the Royal Academy, his father died of influenza. His mother rented out the inn and moved to London to be close to him and to another son who was studying law. Frith contributed to his own support by doing portraits during the long vacation period, making a number of visits for this purpose to the houses of family acquaintances in Lincolnshire. He thus served a kind of informal apprenticeship in the style of the itinerant artists who wandered through the countryside in the days before the camera took over the function of providing people with images of themselves. Frith charged five

pounds for a head, ten for a kit-cat (a portrait of less than half-length, but including the hands), and fifteen for a half-length, all life-sized: "I went from house to house, chiefly among the higher class of gentlemen farmers, staying as long as my work lasted; sometimes flirting with the young ladies, who thought painting 'oh, such a beautiful art!' flattering their mothers—in their portraits, I mean—and, I verily believe, making myself a general favorite everywhere." [16]

Frith seems to have regarded this on-the-job training as more valuable than his work in the Academy schools. Although he was to become a proud Academician and generally defended the institution against its detractors, he had few good words to say for the art training it provided. He felt that too much time was spent on elaborately stippled drawings from antique casts, with too much concentration on close detail and "finish" and too little on construction and composition and on mastering the technical skills essential to competence in painting.

Some painters critical of the Academy schools believed that the deadening routine at the schools was the result of constant turnover in teaching personnel, a system that gave no one the motivation or the continuity to undertake comprehensive reform. Teaching was done by Visitors; these were Royal Academicians who successively took a month's duty, but who, according to the testimony of Frith and others, frequently spent the prescribed two hours reading. Lack of interest was not the only problem. In addition, wrote Frith (who at the time was supporting another in a long series of efforts to reform the schools), many were simply incompetent artists: "I heard one of the most eminent academicians say—in answer to reproaches for his neglect in not attending at the Painting School—'what would be the good? I don't know anything; and if I did I couldn't communicate it.'" [17] (The annoyance that some successful painters had probably always felt over having to assume periodic teaching duties doubtless became even stronger in the 1850s, when the financial rewards of painting began their rapid rise.)

Frith first became an exhibiting artist in 1839, two years after entering the Academy schools. Several of his early works were hung in the galleries of the British Institution, which had first opened in 1806 in Boydell's Shakespeare Gallery in Pall Mall, and in the Suffolk Street galleries of the Society of British Artists, which a secessionist group from the British Institution, led by Benjamin Haydon and John Martin, had founded in 1823. Both galleries were begun in a spirit of criticism of the Royal Academy (in the case of Haydon it was virulent opposition), but artists generally considered them poor alternatives to exhibition at the prestigious Academy

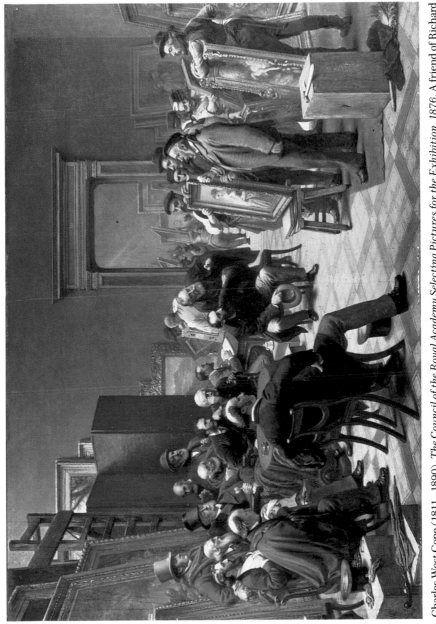

Charles West Cope (1811–1890). *The Council of the Royal Academy Selecting Pictures for the Exhibition, 1876.* A friend of Richard Redgrave's, Cope studied at the Royal Academy Schools and on the continent. Like Henry Wood's 1870 illustration (Fig. 33), this is one of many Victorian examples of the art scene treated as an artist's subject. (By permission of the Royal Academy of Arts, London.)

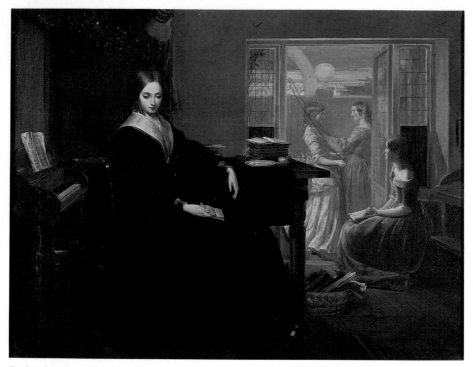

Richard Redgrave (1804–1888), *The Governess*, 1844. This is one of the four versions the artist did of this picture, the first having been exhibited at the Royal Academy in 1843. Redgrave's portrayals of lonely and exploited governesses reflected memories of a sister who returned, ill, from her first position as a governess, and died shortly afterwards. (By permission of the Board of Trustees, Victoria & Albert Museum, London.)

16. William Powell Frith in 1849, at the age of thirty. An Associate of the Royal Academy since 1845, Frith was a painter of historical and literary genre until 1854, when he turned to the modern subjects that made him famous. (After the painting by Augustus Egg, as published in the *Magazine of Art*, vol. 11, 1888.)

er; Mr. Andrews of York, who had made a fortune in the railway mania of 1847; and Mr. Miller of Preston, a textile manufacturer. Miller was a particularly close friend whose collection of modern pictures was, Frith told the Art Union commission in 1866, the best of its kind.[20] Frith and his friend Augustus Egg painted a public-house sign as a present to Miller, "who had just then purchased an estate in Lancashire, for which he was said to have paid a fabulous sum—as, in addition to many hundreds or thousands of acres, a whole village and the public-house were part of the bargain." Miller purchased most of his collection from picture-dealers, but "greatly preferred buying living men's pictures from the artists who had produced them."[21]

Jacob Bell, who commissioned what was to become Frith's most famous work, had made a fortune in his father's wholesale pharmacy business, after his highly individual sense of humor and strong inner rebelliousness had brought about his expulsion from Sass's School of Art and from the Quaker community. Known as a generous patron of English art, and particularly for his collection of pictures by Edwin Landseer, Bell must have enjoyed telling Frith of how his father, "a rigid Quaker, who watched with disapproval his son's purchases of pictures," had been converted to an understanding of the value of art collecting:

shows; they tended to be filled with pictures considered to have poor prospects of acceptance at the Academy and with "second-runs," works already shown there.[18]

In a vivid remembrance from this period of his life, Frith describes the technical difficulties he encountered in painting his first subject picture, illustrative of some lines from Scott's *Lay of the Last Minstrel:*

> Full slyly smiled the observant page,
> And gave the withered hand of Age
> A goblet crowned with rosy wine.

Despite the practice acquired during his portrait-painting tour of Lincolnshire, Frith encountered a combination of technical problems that seemed overwhelming.

I knew far too little of perspective, and consequently the relative sizes of the old man and the page puzzled me frightfully; sometimes their figures were tumbling over each other, and sometimes they were slipping out of the picture. Do what I would, I could not make their feet stand flat on the floor. The boy had a stupid giggle on his face, and stood upon his toes. The old man's beard insisted on looking as if he had tied it on. . . . How well I remember throwing down palette and brushes, and rushing out of the house in despair. . . . After rubbings out and alterations innumerable, the picture was finished. . . . I sent the *Last Minstrel* to the Suffolk Street Gallery, and it was hung among other specimens of imbecility. The whole exhibition was frightfully criticised in the newspapers, and if I were not selected for especial abuse, it was evident, I thought, that I was not worthy of notice.[19]

It was indeed a serious indictment of the art training available in England that Frith began his career with the self-image and technical insecurity of an autodidact, despite the fact that he had attended the schools of the country's most prestigious art institution.

Most of Frith's early pictures were illustrations from literature, set in the eighteenth century or earlier. *Malvolio, Cross-gartered before the Countess Olivia* was his first picture to be hung at the Academy, in 1840. Public notice came soon afterwards, when a scene Frith had depicted from *The Vicar of Wakefield* was chosen the winner of a one-hundred-guinea Art Union prize. (So numerous were paintings illustrating this work that Thackeray, then art critic for *Fraser's Magazine,* insisted on referring to it only as the "V——r of W———d.") Frith's friendship with Dickens, who, pleased by an illustration the artist had done for *Barnaby Rudge,* commissioned several more, was no doubt also helpful in the early stages of the painter's career.

Most of the paintings Frith did during the forties and early fifties were commissioned by patrons, among them, Mr. Gibbons, a Birmingham bank-

William Powell Frith (1819–1909), *The Sleeping Model*, 1853. Frith contributed this picture to the Royal Academy as his Diploma work, the picture that each R.A. was required to present. Having chosen the model for the charming smile represented on his canvas, Frith was dismayed at her inability to stay awake at sittings. Especially interesting is the self-portrait of the impeccably dressed artist and the almost palpable sense of social distance between himself and the working-class girl. (By permission of the Royal Academy of Arts, London.)

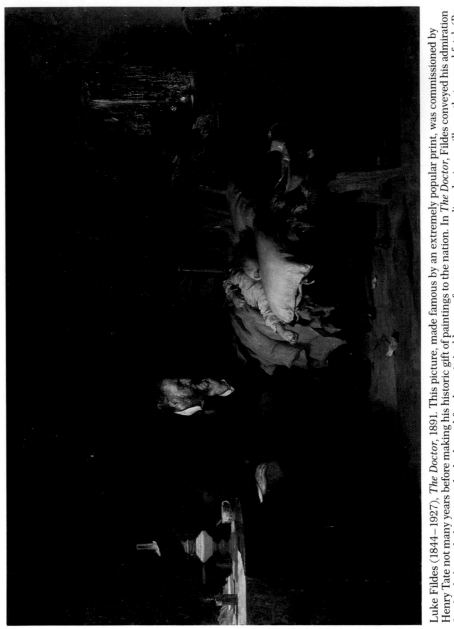

Luke Fildes (1844–1927), *The Doctor*, 1891. This picture, made famous by an extremely popular print, was commissioned by Henry Tate not many years before making his historic gift of paintings to the nation. In *The Doctor*, Fildes conveyed his admiration for the dedicated physician who had cared for the artist's eldest son fourteen years earlier, during an illness that proved fatal. (By permission of the Tate Gallery, London.)

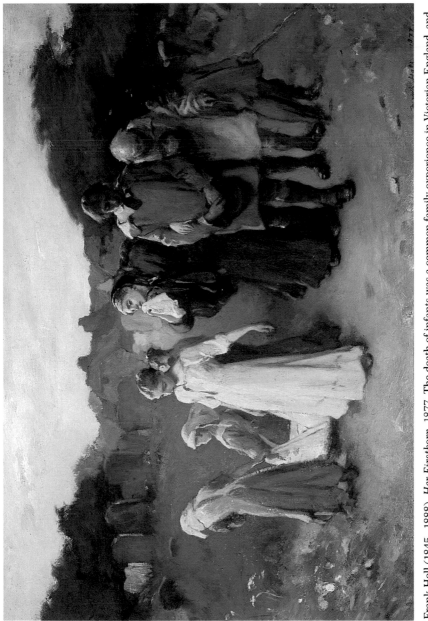

Frank Holl (1845–1888), *Her Firstborn*, 1877. The death of infants was a common family experience in Victorian England, and depictions of maternal grief a recurrent theme in Holl's pictures. (By permission of the Dundee Art Galleries and Museums.)

William Powell Frith, *Derby Day*, 1858. This enormous (40 by 88 inches) and richly detailed canvas became an overnight Academy sensation and continues to be one of the most admired Victorian paintings. (By permission of the Tate Gallery, London.)

Elizabeth Thompson Butler (1846–1933), *Calling the Roll after an Engagement, Crimea* (*The Roll Call*), 1874. This picture brought immediate celebrity to the young artist upon its exhibition at the Royal Academy. (Royal Collection, by permission of Her Majesty the Queen.)

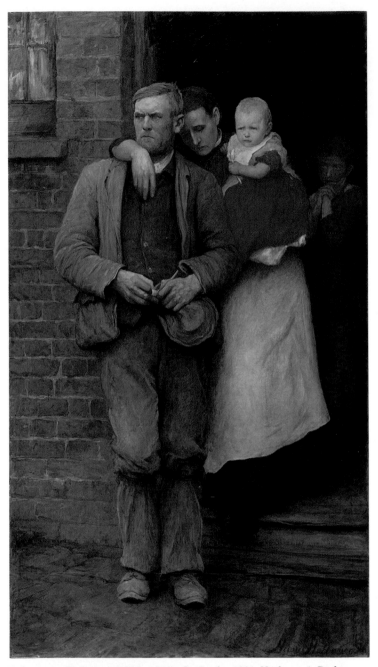

Hubert von Herkomer (1849–1914), *On Strike*, 1891. Herkomer's Diploma
work illustrated the bitter labor strife of the late-Victorian period. For some
viewers, this painting evoked memories of the London Dock Strike of 1889.
(By permission of Royal Academy of the Arts, London.)

"What business hast thou to buy those things, wasting thy substance?"

"I can sell any of *those things* for more than I gave for them, some for twice as much."

"Is that verily so?" said the old man. "Then I see no sin in thy buying more."[22]

In 1850 Frith received the last commission given by one of the most famous patrons of early Victorian art, John Sheepshanks, who seven years later gave his entire collection to the new South Kensington Museum, so that it might be a source of education to the rising generation of artists. Sheepshanks's wealth was derived from his father's Leeds cloth manufacturing firm; born in 1787, he was able to do his picture buying at prices which, by the mid-nineteenth century, were considered "ludicrously small." To those who made such comments, he gave a somewhat petulant explanation: "Well, I always give what is asked for a picture, or I don't buy it at all; never beat a man down in my life. Never sold a picture, and I never will; and if what I hear of the prices that you gentlemen are getting now is true, I can't pay them, so my picture-buying days are over."[23]

Another patron, the banker Gibbons, commissioned Frith's portrayal of the village pastor. This picture was suggested by lines in Goldsmith's poem, *The Deserted Village*, and it led to the artist's election as an Associate of the Royal Academy in 1844, a great honor for a young man of twenty-five. Frith long remembered the excitement of his first Academy Banquet, which was attended by, among other notables, the Duke of Wellington. His comments convey the meaning that annual event held for him and for many of his fellow artists: "The great dinner that takes place before the opening of the exhibition is generally considered *the* public dinner of the year, and when it is understood that those eligible to take part in that remarkable gathering must either be persons of exalted rank, or great as statesmen, military or naval heroes, ecclesiastical or legal dignitaries, or eminent professors of science or literature or (if last, by no means least) well-known patrons of art, it is evident that an assemblage almost unique must be the result."[24]

Frith also remembered a dinner held at the close of the exhibition solely for artists who had participated in the show. On that occasion a memorable speech was given by Turner, in which the great painter, in his rambling and half-incomprehensible style, stressed the need for member-artists to give loyal support to the Academy, comparing them with the warriors of Ancient Rome: "What I want you to understand is just this. . . . When you become members of this institution you must fight in a phalanx—no

splits—no quarrelling—one mind—one object—the good of the arts and the Royal Academy."[25]

In setting down his memory of this speech in his memoirs, Frith makes it clear that he was impressed by Turner's deep devotion to the Academy. It is also clear that Frith believed that many charges made by nonmembers against the Academy's self-serving policies were justified, and that certain proposed reforms were long overdue. Nevertheless, when the institution itself was under attack, he rallied willingly to its defense—as when he told the 1863 commission that complaints made against the Academy came from "a little clique of painters who have contrived to get possession of the public ear through a portion of the press."[26] In the context of the politics of art, it was fitting that when Frith was elected to full Academic status in 1853, it was to fill the place vacated by the death of Turner, another loyal Academician.

Even as he continued to produce "costume pieces" set in earlier periods, Frith thought a great deal about the possibility of depicting contemporary life. He feared, however, that the prosaic dress of the mid-nineteenth century would be jarring; the "hat and trousers" pictures that he had seen had all impressed him as artistic failures. The question of dress is a very important one to a painter, and it was particularly problematical in Frith's day. Academy painters knew that art that aspires to the grand style must (as Reynolds advised) minimize contemporary details that detract from universality. By mid-century, however, Victorian artists were painting small-scale pictures for patrons who, like Thackeray, were tiring of scenes from *Tristram Shandy* and *The Vicar of Wakefield;* furthermore, they were proud of the great age of progress in which they lived and wanted to see it reflected in their works. Victorian artists were thus obliged to cope with the need to depict aspects of modern life that violated their aesthetic sensibility. Dress, which has been called the only original and nonderivative style of the Victorian era, was the most crucial of these aspects; according to Quentin Bell, the age of Impressionism might more appropriately be called the age of the bustle.[27]

Frith ridiculed the aesthetes of the late 1870s who led the revolt against the stiff and elaborate clothes that had been fashionable since about 1830. Draped in limp pastels, they gave events at the Grosvenor Gallery (which opened in 1877) a unique flavor that invited parody. But, like many other artists unsympathetic to the Pre-Raphaelite movement and its cultural manifestations, Frith shared the Pre-Raphaelites' belief that mid-Victorian dress was both ugly and deforming. George Frederic Watts, an ardent ad-

vocate of dress reform, aptly expressed the sentiments of many contemporary artists:

A well-dressed gentleman ready for dinner or attired for any ceremony is a pitiable example—his vesture nearly formless. . . . His legs, unshapen props—his shirt front, a void—his dress coat, an unspeakable piece of ignobleness. Put it into sculpture, and see the result. The genius of Pheidias might be defied to produce anything satisfactory. We see without disapproval ugly, shapeless, ignoble forms, and it must be remembered that these form the language in which the artist has to speak. The human form, the noblest and most interesting study for the artist, is distorted in the case of men's dress by such monstrous garments, and in the case of women's dress by extravagant arrangements which impede all simple nobility and refined grace of movement.[28]

A tawdry dullness in men's clothes, a deforming ugliness in women's— these were what artists and art-loving Victorians saw in the fashions of their day. "I have always thought," wrote Frith,

that the human form should be allowed, in its beautiful, varying lines, to suggest its fitting covering. The gigot sleeve of 1830 was a monstrosity in my eyes, because, instead of following the lines of the arms, it directly contradicted them by swelling into an enormous balloon-shaped bag, extending from the shoulder to the wrist. It was reserved, however, for the present time to surpass all others within my recollection by a fashion so monstrously ugly, so gross an exaggeration of nature, indeed, so unlike any natural form, as to rob the female figure of all its grace. I need scarcely say that I allude to the hideous hump which, in a profile view, succeeds in deforming every woman to whom it is attached.[29]

Even Lord Herschell, the high chancellor, addressing guests at the Royal Academy Banquet of 1886 (the same year that the Impressionists, who so beautifully and gracefully memorialized nineteenth-century dress, held their last group show), called attention to the difficulty that modern dress presented to artists. There is, he said (according to the *Times*'s account of the Banquet), a symbiotic relationship between members of the legal profession and artists. Lawyers, having so much contact with the "unlovely" aspects of human nature, are grateful to artists for lifting them into a "purer and nobler atmosphere" and reminding them "that there is such a thing as a lovely side to human nature." Artists, in their turn, benefit by the legal profession in that one of the first acts of a new appointee to the bench is the seeking out of a portrait artist, who is helped by the fact that, more than other professions, the law has preserved a certain picturesqueness of costume.[30] Augustus John, who began his career a half-century later than Frith, advised that portraits should be done quickly; the brush cannot linger over "shabby and ephemeral garments.")[31]

The artist who chose to paint contemporary subjects needed to find a way to depict the mundane world without sinking into triviality; he needed to find a way to portray reality faithfully while somehow transcending the drabness, vulgarity, and ugliness of modern industrial life, which he believed to be incompatible with art. It was a problem that Frith was able to resolve only in a small number of canvases, and it was upon these, he came to realize late in life, that his reputation was to rest.

Frith's first attempt at a modern-dress subject enjoyed an ambiguous success. Painted in 1852, it was a picture of a servant-girl in the artist's household: "I painted the girl not only in her habit as she lived, but in her habits also, for she was carrying a tray with a bottle of wine on it." Purchased by Jacob Bell, who was convinced that there was what he called "copyright" in it, it was afterwards engraved, and titled, without the artist's knowledge, *Sherry, Sir?* Frith was to write in his memoirs:

What a thorn in my side did that terrible title become! I dined out frequently and dreaded the approach of the servant with the sherry, for the inevitable "Sherry, sir?" rang in my ears, and reminded my neighbor at table of my crime. "A pretty thing enough, that servant-girl of yours; but how you could give her such a vulgar title I can't think." This was dinned into my ears so frequently that I determined I would try to get the obnoxious words changed into some less objectionable. I went to the publisher and unburdened my mind. "Change the title!" said he; "why, it's the name that sells it. We offered it before it was christened, and nobody would look at it; now it sells like ripe cherries, and it's the title that does it."[32]

Frith's protests were probably not as intense as he suggests, since he painted a second version of the picture three years later. According to the *Times* obituary in 1909, a print of it hung for years, and probably still hangs, in the coffee-room of half the inns in England. After using it as their label for many years, the purchasers of the copyright, Williams and Humbert, sherry merchants, registered the picture as their trademark in 1939. Frith "confesses with humiliation" that he was prevailed upon to do a companion piece "to the vulgar *Sherry, Sir?*" in which a modest-looking servant is seen opening a door and looking inquiringly at the spectator. It was called, *Did You Ring, Sir?*[33] In 1891 the *Art Journal* published one in a series of descriptive and generally admiring articles on visits to collections of modern English art; hanging among the various works owned by the late connoisseur David Price of Queen Anne Street, where Turner and Fuseli had once lived, were *Sherry, Sir?* and *Did You Ring, Sir?* A terse review was given these two works: "They were published in a variety of forms, and no doubt achieved the fortunate result of making many homes happy."[34]

Frith admitted that his love of modern subjects had occasionally be-

trayed him into using trifling and commonplace themes; even so, he added, their truth to nature had value as a record of the customs and dress of the time. If this statement was partly rationalization, it also represented a feeling widely shared by Victorian artists who depicted the contemporary scene. At a time when familiar landmarks—social as well as architectural—were rapidly vanishing, these artists had a part to play in preserving the collective visual memory.[35]

Frith's three most celebrated works depict a major theme in Victorian social history: the use of newly acquired wealth and leisure by large numbers of middle-class people among whom were many purchasers of Frith's pictures and engravings. The artist conceived of the idea for the first of these works while at Ramsgate, during a summer holiday in 1851.

Weary of costume-painting, I had determined to try my hand on modern life, with all its drawbacks of unpicturesque dress. The variety of character on Ramsgate Sands attracted me—all sorts and conditions of men and women were there. . . . So novel was the attempt to deal with modern life, that I felt it to be very necessary to be able to show to those whose advice I valued the clearest possible indication of my new venture. When the oil-study was finished I called in the critics. . . . Most critics approved of the subject, but there were several non-contents. One man, an artist, said it was "like Greenwich fair without the fun"; another, that it was "a piece of vulgar Cockney business unworthy of being represented even in an illustrated paper." My non-artist friends were one and all against it; one said, "The interest, which he could not discover, could only be local"; and an academician, on hearing of it, said to a friend of mine, "Doing the people disporting on the sands at Ramsgate, is he? Well, thank goodness, I didn't vote for him! I never could see much in his pictures; but I didn't think he would descend to such a Cockney business as that you describe. This comes of electing these young fellows too hastily."[36]

The painting, known as *Life at the Seaside* (*Ramsgate Sands*) was exhibited, after three years of work, at the Royal Academy show in 1854. It represented, as witnessed from the ocean, a crowded scene of heavily dressed vacationers, a background of houses, cliffs, and bathing-machines, and a "happy family" animal act "consisting of cats and mice, dogs and rabbits, and other creatures whose natural instincts had been extinguished so far as to allow of an appearance of armed neutrality, if not of friendship, to exist among them."[37] Frith, now in his second year as a Royal Academician, had the good fortune of an assignment to the Hanging Committee and was able to place his picture in a highly advantageous location.

Finding a buyer, however, was another matter. There seemed to be no end of commissions for small works, but it proved difficult to find a patron who would buy this large one—one that could "make his name." In these circumstances, Frith took a bold step. He went against his friends' advice to "avoid picture-dealers" and sold *Ramsgate Sands* to the firm of Messrs.

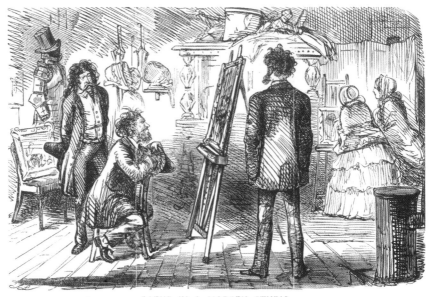

SCENE IN A MODERN STUDIO.

JACK ARMSTRONG HAS PAINTED A MODERN SUBJECT, FROM REAL LIFE, AND PAINTED IT UNCOMMONLY WELL.—STRANGE TO
SAY, HE HAS SOLD HIS PICTURE.
MESSRS. FEEBLE AND POTTER (*very high-art men, who can't get on without mediæval costume, and all the rest of it*) THINK IT
A MISTAKE.—CURIOUSLY ENOUGH, *THEIR* PICTURES ARE UNSOLD.

17. "Scene in a Modern Studio" (*Punch*, 19 April 1856). The tremendous success of Frith's *Life at the Seaside: Ramsgate Sands*, purchased by Queen Victoria at the Royal Academy exhibition of 1854, made it amply clear that the Victorian art public had a strong interest in seeing portrayals of contemporary life. Taking note of this interest with apparent approval, the *Punch* cartoonist ridicules the pretensions and formulaic practices of "high art" men, and implies that their failure may be well deserved.

Lloyd for one thousand guineas. The public response to the work was overwhelmingly enthusiastic, and the queen, who as a young princess had once lived at Ramsgate, expressed an interest in buying it. Sir Charles Eastlake, who as president of the Royal Academy was the queen's intermediary in the purchases she made at its exhibitions, asked Frith for the name of the picture's owner. Frith reports the exchange: "'Bought by a picture-dealer,' said I, 'who for a profit would sell it to her majesty or anybody else.'" Informed of the queen's wish to have the picture, Lloyds agreed to sell it to her for the price they had paid and made their profit by retaining engraving rights and by later selling the plate for three thousand pounds to the Art Union of London, then in the heyday of its success.

Frith's fame was assured by the distribution of fifteen thousand engravings to Art Union subscribers.

The sale of Frith's first large picture is an early example of the important change in the system of distribution of contemporary paintings. The dealer began to replace the private patron as initial purchaser and even as the source of painting commissions. In this major development in the social and economic institutions supporting art, Frith played a very large part.

After this first great triumph, Frith experienced the dilemma that faces all those who make a sensational debut into public life: how to maintain the high level of interest aroused without falling into stale repetition. Great public success, as with *Ramsgate Sands*, always stimulates professional jealousy. This fact, together with the characterization of Frith as a "low" artist, may have had something to do with the "bad hanging" given to the next painting mentioned by Frith, a happy scene of a child's birthday party.

My *Birthday* was a very painful example of the effect produced by its surroundings; being hung in a well-known and dreaded dark part of the large room, and being a low-toned picture, the consequences were dreadful. . . . I very soon discovered that my new effort was considered a great falling off from *Ramsgate Sands*, some kind critics going so far as to say I was "done for"; the decline had begun, speedily to terminate in a series of performances disgraceful to myself and the body which had elected me so prematurely. For a time I was crushed, but a reaction soon took place. Though the subject of *The Birthday* offered no opportunity for the display of character and variety of incident that distinguished the *Sands*, the execution of the picture was not inferior to its predecessor; and I felt sure that, if I could find a theme capable of affording me the opportunity of showing an appreciation of the infinite variety of everyday life, I had confidence enough in my power of dealing with it successfully; but the subject—then, as now and ever, the chief difficulty—where was I to find a scene of such interest and importance as to warrant my spending months, perhaps a year or two, in representing it?[38]

Frith found his answer during a visit in 1856 to the famous annual horse race at Epsom—known as the Derby after the twelfth earl of that name, who had instituted it in 1780. Here it was not the horses and jockeys but the great crowds of spectators, gamblers, acrobats, gypsy fortune-tellers, beggars, and policemen—humanity in its "infinite variety"—that gave Frith the idea for what was to become his most famous picture. Jacob Bell, who had wanted Frith to paint "an important picture" for him as soon as a mutually acceptable subject was found, was delighted by the sketch for *Derby Day*, and commissioned a picture to be painted from it of about five or six feet in length for the price of £1,500. No doubt impressed by the fact that Lloyds had realized three times his own earnings on *Ramsgate Sands*

by their possession and use of engraving rights, Frith made a different ar-
rangement this time. He had his patron agree to a postponed delivery of
the picture, and sold to the dealer Ernest Gambart rights for engraving the
work at £1,500 and rights to its exhibition (after the closing of the Acad-
emy show) at an additional £750. The total, £3,750, was one of the highest
amounts ever paid to a British artist for a single work. When exhibited at
the Royal Academy in 1858, *Derby Day* was an instant success. In his nos-
talgic book, *As We Were* (1930) A. C. Benson wrote:

> The blue riband of the Academy was probably awarded on the day of the Private-
> View, when the smart and privileged crowd in frock-coats and bustles and waists
> were really more intent on pictorial art than on each other. They clustered, they
> broke up, they formed again, and soon they arrived at the verdict which the popular
> taste generally endorsed, when next day the gallery was open to the public. *Derby
> Day* was not only the most popular picture of the year, but for many years the most
> widely known picture in England. . . . The coaches, the gipsies, the fortune teller,
> the sky, the book-makers, the horses were all rendered with the most minute
> finish, every quarter-inch of the picture was in focus: you might say it was an in-
> finite number of little pictures put together with extreme skill.[39]

The picture was later bequeathed to the nation and gave Oscar Wilde the
occasion for a memorable quip when he asked reverently, if it was really all
done by hand.[40]

Wilde's wry comment raises the question of Frith's use of the camera in
painting *Derby Day*. In writing of his preparatory work on *Ramsgate
Sands,* Frith stated that he had used photography to help him paint an
accurate background but had found the results unsatisfactory: "Photogra-
phy was in its infancy at that time; I had therefore to rely on my own draw-
ings of houses, cliffs, and bathing-machines; for though photography, or,
as it was then called, *Talbotyping,* was tried, the result was useless."[41] But
as early as 1850, the London Stereoscopic Company was advertising a li-
brary of ten thousand photographs of "figures representing almost every
incident in human life"; these were posed scenes, and their use appealed
to artists as an economy measure that could save the expense of models
and costumes. According to one researcher, Frith used one of the series, a
posed race-course scene, for *Derby Day.*[42] It seems likely, furthermore,
that he also used on-site photography.[43]

It is known that during these years when the exciting potential of the
camera was being discovered, Frith employed professional photographers.
He hired Robert Howlett to take photographs of as many "queer groups of
figures as he could" from the top of a cab, for use in the preparation of
Derby Day. The photographer Samuel Fry supplied him with photographs
of Paddington, complete with engines and carriages, for his next large

work, *The Railway Station*.[44] Frith's failure to mention the help he received from photography in these two major pictures is significant, for he explicitly states that he employed photographers in several later (and less successful) works—notably *The Marriage of the Prince of Wales* (1863) and the *Road to Ruin* series on the evils of gambling, which he began in 1869, after having photographs taken of students' rooms in Cambridge. It is as if, knowing where his reputation lay, he was unwilling to see it diminished by the admission that he had not performed, unaided, the traditional first stage of large-scale paintings of the past: the fusing of memory and imagination with a secure mastery of light, shade, and perspective, in a preparatory sketch from which the finished work was made. According to Aaron Scharf in *Art and Photography*, Frith's lack of candor on the subject was typical of French as well as of English artists of his time. Scharf comments that only a very secure artist like Delacroix could be open about his use of photography; neither Courbet, Manet, Degas, Gauguin, nor Derain, all of whom frequently employed photographs, mentioned the fact as candidly as did Delacroix, if they mentioned it at all. As the artist Walter Sickert (an English disciple of Degas) later wrote, quoting from a music hall ditty, "Some does it hopenly, and some of the sly."[45]

So great were the crowds pressing to see *Derby Day* that from the very first day of the public exhibition, a policeman had to be called in to stand guard. Only once before in the ninety-year history of the Academy had it been found necessary to place a protective railing in front of a picture: in 1822, when Wilkie showed his famous painting *The Chelsea Pensioners Reading the Gazette of the Battle of Waterloo*. According to Frith, the Academicians had been extremely reluctant to grant Wilkie's picture the needed protection, which they considered invidious proof of its popularity.[46] Although his own work, Frith wrote, was inferior to Wilkie's in all respects, its need of protection was equally great. Jacob Bell, who eventually bequeathed the work to the National Gallery, wrote to Frith that he had seen the policeman powerless to keep viewers' faces further than three or four inches from the canvas.

The nature of the picture requires a close inspection to read, mark, learn, and inwardly digest it; and from what I have seen, I think it not unlikely that some of the readers will leave their mark upon it, unless means be taken to keep them at a respectful distance. I called at the R.A. this afternoon at four o'clock, as I was passing, and found the people smelling the picture like bloodhounds. In the National Gallery, where I went next to see the new old masters, I found post and rail very suitable for the protection of works of art.[47]

Bell's remarks reveal a significant attitude towards art in general and Frith's picture in particular—that "reading" and "learning" from a picture

were important—and also clearly indicate that even this early, he had it in mind to give it to the National Gallery. Bell's formal appeal to the president and Council of the Academy was successful, and the rail was installed. Frith described the triumph in a letter to his sister:

You must really come to town, if it is only to see a rarity in the annals of exhibitions—no less than an iron rail round the *Derby Day,* an event that has occurred once in ninety years. I mean once before this once, and that was when Wilkie exhibited *The Chelsea Pensioners,* in 1822. On that occasion, thirteen of the elderly academicians took to their beds in fits of bile and envy; and though a few recovered by steadily refusing medicine, they never were in good health afterwards. This calamity was the cause of a resolution on the part of the academicians, in full conclave, that so invidious a distinction should never, under any circumstances, be made again; and when Messrs. Bell and Gambart, the proprietors of the *Derby Day* and the copyright thereof, took oath and said they verily believed their property was in danger, the secretary pointed to the towers of Westminster Abbey, just visible through the windows, under which repose the ashes of those distinguished men who fell victims to Wilkie, and then solemnly asked if a similar sacrifice was to be offered to Frith.

"No," said that official; "rather let the picture be scattered to the winds of Trafalgar Square; but be not alarmed, we have had popular works here before. There have been trifles by Landseer and Wilkie against which the public nose has been as severely rubbed as it is likely to be against the *Race-course;* and I assure you, on the part of the president and council, that though a rail was once put round a picture of distinguished merit and popularity, such an 'unfair distinction' will never be made again."

So spake the secretary; but at last it was found necessary (to be serious, I know not how the matter came about) to risk the lives of the envious old boys, for when I went down to the rooms yesterday, I found my precious work protected by a stout iron railing, against which broke a tide of anxious humanity. The oldest frequenter of exhibitions . . . says the like of this attraction was never seen; and I must say, also, that in all my experience I never witnessed anything like the conduct of the crowd. The man who takes the money at the doors says the receipts are some hundreds more than usual, but that is owing to the generally attractive character of the exhibition. You know I told you I should win the trick this time, and I have won it, my dear, without the slightest mistake.[48]

Frith was to see five more of his works accorded the same distinction and wrote sadly many years later that "the delight of the solitary rail triumph no longer exists." After malicious damage to several pictures in the 1886 exhibition, the protection was made general.

There were other detractors besides the jealous fellow-Academicians. One of them, a painter of the "high-aim school"—"by which is meant a peculiar people who aim high and nearly always miss, and who very much object to those who aim much lower and happen to hit"—told Frith that he was planning a picture that would attract even larger crowds than

those that thronged around *Derby Day*. It was, he said, to show Monday morning at Newgate: "The hanging morning, you know. I shall have a man hanging, and the crowd about him. Great variety of character, you know. I wonder you never thought of it."[49] The Pre-Raphaelites, for their part, found Frith's work too slick and artificial. Believing that painting should be deeply serious and moral in intent, they dismissed pictures like *Life at the Seaside* and *Derby Day* as merely entertaining diversions. Ruskin characterized the picture as "a kind of cross between John Leech and Wilkie, with a dash of daguerreotype here and there, and some pretty seasoning with Dickens's sentiment."[50] Ruskin thought *Derby Day* good in its way, particularly in its liveliness and dramatic interest. His disapproval, which rested on moral grounds, came when he judged it from the standpoint of his conception of high art, by which he meant art worthy of being hung in a museum.

And the reason that such a picture ought not to be in a museum, is precisely because in a museum people ought not to fancy themselves on a racecourse. If they want to see races, let them go to races; and if rogues, to Bridewells. They come to museums to see something different from rogues and races. . . . The museum is only for what is eternally right, and well done, according to divine law and human skill. The least things are to be there—and the greatest—but all *good* with the goodness that makes a child cheerful and an old man calm; the simple should go there to learn, and the wise to remember.[51]

There were many who shared Ruskin's dislike of Frith's choice of subject; others, like a dinner-party companion of the artist—who was "tainted with pre-Raphaelitism, . . . but showed much acuteness in her remarks"— felt that even so low a subject might have been "elevated." Unaware of his identity, she spoke to him of his painting in this vein:

You must have seen it—I mean that representation of a race-course. I hope we shall agree in our estimate of that, as we have in so many instances. Now, to me, what is called the *Derby Day* is in a very low style of art—it is vulgar. Perhaps you may say such a scene is necessarily vulgar. There I should join issue with you. A refined painter would have elevated the scene, have filled it with life and character; have given grace and beauty even to women who go to Epsom. All these qualities are conspicuous by their absence in Mr. Frith's picture.

Frith goes on to report his response:

I made up my mind that I must confess myself to be the author of the maligned production; and this I did in a bungling fashion enough, for I said: "I am sorry you don't like it, for I painted it."

Never, never shall I forget that poor lady's distress. I tried to help her, I forget how, but I know I tried. Then she was unfortunate, for she fled from her colors.

"Of course," she stuttered, "I really had no idea—but then, of course, it is a very clever picture; but I confess I don't like the subject."

"No more do I," I declared; "but then you must not quarrel with copper because it is not gold. If I attempted history, or what you call high art, I should make a greater fool of myself than I am generally considered to be."

"Of course you would."[52]

Perhaps the Pre-Raphaelite–tainted lady was echoing the sentiments of the *Art Journal*'s critic. "Truly," he had exclaimed, "we find ourselves in creditable company!"

The thimble-rigsmen are active and vigilant: one youth turns from the table, having lost his all, even to his shirt-studs. There are acrobats, gipsies, vendors of correct lists, professors of prick-in-the-garter, mountebanks, jugglers, and adventurers of every complexion and degree. . . . For ourselves, however, we cannot rejoice that this subject has been painted; we shall always regret that so great and accomplished a master in Art did not select a theme more worthy. . . . The work must be frequently before us for some time to come, inasmuch as it is destined to make a tour of the provinces, where it will give much delight but no "teaching"—at least, none of that teaching which is the highest aim and holiest duty of Art.[53]

Implicit, and frequently explicit, in all of these discussions of *Derby Day* was concern over making the proper distinction between high and low art. On one question—Does the popularity of a work among large numbers of unsophisticated viewers necessarily signify its inferiority as a serious work of art?—Frith was adamant. "The most popular painters in this country," he told the Art Union committee in 1866, in words echoed in his writings, "have been Hogarth, Wilkie, Landseer, and Faed; and I do not think they are either vulgar or common; I think it a great mistake to say a popular thing is a common thing."[54] If *his* art was to be considered vulgar, then at least he would be in good company.

Derby Day retained its popularity among the unenlightened even after the fashion of deriding it, common to higher art circles, had become passé. Frith, as the *Times* wrote in 1909, had long "ceased to appeal, if he ever had appealed, to the higher intelligence of the country." "No workman," wrote Frith's daughter, Mrs. Panton, in 1908, "ever enters our house without eagerly scanning and begging for a verbal description of the engravings of the pictures which hang on our walls, and there is always a small crowd round his best-known picture in the Tate Gallery."[55] As recently as 1922, *Derby Day* was described as attracting more visitors than all the other pictures in that gallery combined.[56] It was admired, one is surprised to find, by Whistler (whom Frith heartily despised), and there have been many indications of renewed critical appreciation of the work as something more than a period piece. Copper or gold, Frith's picture had indeed "won the trick."

Frith was to have one last triumph with a large work depicting modern

life. This was *The Railway Station,* on which he worked "incessantly" from autumn 1860 until spring 1862. In it, "a foreigner whose idea of a cab-fare differs considerably from that of the driver of the vehicle" receives a tongue-lashing, and a criminal is arrested by police officers who were painted from two detectives well known to contemporaries. Frith hoped that the human interest in such incidents would compensate for the un-picturesque look of Paddington and the dullness of contemporary dress. The dealer Louis Victor Flatow, Gambart's major rival, after seeing the oil sketch for the picture, offered to purchase the sketch, the finished work, and the copyright. And he offered a price, Frith writes wonderingly (from the perspective of the greatly altered contemporary art market of the eighties) "that appeared to me then as one of the most exorbitant on record," forty-five hundred pounds.[57] The original contract with Flatow, which Frith included, "as a matter of curiosity" in his memoirs, had reserved to the artist the right to exhibit the picture at the Royal Academy. But this provision was soon given up, and in the final contract, Frith agreed to accept an additional 750 pounds as payment for granting to the dealer exclusive rights of exhibition.

The Railway Station was another sensation. Enormous profits had already been made by single-picture exhibitions held by artists or dealers, usually with the object of securing orders for forthcoming engravings. In 1820, for example, Géricault's *Raft of the Medusa* and Haydon's *Christ's Entry into Jerusalem* had attracted crowds of paying viewers.[58] And in 1860—two years before the debut of *The Railway Station*—Holman Hunt's *Christ in the Temple* was said to have brought in four thousand pounds. Nevertheless, independent exhibitions by English artists were looked upon with disfavor; it was considered an artist's duty to help make the Academy show as attractive as possible. (In 1865, the opposition to the candidacy of Ford Madox Brown at the Garrick Club was attributed to disapproval of a painter who had held "one-man" shows.)[59] In deciding to exhibit this major work outside the Academy, Frith was responding to its ungracious treatment of *Derby Day* with payment in kind.

According to Frith, 21,150 people paid to see *The Railway Station* during its seven-week exhibition. "The subscription for the engraving was equally surprising and satisfactory. The critics contradicted one another, as usual, without doing good or harm to me or the picture. Flatow was triumphant; coaxing, wheedling, and almost bullying his unhappy visitors. Many of them, I verily believe, subscribed to the engraving to get rid of his importunity."[60] Flatow well knew what he was about; he sold the picture, with the subscription list for the engraving, for sixteen thousand pounds.[61]

Engraving rights were clearly crucial to the high prices paid to Landseer, Hunt, Frith, and other artists whose work had wide appeal. But it was already evident by the time of *The Railway Station* that this situation was not immutable. "Photographic piracy"—the distribution of photographic reproductions of a painting in defiance of copyright laws—had already begun, and within two decades it was to end "the swollen value of copyright, which had made mid-Victorian artists' fees what they were."[62] "To protect the print of the *Railway Station*," writes Frith, "the proprietor had affixed notices in prominent places in London containing only these words: *The Railway Station* Copyright."[63] "None," said Frith to the Royal Academy commission of 1863, "will pay for copyright as heretofore if there is no remedy against photographic piracy."[64]

Like *Ramsgate Sands* and *Derby Day*, *The Railway Station* was criticized for its popular nature and lack of "higher" imagination. The criticism was echoed across the ocean in 1876, in the *Official Report of the American Centennial Exhibition*, an account of the exhibit in which the picture had been hung: "Mr. Frith understands, on his own ground, that to be popular it is always necessary to get down to the level of popularity. His pictures show an entire lack of mystery; they are crowded with numerous incidents and stories, well told and calculated to amuse the curious. But this is not art in any high acceptance of the term. The stories once read, we do not return to Mr. Frith's pictures again and again, as we are instinctively drawn by great works of art."[65] It is surely no coincidence that Frith brings into his chapter on *The Railway Station* a rather long digression on Benjamin Haydon, stressing the futility and destructiveness of his fanatical devotion to the cause of high art in England: "A more enthusiastic, well-intending, and mistaken being never existed."[66]

"Mr. Frith," wrote William Sandby in his *History of the Royal Academy*, published soon after this depiction of Paddington Station, "is a married man, the father of a youthful family, and occupies in society as high a position as a gentleman as he has gained in his profession as a talented, wealthy, and successful artist."[67] These admiring words nothwithstanding, Frith still lacked one distinction that was important to anyone who wished to rise high in nineteenth-century British society: the prestige conferred by a title. His hope of gaining a title was doubtless part of his motivation in postponing a ten-thousand-pound commission offered by the dealer Gambart for three paintings of London street life (the payment was to include copyright and all preparatory sketches and drawings) in order to accept the queen's "command" to do a painting of the forthcoming marriage of the Prince of Wales for three thousand pounds. "So you are going to do the marriage picture?" said Landseer upon hearing of the

project. "Well! for all the money in this world, and all in the next, I wouldn't undertake such a thing."[68] But of course Landseer had been, since 1850, Sir Edwin.

Work on the ten-foot-long picture proved onerous, for the ceremony passed too quickly for the artist to do preparatory sketches from life. Some of the foreign guests were painted from photographs they sent to Frith, but a number of English aristrocats were less than helpful in lending dresses and appearing for sittings. It seems likely that Frith compounded his problem. In his memoirs he admits, ingenuously, to a significant omission in his letters to the wedding guests: "In my applications for sittings and dresses I had forgotten to say that the picture was painted for, and by command of, the queen; when the announcement was added, consent in most cases came readily enough."[69] The implication is that the artist's name and reputation ought to have been considered as imperative as the queen's command.

Frith both liked and admired the royal couple, and he was particularly impressed with the prince consort's understanding of the technical aspects of painting; he even altered parts of *Derby Day* after its Academy exhibition in accord with Albert's suggestions: "The prince consort surprised me exceedingly by his intimate knowledge of what I may call the *conduct* of a picture. He told me why I had done certain things, and how, if a certain change had been made, my object would have been assisted. How the masses of light and shade might still be more evenly balanced, and how some parts of the picture might receive still more completion. I put many of the prince's suggestions to the proof after the close of the exhibition, and I improved my picture in every instance."[70] But his positive feelings toward the royal couple did not extend to the nobility in general, whose treatment of artists he often described as inconsiderate and self-serving.

Queen Victoria's manner towards Frith was at first formal and constrained. She had been understandably embarrassed when the young Prince Leopold, who had accompanied her to her first sitting at Frith's studio, remarked at the top of his voice, "I didn't know artists lived in such big houses." According to the memoirs of Frith's daughter, Mrs. Panton, he was silenced at once by his mother's look, "which was quite sufficient to quell the stoutest heart." After the first few sittings the queen stopped addressing Frith through a third person, laughed at his stories, and saw that he received the help he needed from the uncooperative wedding guests: "Dresses sworn by their owners [to be] picked to pieces flew together in a miraculously quick manner; and sittings were given by people who declared themselves on the point of starting to the furthermost parts of the

world." But the hoped-for boon was not delivered. The queen was pleased with the picture but no title was offered to the artist.[71]

Frith may have made a tactical error in trying to combine the enjoyment of royal favor with high remuneration. He already had detractors who were no doubt pleased to agree with the initial judgment expressed by the *Art Journal*:

There is some painful "talk" afloat concerning a proposed picture of the marriage of the Prince, which as we have heard it, is by no means creditable to one of the leading artists of the country. He required, it appears, a preposterous sum for the production of such a picture—in addition to the privileges conceded of engraving and exhibiting the work—for which an eminent publisher would have paid very largely. His "terms" were declined, and rightly; the mistake he has made—to say nothing of the higher and nobler motives that might have guided him—is derogatory to British artists and British art. But sure we are that there are English painters better qualified to produce a work for which the subjects are furnished by the court and aristocracy of Great Britain, and not by the railroad and the race-course.[72]

In its next issue, the *Art Journal* apologized, and withdrew as unfounded its charge that the artist had conducted himself in an unprofessional manner; but it concluded with words of congratulation that clearly conveyed distaste.

The public are aware that in our comments on the commission to Mr. Frith to paint a picture of the marriage of the Prince of Wales, we committed a mistake. . . . When we wrote the statement in question, we fully and entirely believed it—believed that Mr. Frith had demanded a "preposterous" sum for painting such a picture, taking into account the immense collateral advantages of engraving and exhibiting such picture, and that the "terms" had been "declined." No one who reads the *Art Journal*, no one who knows its editor, will for a moment think we put forth this statement in malice, or even ill-will, to Mr. Frith. . . . We readily admit Mr. Frith's assertion, that "he stated his terms, which were acceded to in the most gracious and liberal manner," and are ready and willing to infer that such terms were the terms *originally* proposed by Mr. Frith, that they were not at any time "declined," and we have consequently to express regret that the statement complained of was made—unhesitatingly to withdraw it—and to congratulate the artist on a commission that including picture, engraving, and exhibition—will be the most munificent recompense ever accorded to an artist since Art became a profession.[73]

Questions of social status, his own and that of artists in general, are constant preoccupations in Frith's and his daughter's memoirs. In anecdotes that include encounters with members of the lower classes, Frith presents himself as a kind and self-possessed gentleman, whose politely concealed amusement attests to a sure sense of social superiority. There is, for example, his account of an interview with a woman in charge of an art gal-

lery where Frith stumbles upon a self-portrait painted forty-five years earlier; the picture, the woman tells him, is very valuable, for the artist is "deceased":

> "Deceased!" I exclaimed. "Dead, do you mean?"
>
> "Yes, sir. Died of drink. . . . Most artists is very dissipated. He was dreadful, Frith was. I dare say you have seen the print called *The Railway Station*. Well, my husband used to see him when he was doing it, always more or less in liquor. My husband wondered how he could do his work; but it wore him out at last—the drink did."[74]

A cockney woman's belief that "all artists is dissipated" could be a source of amusement, but the sharing of similar beliefs in the higher echelons of society was a serious obstacle to social mobility. A tone of real bitterness enters into Frith's accounts of upper-class snobbery towards artists. He tells, for example, of the failure of a young bridesmaid at the royal wedding to respond to his request for a sitting; instead, her mother arrived, apparently to investigate the studio's suitability for her daughter's visit. Frith found her "in a bewildered condition" in his drawing room:

> As I entered, the lady—who was looking with a puzzled expression at the different ornaments in the room—turned to me and said:
>
> "I think I have made a mistake; it is the artist Frith I wish to see."
>
> "Yes," said I, "I am that individual."
>
> "Oh, really! and this is your—this is where you live?"
>
> "Yes," replied I, "this is where I live"; then mentally, "and not in the garret where you had evidently been taught that most artists reside; and as I have a coal-cellar I am not forced to keep my fuel in a corner of the garret, and I am not always dining on the traditional red herring."[75]

Frith was proud of the mansion that Prince Leopold had so vocally admired. The house, remembered Mrs. Panton, was big even when his family moved there in 1852 or 1853; in later years a large schoolroom, a spare bedroom, and a night nursery were added. In 1875, Frith turned his old studio into a billiard room. He added almost a complete story, where he built an enormous new painting room and a model's room, a big room for his sons, and additional rooms for the servants. The painting room was approached by "a terrible iron staircase outside the building, so that the models should not have to come through the house itself." The painter Louise Jopling remembered calling on Frith one morning to ask his advice on her work: "The maid, on opening the door, said, in a most supercilious manner, 'The model's entrance is round the corner!'"[76]

Frith expresses resentment toward those higher in the social scale who keep the barriers up, along with determination to keep sufficient distance from those uncomfortably close to the level of his own origins—two classi-

cal marks of the parvenu. Frith had luncheon sent up to his models in the studio while he went out to dine, and some of his comments reveal a clear gratification in the social distance between painter and model. In *A New Model,* a painting exhibited at the Academy in 1891, he shows a poor country girl anxiously waiting for the distinguished Academician to comment on the letter of recommendation she has brought him. He wrote that he did not generally use servants as models because it would turn their heads. And the model he appears to have found most trying was not one of those who arrived drunk or could not hold a pose, but a Mr. Gloster, who, apparently well-born, was "disgustingly familiar": "The man put himself on a level with me at once, and at times his insolence was very difficult to bear." [77]

Besides maintaining an elegant mansion suitable for visits by aristocratic sitters, Frith paid attention to other aids to social mobility. He employed a nanny and a governess for his children; he later sent his daughter to a boarding school in Bath and his sons to Harrow; and he insisted that his children attend church on Sunday, even though he would never accompany them. But his drive towards respectability was too much in conflict with more basic elements of his character to be altogether wholehearted. He allowed his daughter to quit the school in Bath after just three days; she hated the narrow-minded mistress and the "missish girls who had never read either Dickens or Thackeray." He who had once made light of his mother's objections to his working on Sunday found it hard to maintain a façade of respectable piety. His daughter recalled that he had once criticized her for reading one of the Waverley novels, saying that it was not a "Sunday book"; but she argued until he laughed. "Then he was done for, and from that day to this I never heard another word about a book being fit for a Sunday or not." It was on Sundays that the Friths gave dinner parties; some artists were invited, but most of the guests were journalists and actors, a group then "out of the pale of real society." [78]

One can only speculate as to whether any of these friends knew of the existence of Frith's second household. Since the early 1850s, his mistress Mary Alford had given birth to seven children. He married her a year after the death of his wife (the mother of twelve) in 1880. [79] Even if Frith succeeded in keeping his irregular domestic life a secret, there were other limits to his willingness to be single-minded in his pursuit of social mobility, however great its attraction for him. He knew, for example, that the price for social advancement could be very high for an artist. The career of Sir Edwin Landseer led Frith to believe that friendship with the highly born frequently required payment in kind, and his words on his fellow art-

ist amounted almost to a kind of caveat: "Edwin's genius elevated him into the society of what is commonly called 'the great' to a degree equalled only, perhaps, by Sir Joshua Reynolds. I venture to think that the advantage of the connection was entirely on the side of 'the great,' whose scrapbooks and albums were enriched by gratuitous sketches, and whose pockets were often replenished by the profits obtained on the sale of pictures for which absurdly small prices had been paid." Furthermore, Frith saw respectability as clearly unrelated (although not, in his view, inimical) to creativity; it was helpful, certainly, to the volume of picture sales and the health of one's prices, but it reflected only upon the worldly success aspect of an artist's life. One finds throughout his autobiography anecdotes that illustrate an implicit recognition that the true artist has within himself a spiritual nobility, the genuineness of which commands the respect even of the most highly born and wealthy aristocrats.[80]

The years in which the Academy shared quarters with the National Gallery in Trafalgar Square, 1837–1869, were the most successful and happiest of Frith's life. *The Marriage of the Prince of Wales,* shown in 1865, required Frith's second protective rail, and *Charles II's Last Sunday,* a three-thousand-guinea commission by Gambart (who had lost interest in the *Streets of London* project), exhibited in 1867, required the third. The pictures Frith showed in the 1868 exhibition—including a scene from Boswell's great biography in which Johnson and Garrick were the main figures—were reversions to precontemporary dress; indeed, writes Frith, it was fortunate that he did not discard his costume collection when he turned to modern-life paintings, for it proved useful in most of his subsequent work.

Frith was to paint several more contemporary subjects, but none enjoyed the phenomenal success of his earlier works. *The Salon d'Or,* a view eight and a half feet long of the gambling room at the German spa resort of Homburg (which he had visited in 1869) was purchased by Flatow in 1870 for four thousand pounds, including rights.[81] Another picture inspired by a scene Frith had witnessed while at Homburg, of a pretty young woman leaning over to light her cigarette in the flame of a candle held by a waiter, was exhibited at the Academy in 1870 with the title *The First Cigarette,* and it evoked a response similar to that caused by *Sherry, Sir?* This time, Frith angrily defended his picture as representative of the native tradition of popular anecdotal art:

I think Hogarth would have made a picture of such an incident, with the addition, perhaps, of matter unpresentable to the present age. It might have adorned our National Gallery, while I was mercilessly attacked for painting such a subject at all.

I knew very well that if I or any other painter dared to introduce certain incidents (such as bristle over Hogarth's works) into our pictures, they would have no chance of shocking the public that admires the Hogarths on the walls in Trafalgar Square, for the Council of the Royal Academy would prevent any such catastrophe.[82]

Three more titles complete the list of Frith's depictions of contemporary subjects. The first two—*The Road to Ruin* (1878) and *The Race for Wealth* (1880)—were series-narratives, conceived along Hogarthian lines. The third was *The Private View,* which depicted the elite's preview day at the Royal Academy of 1881. Exhibited there in 1883, the picture showed Oscar Wilde surrounded by admirers and various notables— including Sir Frederic Leighton, Robert Browning, William Gladstone, John Bright, Thomas Henry Huxley, Ellen Terry, and the artist's friend Anthony Trollope. Large crowds were again attracted and Frith received the recognition of another protective rail. "Pictures composed of groups of well-known people are always very popular at the Academy," wrote the artist in his autobiography. But this momentary success could not mask the obvious downward trend in Frith's career. The etchings which the Art Union of London had made from *The Road to Ruin* were not popular, although they were done by one of the most eminent French etchers. *The Race for Wealth* was reproduced by the process of photogravure, "but whether from the faults of the pictures, or of the method in which they were reproduced, the result was far from satisfactory." The five pictures of the series were sold, without rights, in 1887 for just over £787 10s. It was difficult for him, Frith wrote in that year, to speak of his own work as his memoirs approached more recent years.

Mrs. Panton chooses 1875 as the year that her father's career reached its peak. In that year, Frith's picture, *Before Dinner in Boswell's Lodgings* (painted in 1868), was sold at Christie's for £4,567 10s.; this was the English saleroom record for the work of a living painter.[83] But that sale was a swan song; the day of the painted literary anecdote and the humorously entertaining story-picture was over. Some of the popular Victorian artists—Millais, for example—died before their works had completely fallen from favor. Others, wrote Mrs. Panton a year before her father's death, "fell on evil times and could scarcely live. I think, save in one or two cases, Prince Leopold would not find artists in palaces now." In 1896, writes Gerald Reitlinger, when Frith was still painting a little, the collapse in the value of his pictures was as complete as at any time in the twentieth century.[84]

Frith offers no extended explanation for his declining sales figures, a fall which we can now better understand in the broader historical context

of changing market conditions. He does, however, suggest two possible causes. The first, which he discusses in a chapter called "Fashion in Art" in his autobiography, is the fickleness of public taste, which, as in fashion, is most pleased by novelty and variety and has little interest in more lasting standards of value. "The caterers for public amusement have to deal with an amalgam composed of ignorance, prejudice, fickleness, and vulgarity to a degree altogether out of proportion to the critical faculty which is the outcome of enlightenment, and by which the truth of public judgment can alone be tested. The goddess Fashion reigns supreme."[85]

Frith admitted, however, that a second cause for his eclipse came from within himself. A narrative painter needs a ready supply of good and paintable subjects, and Frith blamed himself for a drying-up of the capacity to generate these. "Try to do better," he wrote in a diary entry during the lull following the success of *The Railway Station;* "get newer subjects—all depends on subject." He offered a large reward—two hundred pounds—for the suggestion of a subject interesting enough to use in a picture of the size and importance of *Derby Day.* He received extensive correspondence as a result, but he never used any of the ideas sent to him.

The altered fashion, taking hold by the early 1870s, for a more serious kind of picture—whether of social-realist, Pre-Raphaelite, or neoclassical tendency—was certainly one cause of the lessened interest in Frith's works. He had, in fact, tried to move with the times by incorporating a moral statement into his series pictures on the evils of gambling and speculation, claiming that *The Road to Ruin* series was conceived as a protest against the partiality of the law toward the rich and powerful:

I had been to Ascot, and been greatly struck by the legalized gambling on that famous racecourse. If men meet in Hyde Park for the purpose of betting, and are caught in the act, imprisonment will surely follow, though the stakes may only consist of a few shillings. In the Royal Enclosure at Ascot the "curled darlings of the nation" may sacrifice their maternal acres to any extent without the fear of the law.

I remember asking a man learned in the law to explain this anomaly, and he acknowledged his inability, at the same time inquiring whether I was aware that there was one law for the rich and another for the poor.[86]

Whether sincere or opportunistic in their motivation, Frith's efforts along this line were unsuccessful. The *Times* obituary memorialized him as a kind of mid-Victorian relic, who would very likely have been forgotten by the present generation were it not for the continued popularity of *Derby Day* and for the valuable insights that his autobiography provided into the world of mid-nineteenth-century art.[87]

Unlike his daughter Mrs. Panton, who deeply resented the "crumble

and fall of our once happy and distinguished household," Frith was not so much bitter as disappointed by the change in his fortune.[88] If his talents were now undervalued, he was well aware that they had once received more than their due. The sanity of this clear-sighted self-appraisal served him well. In a conversation with his son Walter, published in the *Cornhill Magazine* in 1906 under the title, "A Talk with My Father," the eighty-seven-year-old painter spoke with a remarkable degree of objectivity about the previous era of art in which he had been such a major figure. Chuckling often, and perhaps a bit senile, Frith spoke about the great improvement that he had seen in the Royal Academy exhibitions during the course of his lifetime; while some good work had always been present, most of it, he said, had been rubbish. The great majority of pictures hung by the Academy in the early days of his career would never be accepted in 1906. What amazed him the most was the overall improvement of standards, both in the exhibition and in the Academy schools. To get into the schools of 1906, Frith said, a student had to submit drawings of a very high standard: "I saw some the other day. I'm sure I couldn't have done them. Never, at any time."[89]

Frith died three years after this conversation. In the opinion of the author of the *Times* obituary, he had long "ceased to appeal—if he ever had appealed—to the higher intelligence of the country." But his contribution to the general culture had been significant, not the least in his exemplification of the Victorian ethic of work and in the important influence his paintings had in educating the visual and intellectual sensibilities of a growing art public.

He never scamped his work; it was all done zealously and honestly. This is one of his claims to the recognition of posterity. The other is that these pictures of his, limited as was their aim, did really do a great deal to arouse a sleepy public to the possibilities of art. Their direct effect was to teach a number of people to use their eyes. Their indirect effect was to arouse keen and sometimes fierce controversy, and thus to teach some of the same people to use their minds.[90]

4. *Herkomer, Fildes, and Holl:*
From Social Realism
to Respectability

Hubert von Herkomer was among the best-known of the London artists whose deeply moving portrayals of the poor directly inspired Vincent Van Gogh's now-famous depictions of Dutch poverty in the early 1880s. Van Gogh had first become acquainted with the work of these social-realist painters during his three-year stay in England in the middle years of the preceding decade, when Herkomer and his slightly older contemporaries Luke Fildes and Frank Holl were contributing a series of illustrations of the darkest aspects of urban life to the recently established journal, the *Graphic*. Van Gogh haunted the offices of the magazine in order to get the earliest possible look at the newest illustrations, and later, when he had moved to The Hague, was thrilled to acquire a set of volumes that covered the years 1870–1880.[1]

The career path followed by these three English artists was remarkably similar. All achieved public renown during the 1870s by adapting their work as illustrators to the larger format of oil paintings exhibited at the Royal Academy. But later, when public interest turned away from the social-realist genre, all three became wealthy and famous as portrait artists who depicted (and socialized with) the elite of late-Victorian England. Their dramatic change of course illustrates a number of important developments that took place during the lifetimes of many artists born a generation later than William Powell Frith.

Hubert von Herkomer

Hubert Herkomer was born in 1849 (thirty years after the birth of Frith, whom he survived by five years) in a Bavarian village forty miles from Munich. Then known as the Athens of the West, that city was filled with art treasures of the past as well as works commissioned from living artists, the result of the munificent art patronage of Ludwig I of Bavaria during a reign of twenty-three years that ended in 1848. Herkomer's father Lorenz was a craftsman with impressive artistic talents and a mystical belief in

the sacramental character of the artist's calling; his mother, daughter of the church organist and choir director in a nearby village, was a fine musician.[2]

Like many of his countrymen in the aftermath of the revolutionary events of 1848, Lorenz Herkomer decided to emigrate to the New World. The family arrived in Cleveland in 1851, where a brother of Lorenz had settled, but the newcomers disliked the harsh climate and failed to prosper. Six years later, the family left the United States for England and settled in the debarkation town of Southampton, which Lorenz thought would provide a good market for his handicrafts, a hope that would also meet with bitter disappointment.

Lorenz was his son's principal teacher; Hubert attended the local dayschool for only six months, after which he suffered the first of a number of mental breakdowns that would occur throughout his life. "Six months!" Herkomer later wrote, "the sum-total of my life's school-education!"[3] There was, however, an art school in Southampton, one of ninety provincial schools that formed a national network under the auspices of the Department of Science and Art, with headquarters in the schools at South Kensington in London. Founded with the goal of improving industrial design, the national system followed a mechanical and routinized curriculum; future artists who studied there were among the system's harshest critics.[4]

Herkomer entered the Southampton School of Art in 1863, at the age of fourteen. After having experienced years of his father's teaching, a central element of which included sketching excursions to the unspoiled landscape of Southampton Common, Hubert found the school's method stultifying. It involved a set sequence of drawing, first from the flat (that is, copying artists' drawings and outlines that had been made from casts of statues) and then directly from casts of antique sculpture. There was a heavy emphasis on finish that was to be achieved by endless stippling, a method whereby gradations of light and shade are produced by separate touches: "It was stipple, stipple, stipple, night after night, for six or perhaps nine months, at one piece of ornament something under fourteen inches long. The result would be duly sent in to headquarters and awarded a medal or what not, and the happy student would fancy himself an artist."[5]

In 1865, Lorenz received a commission to execute wood-carved replicas of religious statues in Germany, and decided to take his son to study art in Munich. Although the sixteen-year-old student was deeply impressed by the cultural richness of Munich and frequented art galleries, concerts, and the opera, he was dismayed by the fossilized traditionalism of art education at the Munich Academy. Upon his return to England six months

later, Hubert began a year of study in the South Kensington schools in London, probably on the advice of the Southampton art master. At this time, the main functions of the Schools of Design at South Kensington were the training of art masters for the branch schools (like that at Southampton) and certification for teaching art in the national schools for the poor.

Although Herkomer, along with many fellow artists, denounced the education at South Kensington as dreary and mechanical—Herkomer later referred to it as "that stupid school"—he nevertheless gained some benefits from his year in London. Disgusted by the regimen of drawing from casts, which was a prerequisite for entry into the life class, Herkomer managed to evade this requirement by entering the life class surreptitiously while the master was out and demonstrating such fine drawing skills upon the latter's return that no further work from the antique was required. With him in this class were three future Royal Academicians— among them, Luke Fildes, with whom Herkomer shared his thoughts and aspirations. (Although they had been founded to further the interests of British industry, the government schools of art had never been successful in completely excluding students who wished to become painters rather than designers.) In addition to the valuable experience of life study with like-minded fellow students, Herkomer benefited from visits to the Royal Academy, where he was influenced above all by the work of Frederick Walker, a painter whose portrayals of rustic modern subjects in natural surroundings were inspired by the work of Jean François Millet.[6]

Herkomer's formal art training was now at an end. The years between 1867 and 1875, from his eighteenth to his twenty-sixth year, form a period of career-building. Like many other artists at this time, Herkomer began his career as a book and magazine illustrator who drew on wood. The new popular illustrated magazines and many of the books that were being published in large editions for a rapidly growing reading public featured engravings of drawings made on wood blocks; these were given to engravers, who then cut away the blank spaces (or negative parts) of the design, after which the inked surface was reproduced like type. The artist's work was thus subject to the talent and care of the engraver and was destroyed at an early stage of the reproduction process.[7] The particular genius of the designers of the sixties, as T. S. R. Boase has pointed out, lay in their ability to present material that was technically appropriate for these large-scale methods.[8] Much of the illustrating was hack work, turned out quickly to satisfy press deadlines, but the graphic work of the Pre-Raphaelites and others (including Walker) had given illustration enough prestige to attract some fine painters, like Leighton and Poynter; it is in recognition of their

contributions and of the younger artists they inspired that the decade of the sixties, with five years or so added on each side, has been known as the great age of English black-and-white illustration.[9]

The year 1869, during which Herkomer moved to Chelsea (a neighborhood that had been the residence of such famous painters as Turner, Hunt, and Rossetti, and which was long to continue to be an artists' quarter) was one of promising beginnings. Herkomer's illustrations were published in several periodicals, and several of his paintings were sold to influential patrons. In addition, an exhibit of one of his works in the watercolor room of the Royal Academy led to his admission, in the following year, to the Royal Institute of Painters in Water-Colours. Herkomer had given himself a target of six years to gain admission to one of the societies; it had come in less than one.[10]

The founding of the *Graphic* by William Luzon Thomas in December 1869, the year of Herkomer's first Academy exhibit, was an event of great significance to English art and artists.[11] The engraved illustrations it presented every week linked Redgrave's pictures of poor and overworked seamstresses of the forties with Dickens's and Mayhew's writings of the fifties and sixties, and with the social investigations of Charles Booth, who moved to London in 1875 and began his eighteen-year study of conditions of life in the great metropolis. Indeed, a selection of pictures from the *Graphic* might well have been given the title of Booth's monumental work, *Life and Labour of the People in London*. In an obituary article on Thomas, Herkomer wrote:

It is not too much to say that there was a visible change in the selection of subjects by painters in England after the advent of *The Graphic*. Mr. Thomas opened its pages to every phase of the story of our life; he led the rising artist into drawing subjects that might never have otherwise arrested his attention; he only asked that they should be subjects of universal interest and of artistic value. . . . I owe to Mr. Thomas everything in my early art career. Whether it was to do . . . a twopenny lodging-house for women in St. Giles', a scene in Petticoat Lane, Sunday morning, the flogging of a criminal in Newgate Prison, an entertainment given to Italian organ grinders, it mattered little. It was a lesson in life, and a lesson in art. I am only one of many who received these lessons at the hands of Mr. W. L. Thomas, and it was in this way that he catered for the public in the pages of *The Graphic*.[12]

The *Graphic* gathered together much of the rising young talent of the day, greatly increasing the opportunities for draughtsmen. Some of the artists held regular staff positions, while others contributed on a free-lance basis. Luke Fildes, Herkomer's friend and fellow student from South Kensington days, was a staff member; in addition to providing original illustra-

tions, he redrew the work of other artists that lacked "engraveability." Frank Holl, who had already embarked upon his painting career, spent five or six years in the employ of the *Graphic*. His daughter, in a biography of her father, shows how this job functioned as an economic "cushion" for a painter embarking on his career. The position, she writes, brought "good times" to her parents; the work was regular, and the pay both good and reliable.[13] Even in the years when the demand for the work of living painters continued to be strong, most young artists needed some way to subsidize their earliest pictures.

Herkomer's first drawing for the *Graphic* was of a group of gypsies he had come upon one Sunday. Having induced serveral of them to come to Chelsea to sit to him for a few shillings, Herkomer did his drawing on a full-page-sized wood block purchased for a sovereign. Mr. Thomas paid eight pounds for the drawing, and encouraged him to send others. From that time on, wrote Herkomer, he never lacked work.

He was, however, disappointed in not being offered a regular position on the *Graphic*. He asked to be supplied with subjects, as staff members often were, and was distressed when told that he would have to supply his own: "In my heart I bitterly resented these words, but they were the words I needed: they were the making of me as an artist!" The Sunday after he received this directive, Herkomer wandered into the Chapel of the Royal Hospital in Chelsea, where a group of old veteran-pensioners, wearing their red uniforms, were attending the service. Herkomer arranged for a few of the men to sit for him and made his design for a drawing of the scene that same night. It appeared in the 18 February 1871 issue of the *Graphic*, badly engraved, but admired as a work of promise. Herkomer was paid ten pounds for it and accepted a commission from Mr. Thomas for a watercolor painting of the same subject.

Encouraged by his success and the conviction of fine future prospects, Herkomer decided, early that spring, to take a painting trip to the Bavarian Alps, bringing his father Lorenz along for a holiday. This visit brought Herkomer an acute awareness of the German side of his nature: "Something more than delight in the picturesqueness of this new ground was aroused in me: I felt it *belonged to me*, and that *I* belonged to *Bavaria;* I was of the same race and the same blood that flowed in their veins flowed in mine." But the English predilection for sentiment of art, which had influenced him most strongly through the work of Frederick Walker, never lost its hold and left him the lesson "to seek truth in sentiment and sentiment in truth." The painting in which he combined a Bavarian rural setting with English moral sentiment, was *After the Toil of the Day*, a

depiction of a village street with old wooden houses on one side and a river bordered with apple trees on the other, showing old people and children seated on benches and peasants returning from the fields. Herkomer's choice of the medium of oil and of the painting's large size—it was six feet long—was carefully made. Although watercolor was his first love (he later described his decision to use oil paints as "bigamy"), he recognized that his career required this change: "I could never hope to reach the top of the tree unless I competed with the strong, in the strong material." [14]

In Herkomer's judgment, furthering his career also required that his painting be sold before it was sent to the Royal Academy; at this time of heavy demand for works of contemporary art, preexhibition sale marked out the painters who enjoyed the highest degree of public esteem. [15] But how was this to be accomplished? Dealers, Herkomer later wrote, had not yet taken notice of him, and he thought it impolitic to approach them. [16] With ambition linked to powerful determination, the young artist rejected an offer of 480 pounds from a previous patron, having set as his price the round and magical figure of five hundred pounds. A buyer was found, through the agency of an art collector who was a friend of the artist's frame-maker, and *After the Toil of the Day* was hung "on the line" in the 1873 Academy exhibition. Herkomer refers to this year as a turning point in his life; he had advanced from wood-drawing to watercolor and had now seen his first large oil painting hung in a prominent place at the Royal Academy and given favorable notice in the press.

The idea of painting an amplified version of his picture of the Chelsea pensioners had long been in Herkomer's mind; such a plan would certainly have been encouraged by the recent successes of Frank Holl and Luke Fildes with Academy-exhibited paintings based on earlier wood-drawings. Holl's *Leaving Home*, an enlarged version of the drawing that had won him his job on the *Graphic,* was exhibited in 1873 and received favorable mention in the *Times.* It showed a group outside the third-class waiting room of a railway station made up of a young soldier with his old father and his sweetheart or sister, and a girl in mourning, probably now obliged to enter upon a new life as a governess or milliner's apprentice, anxiously counting out her small store of money. [17] Fildes had experienced a still greater success with his *Applicants for Admission to a Casual Ward.* This eight-foot-long picture, bought by a north country industrialist for six hundred pounds before its exhibition in the Academy show of 1874, had been sold again on Private View Day for twice that price. It was a large version of the drawing which, under the title *Houseless and Hungry,* had

appeared in the first issue of the *Graphic*, as the illustration to an article on the Houseless Poor Act, which allowed some of those temporarily out of work shelter for a night in the casual ward of a workhouse.[18] Police were called in to control the crowds that gathered before the picture, and a protective railing was installed. Fildes had become an overnight celebrity.[19]

Of the three artists, it was Holl who, as winner of several painting medals during his three years at the Academy schools, was best prepared for the production of a large work in oils. Fildes's *Casual Ward* had been painted without previous formal training in the handling of oil paints.[20] Herkomer had been introduced to that medium while at South Kensington, but the training must have been brief and superficial, for he had forgotten whatever he once knew of it when he began work on *After the Toil of the Day*. The challenge of turning a drawing of journal-page size into a large-scale painting was formidable. Handling a canvas eight feet high in a studio that was twenty-four feet long but only eight feet wide was a challenge in itself. Once, while Herkomer was winding up the easel, the upper part of it cracked through the skylight and a shower of broken glass rained down upon him. Herkomer had always worked directly from the object straight onto the canvas, with the help of preliminary sketches, and had no experience in the use of the cartoon or the "squared up" drawing. He had to work out the details of the large group portrait by a process of trial and error, guessing at the correct sizes and distances between figures. Getting the paint to adhere to the canvas was a major problem; the first layer of paint was too absorbent, and it was not until the linen canvas had been soaked with medium five or six times, back and front, after the painting was completed, that he was able to keep the paint from chipping. Perhaps worst of all was the matter of perspective, a system with which Herkomer had not even a rudimentary acquaintance. To get the perspective of the rows of heads of men in the congregation, Herkomer sketched his subjects in pairs, to see how one face lined up against the other. The foreshortened squares of the black-and-white floor were done with the help of a stratagem that derived from the practice of Dürer: a checkerboard placed on a table was observed through a pinhole fixed at arm's length from a glass pane; Herkomer drew the squares as seen in correct foreshortening directly on the glass and then reproduced the design by tracing it onto paper and incorporating the pattern into his picture.[21]

Herkomer called the picture *The Last Muster: Sunday at the Royal Hospital, Chelsea*. It was five by seven feet, with the largest figure nearly life size, and was sold when about half finished to Mr. C. E. Fry, a member

of a well-known photographic firm, for twelve hundred pounds.[22] Herkomer described the subject and the appeal he felt it would have for the English art public in a letter to his American relations.

The scene which forms the subject of my present picture is taken from this place, viz., a mass of old men sitting in their church during service. I call it *The Last Muster*. They are all sitting, some with deep feelings of veneration, others more indifferent. There are about seventy heads to be seen, and all literal portraits. I picked out the most characteristic men and then painted them carefully, keeping their individuality. It is a grand sight to see these venerable old warriors under the influence of divine service. They have been loose (most of their lives), and now coming near their end a certain fear comes over them and they eagerly listen to the Gospel. . . . There is hardly another subject that so appeals to English hearts—men who have fought for their country and have come to their last home preparing for their last journey home.[23]

The reception given the picture fulfilled the artist's highest hopes. It was said that the members of the Royal Academy Council, reviewing the works sent in for exhibition, "instinctively clapped hands" when they saw it; several, including Leighton, wrote Herkomer letters of congratulation. Perhaps the warmest words of praise were given by the *Times*. On 1 May, opening its series of lengthy articles reviewing the 1875 Academy exhibition, its critic called attention to *The Last Muster* as the most remarkable work in the show. In a subsequent article, his analysis made clear that much of its public appeal lay (as the artist had correctly foreseen) in sentiment—did the drooping head of the weak and worn pensioner with refined features signify that he had been touched by the hand of death?—and especially in the sentiment of patriotism.

One of the picture's few detractors was John Ruskin, then in his sixth year as Slade professor of fine art at Oxford. The group of grand old soldiers at Chelsea, wrote Ruskin, was true and pathetic, but hardly artistic enough to count as of much more value than a good illustrative woodcut. He saw the picture's shortcomings as typical of those of the entire exhibition: "The Royal Academy of England in its annual publication is now nothing more than a large coloured *Illustrated Times*, . . . the splendidest May number of *The Graphic* shall we call it? . . . Academy work is now nothing more virtually than cheap coloured woodcut."[24] Perhaps the artist's criticism of his own work, formulated in later years, reflected the influence of Ruskin's views. "It could hardly be called a composition," wrote Herkomer, "as the upper half of the picture was all architecture, the middle half of the picture a dense mass of heads, after which followed a row of hands, then a row of legs and finally a row of boots. It had no begin-

18. Hubert von Herkomer, from a photograph by Elliott and Fry. The artist was elected A.R.A in 1879, four years after achieving renown for his Academy exhibition, *The Last Muster: Sunday in the Royal Hospital Chelsea*, a depiction of elderly veteran pensioners at prayer in the hospital's chapel. (As published in the *Magazine of Art*, vol. 3, 1880.)

ning and no end; it was a section of the chapel congregation 'cut out.'" In 1875, however, he had little doubt of the significance of the public triumph of *The Last Muster.* "It has lifted me," he wrote to his aunt and uncle, "to the very top. My name is permanently established in the list of the first painters. My fortune is made now with this name."[25]

Herkomer was elected an Associate of the Royal Academy in 1879. He regarded this triumph as not altogether satisfactory, since his majority consisted of only two votes, and the runner-up was a woman—Elizabeth Thompson (subsequently Lady Butler), whose military picture *Quatre Bras* had been the main rival for attention at the 1875 Academy exhibition.[26] "Who is this Herkomer, anyway; he is a foreigner, isn't he?" one member of the precious two-vote majority had been heard to say. Apparently, his neighbor's answer was accepted as definitive: "Well, whatever he is, his art is thoroughly British. He's all right; you vote for him."[27]

In 1881, while on a landscape-painting trip in Wales, Herkomer made the decision that would alter the course of his professional life; he would become a portrait painter. The decision was symptomatic of a major shift in the art production of the later part of the century. The Royal Academy exhibition which Ruskin, in the middle seventies, could characterize as a painted version of the *Graphic*, had in great measure become, two decades later, a show which featured portraits. In its review of the 1891 exhibition, the *Art Journal* regretfully noted that landscape paintings had been "shouldered out" by an excess of portraits. Five years later, the *Journal* again complained that the exhibition was diluted by this great flood of portraits, which accounted for a quarter of the total number of pictures, and

observed that many landscape artists had, in fact, turned to the practice of portraiture.[28]

Frank Holl and Herkomer both became portrait painters in 1881, and Luke Fildes followed their example six years later. What were the reasons behind this important change of course thus taken by three of the most successful exponents of social realism and by numerous lesser-known painters?

Essentially, the motivation was both psychological and economic. These artists had come to identify a certain mode of life as a fitting and even necessary mark of success in their profession and saw portraiture as the only likely means by which they could achieve it, now that the market for works of contemporary painting was rapidly contracting. During the 1850s and 1860s, painters, like other members of the middle classes, had become accustomed to a comfortable and expensive way of life. The expenditures of professional men had shown an especially steep rise during these years; seeking outward marks of their increasingly important role in society, they felt a strong desire for show, appearance, and style.[29] The high earnings of painters during the fifties and sixties had enabled them to participate fully in this newly opulent mode of professional life.

Fildes (born 1844), Holl (born 1845), and Herkomer (born 1849), who had all been art students during those years of peak demand for the work of living painters (when men like Frith, Millais, and Leighton lived in houses which impressed even royalty by their spaciousness and luxury), embarked upon their careers during the period that one artist has described as "the fag-end of the boom."[30] The interest in contemporary art remained very high during the seventies and eighties—in 1878, for example, the attorney general, defending Ruskin against Whistler's charge of libel, spoke of the current "mania" for art[31]—but the favor of the critics and of the wealthiest picture-buyers was turning away from realistic works of wide popular appeal to the schools of "poetic" painting (for example, the pictures of the neoclassicists Leighton and Poynter and of the later Pre-Raphaelites), while the general sales picture was becoming increasingly gloomy. "Can it be," asked the *Times,* calling attention to the unusually high quality of the 1885 Academy show, "that artists have been learning the sweet uses of adversity? Are we to suppose that commercial depression, by limiting the eagerness of the public to possess pictures, has stimulated the competitive ardor of those who paint them?"[32]

Wishing to maintain, during the climate of economic uncertainty at the end of the 19th century, the standards of living that had been developed in the heady, expansive decades of the fifties and sixties, the middle classes

needed to cut down on expenditures in ways that would not endanger the appearance of affluence.[33] The Aesthetic movement, which began during the 1860s and blossomed during the seventies and eighties, justified— indeed held desirable—a lessened outlay on paintings, upholding a more restrained and refined ideal of taste, which looked down on the 1860s fashion of covering the walls with them. The higher status now awarded the decorative arts meant that the possession of a painting was no longer the only proof of artistic taste. Instead of hanging half a dozen pictures around a dining room, wrote the *Studio* in 1894, the rich man of the day sought fine decoration. "Artists prefer the effect of a room so fitted, and rank the owner's taste far more highly than one who has a dozen modern average paintings in gold frames. . . . Modern taste holds that a good etching or mezzotint, or even a Hollyer photograph, is to be preferred to the ordinary Institute watercolour, or the average Royal Academy oil. We have all helped to preach this doctrine, and now people put it in practice, we moan for the future of oil-painters."[34]

If in their wish to maintain the style of life developed by their fellow professionals during the fifties and sixties, painters were in a position similar to that of other members of the middle classes, there were nevertheless important differences. The most extravagant of their mansion-palaces required such enormous financial outlays that retrenchment was difficult without a professionally damaging loss of face, for the public was all too ready to judge an artist by the externals of his style of life.[35] Furthermore, the threat to painters' incomes was immediate and direct. While professionals were generally concerned more with increased costs (for example, for household help and school tuition) than with declining incomes, painters were faced by a grim combination of facts: sales were fewer, pictures had to be sold for lower prices, and engraving rights were falling victim to the camera. Most painters who wished to live in the style established during the previous years of high prosperity had to turn to the most reliably remunerative branch of the art. Their career change was, in its turn, responsive to the aspirations of other social groups; the 1880s, in Herkomer's words, were a time when "everybody in any position and possessing wealth, newly acquired or otherwise, was desirous of being painted. The few portrait painters then practicing were more than fully employed."[36]

Frank Holl and Luke Fildes built small palaces like those already established in Chelsea, Kensington, St. John's Wood, and Hampstead during the late seventies and early eighties. The Holls moved into their house in Hampstead in 1881; it had been designed by Norman Shaw,[37] the architect

particularly favored by artists. John Bright, first a sitter and then a friend of Frank Holl, was horrified by the opulence of the new house. "I have not," he said, "patience with the extravagant ideas of young folk nowadays—this house is good enough for a king."[38] Fildes, too, had employed Shaw to design his house on Melbury Road in the Leighton Settlement (so called because the painters who had built there were clustered near the showpiece-home of their president), having moved his family there in 1877. It is startling to read of the grandeur of the new house in the context of Fildes's career, for the move was made just a year after his Academy picture, *The Widower,* showing a man in a poor cottage caring for a small child, had elicited the *Times's* comment that such depictions of squalling children and dirty boots were unfit for English living rooms. Houses like ours, wrote the artist's son, were a background for entertaining; the well of the main staircase, which provided a triumphal ascent to the studio, had all four walls hung with seventeenth-century Flemish tapestries. "One of the finest rooms in London!" remarked King Edward, the first time he came to sit for his state portrait. Fildes decided against accepting a possible offer to succeed Millais as president of the Royal Academy upon the latter's death in 1896. It would just be too expensive, he told his family. The duties of the presidency would necessitate a reduction in his earnings, and he was anxious not to stint on his children's education.[39] The mansion was eminently suitable for a president of the Royal Academy, but a president who was also a family man living on his earnings would have had to face sacrifices in order to keep it and his family in the accustomed style.

For Herkomer, the building of a grand house held a special meaning that added a distinctly personal note to the need he shared with other artists for outward signs of prestige and success. Herkomer's memoirs deal at great length with his plans to build a house; his father had entrusted him with the sacred duty of building a house that would be a fitting expression of the family's extraordinary gifts of craftsmanship. For years, even during times of great economic uncertainty, Lorenz had been making furniture for the house that existed only in his imagination: "The question of money wherewith to build this house never entered our thoughts; it was *going* to be *done,* that was enough. Call it fanaticism, or what you will: it was a *vision* clearly seen in the very darkness of our life at that time."[40] In 1882, Herkomer purchased land in Bushey (a village in Hertfordshire, north of London) on which to build the house and an adjoining art school. The school, whose buildings were provided by a neighbor interested in the

project, was opened the following year.[41] But it took an incredible twelve years of planning, construction, and decorating before the house was considered ready. A visitor to Bushey in 1883 recorded his impressions of Herkomer's establishment. In back of the artist's modest living quarters, which had been put together out of two laborers' cottages, were temporary workshops installed in sheds scattered over two or three acres of ground. One enormous shed had been built on a brick foundation and contained machinery imported from the United States, including a gas-powered engine, circular saws, and turning-lathes.

Mr. Herkomer proposes to build his house from beginning to end with his own hands, assisted by his father and an uncle who is also skilled in wood-carving. They are to be their own workmen, and in that capacity will in turn follow every trade. Even bricklaying will not be despised, and Mr. Herkomer points with glee to a rustic bridge over a pond in the garden as evidence of his capacity in that humble craft. In the smithy he is quite at home, and the necessary iron-work will be forged and wrought under his directions. Not only will the doors and windows, tables and chairs, fire-places, and every kind of wood-work and decoration be completed by amateur labour, but even table-utensils, such as spoons and forks, cruets and salt-cellars, come within the scope of the design. . . .

Museums, cathedrals, churches and other art repositories at home, on the continent, and in America have been ransacked for specimens of beautiful decorative designs in wood, stone or iron. Plaster casts, photographic sketches and architectural drawings abound in every nook and corner of his studios.[42]

Distressed to find that he lacked sufficient technical knowledge of architecture to proceed completely on his own, Herkomer found the help he needed in the person of the American architect Henry Hobson Richardson, whose achievements in structural form and innovative uses of materials are said to have antedated similar innovations in Europe by at least a decade.[43]

The house (called Lululaund after the artist's beloved second wife, who died before its completion) was built mainly of tufa, a kind of limestone imported from quarries near Munich. A round arch between two turrets gave the exterior a Romanesque appearance, while the predominant style of the interior was Gothic. Herkomer's combination of craftsmanship, artistry, and medievalism must have evoked many comparisons with his great contemporary, William Morris. Whereas Morris's dedication to craftsmanship was accompanied by poetic gifts, Herkomer's was complemented by musical talent. So impressive were his musical abilities that the renowned conductor Hans Richter accepted an invitation to Bushey in order to lead thirteen performances of a musical play staged in a theater built in

Herkomer's gardens; Herkomer had written the words to the play and had composed and orchestrated the score.[44]

The cost of Lululaund—which a younger artist characterized as Herkomer's "Rhine-Bayreuth-Bavarian castle,"[45] was estimated at somewhere between sixty-five and seventy-five thousand pounds, not counting the value of the artist's labor. The enormous walls, wrote Robert de la Sizeranne in 1898, will be standing ten centuries hence, if left alone. In 1923, when J. Saxon Mills published his biography of Herkomer, the school buildings had long since been demolished, and the future of Lululaund was in doubt. No endowment had been left to provide for the upkeep of the monument, and in the late 1930s Lululaund was torn down.[46]

So important was this house to Herkomer that it is not an overstatement to characterize his procedures in building up a portrait clientele as a fund-raising campaign for its construction. As the artist explained:

I waited for the moment when I could see clearly that the means wherewith to erect a noble monument were securely forthcoming. That moment appeared when I became a portrait painter, for I was then independent of the ever uncertain sale of pictures. A given size of portrait meant a definite fee, and this definite fee could be earned in a measured time. Given health and life, I had something tangible upon which to form my calculations.[47]

Portrait work was not altogether a new field for the versatile Herkomer, who had already done several watercolor portraits of important personages of the day. He had painted Ruskin (at whose urging Herkomer later accepted the position of Slade professor at Oxford, a post he held from 1885 to 1894); he had gone to Farringford on the Isle of Wight to paint Tennyson, who welcomed him with the words, "I hate your coming; I can't abide sitting," but made up for this unpropitious beginning after an evening's conversation, when he knocked at the door of the artist, who was then undressing for bed, and quickly uttered, "I believe you are honest; good night!"[48] Even more trying as a sitter was Richard Wagner, who, having initially agreed to sit for a portrait commissioned by members of the German Athenaeum, refused to spend any time with the artist, allowing him only the privilege of sketching during rehearsals at the Albert Hall. "He permitted me to be about him," wrote Herkomer, "as he would a harmless dog." But when Wagner saw the completed portrait, he became appreciative and affectionate. "*Sie hexen!*" he said to Herkomer; "Yes, I like to look like that!"[49]

In 1879, a year after the Paris success of *The Last Muster*, Herkomer accepted a commission from King's College, Cambridge, for an oil portrait

of a ninety-year-old diplomat. Herkomer knew that the commission was the result of his successful portrayal of old age in his most famous painting but feared being stereotyped as a painter of old men, a public image that would seriously impede the growth of his portrait clientele. His strategy was to paint a portrait that would establish beyond all doubt his ability to depict men in the full prime of life. Herkomer chose his friend Archibald Forbes, a war correspondent, as his subject. "Standing erect, dressed in self-designed khaki jacket, with hands behind him, he was the very incarnation of strong manhood; with a striking brow, regular features, and a square-set jaw, he showed power in every line." The portrait, a great success at the 1882 Academy, had the desired effect of stimulating a demand for Herkomer's talents in this branch of art. Not surprisingly, the initial commissions were all from men who thought they resembled Forbes, especially in his manly bearing. "I did my best," wrote Herkomer, "to make heroes of them all."[50] Perhaps it was the feeling of insecurity and uncertainty, the sense of the ebbing of Britain's long-unrivaled economic supremacy, that (added to the normal sum of human vanity) caused people to seek to immortalize themselves in oils, as had the ancestors of the aristocracy, some of whose portraits—by Gainsborough, Reynolds, Romney—were then being placed on the market in increasing numbers, as their land-holding descendants tried to cope with the problems of agricultural depression.

The United States held the promise of an additional portrait market of even more impressive dimension. Two visits there by Herkomer during the 1880s, one of nine months' and one of six months' duration, produced enough funds to make a confident start on the great house. Two and a half months of concentrated work in London before the first American trip got the campaign under way. Two letters Herkomer wrote at this time, the first before and the second during his visit to the United States, convey a sense of heady excitement coupled with hard calculation.

I have three sitters every day. . . . I shall have done fourteen portraits in the two months and a half. . . . Here comes in an astonishing item—the extraordinary rapidity with which one can make money. It seems like a dream that I can with my own honest handiwork make so much. . . . In the two and a half months I shall have done thirteen portraits for money (the other one was for myself). These thirteen portraits bring me in six thousand six hundred and fourteen pounds sterling. I have already paid into my bank this year five thousand pounds, so I shall have in the nine months of this year over eleven thousand pounds.

The month of December I hope to work in America. So I calculate in this way— twice a year I will have the two and a half months portrait-painting, making five

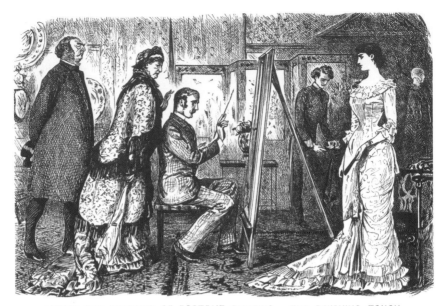

LIGHTS AND SHADOWS OF PORTRAIT PAINTING.——THE FINISHING TOUCH.

Fair Sitter's Mamma. "I'M SURE THE NOSE IS NOT AQUILINE ENOUGH, MR. SOPELY!"
The Artist (with one dexterous sweep of his brush). "IS THAT BETTER?"
Fair Sitter's Mamma. "OH, EVER SO MUCH! NOW THE LIKENESS IS SIMPLY *PERFECT!*"
Fair Sitter's Papa (who is always so contradictory). "HUM! NOW *I* CONSIDER THAT LAST TOUCH HAS SPOILT THE LIKENESS
ALTOGETHER!" [*Sopely's brush was perfectly dry—and so was his canvas!*

19. George Du Maurier, "Lights and Shadows of Portrait Painting" (*Punch,*
15 July 1882). By the early eighties, many artists had turned to portrait paint-
ing as the most reliable means of livelihood. Painters like this one knew how to
manage interfering clients: have a servant prepare tea and acknowledge com-
plaints about the sitter's likeness without taking them too seriously.

months a year for that work. In that time I can do thirty portraits, and that means a
regular sum waiting for me of twelve thousand pounds. This is not a wild specula-
tion but a reality. . . .

Everybody wants to be painted now. . . . Whenever I come to Boston again a
clear year's work is ready for me. . . . I seriously talk of a return in two or three
years' time to get more money to buy all the apparatus for the building of the
house. . . .

When we left Boston yesterday, coming downstairs I had a large stretcher under
my arm, father had the paint box and Lulu the palettes . . . so we call this the
"Herkomer Portrait Company."[51]

Herkomer had good cause for celebration. His income for two and a half
months of work (over £6,000) very likely equaled or surpassed the annual
earnings of many of his wealthy patrons. R. D. Baxter, for example, writ-
ing in the late sixties, gave £5,000 as an example of an upper-class in-

come.[52] (£1,000 could supply a family with horses and carriage, coachmen and groom. Bishops of the Church of England received an average of £6,000 a year.)[53] Well might Herkomer urge his American uncle to sell his property in Cleveland and join in the glory of building the family monument!

Herkomer's talents received wide recognition, although it was also recognized that he did not always live up to them. The art historian and critic Richard Muther, while critical of Herkomer's "greasy technique" and "soapy painting," had praise for his good modeling and vigorous drawing, and considered his late group portraits to be magnificent examples of realistic art.[54] These portraits evoked comparisons with the works of seventeenth-century Dutch painters, and when Herkomer was awarded an honorary degree at Cambridge (in 1908, one year after he was knighted), he was described as the Franz Hals of the age. Of his popularity and fame there can be no doubt; until the mid-nineties, Herkomer was one of the most sought-after artists. William Rothenstein, writing of the portraits he saw while visiting Oxford during that decade, expressed his irritation with dons who always chose the painter in vogue whenever a portrait was to be added to a college hall: "Holl or Herkomer, Herkomer or Holl, was the verdict every time a distinguished Oxonian was to be painted."[55]

But success in portraiture exacted a high psychological price in an age that regarded the artist's freedom to choose and depict his subject matter as essential to his spiritual and aesthetic development. How did painters, especially those previously dedicated to compassionate portrayals of the lives of the poor, maintain self-respect in their new role as flattering delineators of the countenances of the rich? An answer to this question suggests the key importance of two closely related themes. First is the matter of "selling out": how did artists handle the guilt they must have experienced when they sacrificed deeply felt ideals in the pursuit of higher and more secure remuneration? The second area of concern is to identify ego-strengthening social resources available to painters who needed to maintain self-respect and dignity, while knowing that they had chosen that branch of the art which offered least scope for the expression of the highly valued qualities of originality and spontaneity, and for professional autonomy. Under the necessity of producing not only a picture but also a likeness satisfactory to the patron, the portrait artist finds that onerous restraints have been placed upon his imagination and spirit. In the judgment of the art historian Max Friedländer, only the very greatest portrait artists—Holbein, Velasquez, Franz Hals—have been able to escape from the degrading pressure exerted by the pretensions, wishes, and vanity of the patron.[56] "Livery," wrote Walter Sickert, "is honorable wear, but liberty

has a savor of its own."[57] How did painters like Fildes, Holl, and Herkomer manage to keep at least the savor, if not the substance, of artistic freedom?

Luke Fildes

The social conscience of Luke Fildes had been shaped by the socialist ardor of the grandmother who adopted and raised him. She had been wounded in the Peterloo Massacre and was later active in the Chartist movement. Mary Fildes strongly opposed her grandson's career choice. Her comment, upon hearing that his first Academy picture, a Watteau-like boating scene, had been sold for six hundred pounds, was simply "No picture is worth that much."[58] Doubtless, she was pleased when the young artist turned to a serious subject for the 1874 Academy exhibition. His overpowering painting, *Applicants for Admission to a Casual Ward,* a depiction of a line of homeless people applying for tickets to an overnight shelter, was based on *Houseless and Hungry,* an engraving Fildes had done for the first issue of the *Graphic* in 1869. Accompanying the catalogue description of his Academy painting were these words that Dickens had written after he observed a similar group of desperately poor people in Whitechapel: "Dumb, wet, silent horrors, Sphinxes set up against that dead wall, and none likely to be at the pains of solving them until the general overthrow." The *Times* harshly criticized the painting and insisted, in a long review, that Fildes's appeal to the viewer's sentiment was essentially false, even dishonest. Casual wards were fit repositories of human degradation; society had fulfilled its responsibility by providing "such bare shelter and subsistence as may keep life and soul together."[59]

This type of criticism did not discourage Fildes from exploring other examples of social evils in his paintings. His *Widower* in 1876 was an illustration of personal tragedy in a setting of destitution. It was followed by *The Return of a Penitent,* a statement of the injustice and cruelty of the social attitude that allowed no forgiveness to a daughter, whereas a prodigal son's return was celebrated by the killing of the fatted calf. Fildes had wanted to call this picture *The Return of the Prodigal* and regretted accepting the advice that the word *prodigal* could not apply to a woman. The lines from Byron that he quoted in the catalogue were a compromise: "And every woe a tear may claim except an erring sister's shame."[60]

From 1887 until his death forty years later, Fildes painted no further appeals to compassion and the sense of social injustice. The single exception to this statement, *The Doctor,* was painted in 1890–1891, by which time he was an eminent portrait painter with many more portrait commis-

20. Luke Fildes. Like his contemporary Frank Holl, Fildes was a powerful social realist painter and a fine portraitist. He received a number of portrait commissions from members of the royal family, and was knighted in 1906. (As published in the *Magazine of Art,* vol. 3, 1880.)

sions than he could handle. One hundred nineteen of his portraits were exhibited at the Royal Academy, and he did many more that were never publicly shown; members of the royal family were among his socially prominent sitters. By the turn of the century, Fildes and John Singer Sargent were the most highly paid portrait painters in England, Holl having died in 1888 and Herkomer having by then passed the peak of his popularity among the social elite.

Two days after the death of Edward VII in 1910 (and four years after Fildes was knighted), the *Graphic* was given permission to publish a drawing of the king on his deathbed on condition that it be done by Fildes. The artist would have preferred to decline the commission but felt obliged to accept. He was dissatisfied with the results, disconcerted to find that black-and-white work had become difficult for him. Fildes's discomfort with the medium with which he had begun his artistic career may be seen as indicative of a more generally altered identity—a change symbolically expressed in the celebrated picture *The Doctor,* which was commissioned from the artist's sketch in 1890 by Henry Tate, to be part of his gift of a National Gallery of British Art. The picture, whose subject was suggested to the artist by the memory of his own son's fatal illness thirteen years before, depicts a room in a poor family's cottage. A well-dressed physician leans with intense concern over the sickbed of a child. Fildes had spent a week in Devon sketching fishermen's cottages to prepare for the picture, and from his sketches had had a full-sized replica of a cottage interior built in a corner of his studio. Medical friends, having heard that the artist was

preparing "a noble tribute to a noble profession," were eager to sit for the central figure and visited the studio each Sunday morning while the work was progressing. But Fildes used only one model; he had a series of photographs made in which he himself acted the part. The figure that appeared in the completed picture was not an individual's portrait, but a construct developed with the help of these photographs.[61]

The painting was a resounding success. Engravings of *The Doctor* sold widely in England and in the United States, where it was reproduced on a postage stamp issued to commemorate the centenary of the oldest American medical society. In 1891, while the picture was receiving public acclaim at the Royal Academy, a prominent English physician spoke of it in an address to a group of young doctors. "A library of books written in your honor," he said, "would not do what this picture has done and will do for the medical profession in making the hearts of our fellow men warm to us with confidence and affection. . . . Remember always to hold before you the ideal figure of Luke Fildes's picture, and be at once gentle men and gentle doctors."[62] Fildes's painting appealed not only to the sentiment of compassion for the sick and poor, but also to sentiments of professional identity and pride.

The choice of a subject picture at a time of Fildes's high success and phenomenally busy schedule as a portrait artist, the unusual procedure of constructing a model of a poor family's cottage inside a grand studio that received royal sitters, the personal significance of the incident depicted, and the decision to use his own image as the model for an ideal—such a combination of factors indicates that this, his last important genre work, held special significance for the artist. Perhaps this painting provided Fildes with a way to achieve congruence between his past and present identities: he was at once celebrating his own high professional status (for he *was*, throughout the development of the picture, the doctor) and suggesting (through pictorial means) that life lived as a gentleman did not require one to abandon idealism, pity, and compassion—suggesting also that the upholding of professional ideals was for the painter, as well as the physician, a social service.

But the contradiction remained. It is implicit in a letter from Fildes to his brother-in-law and fellow artist Henry Woods; Fildes wrote that despite the high fee of three thousand pounds that Tate had agreed to pay, "I should probably make more money by portraits, which I have to entirely give up [while this picture is in progress]."[63] By painting society's most privileged, the portrait artist was not in fact performing an act comparable with the physician's succoring of the poor and ill; nor could he have the

hope, which he and other painters of social realism had once shared with Dickens, of indirectly leading to the betterment of their lot by moving the hearts of those with some power to change things, whether by individual acts of charity and kindness or by collective social action. The three roles of gentleman, artist, and humanitarian that Fildes had, by means of the imaginative conception of *The Doctor,* tried to make congruent with one another were in reality mutually independent. A career in portrait painting was not the best way for an artist to express and further humanitarian aims, nor was professional status the equivalent of artistic success. It was the sense of this latter disparity that underlay Fildes's bitter remark, made in reference to the commission he had received to paint the new king, George V, in 1911, that the event itself (that is, the fact of the commission) would be regarded by most people as more important than the painting even of his finest picture.

The example of Fildes provides one answer to the initial questions of this discussion: How did artists who left social-genre painting for portraiture deal with the guilt that is likely to have followed such an abandonment of ideals? How did they maintain, or seek to maintain, self-esteem and dignity in the face of the resultant loss of artistic freedom? Luke Fildes appears to have attempted to accomplish both aims by means of a strong sense of identification with the professional ideal. It was an allegiance powerful enough to lead him to criticize his own professional society, the Royal Academy, when he felt it had violated that ideal—as was later the case when, during World War I, it refused to exhibit the works of artists whose origins were in an enemy country, even when they had become naturalized British subjects.[64]

Fildes's strong sense of professional pride was expressed in dramatic confrontations with his famous client Cecil Rhodes, whose portrait was still unfinished when the sitter vehemently declared his dissatisfaction with the artist's work. "I have just sent my secretary with a cheque to pay for the portrait and bring it here," declared Rhodes, "and as soon as it arrives I will burn it. . . . And if he refuses to surrender it, I will have the law on him for breach of contract." Fildes would not accept the check and refused to give up the picture. Rhodes was furious to find that even he could not enforce his demands upon an artist who believed in the dignity of his calling and the quality of his work.[65] Fildes's son described the stormy sittings that must have preceded this incident. Without prior arrangement, Rhodes would send telegrams announcing his pending arrival at the artist's studio. One telegram that arrived late one afternoon so angered Fildes that he refused to receive Rhodes and told him never to come for a sitting

when he smelled of brandy. "Cecil Rhodes might be an Empire Colossus, but my father was an eminent portrait-painter, and once upon a time an Emperor had been known to stoop and pick up a painter's brush."[66]

Frank Holl

Frank Holl came to terms with the similarly altered pattern of his career in a way that reflected his very different temperament and upbringing. Holl's father and grandfather had been engravers and utopian socialists. There was a strong emotional link between their anger at the low status accorded engravers and their political aspirations. His father hated the restrictions that limited him to translations of other men's ideas and longed to be a painter; he spoke of himself as "a nigger driven by a graving tool to earn his bread." Holl's idealism was formed in this atmosphere of straitened circumstances and socialistic ideals, an atmosphere that (according to his daughter) led him to develop an almost morbid sensitivity to every financial expenditure and to the correct use of each moment—and, it would seem, to an extreme belief in the sinfulness of pleasure.[67]

Holl entered the Academy schools in 1860 at the age of fifteen. Two years later, he completed his first large painting, *A Mother and Child*. Like many of his later works, this was a portrayal of dire poverty—a beggar woman, seated on the steps of a church, shielding her starving infant from the driving rain. Holl's next work, painted in competition for the Academy's gold medal award, depicted a biblical subject. Even though he won the medal, Holl commented that the subject was not congenial to him, while the previous picture had been "after his own heart." A few years later, Holl again chose a subject that he believed (following the advice of friends) would further his career; in this case, it was a literary theme—Othello recounting his adventures to Desdemona. But two days before the picture was to be sent to the Academy, the young artist angrily painted out the central figure, vowing that he would never again paint a subject he did not "feel."[68] It was an act of harsh self-punishment, as it meant he would not be represented at the all-important annual exhibition.

In 1868 a portrayal of family bereavement, *The Lord Gave, and the Lord Hath Taken Away; Blessed Be the Name of the Lord,* won a prestigious Academy award that entitled Holl to a year of travel and study on the Continent. (After two months, Holl cut short his stay; a brief period in Italy had convinced him, as he stated to the Academy in his letter resigning the travel scholarship, that his true interest was "to portray the simple, somewhat rugged home-life of the English people.")[69] Queen Victoria, still

21. Frank Holl, self-portrait. Holl is noted both for the remarkable works of social realism that he painted during the 1870s and for the fine portraits produced during the last decade of his life. (As published in the *Magazine of Art*, vol. 11, 1888.)

mourning the death of her husband, wanted to buy the picture when it was shown at the Academy in the following year, but when the purchaser, a friend of Holl's in-laws, declared himself unwilling to sell it, she commissioned a picture on a theme of the artist's own choosing. Holl painted another scene of loss and sorrow, *No Tidings from the Sea*, this time set in a fishing village. The queen paid a hundred guineas for this work.[70]

Despite his growing success, Holl still lacked self-confidence and the assurance of steady income; the latter was now of considerable importance since he had married in 1867. Five years of work for the *Graphic* answered to both these needs and gave Holl the close acquaintance with London scenes that inspired some of his finest work both in black-and-white illustration and in oil painting. Police in the East End came to recognize Holl on his frequent walks; along with the local pawnbrokers and rag-pickers, they often helped him find costumes and props for his pictures. These London sorties led to his social-realist masterpiece, *Newgate: Committed for Trial*; an enormous picture, it measured a monumental sixty by eighty-three inches. It was painted inside the prison after the artist had himself locked in a cell so that he could experience the feeling of imprisonment. *Newgate* was shown at the Academy in 1878 and Holl was bitterly disappointed when it received far less praise than another of his works also on exhibit. The latter work was a portrait, and Holl decided to accept the advice of a popular portrait painter that he turn to that branch of painting. Within a year, Holl was overwhelmed with commissions and well on the way to wealth and fame.[71]

The transition was not an easy one. For one thing, Holl seemed to have a

distaste for painting women's portraits. Even more important, however (since he found no absence of male sitters), was the sacrifice of autonomy, a terrible loss for an artist who had once destroyed a canvas rather than proceed with a subject that failed to evoke a deep response within himself. What made Holl willing to make this great sacrifice?

It is hard to avoid the conclusion that, like so many other artists of the day, Holl had entered into a style of living that required continued high income. In 1877, during a period when the costs of the requisites for an upper-middle-class mode of life were rapidly rising, Holl had bought a beautiful house. A glassed-in garden conservatory, filled with flowers and embellished by a fountain, connected the house to one of London's finest studios. Four years later, feeling the need for a studio larger in size, Holl commissioned the noted architect Norman Shaw to build him an opulent mansion in Hampstead.[72] Having gained the outward status that clearly meant a great deal to him, Holl had somehow to rationalize his loss of freedom since he, as a portrait painter, could no longer decline to paint subjects he did not "feel." He did this first, by specifying to sitters that he reserved the right to destroy any portrait with which he felt dissatisfied, and second, by his conscious effort to redefine and dignify the role of the portrait painter.

The experience by means of which Holl became (or tried to become) "converted" to portrait painting occurred during a visit to Holland, the ancestral home of the Holl family, in 1881, a year of enormous expenditure on the new house. It was in Amsterdam, wrote Mrs. Reynolds, that her father first saw the work of Rembrandt, and was deeply impressed by the dignity of his portraits.

From this time on he became wedded heart and soul to one ideal—to fulfill his mission as a portraitist. Up till now he had been loath to sever the tie that still bound him to genre and subject compositions. Rembrandt . . . fulfilled for my father the function that great art must fulfill for all of us, of showing him the eternal issues beyond the fashions of a day. The mode of Victorian genre lost [its] hold on him, and save under some external compulsion he did not again paint a subject picture with narrative intention.[73]

If, as his daughter suggests, the example of Rembrandt eased the transition to portrait painting for Holl, there is still the question of why he felt the need to drive himself well past the point of a tolerable level of overwork, making it impossible for him to enjoy the fruits of his success. "Hunger for work," he had once written to his wife, "is always on me, and it is when I cannot satisfy this hunger that I get so worn out. . . . If only I could banish my tormenting conscience for work; but that never lets me alone, and if I do nothing I feel of no use."[74] There is more here than the

need to support a family in fashionable luxury. The artist's words strongly suggest the conviction of sinfulness and the need to atone—both for seeking luxuries that his parents would have disapproved and for abandoning the depiction of subjects that deeply moved him.

Holl again commissioned Norman Shaw, this time to build him a "cottage" in Surrey; the new country place turned out to be larger than the family's town house, but Holl seldom had time to visit it. He hardly ever took a vacation, and frequently worked all day on Sunday. Honored by an invitation to contribute to the famous collection of artists' self-portraits at the Uffizi Gallery in Florence, he kept putting off painting it to a time when he would be less pressed, a time that never arrived. It was only during his last illness—recovery from which was perhaps prevented by his premature abandonment of a sick-bed to paint Pierpont Morgan—that this reserved man spoke frankly to his daughter. They would move from London, he told her, and he would live an easier life, painting only occasionally.[75] Frank Holl's death in 1888, at the age of forty-three, was commonly attributed to overwork.[76]

Portrait Painting and Professional Autonomy

For Herkomer, 1888, the year of his chief rival's death, was also the year that his father died. The depression he experienced was caused not only by his sense of irrevocable loss, but also by the feeling that Lorenz's many sacrifices could not be redeemed by his son's success as a portrait painter.[77] In the second volume of his autobiography, Herkomer writes that he worried about whether he had been sufficiently loyal to imaginative art since taking up portraiture. Added to this self-doubt was his sensitivity to the charge that when an artist who has been successful in subject work takes up portrait painting, it must be because he has succumbed to the desire to make money.[78] Frank Holl, Herkomer noted, had also been criticized for this retreat from nobler artistic goals.[79]

Herkomer had two ways of coping with these self-doubts and charges, and of asserting—indeed, of constantly reasserting, for it was the nature of his psychological need that it never could be satisfied—his right to the title of the "free artist" of his father's aspirations. Again and again in his various writings Herkomer delineates a variety of defensive positions and offensive countercharges that together form a kind of arsenal of weapons with which the portrait painter might uphold his honor and dignity: Why, he writes, do not the detractors of today's portrait artists make similar charges against Titian, Van Dyck, and Rembrandt? Why must an artist

keep working, for all his life, in the branch of art in which he first achieved success? Portrait painting is not, as many charge, a facile exercise, but an aesthetically challenging problem; let those who mock try it themselves! The portrait artist is the true recorder of history; there is no more priceless possession in this world than a good portrait of a relative; a portrait can be great art if the painter looks beyond the likeness and aims at a wider pictorial conception. Finally, Herkomer opportunistically "raids" the art-for-art's-sake school for one last ingenious argument in answer to critics: If it is not what you do, but how you do it that counts—form and execution, that is, over content—then why should the choice of one subject be regarded as less worthy than that of any other?[80]

More satisfactory than such defensive claims was the example given by Herkomer's life, which included such a wide range of activities that there could in fact be no justification for labeling him a mere portrait painter; "Versatility in Art" was the title of his *Times* obituary.[81] Unlike Fildes and Holl, Herkomer never allowed portrait painting to take up all of his time. In addition to serving as Slade professor at Oxford, he was deputy-president of the Royal Society of Painters in Water Colours between 1896 and 1898 and head of the art school at Bushey from its founding in 1883 until his resignation in 1904; he also supplemented his income by extensive lecture tours.

The image of the gentlemanly professional man that held such attraction for Luke Fildes was important, too, for Herkomer, who took pride in his connection with professional societies and with one of the great universities. There was, however, another image highly valued in some circles during the later nineteenth century for which Herkomer was especially suited, by inheritance and aptitude. "He was," wrote one critic in 1892, "among the first to preach by example the necessity for the reunion of arts and crafts, to proclaim that the modern limitation of the artist to a specialty, the modern disdain of the painter for the craftsman, is a symptom of feebleness, not of power."[82] His studio, Herkomer wrote, was richly carpeted but was above all a workshop.[83] Portrait painting was just one part of Herkomer's multifaceted career. No other portraitist could claim at once the title of artisan and of professor.

Throughout the first half of the 1880s, Herkomer continued to appear before the public with works that balanced his portrait contributions—some in romantic landscape (craggy and mysterious scenes with dramatic names like *God's Shrine* and *The Gloom of Idwal*), others continuing his earlier portrayals of Bavarian peasants and English poverty. *Pressing to the West,* shown at the Academy in 1884, was a tribute to the sufferings of

his own family in journeying to the New World many years before; it portrayed a group of exhausted emigrants recently arrived at Castle Gardens, the immigrant-receiving station that was replaced by the facility on Ellis Island in 1892. A series of forty small pictures and sketches, *Life and Labor in the Bavarian Alps*, which Herkomer prepared in 1885 for exhibition at the Fine Art Society, included various scenes depicting the unequal treatment of hunter and poacher. In the Royal Academy exhibition of that year, Herkomer showed a painting he called *Hard Times: 1885*. It illustrated the plight of many laboring families who wandered through the countryside in search of work during those years of agricultural depression—their belongings in bundles, a baby wrapped in a shawl. It was inspired by one such group Herkomer had seen resting by the wayside in Bushey. The *Times* appears to have overlooked this painting in its review articles on the exhibition, while lavishing great praise on Herkomer's portrait of a young woman; the picture was called *The Lady in White* because her cream-colored dress and fair complexion appeared before a white background. Herkomer was puzzled by the great success of this picture— it was something of a sensation, and subsequently toured Germany, Austria, France, and the United States—but greatly pleased, for it answered the charge (also brought against Holl) that he could not paint women. Perhaps it was the temptation to capitalize on his success with *The Lady in White* (for funds were always needed for his master project, the house at Bushey) that led Herkomer to concentrate on portraiture for the rest of the decade, thus causing his attack of remorse when his father died.

In 1890 Herkomer was elected a full member of the Royal Academy. It was a great moment in his life, the fulfillment of a long-held dream: "Although honors have come to me from many sources, that was the one for which I worked and longed."[84] The diploma picture, which Frith had regarded, in his offhanded way, as simply part of the price of membership, had great symbolic importance to Herkomer; this picture, which each newly elected R.A. was required to give to the Academy, would be the seal of his success as an *English* artist. In order to secure the privileges of membership at once, Herkomer gave one of his portraits as a temporary deposit to the Diploma Gallery and proceeded to paint the work which was to represent him, for all time, as a Royal Academician. The picture was exhibited in the following year; it was called *On Strike*.

"I can," Herkomer once wrote in another connection, "claim artistic freedom beyond, I think, any artist in England."[85] His choice of this unexpected and controversial subject—for the bitter London dock strike of 1889 remained a vivid memory—may have provided a means of coping with

the guilt attendant upon his earlier abandonment of subject-painting; it may also be seen as a dramatic declaration of artistic freedom. The *Graphic,* which had played such an important role in the earlier careers of the men discussed in this chapter, wrote appreciatively of the picture: "It is called *On Strike* and represents, on a life-sized scale, a stalwart British workman, leaning against his cottage door, while his wife, with a sickly-looking child in her arms, and an appealing expression on her pale face, gently lays her hand on his shoulder. The figures are true types of character, natural and impulsive in their gestures, and the picture shows throughout close and sympathetic observation of nature." The *Athenaeum*'s review was curt: "a large and effective, but unpleasant group of a workman 'On Strike' and his wife." The scale of Herkomer's painting—a factor mentioned in all these reviews—was obviously disturbing to those who feared the threat to English social structure contained in the industrial unrest of the late eighties and nineties. This uneasiness is apparent in the *Times*'s review; the gentle and appealing wife described by the *Graphic* is here characterized only as "unhappy," while the "stalwart" workman has become the "surly" laborer: "Nobody will deny that in these days of labor disputes and acute social questions such a subject is appropriate to art; and in this figure of the gaunt, dogged, and surly laborer, of his unhappy wife and half-famished children, Mr. Herkomer has given us a summary of one side, and a very important side, of modern civilization. We are not sure, however, whether he could not have told his story better on a smaller canvas."[86]

Herkomer, during his twenty-three years as a Royal Academician, continued to be a productive portrait painter. Late in the century, however, much of his work was done in Germany; he had held a kind of dual citizenship since 1888, when he had married his second wife's sister in Landsberg (such a marriage still being illegal in England).[87] Germany had considerable attraction for a portrait painter, offering both high remuneration and prestige. The Scottish painter James Lavery, who had worked there during the previous decade, had observed that a painter's status in Germany was equal to that of a general in the army: he was covered with decorations at public functions and saluted as a person of distinction.[88] "There is," Herkomer wrote soon after returning from Berlin, "an immense amount of money and enterprise in North Germany and the rich like spending their money, which is useful to us portraitists. Thus it is that I find no difficulty in getting double my English prices over there."[89]

Herkomer was particularly proud of the award presented to him in 1899,

the Prussian Order of Merit. To his son Siegfried (whom English friends knew as Bob), he wrote: "I've got it at last! This coveted Order of Merit, and downright pleased am I—nay, deeply touched. . . . To anybody asking you, make it clear I got it as an English artist."[90] At about the same time, Herkomer was awarded the Bavarian Verdienst Order, which gave him the right to prefix *von* before his surname, a privilege, writes his English biographer, that a man so anglicized in habit and sympathy ought never to have adopted.[91] Knighted in 1907, his very signature attested to international prominence: *Sir Hubert von Herkomer*. Thrilled and proud as he was of these marks of high distinction, Herkomer, always conscious that six months marked the limit of his life's formal education, preferred to be addressed as "Professor."

Herkomer died on 31 March 1914 and was buried in the churchyard in the village of Bushey. The timing was perhaps fortunate, for the war would have been agonizing to one so divided in national identity. Herkomer had characterized his feeling for art as essentially English; it led him, he said, to appreciate the importance of sentiment in art. His "blood," however, he thought of as German and said that it caused him to yearn, as his father had, after an ideal. He had often been struck, he wrote, by the absolute separation of these natures in himself: "My mind is as dual as if it belonged to two distinct personalities."[92] This dualism was apparent in the posthumous exhibition of Herkomer's work held at the Academy in May 1914. His paintings shown there included a portrait of the Duke of Wellington, which gained notoriety as the victim of a suffragette attack. Another was a group portrait of the firm of Krupp.

Herkomer was often insightful and informative in his discussions of the major art issues of the day, particularly those relating to art education and to the painter's choice of thematic material, and it may be that his divided national identity brought a certain detachment and freshness to the thoughts he expressed. But he was evasive and self-contradictory when he faced the question of how an artist could at the same time protect his need for complete autonomy and also fulfill his desire for the steady and reliable income that could alone provide the requisites for outer marks of status and success. This value-laden and conflictual question was one that Herkomer, like his contemporaries Fildes and Holl, found difficult to face. All three defended their choice of steady remuneration over artistic autonomy with arguments about the professional dignity and historical importance of portrait painting or with the assertion (made most often by Herkomer) that the artist could paint portraits while at the same time pur-

suing other branches of art, thereby participating in the lesser for the sake of the higher goal. But a close look at the lives of these artists leaves one with no doubt that they all suffered deeply from the conviction that they had sold their birthright for the rewards of high and regular income. Herkomer could point with honest pride to his efforts outside of portraiture, but his knowledge that talent in art is not best developed by running a portrait factory came painfully to the surface in the period of depression that followed his father's death. He knew that he had not shown the full measure of respect for his own impressive gifts. Private patronage alone (and in the last decades of the century, that meant portrait commissions) could keep the artist in the style of the gentleman, but private patronage was, as Herkomer wrote in 1882, one year after he became a portrait painter, a "poisonous influence."[93]

In discussing these artists' lives, I have suggested that their reluctant choice of portrait work could best be understood by placing it within the economic context of the times, by looking at these painters as one segment of the professional classes which were then trying to maintain a high standard of living in economically tightening circumstances. Such an analysis is helpful, but far from conclusive, for one still wishes to know why the allegiance to an ideal of deeply sincere and autonomously created art proved so vulnerable. Why, in other words, did the desire to be a "free" artist not outweigh the need to live like a "gentleman"?

Reynolds and Lawrence had shown that English artists could gain acceptance as members of the upper classes; both lived in a style altogether congruent with that of their wealthy and titled patrons. But the low prices generally paid for the work of most other living artists until about 1850 meant that few painters could follow their model; an artist might dine at the tables of the rich and visit country estates, but few were the painters rich enough to live in the style of their patrons. The period of great demand and high prices for contemporary painting that began at mid-century gave new relevance to the Reynolds-Lawrence model. Frith, Millais, Leighton, Poynter, Alma-Tadema, Stone, Herkomer, Holl, and Fildes—all these and many others were able to live on a grand scale. Art was now frequently mentioned as a respected profession, artists having tangible proof that society highly valued their contributions. The altered patterns of taste and of expenditure that came with the economic depression of the last decades of the century ended this situation. Only a small number of artists were able to go on as before; for others, there was, for a time, the option of portraiture.

Frith, well aware, as he wrote his memoirs during the late 1880s, of the

movement of English artists into portrait painting, discussed the reasons for his avoidance of this branch of art. To a man who once asked him to do a portrait, Frith gave the following reply. He pointed to a figure painted from a model, for which he had received a sum at least as large as the fee for a portrait of similar size. He said that in painting this, he had not been obliged to think of likeness, always a burden to the portrait painter, but had simply selected a model who was an agreeable object of contemplation. In this way, Frith had only himself to please, "whereas the man who undertakes a portrait may be condemned to spend hour after hour in studying the ugly or the commonplace, and please nobody after all."[94] Frith's practice was not, however, altogether consistent with this statement; the multiple likenesses undertaken for *The Marriage of the Prince of Wales* and later for *The Private View at the Royal Academy* were surely not done for the artist's own pleasure and inner satisfaction. Frith enjoyed an easygoing home life, delighting in what his daughter calls the "bohemian" company of actors and journalists, but no reader of his autobiography can come away without the conviction that in public and when not among intimates, he expected, as much as did the unbending Fildes, to be treated as a professional gentleman. One suspects that, had Frith been considerably younger than sixty-nine in 1888, this desire for social status would very likely have led him, too, into the ranks of the portrait painters.

The artists discussed in this chapter, when faced with the need either to compromise their own vision of art or to sacrifice their gentlemanly and opulent way of life, chose to compromise the former. Their reasons reflected a number of factors, both psychological and societal. Perhaps, as some contemporary critics charged, the lack of intelligently nurturing patronage other than for portraiture may have sapped their dedication. The account of these painters' lives and careers strongly suggests that the drive for social mobility in the society of which they were members was so strong as to sweep all before it.

However one chooses to weight these factors, room must be left for consideration of a factor even more basic, namely, the relentless pull of respectability in Victorian society. Fanny Kemble, whose long career as an interpreter of Shakespeare and whose social identity as a member of a famous acting family made her well acquainted with such matters, observed that only in the England of her day did the oppressive and tyrannical power of respectability—"that English moral climate, with its neutral tint and temperate tone"—provide an atmosphere so pervasive that artists had to breathe it in common with other men.[95] Long before Miss Kemble's

death in 1893, however, Whistler and other adherents of art-for-art's-sake had found a different and a purer air to be essential to the artist's life. It was not, however, their challenge alone that would end the reign of respectability in art; it was the effects of that challenge magnified many times by economic change, change that brought to an end the fabulous earning power that had made the respectability of upper-middle-class professionals attainable by Victorian artists.

5. Painting and the
Independent Woman

While feminist art historians have written interesting and valuable analyses of the conditions of female art production in the Victorian period, these accounts have not been drawn upon to any great extent by cultural historians, nor have they been integrated into the broad scope of social history. Perhaps the attention deservedly given to governessing, the major occupational alternative for needy women of the respectable classes well into the 1870s, has made other choices appear peripheral. Perhaps, in addition, the strong association of women's artistic skills with the polite "accomplishments" taught to genteel Victorian daughters—in combination with the satirical images of lady amateur painters popularized by *Punch* and other magazines—have served to perpetuate the assumption that almost all professional artists were male.

There is, however, considerable evidence that women—including genteel wives and daughters facing financial adversity and serious professionals with years of study—benefited significantly from the strong demand for the work of contemporary artists that began to build in the late 1840s and continued for a quarter of a century thereafter. For example, the 1871 census listed over one thousand female painters. Women took part regularly in the annual exhibitions of the Royal Academy and sold many pictures there and at other art shows in London and the provinces. And like their male counterparts, women participated in the art market through the intermediaries of print-sellers and dealers.

As this chapter will show, the world of female painters differed greatly from that of their male colleagues, many of whom were their fathers, brothers, and husbands. Women were denied the all-important recognition of acceptance into the Academy (it had originally included the artists Mary Moser and Angelica Kauffmann, but they did not exercise full prerogatives of membership) and were given limited access to art education for most years of the "boom" market in contemporary art. The difficulty of finding intensive training in life study was especially serious for aspiring

professionals, for such study was held to be the essential core of the artist's preparation and was the foundation of the curriculum for male art students. Other important problems that stood in the way of full professionalism for women painters were the pull of domestic responsibilities (which were equally compelling for the married woman and for the spinster living with parents or other relatives); the presence of large numbers of female amateurs who created an expectation of dilettantism among art teachers, exhibition viewers, and critics; and the widely accepted belief in the inferiority of women's creative powers to those of men.

Women artists played an important role in the early feminist movement in England. The prominence of these female painters, especially in the first campaign for a Married Women's Property Bill, no doubt contributed to the keen public interest that developed over questions regarding women's role in art, an interest demonstrated in columns of the art press, in journals of general culture, and in the novel, the preeminent form of popular Victorian literature. It can hardly be a coincidence that three novels published at mid-century—Anne Brontë's *Tenant of Wildfell Hall,* Dinah Mulock's *Olive,* and the anonymously published *Sisters in Art*—featured as their heroines women who earned their living, and their spiritual independence as well, by means of their skill as artists.

Mid-Century Perspectives

When Roberton Blaine advocated female membership in the Royal Academy (as a witness before the 1863 commission charged to examine the position of the Royal Academy; see chap. 2), he spoke from close personal knowledge of the conditions of female art practice, for his wife was both a painter and a leading member of the Society of Female Artists. The society was founded in 1857 by Harriet Grote with the purpose of "opening a new field for the emulation of the female student, and also a wider channel of industrial occupation, thereby relieving part of the strain now bearing heavily on the few other profitable avocations open to educated women."[1] The society's founding reflected the fact that by the mid-1850s women painters had demonstrated that this field could be a profitable and socially acceptable mode of employment; career patterns had been established that younger women could now emulate.

But even in the favorable art market of the fifties, success was not easily achieved. A woman, far more than a man, needed not only talent and drive, but mentors and influential sponsors as well. And because of their exclusion from the Royal Academy and its schools, most women (except

for those from artists' families) lacked the valuable personal introductions to clients and patrons that came far more easily to men. The juxtaposition of real opportunity with the possibility of bitter disappointment in the lives of women who aspired to be artists may be illustrated by contrasting the career of Emily Mary Osborn and the theme of a painting that the twenty-three-year-old artist exhibited at the Royal Academy in the year the Society of Female Artists was founded. Entitled *Nameless and Friendless,* this well-received picture showed a lovely young woman, identified by her black dress as either a widow or orphan, being turned away by the arrogant print-shop proprietor to whom she has tried to sell her drawings. Osborn, a protégé of the painter and educator James Matthew Leigh and of a highly regarded teacher in his school, had not, like the "nameless and friendless" woman she depicted, been obliged to approach the market without the help of influential supporters. An exhibitor at the Academy and the British Institution from the age of seventeen, she had achieved notable success with two works at the 1855 Academy show, the first of which was a commissioned group portrait and the second a rustic scene purchased by the queen. With the money earned by these pictures, Osborn was able to build a new studio.[2] The dual examples of this successful young painter and her less fortunate sister-artist in the print-seller's shop were present in the minds of those who worked with Mrs. Grote to develop the Society of Female Artists so as to provide needy gentlewomen with encouragement and access to a special market of purchasers—women and men who would visit the society's exhibitions and buy pictures there, either out of charitable motivation or because they were more affordable than the high-priced Academy works.

The society was closely, albeit informally, associated with the early feminist movement, among whose leaders were the art historian Anna Jameson and the landscape painter Barbara Leigh Smith, who is best known by her married name of Bodichon. Harriet Grote's subsequent activities would continue to reflect her dual interests in art and the advancement of women: she later wrote a biography of the popular French artist Ary Scheffer and played a prominent role in organizing the first petition for female suffrage.[3] With Mrs. Jameson as mentor, Barbara Bodichon was at the center of a group of young women who carried out a major campaign petitioning Parliament for legislation to give married women control over their own property and earnings.[4] The 1856 campaign for a Married Women's Property Bill collected twenty-six thousand signatures and is generally regarded as the organizational initiation of the feminist movement in England.[5]

In 1857, following Anna Jameson's suggestion, Bodichon and her col-

22. Born into a prominent Unitarian family (her father and paternal grand-
father were reformist members of Parliament), Barbara Leigh Smith Bodichon
(1827–1891) was a highly regarded and successful watercolor landscape
painter and an inspiring leader of the early feminist movement. She was also a
founder of Girton College, Cambridge. This painting by Emily Mary Osborn
conveys a sense of Bodichon's remarkable personal presence. (By permission
of the Mistress and Fellows, Girton College, Cambridge.)

leagues founded the *English Woman's Journal,* whose columns gave strong emphasis to the importance of opening new avenues of employment to women and to widening opportunities in those occupations to which women had already gained entrance; before long, an employment agency developed in the *Journal's* Langham Place office. The advancement of women's education was a closely related priority of these reformers. Bodichon would later donate ten thousand pounds earned from the sale of her pictures to the founding of Girton College, the first institution established for the university education of women.[6] A striking portrait of her by Emily Mary Osborn was presented to Girton in 1884 by a group of Bodichon's friends.

Acutely aware that many among the growing numbers of unmarried middle-class women continued to believe that the only avenue of employment appropriate to their station was the overcrowded and notoriously underpaid profession of governessing, the *English Woman's Journal* crusaded for a broadened definition of occupational respectability. Why, it asked, should social derogation be an expected outcome for women engaged in business, when similarly occupied males suffered no such penalty? Middle-class parents were urged to turn away from the dominant mode of educating their daughters to be fit only for lives of genteel leisure and perpetual economic dependence. Anna Jameson summed up the problem in stark terms: "There are 800,000 women over and above the number of men in the country; and how are they all to find husbands, or find work and honest maintenance? The market for governesses is glutted."[7]

The problem could hardly be ignored, even by those unsympathetic to feminist solutions. The 1851 census, by confirming that there was a large (and apparently growing) surplus of females over males, called into question the wisdom of educating respectable young women on the assumption that they would move from the comfortable protection of their fathers to that of their husbands. According to the analysis made by the social critic and writer W. R. Greg, the 1851 census showed that only fifty-seven out of every hundred women over the age of twenty-one were married; thirty were spinsters; and twelve widows. Spinsterhood was no occasional misfortune, but a likely prospect for a sizable minority of women. The situation was to become even more serious during the two following decades, when the population of "surplus women" increased by 16.8 percent.[8] Middle-class parents of young women were particularly concerned that so many eminently suitable males were choosing to marry late, if they married at all, while numerous others chose service in the empire or emigration to the colonies.

The implications of what came to be called "female redundancy" were argued at length by authors and journalists. The issue was given a great deal of discussion throughout the latter half of the century in the columns of the art press, which regularly philosophized about the nature of women's talents, occupations, and responsibilities in the context of reviews of the work of female painters and in discussions of their access to art education. The prominence of this issue as it related to female art practice reflected a widespread awareness among well-informed observers—including readers of the *Art Journal* and other publications dealing with cultural matters— that many women were earning income through their work in art, as were their counterparts in the fields of journalism and literature. Proponents of legislation to protect married women's earnings heightened this aware- ness in their 1856 petition, calling Parliament's attention to the fact that modern civilization, in extending the sphere of occupations for women, had "in some measure broken down their pecuniary dependence upon men"; lower-class women were widely employed in factory work and other occupations, while women of the "middle and upper ranks" of society were now entering the fields of literature and art.[9]

The respectability of the latter two professions was typically attributed to the fact that they could be pursued by women within the protection of their accustomed domestic surroundings. In the words of Dinah Mulock, a well-known popular writer at the time her essay "Female Professions" was published in 1858, "We may paint scores of pictures, write shelves-ful of books . . . and yet we ourselves sit as quiet by our chimney-corner, live a life as simple and peaceful as any happy 'common woman' of them all."[10] Mulock, whose writings provide valuable insights into the situation of women painters, had considerable knowledge of the workings of the art world. She had spent a year (1843) studying drawing at the Government School of Design, and enjoyed an especially close relationship with her brother Tom, an aspiring painter who attended art school with several of the future Pre-Raphaelites. Her widely read occasional essays and fictional accounts of art careers also reflected knowledge subsequently gained from varied personal connections with a circle that included art students, paint- ers, critics, and illustrators. These writings—especially her 1850 novel *Olive*—helped to strengthen the widely held belief that, while art practice could indeed be readily accommodated within the setting of feminine domesticity, the highest levels of artistic achievement were almost cer- tainly—and appropriately—out of the reach of women.[11]

Numerous expressions of this belief appeared on a regular basis in jour- nals of general culture and in the art press. For example, the novelist and biographer John Cordy Jeaffreson, writing in 1870 in the journal *Art Pic-*

torial and Industrial, suggested that the vocation of art, "from the privacy of its functions," appeared to be well adapted "to the retiring disposition and delicacy of women." If women did not excel in a vocation so well suited to their natural talents, it was probably because their energies were usually at some point redirected towards domestic responsibilities, while their male counterparts could labor, in this as in other fields, "with undivided attention and all their force."[12] The notable exception was the French animal painter Rosa Bonheur, perhaps the most admired woman artist in Victorian England from the mid-1850s, when the dealer Ernest Gambart exhibited her enormous picture—approximately eight feet by seventeen feet—of a scene in the Paris horse market and introduced the artist to London society. Bonheur's strongly masculine demeanor and dress, which evoked comparison with George Sand, were taken as clear proof of the incompatibility of impressive achievement in art with the nature of women, except for those few who were willing to "disown" their sex.[13]

A number of professional women artists of the later nineteenth century would reject Mulock's view that female art practice could be easily accommodated within the setting and expectations of domesticity and would also disagree with her judgment that women artists should accept appropriate limits to the scope of their ambitions. These women painters would find in Jeaffreson's—and Victorian society's—characterization of the female (as delicate, retiring, self-effacing) one of the principal obstacles to their professional status and advancement.

The interest in female art careers that emerged beginning in the late 1840s no doubt reflected the fact that some women artists, benefiting from the rapidly expanding market for contemporary paintings, were receiving relatively high remuneration—high, that is, only in comparison with other fields of female endeavor, for women's canvases consistently sold at far lower prices than those by male artists.[14] This new appreciation of art as an attractive and effective means of support for independent women was noted by Harriet Taylor, John Stuart Mill's companion and future wife, in a letter she wrote in 1848 to their friend W. J. Fox. Well known as a charismatic Unitarian minister and Radical politician, Fox was also the editor of a journal, *Monthly Repository,* that gave warm support to feminist ideas. Bitterly condemning society for placing narrow limits on employment options for women, Mrs. Taylor parenthetically mentioned art as the only decently paid female occupation.

The progress of the race *waits* for the emancipation of women from their present degraded slavery to the *necessity* of marriage, or to modes of earning their living

which (with the sole exception of artists) consist only of poorly paid and hardly worked occupations, all the professions, mercantile clerical legal & medical, as well as all government posts being monopolized by men.[15]

Harriet Taylor's reference to the status of female art careers in 1848 had immediate personal relevance to the recipient of her letter. It was during that revolutionary year that Fox's daughter Eliza, a talented young painter, prevailed upon her father to allow the use of his library for a class in which women art students and painters met to draw from the nude model. Eliza Bridell-Fox would later become a successful artist and art educator and a tireless advocate of wider opportunities for women in the art profession. An active member of the Society of Female Artists, she painted a large oil portrait of her father for its 1858 exhibition. The *English Woman's Journal* considered this to be an especially fitting contribution to the show, for Fox's "noble sense of justice to women has been marked at every stage of his public and parliamentary career."[16]

In taking note of the strong link between the feminist movement and the first organization of women artists, it is important to recognize that middle-class nineteenth-century feminism encompassed a variety of viewpoints, some of them strongly traditional by late twentieth-century standards. For example, many women artists who supported legislation to protect married women's rights to own and control their own property would also have agreed with Mrs. Jameson's emphatic affirmation of men's natural and exclusive right to preeminence in the public sphere:

The natural and Christian principles of the moral equality and freedom of the two sexes being fully recognised, I insist that the ordering of domestic life is our sacred province indissolubly linked with the privileges, pleasures, and duties of maternity, and that the exclusive management of the executive affairs of the community at arge belongs to men as the natural result of their exemption from the infirmities and duties which maternity entails on the female part of the human race.

And by maternity I do not mean the actual state of motherhood—which is not necessary nor universal—but the maternal organisation, common to all women.[17]

Traditionalism notwithstanding, this pious woman, famous (and still respected today) for her writings on Christian art, could astonish and disarm the young painter George Dunlop Leslie by her humorous but determined advocacy of the right of female art students to enter the prestigious Royal Academy schools and engage in life study alongside their male counterparts.[18]

Soon after Mrs. Jameson's death in 1860, *Macmillan's Magazine* published a tribute to her memory written by the Reverend F. D. Maurice, the theologian and Christian Socialist whose work to improve the status of

governesses had led, in 1848, to the founding of Queen's College for Women, on the assumption that better educational qualifications would improve governesses' status and salaries.[19] As indicated by his article's two-part title, "Female School of Art; Mrs. Jameson," Maurice's tribute was made by way of urging support for an institution that, he suggested, furthered the goals that the art historian and feminist had so devotedly served.[20] The Female School of Art had been founded in 1842 with the dual aim of improving ornamental design in English manufactures and enabling "young women of the middle class to obtain an honourable and profitable employment." A brief look at its history, from the year of its founding (when it was known as the Female School of Design) until 1859, the year the school's government subsidy was withdrawn, provides an introduction to several issues of central importance to the social context of women's art practice during the Victorian period.

At first sharing the premises of the Government School of Design at Somerset House (established in 1837 for male artisans), the Female School (as it was less formally known) flourished for its first six years under the dedicated leadership of the artist Fanny McIan. Fees were modest, and the director admitted as students only women whose financial situation required them to become self-supporting.[21] But a new Management Committee appointed in 1847 to oversee the Government and Female schools saw fit to curtail Mrs. McIan's authority and moved the school to a highly undesirable location. Anthea Callen, in her book on women in the Arts and Crafts movement, ascribes the committee's action to male jealousy: the women's annual exhibitions were so far superior to those of the male students that it had been found expedient to establish a separate set of prizes in order to save the men from continued embarrassment. The Female School was relocated, during the summer break of 1848 and without Mrs. McIan's knowledge, to rooms above a soap factory in the Strand, near the theatrical district of Drury Lane. Parents voiced bitter objections to the bad neighborhood and the dark, damp, unventilated building. Students sometimes fainted due to the stifling air and had to be carried outside.[22]

The school's site, name, and a significant portion of its constituency were again changed in 1852, when the noted civil servant Henry Cole became head of the new Department of Practical Art. Cole's policy implemented his belief that the school could be run more cheaply by expanding the number of its pupils, raising tuition, and cutting in half the number of staff per student. In order to increase revenue still further, he encouraged the attendance of a group formerly excluded, that is, women interested in art as a genteel accomplishment, who were now welcome to attend at a

special, higher fee.[23] But Cole's decision to open the Female School to amateur students led directly to the withdrawal of the school's subsidy in 1859 by the government, which justified this decision on the grounds that the state should not finance an institution that served the accomplishment needs of ladies; women of limited means were advised to attend other government schools in London.[24]

In 1860, when F. D. Maurice issued his appeal for public support of the Female School, women who needed to work still represented the majority of its students, but many amateurs were also enrolled. According to the report of a committee formed to support the school's continuance, quoted at length by Maurice, among the 118 students attending the school, only seventy-seven were studying "with the view of ultimately maintaining themselves." The pattern was similar to that which had developed at Queen's College; although established for future governesses, it had also attracted students with no need for paid employment. Maurice's justification of the mixed constituency served by Queen's College also had relevance to the Female School of Art: "Those who had no dream of entering upon such work [that is, governessing] this year, might be forced by some reverse of fortune to think of it next year."[25] The economy of early Victorian England was volatile; most businesses were small in scale and vulnerable to periodic downswings and market fluctuations. Bankruptcy rates were high. Only the wealthiest professional men had enough savings to insulate their families from the effects of bad times, and a father's untimely death was likely to cause immediate and disastrous loss of income and mode of living.[26] This terrible insecurity made it prudent for daughters and wives of businessmen to have some degree of preparation for unanticipated financial setbacks.

But Maurice had an additional reason to urge support for an institution that enhanced the art education of women of varying financial status and prospects. This reason was implied in his expression of concern that the current situation of the Female School be thought of in the context of "the power which women may exert in raising or in corrupting [art]"; such power was held in great measure by genteel students whose art training—and ample leisure—would enhance their ability to play active roles in "elevating" public taste, whether as gallery visitors, purchasers of pictures and engravings, or, in exceptional cases, as writers in the numerous periodicals of the day. Given women's power to influence the shaping of the general culture of which art was a part—and Maurice's strong conviction that "not the conventions of the world, but the will of God" had assigned characteristic faculties to each sex—the future of the Female School of Art was properly to be considered as part of a still broader question.[27] To

phrase this question in terms familiar to Victorians: What were the appropriate *functions* of women in art?

The question was taken up by the *Art Journal* in an article entitled "Woman and Art: The Female School of Design," which appeared in the year following Maurice's essay. The author, Thomas Purnell, combined his expression of support for the Female School with a more extended inquiry into women's position in the contemporary art world, explicitly situating his analysis within the social context of middle-class female redundancy. Noting the urgency of the difficult and pressing question of "what share of the ordinary avocations of life may fairly be assigned to woman," Purnell began by expressing strong agreement with those who gave the traditional answer, that woman's first allegiance was to the home, and that a woman "guilty of transferring that allegiance elsewhere" could rightly be condemned. But he added that this readily agreed-upon answer "is indeed, at the best, of very limited application [since] it wholly ignores—what constitutes a vast and terrible proportion of the sex—those who have no domestic duties that need their care. . . . Marriage is not the lot of all." Purnell indicated that his concern was not for upper-class women, who would continue to enjoy every luxury whether married or single, nor for lower-class women, to whom "the necessity of earning their own bread is so apparent from their earliest years, that . . . [they] accept their lot with patience, and are able and willing to work at whatever offers itself." His chief concern was with women of the "intermediate" or "respectable" classes; it was here that the young, unmarried woman

becomes a burden and continual source of uneasiness at home. Suppose reverses or misfortunes in business, or a "British Bank" collapses, or Death makes a call upon the head of the family before he has made a provision for it, or a guardian misappropriates the provision he has succeeded in making—what is to become of her then?

Here are women demanding of us employment whereby they may earn their livelihood: what shall we give them to do?

Purnell made amply clear that his advocacy of wider employment opportunities for "respectable" women had nothing to do with the "chimera" that held the sexes to be equal; indeed, their inequality had been settled by "the consent of all ages, together with actual anatomical and physiological investigation." But since civilization had advanced beyond the times when "man's sole occupation consisted of war and the chase," pursuits for which the female sex was naturally incapacitated, woman was now able to take "a share in man's labour." It was therefore appropriate to ask the question, What share is to be assigned her?

Like F. D. Maurice, Purnell believed that the Female School of Art,

"founded expressly for the purpose we have been considering," had provided one answer to this question and pointed to the success of its graduates as industrial designers and as teachers, both in families and in schools. But he extended his argument on behalf of female education to include a group of women who seemed to have escaped Maurice's notice: women who were studying art neither for commercial purposes nor for the enhancement of leisure hours, but in preparation for careers as professional painters. "Art," he wrote, "is the profession in which, more than all others, women may be expected to excel, and even successfully compete with the stronger sex," carefully adding that he would make no similar claim for any other profession. To those who might accuse him of showing disrespect to art by emphasizing its value as a means of livelihood for women, he pointed out that neither Michelangelo nor Turner had, after all, been indifferent to the matter of remuneration. Purnell ended his argument with a clear and emphatic statement of its specific purpose, namely, "to arouse sympathy with the object we desire to promote, . . . the useful and honourable employment of those who are unhappily compelled to labour in order that they may live."[28]

Purnell's comments reflect the fact that even though the Female School did not offer a course of study for women interested in painting careers, some of its students had enrolled with this goal; so limited were the opportunities for women's art education at mid-century that this institution, "the only art school of any size for women in England in the nineteenth century," inevitably attracted aspiring professionals.[29] The most prominent private art schools open to women during the 1850s—Cary's, formerly called Sass's, after its founder, and Leigh's (known after 1860 by the name of its new owner and director, Heatherley) had serious drawbacks for the female art student and for her parents. Cary's, which had long served as a preparatory school for young males who aspired to advanced study at the Royal Academy, charged high fees. Leigh's did not require matriculation and was reasonably priced, but its French-inspired open *atelier* system did not usually provide much individual instruction and the school does not appear to have been as widely known to women during the 1850s as in the following decade, when it provided training to significant numbers of female artists.[30] Until other schools began to widen educational opportunities for women painters—a process that began at the start of the 1860s, when the first women students were admitted to the Royal Academy schools, and gained impetus with the establishment of the Slade School of Art in 1871—the Female School was both a resource and a frustration to the serious woman painter.

One artist who left a brief commentary on her experience at the Female School was Eliza Turck, whose life story exemplifies the image of genteel respectability endangered by a sudden change in family fortune, an image repeatedly invoked in discussions of women's art education during the Victorian period. At first a talented but desultory student, Turck developed a very different self-image after her father, a London banker, failed in business during her period of enrollment at the Female School. Her reactions to that institution, in the context of a remarkably thoughtful account of her own artistic development, were related to Ellen C. Clayton, who included them in her 1876 book, *English Female Artists*. Turck's story reveals a great deal about the interplay of artistic talent, parental expectations, and financial motivation in the life of a talented young Victorian woman.

Miss Turck showed an early love for pencils and paint-boxes, and her mother having herself a great natural talent for drawing, besides being a woman of advanced and cultivated ideas, the child enjoyed the advantage of sound and practical teaching in the elements of art. . . . Not, indeed, that any special training for a profession was for a moment entertained. It was partly to gratify a beloved and indulged child, partly with the idea of encouraging her to acquire an elegant accomplishment, that she was allowed to follow the bent of her gift for drawing. . . .

[In 1848] Eliza Turck was placed for six months at Cary's School of Art, where, although studying in somewhat amateur fashion, she made good progress. Afterwards she took lessons in oil painting, during another six months, from Mr. W. Gale. Then, being left without regular instruction, and not feeling sufficient power to work well without some stimulus, a period of comparative idleness ensued, broken by occasional fits of hard work, succeeded by great discouragement, after the manner of clever, enthusiastic young girls left to their own unguided resources. In 1852 Miss Turck entered the figure class of the Female School of Art . . . and remained there for a whole year, vainly trying to satisfy a wholesome appetite for study with dry bones. For in those days no advantages whatever were offered in the Government schools to those female students who desired to attain proficiency in any branch of art, except decorative art. No models were then allowed, no draperies or other accessories. The "Figure Class," as it was pompously, if ironically, designated, was "instructed" in one small room, containing a few casts from the antique, the instruction being imparted during one daily visit from the lady superintendent. During the time spent here by Miss Turck occurred her father's failure in business, which naturally induced her to take an even more serious view than before of her favourite pursuit. Although her family still continued somewhat to discountenance the idea of an artist's career for her, she herself never ceased from that period to regard painting as the occupation of her life.[31]

It is significant that the arguments regarding the mission and appropriate constituency of the Female School of Art took place during those years

23. "Female School of Art, Queen's Square: The Life Class" (*Illustrated London News*, 20 June 1868). At the Female School of Art, the term *life class* always referred to the costumed model. This picture conveys an atmosphere of serious art study.

when enthusiasm for contemporary art took on the character of a popular movement—a movement sanctified by the inspiring words of the prophet Ruskin and intensified by the enormous growth of a prosperous middle class that regarded the possession of paintings by living artists as emblems of success and standing. It was no wonder that artistically inclined women who felt themselves a part of this movement—and whose other activities were circumscribed by prevailing social mores—would come to find that talents initially trained to serve as genteel accomplishments could serve them well in times of financial need. Single women, particularly as their numbers grew and as marriage prospects lessened for many, would come to see art practice as a possible lifetime profession, an option equally respectable but far more remunerative than that practiced by England's twenty-five thousand governesses (the number reported in 1851).[32] This new awareness lent urgency to several closely related questions. What

were the appropriate modes of art education for women? Which art genres were best suited to female practice? And perhaps most important of all, how could the realities of art practice be molded to fit the approved image of Victorian womanhood?

Even before the late 1850s, when the *English Woman's Journal* was calling attention to art as an effective vehicle for female autonomy, answers to these questions were being presented by women writers in novels read by thousands of Victorian readers. An examination of three of these works can teach us a great deal about the emerging cultural image of the female artist and introduces issues and concerns that gave the world of Victorian women painters its characteristic atmosphere and tone.

Artist-Heroines of Mid-Nineteenth-Century Fiction

Several years before the feminists of Anna Jameson's circle began to urge parents to educate their daughters so that they would never face the necessity of becoming governesses, Charlotte and Anne Brontë, former governesses themselves, published novels that deeply impressed—and often outraged—their contemporaries. The first of these, Charlotte's *Jane Eyre,* which appeared in 1847, has been called the Magna Carta of the governess. The second—which I shall discuss here—was Anne Brontë's *Tenant of Wildfell Hall,* published in 1848. This work, perhaps the first sustained feminist novel, tells the story of Helen Huntingdon, who takes flight, with her son, from a profligate and abusive husband. The novelist May Sinclair once wrote that Helen Huntingdon's slamming of the bedroom door reverberated throughout Victorian England.[33] The English heroine's dramatic action took place three decades before the far more famous departure of Ibsen's heroine Nora.

The motive for Helen Huntingdon's courageous (and unlawful) pursuit of moral and financial independence is to save her son from the influence of her husband and his loose-living friends. The vehicle for her course of action is a strong artistic avocation, which she develops and exploits with a cool and practical intelligence. (Anne Brontë was herself an amateur artist and a musician of above-average proficiency.) With assistance from her servant, Helen sells the pictures she has painted to "a picture dealer in a distant town," and begins working "from dawn to dusk" to improve her skills and ensure her ability to be self-supporting. With her brother's help she is able to move, under a pseudonym, into the old and abandoned family residence of Wildfell Hall, where she sets up a studio, immediately finds herself the subject of the neighbors' curiosity, and meets Gilbert

Markham, the admirable man she will marry at the conclusion of the novel, after her husband's death.

Brontë calls the reader's attention to Helen's progress as a self-instructed artist by means of Markham's sensitive observation of the difference between an example of her early work and the far more confidently painted pictures of recent times. He comments that her earlier work, when she had painted as a genteel accomplishment, had "far more careful minuteness of detail, and less of that freshness of colouring and freedom of handling, that delighted and surprised me." Helen's spiritual progress—from enslavement to a bad marriage to the realization of personal autonomy—has its parallel in her artistic development, which moves from feminine timidity to the self-confidence of mature womanhood.

The integral connection of Helen's art with her moral and spiritual autonomy is made melodramatically explicit when the reader is presented with the portion of the diary that Helen had kept during her life with her husband. An entry in the diary relates how Walter Hargrave, one of Huntingdon's dissolute companions, attempted to seduce her after learning of her plan to take flight. The would-be seducer finds Helen working at her easel, busily "mixing and tempering [her] colours." He tries to convince her to run away under his protection, assuring her that she has nothing to lose, since she will in any case have sacrificed her reputation by leaving her husband. When he physically approaches her, she holds him at bay with her palette knife, which Brontë presents as a talisman that protects Helen from the power of evil.

The plot of the novel is convincing chiefly because the reader accepts the assumption that Helen's artistic gifts can provide her with a significant level of income; the book might almost have been subtitled "*Saved through Art.*" Brontë describes the mechanism of her heroine's financial independence briefly but quite specifically by having young Arthur declare, early in the novel, "Mamma sends all her pictures to London, and somebody sells them for her there, and sends us the money." It is clear, however, that the author's central concern is not to help women enter or advance in the art profession. It is rather to offer a powerful and insistent warning that conventional Victorian marriage is incompatible with spiritual autonomy. In the chapter that follows the heroine's near-seduction—appropriately titled "Hope Springs Eternal"—Helen cautions Esther, Hargrave's lovely young sister, to be cautious about marriage, whether for money (in accordance with the social ambitions of Esther's mother) or for love, the untrustworthy motivation that had brought about Helen's own misery. And although the novel ends on the traditional note of a rapturous new mar-

riage (after the death of Helen's first husband), the reader is carefully informed that this is not the same form of marriage that Esther was warned against. When Gilbert Markham expresses fear that Helen may change her mind about accepting his proposal, she responds that it will be his fault if she does: "I never shall, unless you bitterly disappoint me. If you have not sufficient confidence in my affection to believe this, let me alone." And when Helen asks Gilbert to consider allowing her elderly aunt to spend her remaining years with them, his response—"By all means, dearest Helen!—do what you will with your own. . . . We will live either here or elsewhere as you and she may determine"—is all that the feminists of the Langham Place circle would later wish for.

The heroine of Dinah Mulock's novel, published in 1850, is Olive Rothesay, who while living with her widowed mother in two rented rooms of a cottage in the "western environs" of London, learns, through the arrival of a creditor's letter, of a large debt her father had incurred just before his death.[34] Obsessed by the need to repay the debt and thus remove a mark on the family's honor, Olive eventually settles on a plan to develop her skill in drawing by enlisting the aid of Michael Vanbrugh, the owner of the cottage and an artist who disdains commercial success and aspires to the heights of greatness achieved by the Renaissance masters.

Like Helen Huntingdon, Olive decides to become an artist for strictly financial reasons. And both heroines make that decision in response to desperate situations and out of a conviction of individual responsibility—Helen to her son's future, and Olive to her parents' honor. But the two women experience artistic creativity in very different ways. For Helen, painting is a deeply absorbing and pleasurable pursuit but never a transforming passion. Olive, however, allows herself (if only briefly) to experience the overpowering joy of the creative act of painting. As her talents grow with intensive study and practice under Vanbrugh's tutelage, she begins to feel a sense of transcendence that mirrors her teacher's Faustian identity and unworldly isolation. In response to his declaration that the true artist renounces human ties for the worship of beauty, Olive responds, "I too, am one of these outcasts. . . . Woman as I am, I will dare all things—endure all things. Let me be an artist."

This development in her heroine's mental universe allows Mulock to speculate on two themes that would remain central preoccupations throughout her long and prolific career: the nature of female responsibility and the meaning of woman's work. In developing her talents as a painter, Olive has been drawn dangerously close to Vanbrugh's masculine self-absorption and unbridled ambition. This departure from feminine norms

is made to seem appropriate in Olive's case, for a spinal deformity—causing some degree of hunchback—has weakened her attractiveness and led her to misconstrue her truly feminine nature. Her deformity also provides an advantage in furthering her career: she can go out alone on long walks, spend days of study in the British Museum and in picture galleries, and return in the darkness of evening without the fear that other women would naturally experience in such circumstances.

Before long, Olive's works are shown at the Royal Academy and she earns enough to pay off her father's debt and even to contemplate the likelihood of attaining wealth and fame. Mulock (who did not marry until she was thirty-nine) has Olive attain through her own efforts the independence that allows her to decline offers of marriage, proposals that other young women, lacking the power to support themselves, would have been obliged to accept.

But at this point Mulock declares her belief that although women can come close to artistic greatness, the heights of creativity are reserved to men, and that women's deepest rewards come from human connections— from love, and from honoring the responsibilities that result from the ties of love. In the novel, therefore, Olive's painting career is happily eclipsed by the fulfillment of her feminine identity that occurs when she falls in love and marries a man of deep scientific learning who was the purchaser of her first picture and, as the improbable plot must have it, her father's creditor! No longer a practicing artist, she rejoices in her return to her native Scotland and in her new role as a devoted, dependent wife, who with "clinging sweetness" and an "upward gaze" at her husband, is now for the first time described as "a type of true woman."

An interesting counterpart to Mulock's *Olive* is her novel, published one year earlier, *Cola Monti: A Tale for Boys*, about a gifted young Italian-born artist who overcomes poverty and obscurity to achieve eventual renown as a great painter of "high art." These successively written books convey the author's thoughts on the implications of gender for artistic talent and expression. Both Cola and Olive are gifted painters, although the latter's artistic progress seems quicker and easier. A central message in both books is the importance of self-dependence and hard work: "God Helps Those Who Help Themselves" is the subtitle of the earlier story. But the final characterization of the newly married Olive provides an instructive contrast to the concluding description of Cola as a "man of Genius," who presses on "toward that high destiny which will make him famous in his day, and remembered after death with that renown which so many men are willing even to die for." The heights of artistic genius, sought after by

Vanbrugh and attained by Cola Monti, are an exclusively male province. Nevertheless, women's absence from the pinnacle of creativity does not signify loss; their nobility lies, instead, in love and service to others.[35]

Mulock's readers appreciated her keen understanding of the situation of the single, middle-class woman with inadequate means of support; the problems attendant upon this status were dealt with both in her fiction and in a collection of essays, *A Woman's Thoughts about Women,* published in 1858. This book became one of the most popular mid-Victorian manuals of advice for women.[36] In writing about the position of "redundant" genteel women, Mulock was reflecting upon her own life experience. Daughter of an improvident, charismatic evangelical preacher who abandoned his children after his wife's death in 1845, Dinah Mulock had entered upon her literary career when she was almost destitute.[37] Thus she was accurate in characterizing herself, in *A Woman's Thoughts About Women,* as a "working woman, who has been such all her life," and, moreover, as one who wrote at a "curious phase of social history, when marriage is apparently ceasing to become the common lot, and a happy marriage the most uncommon lot of all." It was to women in her own position, "namely, the ordinary middle ranks of unmarried females," those single women of the "supernumerary ranks, which, political economists tell us, are yearly increasing," that her book was addressed.[38]

After almost a decade of successful self-dependency, what advice did the author of *A Woman's Thoughts* offer to other unmarried, genteel women? Although Mulock emphatically differentiated herself from her feminist contemporaries—reconfirming the moral of Olive, that "our natural and happiest life is when we lose ourselves in the exquisite absorption of home, the delicious retirement of dependent love," and condemning as "blasphemous" the "outcry" for equality of the sexes—she was close to her feminist contemporaries in warning that

in spite of the pretty ideals of poets, . . . this fact remains patent to any person of common sense and experience, that in the present day, whether voluntarily or not, one-half of our women are obliged to take care of themselves—obliged to look solely to themselves for maintenance, position, occupation, amusement, reputation, life.[39]

Mulock insisted that women had the right, equal to that of men, to earn income from the products of their labor—she would later (1869) write a highly autobiographical novel, *A Brave Lady,* in support of a renewed campaign for a Married Women's Property Act.[40] Like Barbara Bodichon, Mulock denounced prevailing practices in childrearing and education

that conveyed the assumption that "helplessness is feminine and beautiful," and held that work and the capacity for self-dependence were not only of practical but of deeply religious significance. The greatest blasphemy of all, that to which genteel female education all too often led, was the implicit denial of individual moral responsibility. "Is a woman's divinity," she wrote, "to be man—or God?"[41]

Mulock's analysis moves from the importance of work to the question of what sort of work a woman can do. Women with good incomes should prepare for the possibility of financial reverses and, like all women, should understand the management of money; they should work to create happiness for their families and should devote time to charitable pursuits. For educated women who must support themselves, Mulock identifies four professions: the instruction of youth; painting or art; literature; and the various fields of entertainment, including acting, singing, and musical performance. Her discussion also provides interesting background to her own choice of literature over art or teaching.

Governessing, writes Mulock, is a profession degraded by the low standards of the great numbers who choose it; improvement in the status of this profession can only come by the insistence upon higher standards of preparation. Public entertainment is a morally dangerous profession because of the spirit of competitive selfishness that is fostered by the life of the *artiste;* nevertheless, a woman can mold this profession to her own standards, and no one should avoid the life of the performer who has a strong sense of calling in that direction. Mulock considers art and literature as "safer" professions for women in that both can be conducted at home, but points out that female artists face barriers to full success that have no parallel in the life of the female writer:

I put art first, as being the most difficult—perhaps, in its highest form, almost impossible to women. There are many reasons for this; in the course of education necessary for a painter, in the not unnatural repugnance that is felt to women's drawing from "the life," attending anatomical dissections, and so on—all which studies are indispensable to those who would plumb the depths and scale the heights of the most arduous of the liberal arts. Whether any woman will ever do this, remains yet to be proved. Meantime, many lower and yet honourable positions are open to female handlers of the brush.

But in literature we own no such boundaries; there we meet men on level ground—and, shall I say it?—we do often beat them in their own field. . . . Any publisher's list, any handful of weekly or monthly periodicals, can testify to our power of entering boldly on the literary profession, and pursuing it wholly, self-devotedly, and self-reliantly, thwarted by no hardships, and content with no height short of the highest.[42]

The endless repetition in the Victorian press of Mulock's counsel that her sisters of the brush limit themselves to modest genres and ambitions—an argument not of her invention—made it all the harder for women painters to beat men "in their own field." Unlike their counterparts in literature, women painters found their field to be a well-defended, heavily guarded male preserve.

Female Art Education as a Quest for Moral Perfection

In 1852, a short novel about women's art education—*The Sisters in Art*—was serialized in seven parts by a new and ponderously named journal, the *Illustrated Exhibitor and Magazine of Art*. Anonymously published, the story may have been the work of the writer Mary Howitt, her artist-daughter Anna Mary, or a member of their circle, which included several of the Pre-Raphaelite painters.[43] Anna Mary was a close friend of Barbara Bodichon—as was Dante Gabriel Rossetti, who spoke highly of Bodichon's talents as a landscape painter—and both Howitt women were active members of Bodichon's Married Women's Property Committee, along with Anna Jameson and Eliza Fox.[44] Although authorship of the novel is in doubt, the narrative is clearly situated at the intersection of art and the early feminist movement.

Although its exhibits did not include a painting section, the Great Exhibition of 1851 had nonetheless generated strong interest in art education, for pride in English manufactures had been accompanied by considerable concern that the deficiencies in the design of English goods might lessen their competitiveness in international markets.[45] This concern prompted the appointment of Henry Cole—who, with the prince consort, had masterminded the exhibition—to the directorship of a new office at the Board of Trade that was called the Department of Practical Art. Cole's charge was to increase the efficiency of the Schools of Design and to further art education as applied to manufactures—"wants which the Great Exhibition of last year made very manifest."[46] Confirming the stimulative effects the exhibition had on public interest in art education as an instrument to further both international commercial competition and the cause of peace, the poet Philip James Bailey wrote:

> Then came that great event, the Exhibition,
> When England dared the world to competition. . . .
> .
> Peace-men had then their beatific vision;
> And Art-schools were to render earth Elysian.[47]

The high level of interest in art education held special relevance for women, given the increasingly prominent belief that art and design were suitable vehicles for their talents. It was within this climate of opinion that the author of *Sisters in Art* celebrated the efforts of a triad of heroines to establish an exemplary school for the education of female artists—certainly an unusual theme for a novel.

Though unrewarding as a work of fiction, *Sisters in Art* reveals a great deal about the mid-century intellectual undercurrent that questioned prevailing Victorian expectations of genteel feminine passivity and dependence. Four themes in this relentlessly didactic story are especially striking: an emphasis on the spiritual value of work within a social context of close female friendship; a preoccupation with money and responsible stewardship; a widened view of art education as closely associated with moral education; and an emphasis on design as the most appropriate vehicle for female talent, accompanied by uneasy reticence about the inclusion of life study in the training of women artists.

Like Dinah Mulock, the author of *Sisters in Art* was troubled by the essential contradiction that a society that valued work above all else (Walter Houghton has suggested that except for *God,* the most popular word in the Victorian vocabulary must have been *work*)[48] nevertheless condemned women of the respectable classes to lives of conspicuous and empty leisure. When the chief "sister," Alice Law, fervently chooses work over genteel leisure, her choice resonates with the spirit of Carlyle, who had held that "properly speaking, all true Work is Religion," and idleness "perpetual despair."[49] At the story's grand climax, when the sisters have finally established their great new female school, the suggestion is made that once they have married, they may leave this work to others; but it is also made clear that they will certainly not be idle, for they are the vehicles of the author's belief that work is the means by which women's natural talents are made to serve the goal of human progress and perfection.[50]

For all her emphasis on artistic and spiritual perfection, the author of *Sisters in Art* constantly intrudes upon the narrative to offer details about money. She explicitly criticizes laws regarding money that clearly serve only male interests and brings her strongest condemnation to bear on the legally and socially sanctioned tyranny that wealthy males commonly exercised over economically vulnerable women. Indeed, rebellion against the power wielded by a wealthy and tyrannical man is central to the plot of the story. But the author also emphasizes that in the safe-keeping of the high-minded and philanthropic of both sexes—and with the advice of

cultivated and practical men—money can set free the power of women to ennoble society. Moral character and dedication to art are shown to be closely intertwined, but without money to activate them, they can lead to bitter frustration.

If true art education for women is a kind of moral education, then what is the reader to make of a story in which the daughter of a noble-hearted and kindly sculptor is seen by all as unworthy of compassion and forgiveness because she has worked as a nude model to artists? The reader is led to believe that the morally dangerous environment of the Drury Lane neighborhood has proved so thoroughly corrupting an influence that the model is now beyond society's redemption. It can hardly be a coincidence that this was the same neighborhood to which the Female School of Art had been moved in 1848. Harshly critical of mid-century England's failure to provide adequately for women's art education, the author of this story bitterly denounces the existing Female School of Art as nothing less than "a national disgrace."[51]

It is significant that the author of *Sisters in Art* seems to express approval of the traditional practice of drawing from plaster casts in the education of artists. We know that Victorian women studying to become professional artists generally held a very different view of the matter. Painters like Eliza Turck, and most of the women who gathered at this time to pursue life study in the library of W.J. Fox, repeatedly expressed dissatisfaction with the use of casts as a substitute for study from the living model. It was an educational deficit that no male student had to confront. Although *Sisters in Art* does not explicitly oppose life study in women's art education, the weight of the narrative suggests painful ambivalence about the practice. In the story, the two central sisters have engaged in life study at Mr. C's academy (obviously referring to Cary's art school), but neither offers a single approving comment about that aspect of the school's curriculum. And at the end of the tale, provision for life study is conspicuous by its absence in the rapturous tour the reader is given of the sisters' great new institution.

Of crucial importance to the narrative is the fact that the sculptor's daughter is not condemned in general terms as a fallen woman or even as a prostitute, but specifically as an artist's model. The legitimacy of the role such women played in the world of high art is not questioned; in the narrative, the French artist who employed her is described admiringly as a great and noble man. But the nude female model was a profoundly troubling figure to Victorian women whose dedication to art was linked to

conceptions of purity. It is not surprising that the anxiety level rose when increasing numbers of "pure" young women—daughters of country doctors, clergymen, and others in the respectable social ranks—began to aspire to careers as professional artists.

Opposition to study from the nude model in women's art education was more than a reflection of Victorian prudery; it derived in great measure from the fear of *contamination* by association with artists' models. It was to prevent the possibility of such association that genteel society sought to maintain an "unbridgeable gulf . . . between the chaste and unchaste" and to treat the unchaste with the "indiscriminate severity of social ostracism."[52] It was accepted that men might not be damaged by some measure of association with women who had lost respectability, but such was not the case for genteel young ladies. Ray Strachey has described female Victorian society as sharply divided into two segments.

In one section of society there stood the sacred hearth and the inviolable family, and there women were, in theory, sheltered and respected, not so much for themselves as because they were the centre of the home and the guardians of the "honour" of their husbands. In the other section there were women, too, equally necessary, but very differently regarded. These women were not honoured either for themselves or for any other thing. They were exploited, bullied, and ill-treated, cooped up in the brothels of the great towns. . . .

These two worlds existed side by side, but the women of the one had no contact with the women of the other. Men could, and did, pass freely between them, but for women there was a great gulf fixed. . . . These victims of society had no claims upon and no relationship with the virtuous woman. It was contamination for her to touch them, or even to know of them, for they were outcast.[53]

An art education that emphasized design or the small-scale painting of such feminine subjects as flowers and birds could evade the issue of the woman art student's association with models. Although in *Sisters* the heroines are in no way harmed by their own experience of life study or by their association with the sculptor's daughter, they are clearly presented as exceptional; as highly educated and saintly women, they are not susceptible to influences that might bring harm to others whose characters were yet to be formed and strengthened. Thus, the author of *Sisters in Art* gives fine art study for women a subsidiary role in favor of "a formula of art especially her own—that of design."

Pamela Gerrish Nunn astutely comments that the notable encouragement of exhibitions of women's handiwork during the 1870s and 1880s reflects not only the rise of the Arts and Crafts movement but also the resistance of male artists and the institutions they controlled to the grow-

ing competition of female practitioners in the fine arts.[54] In a similar vein, one may wonder whether some of the proponents of art education who emphasized the strength of female talent in design and in such "lesser" genres of art as flower painting, portraits, and still life may have been partly motivated by the desire to encourage an avenue of art education that avoided the difficult problem of keeping young women artists safely away from the living counterparts of the sculptor's "fallen" daughter.

6. *Progress and Obstacles: Women Painters from Mid-Century to the Close of the Victorian Era*

It is striking that in the course of their energetic pursuit of art education, neither Olive Rothesay nor Alice Law makes any mention of the most prestigious institutions established for that purpose in England, the schools of the Royal Academy. Reflecting the attitudes of women artists of their day, the two heroines apparently accepted as axiomatic the continuation of the time-honored restriction of those schools to male students. But developments later in the 1850s—especially the campaign for a Married Women's Property Bill, in which women artists played a prominent role, the founding of the Society of Female Artists, the continued growth of an art market that benefited many women painters, and the deepening awareness of the problem of middle-class female redundancy—made it inevitable that the longstanding exclusion of women from the Royal Academy schools would become subject to question and, eventually, to challenge.

That challenge took place in April 1859, in the form of a letter signed by a group of thirty-nine women artists and sent to each of the forty Academicians. It was a newsworthy event; the widely circulated and influential *Athenaeum* saw fit to print the letter in its entirety. The signers asked the Academicians to support the opening of the R.A. schools to women. They pointed to the enormous increase in the numbers of women artists since the Academy was first established and to the contributions women made to the annual Academy shows at which many "ladies" regularly exhibited their work. Indeed, the participation of female painters in those exhibitions signified that while the profession was in many respects "fairly open to women," deficiencies in their art education placed them at an unfair advantage when compared to young men who received, at no cost, the best art education then available in England. Women artists were typically obliged to begin the practice of art without adequate preparation and were therefore unable to fully develop their talents. Among the signers of the petition were Barbara Bodichon, Eliza Fox, Ellen Clayton, Margaret Gillies, Anna Jameson, the Mutrie sisters, E. Osborn, Henrietta Ward, and Laura Herford.[1]

158

In the following year (and probably with the tacit encouragement of Academy president Sir Charles Eastlake), Laura Herford, a former student at Leigh's academy and a member of Eliza Fox's life-study class, became the first artist to break the bar against women in the schools. She was accepted after submitting an application that provided her first initial in the place of her given name; once they had admitted her to the schools on the basis of the quality of her drawing, even the most obdurate among the Academicians had to admit that it was practice, rather than rule, that had kept women out. Although it would be many years before significant numbers of women would have the opportunity to study at the Academy in a program comparable to that which was offered to male students, Herford's 1860 victory ushered in two decades of real progress in women's art education. In 1877, the *Englishwoman's Review* wrote that although women painters still found obstacles to successful careers in art, conditions of art education were being "rapidly equalised for men and women. It is no longer possible . . . for a girl to believe that there are twenty difficulties placed in the way of a real artistic career for her which are all carefully removed from the path of her brother."[2]

By the last decades of Victoria's reign, women interested in art could consider not only a wide choice of schools in London and the provinces, but were also informed of numerous opportunities for foreign study by books and articles on the subject.[3] One interesting piece of reportage on female art education across the channel was provided by Dinah Mulock in 1887, in a short essay entitled "A Paris Atelier," published in a book she characteristically called *About Money and Other Things*. It was a sympathetic description of a colony of female English art students living in Paris in straitened but altogether respectable circumstances. Mulock assured readers who might consider Parisian residence as inevitably corrupting that "though Paris is not a desirable place for a girl to live and study alone," a busy and productive residence in that city "is not likely either to degrade or deteriorate her."[4]

Once again reminding her readers of the large proportion of women, old and young, who "have either no masculine protectors at all, or such as are practically useless, if not worse than useless," she urged that "working women in all ranks, from our queen downwards, are, and ought to be, objects of respect to the entire community." Reflecting her own experience of late marriage and motherhood (in 1869 she and her husband had adopted an abandoned, nine-month-old baby from a parish workhouse, a highly unconventional action in those times),[5] Mulock ended her article with an offer of hope to the hard-working female art student: "If Love comes, he will enter/And soon find out the way." And even if love never

comes, she "will be all the happier and a better woman for having put her life to useful account."[6]

Mulock's essay provides evidence of the continued and integral connection of an important segment of women studying art to unmarried and amateur status. She describes the Paris atelier women as dedicated art students who will nevertheless gladly give up painting if and when the opportunity for marriage presents itself. Mulock's essay also shows that concern regarding the appropriateness of life study for women students had not disappeared by the late 1880s. There is a markedly defensive tone in her description of the all-female atelier, where "we have the draped model in forenoons, the nude of afternoons," with "Monsieur" providing about two minutes of brief instruction to each student. Mulock was careful to call her readers' attention to the proscription of study from the male nude and to the complete separation of women students from young men studying under the same artist: "Our work is quite separate. We seldom meet them, and if we [do], we are too busy for any nonsense." The students' life in their quiet *pension* takes on a convent-like atmosphere in the author's narration of the words of one young votary:

We have one room, which is both sitting-room and bedroom. . . . We cook our own breakfast over a spirit-lamp at eight A.M., and go straight to the atelier, where we work till twelve. Then *dejeuner,* and work again till five P.M. . . . We can go down to dinner in the *salle-à-manger* if we like, but more often we boil our own kettle, have tea and an egg, and spend the evening over a book. It does sound rather a monotonous life for us, and yet we all find it so very attractive that the weeks slip by only too fast.[7]

Had it not been for the contracted art market of the 1880s, some of these art students might have realistically aspired to the income and success that gifted, resourceful, and determined women like Helen Huntingdon and Mulock's own Olive Rothesay had attained a generation earlier. Instead, study had become an end in itself; these English students in Paris were, in Mulock's favorite phrase, "working women" insofar as they were not idle but could more accurately be described as permanent amateurs. Male art students, too, had to deal with the altered economic prospects of the closing decades of the century, but the differences between their situation and that of their female counterparts were striking. Marriage, whether by its absence or presence, played a vastly different role in the lives of women painters. When art study began to attract enormous numbers of young women—most of whom continued to hope that love *would* bring a welcome change of direction to their lives—the old presumption of female dilettantism was strengthened. In its turn, that presumption hampered

the progress of women who worked hard to meet the more rigorous standards that would support professional careers.

It is no coincidence that all the artistic productivity of the heroines of the three mid-century novels discussed previously takes place while these women are single (or in Helen's case, married in name only), and that the authors' interest in their artistic work diminishes or ends with the appearance of appropriate marriage partners. In Victorian England, women were encouraged to study art and to pursue acceptable kinds of painting careers as long as they remained single; once married, however, painting was appropriate only as an avocation, for attention to husband and family was always expected to take precedence. Only dire financial need or marital crisis could justify a return to serious painting. In the absence of such overwhelming need—which many "right-thinking" Victorians looked upon as a disgrace or as a tragic misfortune—the rigorous demands of professional art practice were considered to be inappropriate for the wife and altogether unthinkable for the mother.

There were, of course, significant exceptions to this typical pattern. For example, Eliza Fox, Barbara Bodichon, Henrietta Ward, Henrietta Rae Normand, and Gertrude Massey all combined marriage with professional careers in art; except for Bodichon, each of these women combined feminism with marriage to a fellow artist. Throughout the Victorian period, however, their choice continued to be perceived as the violation of a well-accepted social norm.

Henrietta Ward attributed her success as a married artist (and mother of a large family) in great measure to the fact that her husband Edward, who was "greatly in advance of his age in broadmindedness," observed a rule that she "was not to be disturbed during certain hours of the day." But not even the focused professionalism of Henrietta Ward—an artist who was daughter, granddaughter, and wife of artists and who proudly wrote that she had learned to draw and paint before she could read—could ensure immunity from social pressure. As a young mother, she had been persuaded to give up painting for one miserably unhappy year after receiving a lecture from the elderly widow of a Royal Academician, who said, in Ward's words, that "I was very wrong not to make my child's clothes and give all my time to domestic matters, and that if I did my duty to my husband and home there would be no time left to paint."[8]

The expectation that even the most talented female painters would abandon art when they married was felt in full strength even at the Slade School of Art, which had welcomed and nurtured the talents of women students since its founding in 1871. The late 1890s was a period of female

brilliance at the Slade; in the judgment of the painter Augustus John, the school's "Grand Epoch" was a time when the male students "cut a poor figure" in comparison with the women. "But," wrote John over a half-century later, "these advantages for the most part came to nought under the burdens of domesticity which . . . could be for some almost too heavy to bear." A striking example was the gifted Edna Waugh, who had enrolled at the school at the age of fifteen, won a scholarship, and was generally considered a Slade prodigy. But her brilliant promise proved to be short-lived. Waugh married at nineteen, and "even her best-known work, a series of haunting illustrations to *Wuthering Heights,* remained unfinished."[9]

Given the prevailing assumption that marriage entailed the sacrifice of female painting careers, it is not surprising that some women were ambivalent about marrying, and that others were altogether unwilling to give up the advantages that continued spinsterhood offered to their progress as professional artists. To successful women artists—such as the portrait painter Margaret Gillies, the flower painters Martha and Annie Mutrie, and the painter of social themes Emily Mary Osborn—it may well have appeared that marriage could deprive them of greater rewards than it was likely to provide, especially before the enactment of legal protection for married women's earnings in 1882. For example, Joanna Boyce, an artist whose work had evoked Ruskin's praise, agonized endlessly over whether to marry. In letters written to her future husband during the mid-1850s, she expressed deep and painful ambivalence. Although she finally agreed to his proposal, Boyce insisted upon an engagement of two or three years in a correspondence that discussed marriage with such words as "slavery," "dependence," and "degraded."[10]

An especially revealing expression of women painters' fears that marriage would compromise or end their art careers exists in several letters written at about 1880 by the accomplished Louisa Starr to her cousin Enrico Canziani, an Italian engineer three years her junior and her future husband. In 1862, at the age of sixteen (after preliminary study at Heatherley's), Starr had been one of the small group of female students who entered the Academy schools in the wake of Laura Herford's victory. Her progress there was remarkable; in 1865, she won the first Academy medal ever awarded to a woman and two years later received the prestigious gold medal with a scholarship of sixty pounds. Her triumph was mentioned in *Punch,* which praised the "bright new *Starr* in the horizon of Art, who won the Academy Gold medal for the best historical painting, the only one of her sex who has so triumphed since Sir Joshua first took snuff in the presidential chair."[11] Henrietta Ward, writing some six decades later, re-

membered her sister-artist in the context of the "St. Paul–like feelings about women's achievements" that then prevailed at the Royal Academy.[12] Starr had many suitors but did not marry until 1882, by which time she was thirty-seven years of age and a well-established painter.[13] In a prenuptial exchange of letters, she elaborated her conditions in a kind of informal marriage contract. Starr cautioned Canziani:

[Do not forget] that I am an artist. . . . You cannot change it. You cannot cut out of my life what has been. Therefore think well if my artist nature will suit yours. Do not love me now for what I am, and afterwards expect me to change from that, for that I fear would bring great unhappiness to both. . . .

I quite appreciate your feeling about my working, and I do not think it would be wise or right to *depend* upon what I make, but so far as it lies in my power to make a little money, you need not fear to let me do it. . . . I am sure you would not . . . wish to stop what has made the happiness (such as I have had) of all my life. . . .

As regards income, I thought that if, as you said you have about £500 or £600 a year, I could in one way or another add £300, or even £400, we should be very comfortable indeed, and then without anxiety you could seize every opportunity of getting on both in London and in Italy.[14]

The forceful independence that is such a remarkable feature of these letters to a future husband reflected the artist's mature age and years of professional practice and recognition. It is likely that her words also echoed the strong public interest in the renewed efforts for a Married Women's Property Act that had begun in 1880, when the Liberals' return to power brought many supporters of women's causes into Parliament and diminished the ranks of legislators unsympathetic to them. The long-awaited bill finally passed in 1882, the year of Starr's marriage.[15] Society, commented Dinah Mulock five years after the passage of this landmark legislation, had discovered that men and women, though different, are equal, and had made marriage "financially, a partnership with limited liability. By recent laws a married woman is, as regards her property and a good many of her rights, just as free as if she were single. And no honest, honorable man, no wise and tender husband, would wish it otherwise."[16]

Sharing Mulock's piety as well as her belief in marriage as a partnership of morally responsible and fully autonomous individuals, Starr would not participate in a traditional marriage ceremony with its ritual promise to obey, insisting that this "was a religious ceremony and not a tea-party."[17] Like Mulock, this remarkable artist embodied many of the virtues of Samuel Smiles, whose book *Self-Help* she gave to her daughter. "Do not fritter away your time," Estella Canziani remembered her mother saying. "Never prevaricate, or make excuses, speak the truth, speak simply, do not

use slang. . . . You are responsible for the whole of life."[18] In so many ways a precursor of the twentieth-century professional woman, Starr held to mid-Victorian beliefs not only in her Smilesian moralizing (and in her insistence upon her daughter's immediate and unquestioning obedience to maternal authority), but also in her advocacy of a distinctly female role in art that emphasized woman's responsibility to further the cause of moral purity.

Starr set forth her ideas in a speech before the 1899 conference, "Women in Professions," held in London under the auspices of the International Congress of Women. The title of her talk was "The Spirit of Purity in Art and Its Influence on the Well-Being of Nations." She used this important platform to denounce the moral dangers she saw both in the art-for-art's-sake movement and in the increasing use of sexually suggestive advertising. Women, as upholders of purity, had a critically important role to play in strengthening the lessened hold of the ideal in art: "We women are heavily handicapped in Art, as in all else, by the fact of our womanhood and its duties. I hold that when a woman has a profession it means in most cases that she has two professions. But, however short of our ideals . . . we may fall, owing to the inevitable circumstances of our lives, still one thing we can always do—we can uphold the right in Art, as well as the right in life."[19]

It was ironic that this speech should be delivered by an artist who had embarked upon married life, two decades earlier, determined to see that her new status would not compromise her professional career, for the belief that women's limited attainments in art *inevitably* resulted from gender-linked handicaps had long served to limit their professional aspirations and opportunities. By implication, of course, such handicaps placed limitations on the talents of unmarried women as well; the spinster was expected to be self-sacrificing for anyone in the family who needed her.[20] The belief that womanhood and its duties constituted inevitable and serious obstacles to artistic achievement (in combination with the commonly held assumption that women were inherently inferior in artistic imagination) was endlessly repeated throughout the Victorian era and was heard ever more stridently as the competition for sales intensified during the eighties and nineties. Typical both in ideology and in tone was an article entitled "Woman, and Her Chance as an Artist," published in 1888 in the *Magazine of Art;* the anonymous author issued the stern warning that "the generally accepted principle that imaginative creation is out of the range of feminine capacity is nowhere more apparent than in art, and the sooner the truth of this is recognised by the sex, the better it will be."[21]

The occasion for this article was the news of the "extaordinary prepon-
derance" of women over men in the competition for admission to the Royal
Academy schools; in the following year the *Magazine of Art* reiterated its
judgment that this striking female success clearly indicated that the test
for admission was deficient and in need of immediate reform.[22] The "femi-
nization" of the Royal Academy schools that occurred during the eighties
and nineties, while it evoked occasional expressions of pleasure from those
who, like the Academician Henry Stacy Marks, saw women's presence as a
refining and civilizing influence on the once-unruly male students, was
looked upon by others who shared the *Magazine of Art*'s distress as a
sign of serious decline in institutional vitality. G. D. Leslie, for example,
setting down his reminiscences of the *Inner Life of the Royal Academy* in
1914, associated masculine roughness with the assertive spirit essential
to creativity and characterized the female students—"young ladies in
pretty evening dresses, [who] received their medals . . . with smiles and
blushes"—as lacking in the "self-reliant conceit which so often charac-
terises the brightest geniuses of the male sex. Constable used to say that if
you robbed an artist of his conceit you might as well hang him at once."[23]

Even those more welcoming to women artists than Leslie had to face
the harsh fact that the success of female students seldom extended past
the period of matriculation. One of the most thoughtful analysts of this
situation was the feminist art critic Florence Fenwick-Miller. Writing in
the *Illustrated London News* in 1891, Mrs. Fenwick-Miller discussed the
Royal Academy's entrance examinations, which had been reformed in ac-
cordance with the urgent advice provided by the *Magazine of Art* two
years earlier, that is, revised with the intention of enabling more male ap-
plicants to pass and more female applicants to fail. The interesting result
of this change was that, while the first group of women to take the new
test did in fact score as poorly as it was intended they should, they quickly
recovered the lost ground in the second year of the new rules. This very
success, wrote Fenwick-Miller, was a sign of women artists' most signifi-
cant and tragic weakness: "Indeed, women are, perhaps, less successful
in the long run just because they are so easily induced to do precisely what
is asked of them. In almost all art they fail (most of them) to reach the
higher altitude because their work is too timid, commonplace, and con-
ventional."[24] This feminist explanation of the failure of women to carry
their Academy successes into the world of art practice was remarkably
close to the traditionalist spirit of Leslie's remarks about the artist's need
for "conceit." Both writers were responding to a phenomenon of major im-
portance in the late nineteenth-century art world: the greatly increased

FEMALE SCHOOL OF ART—(*Useful Occupation for Idle and Ornamental Young Men*).

24. "Female School of Art" (*Punch*, 30 May 1874). As suggested by this crowded scene of well-dressed students, the Female School of the mid-1870s attracted large numbers of middle-class women. The cartoon pokes fun at the motivation of the art students and their model.

numbers of female amateur artists (like those in Mulock's Paris atelier). This highly visible amateur female presence in the art world was frequently mentioned by male artists unsympathetic to women's issues; it constituted one of the most serious obstacles to the careers of professional women painters.

In considering this problem, we should keep in mind both meanings of the word *amateur:* one who undertakes a pursuit primarily for pleasure rather than remuneration, and one who undertakes it without the highly trained expertise of a professional (as conveyed by the word *amateurish*). Female amateur artists of the mid-Victorian period had typically received girlhood instruction in art as a genteel accomplishment. (A young woman's attractiveness to a future husband was thought to be enhanced by her ability to draw; during country visits, she was expected to occupy herself

by sketching local sites and scenery. For this reason, governesses were expected to possess at least a basic level of skill in drawing.) Many of those who studied art as a youthful accomplishment later chose to pursue it as a pastime, for the same reason (as one of Ellen Clayton's practitioners candidly put it in 1876) "which now daily fills the skating rinks—want of anything to do at home."[25] Indeed, many women of the upper middle classes now found they had far more time for avocational pursuits, for the number of domestic servants increased rapidly during the sixties, and in the two following decades their ratio to the total employed population reached its highest point.[26]

Before newly established art schools in the last decades of the century broadened earlier patterns of genteel instruction, female amateurs had typically painted in watercolor, and their pictures were most often small in scale, favoring the "feminine" genres of portrait miniatures, flowers, fruit, and animals. (The number of male amateur painters appears to have declined in the latter half of the century, reflecting the public schools' emphasis on more "masculine" pursuits, such as competitive games and billiards.)[27] With the growth in the number of London art schools and of government schools of art throughout the country (by the end of the century there were three hundred provincial branch schools), the curriculum available to amateurs expanded beyond those small-scale genres. It is important to remember that many women enrolled in the government schools studied in vocationally oriented programs for art-teaching certification or crafts training. One of the most highly regarded crafts programs was the course in pottery painting at the Lambeth School of Art; from the sixties through the nineties successful completion of this course frequently led to employment at the affiliated Doulton pottery studios.[28] But most of the women who studied fine art and exhibited paintings in the closing decades of the nineteenth century (a time when even established male artists found it difficult to sell their work) did so with little realistic hope of establishing self-supporting careers, although many held vaguely formulated ideas of becoming professional artists, either until or (if need be) instead of marriage.

It is understandable that women who had the option of some level of continued familial support would choose to paint, for the other career opportunities open to them at this time lacked both status and decent remuneration. Many of those without independent income continued to be driven to governessing well into the 1870s. Gertrude Jane King, secretary of the Society for Promoting the Employment of Women, spoke movingly about this problem before the Civil Service Commission in 1874: "Many

come to me who have been thoroughly well educated and say, 'Is there nothing that I can do but teach?' And it is almost impossible to recommend anything except artistic work, for which, of course, all have not talent."[29] Louisa Starr's 1875 picture of an exhausted daily governess (a woman who taught students in their homes) was based on the example of a woman she had met while painting a portrait; it was titled *Hardly Earned*.[30]

Although new avenues of employment did open for women in the late years of the century, many of the available positions—for example, post office work and secretarial service in business and government—were unappealing to the upper-middle class, for whom teaching (in schools that superseded the at-home tutoring of the governess) continued to be the only option. While painting could not offer the promise of significant income to the overwhelming majority of those who sought to practice it, its pursuit could fill vacant hours for women whose needs were at least minimally provided for, and involvement in the fine arts continued to carry a glow of social prestige that was believed to enhance the prospects of marriage.[31]

Amateur activity in art, engaged in with considerable showiness by the rich and well-born, had long been a prominent feature of the Victorian social landscape. Exhibits of the art work of aristocratic amateurs had long enhanced the prestige of painting in England. The queen, an enthusiastic amateur whose responsibilities allowed her little time for practice, added to the social luster of genteel art by sponsoring exhibitions of pictures, the proceeds from which were designated for charitable causes. The dealer Ernest Gambart took advantage of the prestige of amateur art practice (and enhanced his own status and reputation) when he successfully staged a philanthropic exhibit for the benefit of widows and children of officers killed during the Crimean War. Drawings by several members of the Royal Family were shown, and Gambart cleverly made the first bid of 125 guineas for a watercolor by the fifteen-year-old Princess Royal. (Subsequently, Gambart had the watercolor lithographed and earned over a thousand pounds from the subscription list.) Drawings by Prince Alfred and the princesses Alice and Helena were sold for 30 guineas each, and the drawing of a knight in armor by the Prince of Wales sold for 55 guineas. People crowded the exhibit each day, eager for a look at the work of these amateur-artist notables, and Gambart formed a long and valuable friendship with Victoria.[32]

Genteel amateurs might seek the recognition that came from participation in public exhibitions, but it was often said that, lacking the stimulus

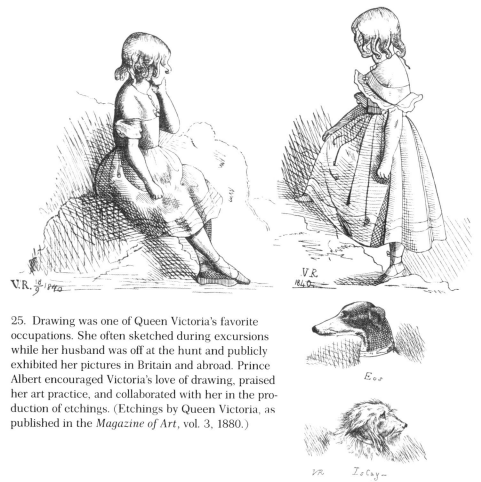

25. Drawing was one of Queen Victoria's favorite occupations. She often sketched during excursions while her husband was off at the hunt and publicly exhibited her pictures in Britain and abroad. Prince Albert encouraged Victoria's love of drawing, praised her art practice, and collaborated with her in the production of etchings. (Etchings by Queen Victoria, as published in the *Magazine of Art,* vol. 3, 1880.)

of financial need, they would seldom be willing to develop the discipline necessary for professional mastery. Thus, the painter Louise Jopling, whose life circumstances had required her to be self-supporting, attributed the scarcity of women artists of the first rank to the fact that most girls studied painting for pleasure and lacked the urgency that came with the need for income, while the gifted Louisa, Marchioness of Waterford, characterized her own work as "the work of one who would have been an artist if it had been her fate to earn her bread and go through a greater amount of study."[33] It was the judgment of Florence Fenwick-Miller that

Lady Waterford's talents had been "overlaid and smothered by her social position."[34]

Women writers had voiced concern about female dilettantism in art long before Florence Fenwick-Miller began her career as art critic. As early as 1857, the year the Society of Female Artists was founded, Dinah Mulock had cautioned of the harm done by "the great influx of small talents which now deluges us," suggesting that "if half the books written, and pictures painted, were made into one great bonfire, it would be their shortest, easiest, and safest way of illuminating the world."[35] Bessie Parkes, a feminist leader who, with her friend and colleague Barbara Bodichon, had dedicated herself to advancing professional opportunities for women, expressed similar feelings of uneasiness in 1866. "Not only young women of special talent," wrote Parkes, "but young women possessing very little, now devote themselves to one of the many branches which cover the whole debatable land between the sublime and the ridiculous."[36]

Both Mulock and Parkes foresaw the great harm that genteel amateurism could do to the prospects of women of high levels of talent and dedication who sought to become professional artists. Educational prerequisites and examinations could not be used to differentiate the amateur from the professional in painting as they could in law, medicine, and other professions. Women of the genteel classes had leisure time (in excess) and few socially acceptable ways of using it; painting, if studied under properly controlled conditions, was one of them. It was ironic that the efforts of professional artists such as Eliza Fox, Emily Mary Osborn, and Henrietta Ward eventually succeeded in opening the Royal Academy schools not only to aspiring professionals but also to so many dilettantes. Criticisms made of female dabblers often cast aspersions over the wide field of female practitioners, without regard to their levels of talent and ability. In 1870, the *Graphic*, in an article entitled "Our Daughters," complained about the growing number of unmarried women whose uninspired attempts in literature and art were motivated by financial need that was far too seldom accompanied by talent. In the interest both of the general culture and of these unfortunate young women, parents were urged to provide their daughters with a sum of money that would allow them to live at least on a scale of modest respectability. "Who paint the bad pictures that disgrace our female-artist exhibitions? Who write our poorest novels? Who encourage sensational literature? . . . The women who find themselves cast upon society, by the present unwise and inexpedient system of taking no thought for the morrow. . . . Let us, therefore, not only give our daughters a little thorough education and a little intercourse with the outer world, but a

little provision against a rainy day."[37] In addition the *Graphic* strongly advised parents to modify the unrealistic standards of married opulence that were causing many young men to cling to bachelorhood. The challenge of maintaining a young woman in the mode of life to which her father's income had accustomed her was indeed a daunting one for a bachelor just beginning his career.[38] As the *Graphic* suggested, male reluctance to marry was one of the causes that led so many women, in the absence of attractive alternatives, to take up the fashionable pursuit of art. The increased opportunities that existed for female art study facilitated that choice.

The phenomenal growth of the problem of female amateurism in art evoked comments that were far less compassionate during the 1880s and 1890s. One of the most hostile outbursts was delivered by the critic Frederick Wedmore in an 1894 speech to art students entitled "The Responsibility of Painting." Wedmore decried the proliferation of poor pictures by amateurs and fourth-rate professionals, a group he implicitly identified as female, and gave this warning:

Ladies, if it is *professional* artists that you want to be, think how many other pursuits are open to you. And why should you choose this one, if you have not a gift for it? . . . Paint, up to a certain point for your pleasure if you will—sketch when the days are longest in a summer holiday; but do not frame, do not exhibit, do not add to the Minor Exhibitions, do not have any grievance against the Royal Academy, unless some one who knows, and has the courage to be honest, tells you Painting is your line.[39]

Tessa Mackenzie's 1895 guide to London's art schools listed fifty-six schools in London alone, of which fourteen were affiliated with the National Art Training School at South Kensington; that school also functioned as the center of the nation's network of provincial schools. The government-affiliated schools were described as "to a great extent industrial." Most of them offered instruction for students who wished to qualify for art teaching certificates, as well as evening classes for artisans that charged only nominal tuition fees and were oriented towards industrial design. Several of the schools also listed daytime classes in handicrafts, for example, stained glass and painting on pottery. Life study for "ladies" was frequently included in the curriculum, sometimes at an added charge, and several schools indicated that they prepared students for entry into the Royal Academy schools.[40]

The private schools, a number of which were founded by painters in need of new sources of income in the weakened art market, offered a variety of curricula and of pedagogical approaches to art. Life study was fre-

quently offered, with separate classes for male and female students. Several schools offered their services exclusively to "ladies," while those that served both sexes often had different arrangements and fee structures for day and evening classes and for male and female students. For example, at the Berry Art School, gentlemen could attend life classes in the evenings and ladies in the afternoons; the monthly fee for the ladies was 15s. while the gentlemen paid 10s. In Mr. G. F. Cook's school, ladies paid one guinea a month for three afternoon classes a week, while the charge to men, who are referred to as "professional students," was 7s. 6d. a month "instead of one guinea."[41] Only students who aspired to become professional artists were eligible to study at Herkomer's well-known school in Bushey, and the artist strictly limited female admission to unmarried women under the age of twenty-eight. When the recently married Gertrude Massey tried to apply, he refused to look at examples of her work and told her "to go home and learn to make puddings."[42]

Among the artists who found student tuitions a more reliable source of income than picture sales in the late-century art market was Henrietta Ward, who had been left with a large family to support upon her husband's death in 1879. Mrs. Ward developed her school so as to take full advantage of her aristocratic connections. Tessa Mackenzie's *Art Schools of London* guide book pointed out that her studio, situated in Belgravia, was "chiefly patronized by the daughters of people in the higher ranks of society, and to encourage steadfastness of purpose in the youthful amateur mind is the chief aim in Mrs. Ward's artistic instruction." Mrs. Ward's youthful amateurs included members of the Royal Family and the living model sat to them "draped only." In later years the artist would remember the crowded hall at her school, filled each morning with parents and guardians anxious to place their daughters in her care. Perhaps she would have agreed with Herkomer's judgment that parents of eccentric and unmarriageable daughters often chose art school as their best alternative.[43]

The widespread availability of art education for women would have appeared astonishing to those old enough to remember the limited opportunities of a generation earlier. But these advantages were to a considerable extent offset by the large numbers of female dilettantes whose presence continually frustrated the efforts of those who aspired to professional standards. Laura Knight, who in 1936 would become the first woman Royal Academician since Angelica Kauffmann and Mary Moser, wrote in her memoirs that most women art students of the late nineteenth century were not seriously devoted to painting; it was a pursuit they had chosen to add to their premarital accomplishments. She remembered her

distress when the coeducational art class she had been attending (at about 1890) was divided into separate men's and women's sections and attributed the inferior teaching in the female class to the teachers' well-founded expectation that the students were all dilettantes.[44]

The Society of Female Artists had been burdened, since its founding in 1857, by the divergent aspirations of the three principal segments of its constituency: middle-class women seeking to derive needed income from proficiency levels that were often quite modest; genteel amateurs of varying degrees of aptitude; and professional painters. Within a few years of the society's founding, there was a strong and much-noted tendency for some of the most successful women artists to distance themselves from the organization and to show their work instead in the more prestigious mixed exhibitions. As early as the second annual exhibition, the absence of eminent female painters was noticed, and the *English Woman's Journal* felt it necessary to urge the virtue of "a long pull, and a strong pull, and a pull all together." It is understandable that women enjoying some degree of professional recognition would hesitate to join in a kind of exhibition that the *Art Journal*'s critic characterized, six years later, as designed "to give a chance of sale to works of a quality which could not otherwise find opportunity of making their merits known." This exhibit put even a sympathetic critic "to severe trial."[45]

Perhaps the most revealing testimony regarding the society's uneasy relationship with professional women painters may be found in Ellen Clayton's account of the celebrated Elizabeth Thompson, who at the age of twenty-seven became the sensation of the Royal Academy exhibition with a remarkable military picture, *The Roll Call*. So great was its celebrity that policemen and a rail were required in order to regulate the crowds; the original purchaser could hardly deny his queen's request to become the owner of this acclaimed painting. Although Thompson had promised "not to desert the Lady Artists" in the aftermath of her triumph, many members of the Society of Female Artists believed that "nothing more need be expected from her." When the young painter failed to send in the new work she had promised for the next Society of Female Artists' show, the difficulty had to be "pleasantly tided over" by the honorary secretary, who tactfully suggested that Thompson instead reexhibit one of her early works.[46] It was clear that a woman artist who had achieved recognition in more prestigious settings had little to gain by sending her best and most current work to the female exhibition.

Even though the Society of Female Artists tried at various times to professionalize, adopting such measures as limiting membership on its man-

26. Elizabeth Thompson Butler painting at Dover Castle, 1898. Lady Butler became famous in 1874 with the exhibition of her most celebrated military painting, *Calling the Roll after an Engagement, Crimea (The Roll Call)*. In 1879, the artist came close to winning election as A.R.A., but lost to Hubert von Herkomer. (After a photograph included in Wilfred Meynell's monograph, 1898. National Army Museum, London.)

agement committee to professionals and charging fees to nonprofessional exhibitors, it was powerless to alter the correct perception of ambitious artists like Elizabeth Thompson that success could be hampered, and certainly was not enhanced, by showing their work in the women's exhibitions. The society played an important role in providing valuable assistance and encouragement to many women artists; the art classes Eliza Fox held under its auspices elicited warm praise from the *Art Journal*. Nevertheless, the reluctance of some prominent women painters to take part in the society's annual exhibitions suggests that they agreed with the unequivocal statement made by the internationally recognized artist Anna Lea Merritt: "Recent attempts to make separate exhibitions of women's work were in opposition to the views of the artists concerned, who knew that it would lower their standard and risk the place they already occupied. What we so strongly desire is a place in the large field: the kind ladies who wish to distinguish us as women would unthinkingly work us harm."[47]

This statement appeared in 1900 in an article, "A Letter to Artists: Especially Women Artists," in *Lippincott's* Philadelphia-based monthly magazine. Born in America and "grafted on England," Merritt wrote at the height of a long and successful career. Although her remarks were more

judiciously worded than his, her sentiments were not very different from those expressed by Frederick Wedmore six years earlier. The purpose of Merritt's article was "to point out to my countrymen some defects that we see in the very special care with which art has been fostered in England." She deplored the fact that "an excessive number of young ladies with very moderate ability come to art for a living," attributing this problem to two causes. The first was the proliferation of art classes as a result of the expansion of the South Kensington system; the wide availability of these classes was a powerful social magnet to young women—even farmers' daughters in agricultural neighborhoods had learned to disdain poultry and butter and instead rode miles on their bicycles to study "art" at one of the South Kensington branches. Because of the overexpansion of art education, Merritt wrote, amateurs now constituted a large proportion of England's 5,050 artist-exhibitors.

The second reason that so many young women were seeking art careers could be found in the status of unmarried women of the educated classes; in Merritt's view, this was an intensification of the situation that the *Graphic* had called attention to a generation earlier. "People who formerly felt it a dishonor not to provide for their womankind now let them do many things," observed Merritt, "but of all businesses *art* is the most popular and fashionable." Apparently ignoring the slow art market, or hoping that the demand for contemporary art would soon regain its earlier momentum, many young art students naively believed that they would be able to make a living from their pictures. Merritt urged young women to be realistic about their true prospects as artists and warned that a significant outlay of capital was essential in order to begin a painting career: "A young artist on leaving the schools cannot make any mark here in England unless sure of finding two hundred pounds a year for expenses of studio, models, and materials. Let girls consider this."[48]

Even if the art market had been more lively or the amateur glut less imposing, Merritt believed that women would continue to find painting success elusive, for in her view the most basic obstacles of all existed within themselves. It was an unfortunate fact that some of the most characteristically feminine virtues—for example, thriftiness, industry, and altruism—had the effect of seriously undermining creativity: "Some near relative may be ill, and a woman will give her care and thought where a man would not dream of so doing, where no one would expect it from him." Furthermore, only the male painter could have the greatest advantage of all: the time-saving help of a wife. Given her conviction of the inevitable conflict between art practice and female responsibilities in mar-

riage, it is worth noting that Merritt had intended to abandon art practice when she married her teacher in 1877, and that she resumed painting only after his death, a short time later.[49]

Merritt's analysis of women's place on the English art scene may not have been altogether representative of views held by other female practitioners, since her own talents had been developed elsewhere; she was a mature artist when she came to London in 1871 at the age of twenty-seven, having spent four years of travel and study on the Continent. But since the mid-1870s she had thought of herself as British: "My real interests and understandings were all there and my dearest friends and my view of art and oh, most of all, Henry Merritt, the great guide and friend who had become . . . the very centre of my life."[50] In the context of this proud sense of identification with her adopted country, Merritt's denunciation of the Royal Academy is all the more striking. In her view, the Academy's refusal to elect a woman member, even in an honorary capacity, constituted the only *institutional* impediment to female success in the art world. This was such an important and troubling obstacle that women seemed reluctant to discuss it. "It may be partly for want of this recognition and encouragement," wrote Merritt, "that women often fall short of the expectations formed for them." Nevertheless, this artist, who had won prestigious prizes and the honor of a place in the Tate Gallery, was optimistic that "when a lady comes whose art is unmistakably deserving of this distinction I do not believe it will be withheld. It would be a great encouragement to us all."[51]

For some years before writing her "Letter to Artists," Anna Lea Merritt had been one of the few successful women painters of the nude in England. Florence Fenwick-Miller had cited her and Henrietta Rae as significant exceptions to the timid conventionality of most women artists. These two painters, wrote Mrs. Fenwick-Miller in 1891, had shown a rare degree of courage and self-reliance by continuing to paint and exhibit depictions of the nude—specifically, of the "undraped female figure"—even after the "storm of abuse" that raged over their 1885 Royal Academy exhibitions.[52] That controversy had begun with the publication of a letter to the *Times* (printed under the title, "A Woman's Plea") censuring as indecent several pictures on exhibit at London's two principal art galleries, the Royal Academy and the Grosvenor. The writer, who signed herself "A British Matron," mentioned no artists by name but was particularly agitated that female as well as male artists had submitted pictures "before which a modest woman may not stand hanging on the arm of father, brother, or lover without a burning sense of shame." In her closing salvo she wrote

27. Anna Lea Merritt (1844–1930). Photograph of the artist at work. (Private collection.)

that "it needs but pictures of unclothed men, true to the life, executed by the same skilful hands, to complete the degradation of our galleries' walls."[53]

Before the editor ended the printed controversy on 28 May, eighteen correspondents had taken part in the discussion. Among them were: "An English Girl," "Common Sense," "A British Parent," "Clericus," "A Member of the Reform Club," and several artists. Some argued that "under the specious veil of art the fine feelings and sensibilities, the chasteness and the innocence, of the rising generation are being swept away" and discerned the "stealthy, steadfast advances of the cloven foot"; others criticized the "prurient imagination," of the "British Matron" and observed that a sensitive artistic depiction of the nude was far more modest than the low-necked dresses, "dress-improvers" [bustles], and the "galaxy of semi-nudities in a modern ballroom."[54]

The "British Matron"'s special concern, that female artists were prominent among the painters of the nude, was echoed by "X.Y.Z." of the Church of England Purity Society, who called attention to the "promiscuous entry of students into 'life schools.'" At the Government School of Art at Kensington, "X.Y.Z." warned, "there are classes of young men and young women (in separate rooms) drawing from almost naked models—men and women." Anxiety regarding the exhibition of painted nudes—especially by female artists—was intensified by the knowledge of the widened availability of life study in the art education of a large constituency of young women.

In his introduction to a volume of essays on the professions, the social theorist J. A. Jackson has called attention to the close relationship of these occupations to basic and sensitive areas of human knowledge, areas that outsiders typically perceive as imbued with qualities of the sacred and the mysterious. The professional is a person sanctioned to become a "high priest" of one of these highly charged areas of knowledge and competence. Aspects of his or her training require not only intellectual mastery but also activities that are normally "taboo." The artist's drawing of nudes in a life class represents both the professional's initiation into such mysteries and a socially sanctioned violation of a taboo of central importance in Victorian life.[55]

Male students at the Academy schools received Victorian society's ideal "initiation" in a life class held under the auspices of an organization with official ties to the state. For women artists, this key prerequisite to full professionalism was problematical except perhaps for those artists born into painters' families. Henrietta Ward's initiation into mysteries, for example, was probably a gradual and natural process. Hence the charming lightheartedness in this anecdote about her husband's drawing of a rather special nude figure:

When Edward turned his attention to his picture of Napoleon and Her Majesty, he found some difficulty in getting the pose of the figures as he desired them to be. So he followed a method I always used, and drew each figure undraped, in pink chalk, the effect being rather ridiculous in the first stage. No sooner had he done this, and we were consulting together about some minor points, than we received a message that the Queen was coming immediately to see the picture.

Our consternation was great, and Edward, who was never resourceful in an emergency, looked petrified. "Good Heavens! What shall we do?" he said in a tragic tone. "The Queen must never see herself like this." I could not help laughing at his horror. "There is only one thing to do; you must wipe them out."

Edward set to work energetically with a rag, and after undoing a whole morning's labour a second messenger arrived to say the Royal Visit would be deferred till the next day.[56]

Very different was the initiation process experienced by Mrs. Ward's contemporary, Joanna Mary Boyce, daughter of a wine merchant–turned-pawnbroker, whose agonized letters on marriage were referred to earlier. Boyce wrote home from Paris in the mid-1850s, where she had engaged in life study at Thomas Couture's atelier, that "although she had felt anxious and reluctant about it at first, she was now sure that any girl could study from the nude model as though it were a bunch of flowers or a landscape, and come to no harm!"[57] It is significant that Boyce had not overcome her uneasiness about life study before going to Paris. Drawing from the nude is not likely to have been a completely unfamiliar practice to her. She had been a student at both Cary's and Leigh's in the late 1840s or early 1850s, and she had a wide social acquaintance with artists who were friends of her brother, a painter in the Pre-Raphaelite circle who had studied at the Academy schools. Nevertheless, removal from England and from her disapproving mother seems to have been necessary in order for her to develop the self-confident mastery over a "highly charged" aspect of life that characterizes the professional. Boyce's comments—and similar expressions by other female artists into the early twentieth century—make it clear that the advantages of Parisian study were not limited to better methods of pedagogy. A factor of at least equal importance was the psychological relief from the pressures that Victorian respectability exerted over their art education, especially over the life class.

In England's most prestigious art schools, the Royal Academy and the Slade, the "British Matron"'s spirit was in evidence whenever the nude or partially draped model was posed before female students. At the Royal Academy, where women had petitioned for life study since their acceptance as students in the early 1860s, study of the nude figure was not allowed until 1903. A sense of barely concealed fear pervades the language in which the Academy, in 1893, conceded—with conditions—to female students' requests for study from the male model:

It shall be optional for Visitors in the Painting School to set the male model undraped, except about the loins, to the class of Female students. The drapery to be worn by the model to consist of ordinary bathing drawers, and a cloth of light material nine feet long by three feet wide which shall be wound round the loins over the drawers, passed between the legs and tucked in over the waist-band; and finally a thick leather strap shall be fastened round the loins in order to insure that the cloth keeps its place.[58]

Even though life study had constituted the central core of the curriculum for male students at the Academy schools since 1768, women students throughout the Victorian period were obliged to seek this instruction else-

28. "Life Class at the Slade" (*Magazine of Art*, vol. 6, 1883). This picture shows male and female art students working together from a partially draped model. Study from the nude model, considered essential for male students, was not allowed for women at the Slade until the closing years of the century.

where. Until the Academy established a separate life class for women in 1903, female Academy students were obliged to provide themselves with the opportunity to study from the nude model in cooperatively organized evening classes or in other studios and schools.[59]

The curriculum at the Slade School of Art, established in 1871 at University College in London, emphasized life study as the sine qua non of a serious art curriculum. "Constant study from the life-model," said Edward Poynter (a distinguished painter of the nude who would later become director of the National Gallery and president of the Royal Academy) in his opening address as the school's first director, "is the only means of arriving at a comprehension of the beauty in nature and of avoiding its ugliness and deformity; which I take to be the whole aim and end of study."[60] From the first, the Slade welcomed women students and took their talents seri-

ously. Within a year of its founding, the school, which had at first required female students to come to class through a separate entrance, allowed mixed classes in the study of the draped model. But it was not until 1898 that women at the Slade were permitted to progress from study of the "half-draped" model (in classes instituted by Poynter, who considered that there were "many prejudices to be overcome" even in following this prudent course) to study from the nude.[61] The setting was that which Tessa Mackenzie's 1895 guide to London art schools, had referred to as "the usual way"—that is, with male and female students meeting in separate classes.

It was not only the grudging and painfully gradual progress from draped to nude models that continued to bring the Victorian sense of guilt into the women's life class. The psychological burden was made greater still by art school policies toward female models, who were still regarded, at the turn of the century, as they had been by the author of *Sisters in Art* fifty years before, as fallen women.[62] Ritualized forms of behavior were regularly prescribed in art classes in order to protect the students—especially female students—from the possibility of "contagion" that might result from normal social interaction with the model. Life study seems to have been offered—or canceled—inconsistently at schools affiliated with the South Kensington system, depending upon the headmaster's philosophy of art education and sometimes in response to pressure from the students.[63] Gertrude Massey's description of a life class at a government art school she attended in the early 1880s conveys a sense of the constrained atmosphere that must have been characteristic of other art schools of the time:

Compared with the art classes of Paris our class was laughable. . . . Although we would spend hours drawing or painting from the model, we were not allowed to enter the studio until she was posed, and goodness only knows why. No mere male was allowed to enter the room while we were working. When it was time for the professor to examine our studies, we were ordered outside into the draughty corridor. The poor man waited with a solemn face until every girl had left the room. Then, and not a minute before, he entered the studio and wrote his criticism on the corner of each drawing. When he came out—and shut the door—then we all flocked back.

Such conduct was inexcusable and psychologically unsound. . . . Contrast that teaching with the modern method where students begin with the nude, and the professors move about the studio freely among students of both sexes.

However, we had got a nude class, and we were wisely content with small mercies.[64]

At the Slade, Professor Edward Poynter "could not be seen with students in the women's Life Room while a nude female was posing. They

had to file out when he came in, and he wrote his criticisms, in their absence, around the margins of their drawings."[65] Even in the mid-nineties, when the Slade was directed by the French-educated Fred Brown, models and students were forbidden to converse.[66] Yet despite these and other restrictions, opportunities for life study became more widely available and more acceptable for women students in the late years of the century. For example, Mrs. Walker's Art Classes for Ladies offered study from "the live model, both male and female." Models posed on alternate days in costume or in the nude, and parents were assured that by choosing this school, instead of a larger (and presumably less carefully supervised one), they could "send their daughters to study drawing and painting under the direction of a good artist, and the supervision of a lady."[67]

As was evident in *Sisters in Art*, the female nude model was at the center of an acutely painful conflict for those who believed in the exalted moral value of "high art." How could art's mission to inspire and elevate the nation's spirit be pursued and celebrated when the practice of painting required close association with young women who would shamelessly disrobe in unprotected, unchaperoned studios? Such association was morally ambiguous whether these women were of bad character or were (in the words of a *Times* correspondent) young innocents "whom hunger and want have driven to one of two courses, each equally humiliating, if not quite equally deplorable."[68] In her 1863 novel *Lost and Saved*, Caroline Norton created a powerful emotional climax by portraying the near-descent of a desperate young woman into the model's career. *Lost and Saved* tells the story of a beautiful and virtuous young woman whose vulnerable innocence allows her to be deceived into a sham marriage to the man she loves. Cruelly abandoned by him and without other means of support, Beatrice Brooke seeks for some way to earn income for herself and her baby. Efforts to sell her drawings meet with no success, but a comment overheard in the print shop, that she resembles the young woman in a picture by a London artist, suggests the idea of applying to him as a model. The account of her interview with the painter shows both her painful ambivalence and the artist's almost paternal concern for the implications of her decision.

"Is it as a draped model you wish to sit? or—" he hesitated: "Mr. Howard, Mr. Uwin draw from the undraped model: I do not."

The crimson flickered and died out again in Beatrice's cheek, while he considered her, pausing. . . . "Do you know what it is you undertake? and how little is earned by it? Do you know that tenpence an hour is a common scale of reward to models—even models as beautiful as you are?" . . .

Beatrice turned deadly pale, and leaned back in the chair. . . . He called into an inner room. "Harriet, will you bring a glass of wine? It is my sister," added he, . . . as a tall-severe-looking maiden lady entered with a decanter.

"Has the sitting been too long for Lady Fosbrooke?" she said graciously.

"You mistake, Harriet. This young lady . . . has been consulting me about becoming a model."

"A MODEL!" The amazed horror with which the spinster sister looked at Beatrice as she pronounced this word—eyeing her from head to foot as she did so—words cannot describe. . . . "A model! I advise you to do anything else you can, young woman! Teach anything; work at anything, if you are in distress; but don't turn MODEL!"

And with a parting glance of severe deprecation at the pale beauty of Beatrice's face, she disappeared.[69]

Like the painter in Caroline Norton's story, a number of Victorian artists and critics felt uneasy about the employment of unprotected young women as models. Both Thackeray and Ruskin objected to depictions of the nude "on general moral principles"—the latter characterized Mulready's drawings of nudes as "degraded," "bestial," "vulgar," and "abominable."[70] (It is worth noting that despite her "Victorian" image, the queen expressed admiration for Mulready's nude drawings and appreciatively accepted one as a gift from the artist.)[71] One of the most extreme denunciations of the employment of nude women models was made by the artist J. R. Herbert, in testimony before the Royal Academy commission of 1863: "I would exclude altogether the nude female model from the Academy, because I conceive that art, the true aim of which is to elevate and to divinize, does not require the use of anything which might corrupt him who studies or the person who sits as the model."

Even artists who took strong exception to Herbert's position found it hard to deny that the painter's studio was a morally dangerous place for a young woman. It was a problem to which Mulready himself had given careful thought, as indicated by his written record of the advice he gave to models. He cautioned young women against bringing attitudes of naive trust into the studio and urged them to exercise careful control over their situation. Socializing or even conversing with male artists, whether they were married or single, was to be avoided: "An intelligent woman, who at the commencement of this dangerous profession, is well prepared for . . . danger, will have much fewer cases of trouble, than poor innocent creatures who with distracted minds are flung unprepared amongst its smiling faces, flattering manner, its painting and gilding."[72] Holman Hunt shared Mulready's sentiments about the dangers of the modeling profession; his plans (never carried) out to marry his model Annie Miller included a care-

ful effort "to destroy as far as was possible all traces of her former occupation, viz. that of sitting to certain artists."[73]

Even artists who defended the employment of nude models sometimes betrayed uneasiness about the social implications of the practice. William Powell Frith, for example, although he no longer drew or painted from the undraped model, insisted that he had known "numbers of *perfectly respectable* women who have sat constantly and habitually for the nude." But his narration of an incident from the life of one of his models suggests a far greater degree of ambivalence. A modest, respectable-looking girl came to sit as a costume model for Frith at the recommendation of a friend. After several sittings, Frith became convinced that he had seen her before and suddenly recognized her as a young woman who had once posed nude while he was a student in the Royal Academy Life School. Frith had then been struck by the sight of tears flowing down the model's face:

"Surely, Miss B—, I cannot be mistaken; you sat for Mr. Jones at the Royal Academy?" She blushed terribly, and tears came again.
"Now tell me why you did such a thing?"
"I did it," said she, "to prevent my father going to prison. He owed three pounds ten, and if he couldn't have paid it by that Saturday night he was to be arrested. The Academy paid me three guineas for the week, and saved him. I never sat in that way before, and I never will again." And I believe she never did.[74]

Regardless of their own attitudes and behavior towards models, male and female artists were acutely conscious both of the low social status of professional models and of the prevailing social climate that condemned women who posed nude. Even the unconventional Barbara Bodichon had felt constrained to keep Elizabeth Siddal's modeling career from becoming known when, in 1854, she and Bessie Parkes made arrangements for lodgings and a rest cure for Rossetti's chronically ill "stunner" and future wife. Bodichon wrote to Bessie Parkes that Siddal was "of course under a ban having been a model (tho' only to two PRBs [Pre-Raphaelite Brothers]) ergo do not mention it to any one."[75] Henrietta Ward, while reminiscing about four female models who later married Royal Academicians, carefully noted that they were among those who had posed "for the draped figures in my pictures."[76]

In 1883 the Royal Academician John Callcott Horsley called attention to the issue of the nude model in a speech in which he denounced study of the female nude as leading to immorality. Horsley's comments (which won him the name of Clothes Horsley) evoked a strong response from the artist George Frederic Watts, whose didactic paintings included many portrayals of idealized nudes. Watts held that the inspirational form of art of which he was a practitioner was altogether unthinkable without prelimi-

nary study from the nude model. He seems to have believed that the ritu-alization of life study within art schools provided social control both to model and artist. Yet Watts's response was somewhat qualified. While denying Horsley's charge that women who model nude lead immoral lives, Watts held that such charges should not have been brought before "out-siders," but limited to the discussion of professional painters. The implica-tions of his argument suggest that the growth of a heterogeneous art public might jeopardize a time-honored and essential system of study: "Practices pursued in the light of day for a century without any apprecia-ble evil result need not alarm the most timidly sensitive, but it might be extremely dangerous to turn the tide of an unenlightened public opinion upon such a system of study." Watts warned that if students were unable to find models in an art school, they would be driven into disreputable so-ciety and companionship "in order to obtain means to study."[77]

As indicated in Frith's anecdote concerning the remorseful Academy model, the degree of status difference for the costumed versus the nude model was significant. As late as 1909, John Galsworthy made use of the distinction in his novel *Fraternity*, in which the philanthropic Mrs. Tallents Smallpeace, widow of a famous connoisseur and vice-president of the For-lorn Hope for Maids in Peril, suggests that this society might be of use to the young model, who had sat for a woman artist-friend, since modeling "is an unsatisfactory profession for young girls," adding: "Of course, there are many very nice models indeed . . . especially if they don't sit for the—the altogether."[78]

Increased public discussion of artists' models during the final two de-cades of the nineteenth century no doubt reflected the growth in the num-ber of art schools that offered classes in life study. The expansion of this aspect of art education must have attracted many newcomers into model-ing, an occupation that, for all its lack of respectability in the eyes of the middle class, appears to have offered many attractive young working-class women a measure of economic and social opportunity.[79] In the 1896 edi-tion of *Life and Labour of the People in London*, Charles Booth presents a positive view of the occupation: "Female models as such lead a pleasant life, and in the end often marry one or other of those to whom they have been sitting. Those of them who are not fortunate enough to do this not infrequently end by going on the stage."[80]

"Perhaps," Ellen Clayton had written in 1876, "there is no more vexed subject, or one more difficult of satisfactory solution, than this matter of drawing from the life by ladies studying figure-painting."[81] Louisa Starr's 1870 picture *Undine* had been painted from models posed in tights or "combinations" (a set of two-piece underwear), and women painters who

did not follow a similar practice at this time caused considerable un-easiness among some segments of the art public.[82] Henrietta Rae, Anna Lea Merritt's contemporary and one of the best-known women painters of the nude, once received a letter urging her "to pause upon the brink" rather than continue to paint the nude; the phrasing implicitly attributes to the artist the "fallen" status of her nude model. Another of Rae's corre-spondents warned that while it might seem acceptable for women models to sit to others of their sex, this practice nevertheless "habituates them to sit thus also to men" and "so far as a large proportion of men are con-cerned, the presentation of beautiful women so scantily draped cannot but appeal to passions that are already of volcanic force in their nature."[83] John Galsworthy conveys the feeling of unnaturalness and strain regarding the depiction of the nude that such currents of opinion could create, even in the mind of an artist as sophisticated as his character Bianca; "though she discussed the nude, and looked on it with freedom, when it came to paint-ing unclothed people, she felt a sort of physical aversion."[84]

The accusation that women painters of the nude might be, like their models, "on the brink," suggests that female artists may have had good reasons for keeping a strong social distance from those who sat for them, for there were unexpected points of intersection, outside the studio, in the lives and careers of female artists and models. As Mrs. Ward, Charles Booth, and many others pointed out, models often married the painters for whom they worked; thus their status as artists' wives would have placed a number of them in social circles frequented by some female painters. Oc-casionally, models took up painting themselves, as was the case with Elizabeth Siddal, who attracted Ruskin's praise and patronage. Anna Lea Merritt, in condemning rampant female amateurism in painting, included the comment that even models were taking up art. And there must have been other young artists besides Louise Jopling who were mistaken for models when they visited the studios of male colleagues.

Under circumstances such as those depicted in Caroline Norton's *Lost and Saved,* modeling could follow naturally from the failure of destitute young women to earn sufficient funds through art. The decision of Gwen John, a former Slade student and sister of Augustus, to model in the nude when she desperately needed money is not likely to have been completely unprecedented. It is significant that she felt deeply ashamed of this course of action and that not even the strident bohemianism of her brother pre-vented him from expressing strong bourgeois-like disapproval.[85]

Like the female model in male artists' studios, the woman painter who employed male models often worked in unprotected and socially ambigu-ous situations. Edward Poynter had suggested as much in his statement

that study from the (male) half-draped model would be an advantage that the Slade, a public institution, could offer to women for whom such study would be "almost impossible" in a private studio, and his comments referred to the painting class, certainly not to a situation in which a woman worked alone in the model's presence.

In her memoirs, Henrietta Ward described a "gruesome experience" that occurred during the course of a sitting with a soldier-model. The incident, which may have influenced her subsequent decision to specialize in the painting of women and children, occurred during the course of work on her 1854 picture, *A Scene from the Camp of the 79th Highlanders*. The artist, then a twenty-two-year-old married woman, had arranged for a thatched shed to be built inside her studio to simulate the huts used by soldiers, and had hired one of the queen's pipers to sit for her. At the first sitting, Mrs. Ward suspected that the model had been drinking; at the second, he went berserk and, moving threateningly close to her, brandished his dagger. Although terrified, she managed to keep calm until the model, exhausted after his mad frenzy, collapsed on the floor. As the daughter and wife of artists, Henrietta Ward would have been accustomed to the presence of models of both sexes and perhaps felt deceptively safe working in a house where Edward Ward also had his studio, but in her moment of need both he and the servants were out of calling distance.[86] Writing in her old age, Mrs. Ward took pleasure in remembering the fine review that the *Art Journal* gave to this picture of the "poor mad piper"; the importance of this picture to her career was confirmed by Ellen Clayton, who, writing in the mid-1870s, mentioned it as the work that had established the painter's reputation. In view of the admiration received by this painting, the story of the frightening incident that attended its production, if it became known to other women painters, would have given them pause to consider the wisdom of painting from male models, especially given the reputation many of them had for drunkenness.

A far more satisfactory experience with male models is included in Elizabeth Thompson's account of the preparatory work begun in 1873 for her most famous painting, *The Roll Call*, exhibited at the Royal Academy in the following year. The artists engaged a number of models—most of them former soldiers—and posed them in tight pink "shell jackets" so that she could draw the figures well before painting the heavy coverings of their military uniforms. In her memoirs, Thompson mentions the help she received from the headmaster of South Kensington, where she had studied, and from Dr. Pollard, the family doctor, in renting a studio and hiring models. She makes no mention of the presence of a chaperone during the series of sittings, which lasted for five or six hours each day, although she

does say that Dr. Pollard helped officiate at the two open studio days held just before the painting was sent to the Academy.

Thompson's apparently relaxed attitude toward working in her studio with male models who simulated the nude in their tight pink jackets is likely to have reflected her somewhat bohemian (and wealthy) background as the daughter of a musician-mother and of a father who, after unsuccessfully running for Parliament, devoted himself instead to the education of his two daughters, much of which took place in Italy. Her unconstrained and humorous attitude towards life study is apparent in the tone of an 1866 diary entry describing the first male model she drew in the life class at South Kensington; the twenty-year-old artist commented that his heavily armored upper torso contrasted with the "sadly modern" nature of his dress below the waist, "for his nether part was not wanted." Less conventional still were the artist's later musings: "How strange it seems that I should have been so impregnated, if I may use the word, with the warrior spirit in art, seeing that we had had no soldiers in either my father's or my mother's family!" Perhaps it was this striking image of warrior spirit impregnation that shaped the artist's response to Ruskin's famous words of praise for her military painting *Quatre Bras*, exhibited in 1875. Ruskin admitted that he had approached this picture with "iniquitous prejudice," since he had always held that "no woman could paint." This painting, however, was different; it was "an Amazon's work." "I was very pleased," the artist wrote, "to see myself in the character of an Amazon."[87]

Given the high level of public interest in women artists—an interest attested to by the publication of Ellen Clayton's two-volume work on English female painters in 1876, and cast in a new light by the near-election of Elizabeth Thompson to the Royal Academy in 1879—it is hardly surprising to find that some female artists (including Miss Thompson) were objects of controversy.[88] Painters who were unmarried and attractive had to be especially careful of their reputations; no doubt Louisa Starr's mother had something like that thought in mind when she insisted upon acting as chaperone to every sitting in the drawing room, which had become her daughter's studio.[89] Perhaps Mrs. Starr had heard reports of Louisa's tactics for recruiting a male model for the depiction of a scene from *The Merchant of Venice*. "When I was a girl, and painting [this] picture," the artist later wrote,

I wanted a good model for my Bassanio. I had been told that Rowney [proprietor of an art supply shop] kept a list of models, so one afternoon I went to inquire. Two tall, thin, angular ladies, with spectacles, evidently amateurs, were buying painting materials, and I, a small thing in a brown mushroom hat, went to the counter, and said to the man serving: "Have you a tall, handsome, dark young man? He must be

29. Louise Jopling (1843–
1933). A well-known painter of
genre, landscape, and portraits,
Louise Jopling exhibited at the
Royal Academy and the Gros-
venor Gallery and later opened
an art school. (After a photo-
graph by A. Boucher, as pub-
lished in the *Magazine of Art,*
vol. 3, 1880.)

gentleman-like, and about twenty-eight to thirty." The shopman stammered some-
thing about inquiring and disappeared rather abruptly, I fancied, and when he re-
appeared at last, saying they hadn't one at present, but would be most happy to let
me know when they had; I did not quite see why he should be twinkling all over,
down to the very end of his nose; nor, when some instinct made me glance up at
those two elderly ladies, could I understand why, with chins held indignantly high,
they should regard me with such freezing and glowering countenances.[90]

As professionals who had been initiated into mysteries—sometimes in-
completely and only with society's grudging approval—unmarried female
artists (especially if they were young) had to guard their reputations out-
side as well as within the studio. Louise Jopling, a successful woman artist
whose many friends included Millais, Frith, and Whistler, carefully culti-
vated an image of respectability after she separated from her husband
in the early 1870s; a gambler deeply in debt, he had attempted to gain
custody of their children and of her earnings as a painter. After winning
a judicial separation that involved a process simpler than divorce (and
which she in any case preferred, being "too much in love with my profes-
sion to run the risk of abandoning it by marrying again"), Mrs. Jopling
made sure to take her sister along as chaperone when attending the the-
ater with male friends. "I have not much respect for Mrs. Grundy," she
wrote. "Still, it will certainly be to my advantage to act as if I had." But

even this prudent behavior did not protect her from gossip and occasional bizarre approaches, such as a letter from a stranger who, having learned of "the disadvantages at which female artists work . . . by not having proper opportunities of studying from the nude figure," thoughtfully offered "to stand, or sit, as a nude model" as a service to "respectable and talented ladies."[91]

It has already been suggested that some degree of anxiety at the increased practice of female painting of the nude may have contributed to the strengthened current of hostility to female artists that developed (not coincidentally) with the depressed art market of the last two decades of the century. There were numerous reiterations of the argument that, lacking the creative imagination essential to great painting, women should be satisfied with careers in design, an extension of their domestic responsibilities for which they were far better suited.[92] This current of opinion continued well past the Victorian era. For example, in a generally admiring book on Henrietta Rae published in 1905, her biographer Arthur Fish commented that she was an artist, and a successful one as well, "in spite of her sex."[93] And John Galsworthy, in describing an art critic who appears as a character in his 1909 novel *Fraternity,* wrote, with apparent confidence that his readers would accept the generalization, of the critics' "natural male distaste for the works of women painters."[94]

But despite this continued (and possibly even strengthened) prejudice towards women painters, the improvements that had been made in women's art education since the 1860s—and evident progress in other areas of female endeavor—meant that times had changed, even if the full implications of change were still barely visible. Furthermore, societal insistence on a refined dilettantism that would restrict women painters to small-scale work and to subjects deemed appropriate to their nature— flowers and still lifes, women and children—was increasingly unacceptable to those women who had cast off Victorian roles and expectations.

The early twentieth-century painter Nina Hamnet has left a vivid personal account that dramatically juxtaposes the old and the new worlds of the female painter. She began her period of study at the Pelham School of Art in South Kensington in 1905, at the age of fifteen, in preparation for application to the Royal Academy schools. The Pelham students were refined and snobbish; mostly of well-to-do families, they appeared to have been sent to the school "to await the happy moment when they would find husbands." Nina lived with her grandmother and wore a stiff linen collar and tie and corsets with bones; her grandmother held to the Victorian opinion that women's backs did not have strength enough to support them.

REMOVAL OF ANCIENT LANDMARKS.

Lady Gwendoline. "Papa says I'm to be a great Artist, and exhibit at the Royal Academy!"

Lady Yseulte. "And Papa says I'm to be a great Pianist, and play at the Monday Pops!"

Lady Edelgitha. "And I'm going to be a famous Actress, and act *Ophelia*, and cut out Miss Ellen Terry! Papa says I may—that is, if I *can*, you know!"

The New Governess. "Goodness gracious, Young Ladies! is it possible His Grace can allow you even to *think* of such things! Why, *my* Papa was only a poor Half-pay Officer, but the bare thought of my ever Playing in *public*, or Painting for *hire*, would have simply *horrified* him!—and as for acting *Ophelia*—or anything else—gracious goodness, you take my breath away!"

30. George Du Maurier, "Removal of Ancient Landmarks" (*Punch*, 25 June 1881). In the context of satirizing an "aesthetic" aristocratic household, Du Maurier takes note of changed attitudes toward public participation in the arts for unmarried women.

By this time, women art students were drawing from the nude model even in proper schools like Pelham, a practice that created jarring disparities with traditional practices relating to dress. Hamnet writes: "I was now sixteen. I drew from the nude at the Art Schools, but I had never dared to look at myself in the mirror, for my grandmother had always insisted that one dressed and undressed under one's nightdress using it as a kind of tent. One day, feeling very bold, I took off all my clothes and gazed in the looking-glass. I was delighted. I was much superior to anything I had seen in the life class and I got a book and began to draw."[95]

7. Art Publics
in Late-Victorian
England

L. V. Fildes, looking back at his father's career from the vantage point of the mid-twentieth century, differentiates the art scene of our age from that of the Victorians by pointing out two salient characteristics of the earlier time. The first was the close relationship between nineteenth-century artists and their viewing public. The second was the fact that art in the Victorian era reached a far wider range of social classes, from the rich who could buy highly-priced paintings, to those further down on the social scale who purchased engraved reproductions of those works, to those lower still who experienced the work of contemporary artists in cheap illustrated books and, before photography had developed its familiar modern functions, in newspapers and periodicals.[1] There was a high level of public awareness of painters and graphic artists, a high degree of interest both in their work and in their mode of life. Evidence of this celebrity status abounds in artists' memoirs. One delightful example, given by Frith, is found in the words of an artist's model named Bishop, who had been sitting for a character in *Derby Day* when he suddenly disappeared for six weeks. Bishop had been arrested in the course of a fight that, he said, he had entered in the defense of the painter Webster—"a nice gentleman he is, and I've often set for him"—and was given a prison sentence of three weeks.

That made me wild, and I up and says, "You call yourself a beak?" I says. "Why, you ain't up to the situation; and I'll tell you what, I'm a artist's model, and I sits for them as draws for *Punch;* and I'll have you took and put in *Punch*, you just see if I don't." The beak opened his mouth at that. He ain't often spoke to like that, you bet, sir; and after a bit he says, "Now you will go to prison for *six* weeks"; and that's where I've been, sir.[2]

Bishop, in his naive attempt to coerce the magistrate, was no doubt convinced that the latter was sure to have a respectful acquaintance with *Punch* and its artists and would therefore be impressed by the model's reflected glory and prestige. In fact, *Punch* made household words not only of the names of its own artists—Leech, Tenniel, Du Maurier—but con-

tributed to the celebrity of painters in general by publicizing their work and their activities. This publicity was itself based upon the assumption of some previous knowledge on the part of its readers; picture galleries and artists' studios, writes L. V. Fildes, were so often represented in *Punch* as the scene of social events that they must have been places with which readers were assumed to be familiar.[3] If they did not already have this familiarity, then reading *Punch* would encourage them to acquire it.

How was this familiarity achieved? What groups of people, from which segments of society, were attending painting exhibitions and enjoying visits to studios? Some answers to these questions can be suggested, thus giving insight into a neglected aspect of nineteenth-century social history and adding to our understanding of the functioning of the major art institution of Victorian times, the Royal Academy, and of its short-lived rival, the Grosvenor Gallery. It is important to keep in mind that the various London art publics may have differed in some respects from those in other cities where contemporary paintings were regularly exhibited, such as Manchester, Liverpool, or Glasgow. But London was the undisputed art center of Britain. No aspiring painter, even if he or she chose (or was obliged) to live elsewhere, could be indifferent to the Royal Academy; few art lovers, whatever their feelings towards that institution, would willingly have missed its yearly show.[4]

Of the several hundred thousand people (355,000 was the average during the eighties and nineties) who paid their shillings to enter the annual exhibition of contemporary art at the Royal Academy—known as the Summer Exhibition, it was held from the first Monday in May until the first Monday in August[5]—a small but significant fraction had already marked itself out as an actively involved, inner circle of art lovers. This group, numbering perhaps a few thousand, had already seen some of the most important pictures in the show. Much can be learned about this informed art public by investigating the various social forms through which these previews had taken place.

The first of these, known as Show Sunday or Picture Sunday, differed from other preexhibition viewings in its altogether unofficial character. It is difficult to date precisely the beginning of the custom of large numbers of people visiting painters' studios on designated Sundays. There must have been others who followed Millais's practice of welcoming fellow artists for conversation and criticism on Sunday mornings.[6] It was natural for such company to have been enlarged by an occasional amateur, a friend or relation, or a potential patron. Frith, writing in the late 1880s, mentions a Sunday showing of *The Old English Merry-Making* during the mid-1840s,

soon after his election to associate membership in the Academy, "to many of my friends and others whom I scarcely knew," but differentiates that visit from Show Sunday, which, he declares, is a custom "common to the present time."[7] He does use the term, however, in describing previews of two of his most famous pictures during the fifties. Many people, he writes, came to see *Ramsgate Sands* on the third of April, Show Sunday of 1854,[8] while the Sunday viewing of *Derby Day* a few years later was made especially memorable by the visit of a former model, who, furious at finding that she had been painted out of the picture and replaced by another figure, threatened to put her parasol through it.[9] Although the practice was not yet general—Herkomer writes that only a few artists came to see *The Last Muster* before it was sent to the Academy in 1875; the fashionable Show Sunday, he adds, did not exist then[10]—Picture Sunday appears to have become customary at studios of several eminent painters by the early seventies. The advantages to a painter, in stimulating public interest in his work and attracting buyers, were of sufficient value to motivate even a strict sabbatarian like Thomas Faed, who would not enter his studio on a Sunday, to open it to those who would. Religious though he was, Mrs. Jopling told Frith, who had suggested a visit to Faed's pictures on Show Sunday, 1871, he was quite willing to look at his visitors' cards![11]

As the numbers of Sunday viewers increased, artists frequently expressed their annoyance in finding themselves as much the center of public interest as were their paintings. Mr. and Mrs. E. M. Ward, both artists, preferred to give invitational private views rather than risk the unknowns of the "open house" but were distressed to find that it was difficult to keep crashers from entering when the guest list was large and included many unfamiliar faces. "Artists," wrote Mrs. Ward, "appear to possess a peculiar attraction to some people. A deep curiosity exists to see the inner workings of studio life, and I have often been amused, and sometimes irritated, by this trait in those who obviously are without a trace of artistic feeling."[12]

By the 1880s, Show Sunday was a well-established tradition. The chosen day came a month or so before the opening of the Academy exhibition; Show Sunday of 1883 "fell" on the eighth of April, writes L. V. Fildes. J. G. Millais remembers accompanying his famous father to Leighton's Show Sunday reception, late in March 1895, where they found the president surrounded by "a crowd of picture-lovers, and the usual array of so-called 'smart' people." At some studios, there was a spillover from one designated day to almost any Sunday, or sometimes to both Saturday and Sunday; Watts, in 1881, built a studio addition to his home solely for the purpose of receiving visitors on both those days.[13] Such a wide extension of the single

31. George Du Maurier, "Picture Sunday" (*Punch*, 29 March 1873). At the peak of wealth and prestige in the early 1870s, artists were now socially approved marriage partners for genteel young women. *Punch* satirizes the naive flattery that must have been a part of the "Picture-Sunday" scene, especially in the studios of young and handsome bachelor-artists. Note the presence of the older male chaperone in the background.

" PICTURE-SUNDAY."

(*It is very difficult to know exactly the right thing to say to an Artist about his Pictures. We recommend unlimited praise ; but do not enter into details.*)

" O, MR. ROBINSON! YOUR PICTURES ARE *QUITE TOO MORE THAN LOVELY!* SURELY YOU ARE THE *GREATEST ARTIST THAT EVER LIVED!* ARE YOU NOT? *CANDIDLY!*"

" WELL, I DON'T KNOW. THERE WAS MICHAEL ANGELO, YOU KNOW, AND HOGARTH, AND—AND——"

" O, YOUR PICTURES HAVE ALL THE INEFFABLE REFINEMENT AND PURITY OF HOGARTH, ALL THE IRRESISTIBLE HUMOUR OF MICHAEL ANGELO, AND—AND—SOMETHING QUITE *YOUR OWN,* WHICH I HAVE *NEVER PERCEIVED IN THE WORKS OF EITHER OF THOSE MASTERS!*"

Show Sunday turned what was originally intended as a preview into an alternate form of exhibition.

Crowds at an artist's studio gave visible proof of success and celebrity. Luke Fildes's wife "instituted a system by which the parlour maid, stationed on the landing outside the studio door, dropped a coffee bean into a brass bowl for every visitor who came up the Triumphal Staircase." The tally in 1883 was just short of seven hundred; a few years later, Mrs. Fildes would regard a total of less than a thousand as evidence of a decline in her husband's popularity. Some painters, however, unnerved by the large numbers and inappropriate motivation of many of the Show Sunday visitors, participated in the custom with great reluctance. "The round of the studios," noted the *Art Journal* in 1881, "was accomplished this year by greater crowds than ever. An artist who lives in an unget-at-able and rural

district stated to us that his neighbourhood had been scandalised and up-set by the visits on a Sunday of over two hundred and fifty persons, for the most part uninvited carriage folk. They appeared to have come to see the studio, and if possible the live artist, rather than the pictures, as to which they were, almost every one of them, as regards criticism, fortunately stricken with 'paralysis of the tongue.'"[14]

By the late 1880s, Saturdays and Sundays were commonly open studio days and artists were using the custom to try to help stimulate the less-ened demand for their work. Herkomer noted in 1891 that young artists were now sending invitations to a large and unselective list of people in the hope of attracting crowds. Frith gives ample evidence that studio "squashes"—that is, overcrowded receptions—persisted well into the days of the depressed market; the problem for him was to keep "that picture-seeking multitude" select. Evidently, the visitors included unscrupulous treasure-hunters, for in the aftermath of Show Sunday, Frith often found that he was missing photographs and letters that had been left on his drawing room table: "Is 'Picture-Sunday' the day selected by these ma-rauders for their plunder?"

Frith goes on to relate an episode witnessed by a friend in the neighbor-hood of Melbury Road, the area known as the Leighton Settlement in rec-ognition of the presence of the grand studio of that painter and of other artists' homes in its vicinity. A man and a woman, "to all appearance of the well-to-do class," were observed wondering at the crowds they saw—carriages standing about, people going in and out "like bees at a hive." Having inquired of a footman as to the event that was taking place, and being assured by him that visitors could enter the famous studios without charge, they entered, looking a little at the pictures, and a great deal at the rest of the company. Frith expressed the hope that when these "guests" departed, it was without taking something with them that they could not call their own.[15]

Show Sunday was an institution that reflected very clearly two separate but related tendencies in English life in the latter half of the nineteenth century: the secularization of society and the sanctification of art. A dra-matic example of the triumph of the spirit of secularization in the art world occurred in 1887 at a meeting of the Society of British Artists, when Whistler, its president, suggested the innovation of Sunday teas to attract visitors and purchasers. An old member rose to his feet; casting his gaze upwards, he condemned the suggestion to break the Sabbath. His remark, writes one of Whistler's devotees, was greeted by loud laughter from all the younger members, who passed the proposal.[16]

32. George Du Maurier, "Picture Sunday" (*Punch*, 9 April 1887). *Punch* calls attention to the power wielded by influential critics, whose words took on even greater importance as the market in contemporary painting continued to contract. The artist's wife realizes that anxiety for her husband's success has led her to become inappropriately importunate.

PICTURE SUNDAY.

Artist. "You'll come and see my Pictures before they go!"
Influential Critic. "My dear Fellow, I never go and see Pictures in Fellows' Studios—it's such a Bore, you know. Everybody saying the Pictures are too Charming, and too Delightful, and all that!"
Artist's Wife (nervously). "Oh, there's never anything of that sort in our House—a——!" [*Wishes she hadn't spoken.*

As for the sanctification of art, it was Ruskin who in many writings had expounded the idea that art is an essential link with humanity's own highest nature and therefore between man and God. The reaction against Ruskin's piously moralistic art interpretations that had taken place, among the cultural elite, by the eighties, did not necessarily signify acceptance of Whistler's view that art and its concerns were altogether separate from the spheres of morality and religion.[17] Charles Waldstein, for example, a Cambridge archaeologist interested in problems of art and philosophy and twice Slade professor of art, charged that Ruskin's religious and moral biases had interfered with his aesthetic sensitivity and had distorted his appreciation of art's origins and functions. Yet Waldstein specifically included religion in his own aesthetic framework. The philosopher of art, he wrote, must analyze his subject with the same objective spirit sought by the biologist; such dedication "will in itself be a high moral act, pleasing to God."[18] The Oxford philosopher R. L. Nettleship, writing in 1889, held

that there was a necessary relationship between art and morality; people should feel, he said, that "so far as they are *really* in an 'artistic' state of mind, they cannot be in an 'immoral' state." [19]

Roger Fry, who had profoundly shocked his parents by announcing, in 1888, his decision to become a painter, frequently echoed Whistler in deploring the English determination to "harness all art to moral problems"; [20] he was, nevertheless, suspicious of the doctrine of art-for-art's-sake and elaborated (in an essay published in 1909) a view of art that comes close to equating it with a religion of mystical (rather than dogmatic) character. [21] Just as the religious mystic may hold that the religious experience, good and desirable in itself, corresponds to certain spiritual capacities of human nature, so, wrote Fry, the artist may declare "that the fullness and completeness of the imaginative life he leads may correspond to an existence more real and more important than any that we know of in mortal life." [22] Benefiting from the thrust of Whistler's stylish iconoclasm, Fry performed an important function for his enthusiastic lecture audiences by purifying Ruskin's view of the sacredness of art of its moralistic anachronisms.

In Fry's view, it is not religion but art that enables us to transcend the earthly, necessity-bound, sensual part of our nature and thereby to make contact with a higher reality.

Most people would, I think, say that the pleasures derived from art were of an altogether different character and more fundamental than merely sensual pleasures, that they did exercise some faculties which are felt to belong to whatever part of us there may be which is not entirely ephemeral and material.

It might even be that from this point of view we should rather justify actual life by its relation to the imaginative, justify nature by its likeness to art. I mean this, that since the imaginative life comes in the course of time to represent more or less what mankind feels to be the completest expression of its own nature, the freest use of its innate capacities, the actual life may be explained and justified by its approximation here and there, however partially and inadequately, to that freer and fuller life. [23]

If some of the Show Sunday pilgrims were simply out for a holiday jaunt (the enjoyment of which was perhaps enhanced by the feeling of pleasurable release from the bonds of Sabbath-keeping childhoods), there must have been many others who, in the years of the waning of Ruskin's direct influence and of the maturing of Fry's thought, considered a Sunday spent looking at pictures as "in itself a high moral act, pleasing to God." [24] It was a case of oddly crossed trends; an attitude had developed, within an ever-more-secular society, that gave to art much of the emotional weight that had once belonged to religion.

Of the more restricted art publics directly formed as adjuncts to the Academy's plans for its exhibitions—at Varnishing Days, Press Day, the Royal and Private views, the Banquet and the Soirée for nonmember artists—two were unique in being composed exclusively of artists.[25] Many painters distrusted popular success even as they eagerly sought it; the judgment of their peers was the only one that many artists genuinely valued. Yet, until the last decades of the century, when the hegemony of the Academy was broken and small groups of like-minded artists drew together to form alternative exhibition plans, a surprisingly high degree of social isolation among painters seems to have been common. This lack of peer group companionship was never total; the Pre-Raphaelites were, for a time, a cohesive social group, and there always existed a variety of sketching clubs and jointly taken summer landscape-painting trips. But the sketching clubs were mostly attractive to young artists, and the friendly summer vacations stood out as exceptions in the prevailing pattern of isolation. Visitors to the Continent frequently commented on the very different conditions that prevailed in art centers there, not only among European artists, but also among the English who settled abroad. In Paris, atelier study and cafe life brought artists together; in Rome, painters frequently visited each other's studios, offering suggestions and criticisms with a freedom unknown in England. It was this peer group congeniality that, in the judgment of A. Paul Oppé, caused a number of English artists working in Rome to become permanent expatriates. Oppé suggests three possible causes for the relative isolation of painters in England. The first was the need to cultivate and protect originality of subject matter and method in a country where novelty of content was highly valued and where for long years many artists had to be, so far as the skills of their trade were concerned, autodidacts. The second cause was geographical isolation, for painters, along with other prosperous members of the middle classes, had migrated in considerable numbers to the more comfortable suburbs, where the distances separating occupational peers was often great. Finally, there was a psychological distance in the distaste felt by some of those newly admitted to higher social rungs towards less successful colleagues.[26]

Although this relative isolation of painters from their fellows was in great measure self-imposed, its results were often deplored, and the value (both social and educational) of Varnishing Days, when artists gathered together to add finishing touches to their pictures, was well recognized. Many painters, commented Mrs. Jopling, saw one another only on these occasions;[27] it was, in the authoritative view of G. D. Leslie, the only time

that both ranks of Academy members—the R.A.'s and the A.R.A.'s (associate members who were allowed no part in the governance of the institution)—met together "in freedom and equality."[28]

For a period of forty-three years, 1809–1852, Varnishing Days were the exclusive privilege of these Academic brethren. The rule that established the custom stipulated that three days or more might be allowed to members for the purpose of varnishing or painting on their pictures in the places allotted to them.[29] By the time that Frith became an A.R.A. in 1844, Varnishing Days had been extended to nearly a week and included convivial luncheons served in the Council room, the place where exhibition entries were judged: "I saw gathered round the table the greatest artists of the country, venerable figures most of them; in my eyes an assembly of gods."[30]

One highly prized feature of Varnishing Days during this period was their inclusion of the privilege of observing and learning from the greatest English painter of all. It was on these days that Turner temporarily abandoned his reclusive way of life and demonstrated his skill and genius in the presence of this privileged public.

On such occasions, Turner appeared at early dawn, wrapped up in an overcoat with a handkerchief thrown loosely round his throat. He worked from that time until nine o'clock; then he breakfasted. He resumed work as soon as he had finished his meal, and went on until luncheon time, at one o'clock. After that he again went to work, and remained at it until seven P.M. He never, during these long hours, lost an instant, but toiled with all the enthusiasm of youth. It was marvelous how he could bear so great a strain.

Though it was well known that Turner was a very silent man, he would allow his attention to be diverted, at the request of a friend, to look at a young Associate's picture. . . . His manner all through the varnishing days was very buoyant, and he seemed to be the only one amongst the exhibitors who kept up his spirits during that anxious time.[31]

Turner's heavy reliance on Varnishing Days was well known. It was said that in his last years he purposely sent unfinished works to the Academy, relying on those days of intensive painting to fit them to their surroundings. When mounting protests, particularly from nonmembers bitter at their exclusion from so valuable a privilege (and from members who felt the justice of their complaint), finally led to the abolition of Varnishing Days in 1852, the year following Turner's death, Academy president Charles Eastlake commented that the practice would have been discontinued much earlier but for the fact that Turner's pictures had so greatly benefited by the custom. But the technical advantages of on-the-spot finishing

were only part of the reason for Turner's attachment to this custom. It would have broken Turner's heart, wrote the painter Charles Robert Leslie, if Varnishing Day had been abolished. Whenever such a measure was hinted at, Turner responded with deep feeling: "Then you will do away with the only social meetings we have, the only occasion on which we all come together in an easy, unrestrained manner. When we have no varnishing days we shall not know one another."[32]

For the decade-long period during which Varnishing Days were not held, this important art public was unable to gather in the same way. Academy artists met at other exhibition functions, but the presence of so many others and the admixture of social demands meant that the valuable educational interchanges that had been fostered by Varnishing Days were foregone. Turner had clearly been right in the value he had placed on those days of meeting. In the well-considered opinion of Richard Redgrave, one of the privileged recipients of Turner's kind, albeit cryptically offered words of advice, Varnishing Days were an empirically developed, quintessentially native institution, voluntary and noncoercive, but performing a crucial function as a corrective to the excessively individualistic bias of English art education.

The English school is constituted on the system of individual independence; each artist, after having learnt the mere technical elements, the handicraft of his art, practises it almost irrespective of the rules and traditions of his predecessors. In England, the *atelier* system of the Continent—a system where the pupil enters upon all the knowledge of his master and follows all the traditions of the school—is all but unknown; while even our academic system leaves the student, after he has obtained a command of the language of his art, quite free as to his mode of using it, and has the merit of forming artists of varied originality, because untrammelled by rules and systems; if it has also the fault of leaving the rising body ignorant of any general code of law or precedent to guide them in their practice.

Now on the "varnishing days," when painting was going on in common, much of precept, much of practice, and much of common experience, were interchanged. The younger members gained much from the elder ones, and many useful hints and suggestions from one another. Who does not recollect the valuable remarks of David Wilkie, William Etty, C. R. Leslie, John Constable, and William Mulready, and, above all, of Turner? though from him . . . it was conveyed in dark hints and ambiguous phrases.[33]

Their value having become increasingly apparent during their ten-year absence, Varnishing Days were restored in 1862, this time with a provision for a separate day for nonmember exhibitors, those significantly known as "outsiders."[34] The Academy's move in 1869 to the far larger quarters of Burlington House allowed for a substantial increase in the number of

works shown by outsiders and led to the formation, on Outsiders' Varnishing Day, of a unique artist-public, a kind of national convention of painters from all parts of England, Scotland, and Ireland. The members of this public differed from the Academician-varnishers who preceded them in two important ways other than the all-important fact of their outsider status. Many were part-time or amateur painters: provincial art masters and gentlemen-artists, and, increasingly, many women, at a time when there were no female holders of either rank of Academic status. In 1881, for example, there were nearly 150 women exhibitors. As most of these female participants were watercolor artists who had come to visit rather than to varnish, their presence—along with that of many oil painters of both sexes who came less to retouch their pictures than to see how the Hanging Committee (known to the disillusioned as the "hangmen") had treated them—gave Outsiders' Varnishing Day the character of a special sort of private view.[35] It was an occasion during which new acquaintances might be formed and old ones renewed, while the paintings might be examined with a degree of concentration difficult to achieve once the exhibition was opened to the jostling crowds.

An extremely important result of Outsiders' Varnishing Day, one certainly not intended by the host institution, was that it provided the best possible time and place for a focusing and intensification of anti-Academic feelings. The *Art Journal* wrote in 1882 that it was interesting to watch groups of outsiders on their Varnishing Day, gathering round the work of an unknown man, discussing it and inquiring about him, while it was sad to see one who had "grown grey in the service of Art without obtaining more than her smallest favours, perched at the top of a ladder, giving a coat of varnish, or a few last loving touches, to the work which, when he sent it in, he perhaps fondly hoped might bring him the fame that had so long eluded his grasp."[36] If the gray-haired painter's work was highly esteemed by this special public, then such a scene would emphasize how the Academy had long mistreated talented outsiders and blocked the development of their careers by rejecting good pictures and hanging others where they were barely visible. The outsiders were a diverse group, but there was a strongly unifying factor in the resentment that many felt towards the Academy, a feeling understandably most intense among those with the highest degree of commitment to art as a career and means of livelihood.

Two aspects of Academic behavior were particularly galling to outsider artists: the rudeness and lack of consideration shown them in exhibition arrangements and the unfair advantages utilized by Academy members.

33. Henry Woods, "The Council of Selection of the Royal Academy" (*Graphic*, 7 May 1870). Like other artists who began their careers as illustrators—such as his brother-in-law Luke Fildes—Henry Woods had a personal interest in the Academy's method of selecting pictures. Woods first exhibited at the Academy in 1869 and became a full Academician in 1893.

Royal Academicians had a right to show eight works and were favored with the most advantageous hanging positions, including "the line."[37] It was a privilege always under attack, even by some conscience-stricken R.A.'s, for the practice of giving over so much of the best hanging space to Academicians, some of whom were long past the days of their best productivity, meant that outsiders' paintings were far more likely to be disadvantageously hung, or perhaps not hung at all for want of space. Sometimes, pictures officially rejected by the Council jury were hung in the exhibition, and pictures officially accepted sent home, because the Hanging Committee considered the remaining spaces to be no better than insulting to a good picture.[38] Frith was one of the outsiders' allies on this issue; he felt that it would require the genius of a Reynolds or a Gainsborough to produce eight works in a year, all of which would be worthy of public scrutiny. Frith's comments, included in his widely read autobiography, would have seemed especially timely to a nonmember artist in the late eighties, for whom good hanging in the Academy exhibition very likely meant the

difference between selling a picture and taking it home to an already over-stocked studio:

I am an example of the truth of what I say, for in the year 1875 I, for the first and I hope the last time in my life, exhibited eight works and those worthy of being seen might certainly have been counted on the fingers of one hand—indeed, I am not sure that there would not have been a finger or two to spare even then. . . . Quality, and not quantity, should be the guide of the academic contributors to the exhibition, as well as of those who have the selection of the works of outsiders.[39]

The rude treatment that infuriated outsider artists had a great deal to do with the timing and manner with which they were informed of the fate of their submitted pictures. A painter, having gone to the expense and trouble to get pictures submitted to the Academy by sending-in day, a month before the exhibition, might very well have no idea, until Varnishing Day, of whether any had been accepted and hung. Artists with a "friend at court," whether an R.A. or a hall porter, could perhaps get the information from a private source;[40] others might have to submit to the humiliation that so deeply impressed one participant:

The Royal Academy in those days treated all artists who were not members of their society with the very scantiest courtesy. We had to stand on Varnishing Day, some inside the door, some outside in the square, like casuals seeking relief at a work-house, and shout out our names to a janitor posted in a box, who referred to a book, and gave the information as to the fate of our pictures in tones which [Minos], announcing which circle in hell was the destiny of the unfortunate souls trembling before him, might have envied. A nice old gentleman with a white beard was standing next to me; he gave his name, and presently "All chucked!" was shouted from the box in a voice that would have reached to Charing Cross. I caught sight of his face, and of tears that had started to his eyes at the disappointment and ignominy of the whole proceeding.[41]

The public of outsiders met once more at exhibition time at a formal reception first called the Conversazione and later known as the Soirée. Held during the first week of July, before the annual migrations of painters (especially landscape artists) to the country and abroad, it was given as a gesture of friendliness and hospitality by the Academy to the wider community of artists. The exhibition rooms were lighted for this event, and refreshments and entertainment were provided. Many outsiders must have felt honored by the occasion and by the opportunity it gave them to receive the personal greeting of the president. A young artist, perhaps new to London, would certainly have been thrilled by the invitation; such must have been the reaction of the twenty-year-old Herkomer, who, upon receiving a Soirée ticket with the acceptance of his first picture by the Acad-

emy in 1869, hurried to a Chelsea pawnbroker's to hire a dress suit for the occasion.[42]

Other artists, older and more suspicious of Academic ways, accepted the Soirée invitation with more measured appreciation, or else refused it altogether. What were the reasons for their angry response to the Academy's hospitable overtures? In reality, they charged, the Soirée was a clever means by which Academicians extended their own business circle by inviting friends and patrons who had never been, and never would be, exhibitors. As they saw it, a major affront was included with each ticket sent to outsiders, in whose honor the event was ostensibly being held; R.A.'s and their friends were given extra tickets for guests, while outsiders had to come alone. One irate painter who refused to accept the invitation did so on the grounds that he would not do for the Academy what he would not do for a private host, that is, accept the exclusion of his wife from a social invitation that allows other men to attend in the company of their spouses.[43] This insult was acutely felt by women exhibitors, whose number increased steadily during the last quarter of the century. If a woman painter had no male friend with a ticket of his own, she could not attend the Soirée without suffering a serious loss of reputation for breaking the social taboo against going out alone at night.

William Laidlay, whose 1898 polemic against the Academy provides a comprehensive catalogue of outsiders' grievances, charged that the Academy habitually spent three times as much on the Banquets to which celebrities and patrons were invited than they spent on the Soirées that artist-exhibitors were invited to attend. This difference in expenditures, combined with the galling restrictions on guests, led Laidlay and like-minded artists to regard the Soirée as a direct insult to nonmembers whose works hung in the annual exhibition.[44]

Laidlay's list of charges probably had little effect upon the authority and standing of the Royal Academy, which were already in serious decline well before the time of its publication. Despite the Academy's dominance and earlier prestige, its unfair practices had often been subject to public censure. If the outsiders' complaints were already familiar to informed art lovers, it was owing to the work of another art public, one which played a crucial role in the informing and shaping of public opinion: the art critics. Who were they, and why was their relationship with the Royal Academy characteristically a hostile one?

For at least two full decades beginning in the mid-1840s, when the first volumes of *Modern Painters* made their sensational appearance, Ruskin was *the* art oracle of the nation; young painters sought his approbation,

while patrons importuned him for advice. (Leighton, carefully building his career on the basis of his impressive Academy debut in 1855, wrote regretfully to his mother that although the great critic had spent three hours in his studio, "he did not say anything I could quote about my paintings."[45] Ruskin's *Academy Notes,* critical commentaries on the current exhibition, were published regularly during the late fifties and sold in the streets outside; although they included praise as well as blame, the arrogant tone and withering criticisms outraged many Academicians, some of whom were seen to cross the road and walk on the other side whenever the author appeared.[46] In 1860, however, Ruskin's career dramatically changed course. That year, which saw the publication of the last volume of *Modern Painters,* also saw the appearance of the first of his treatises on political economy, which included denunciations of laissez-faire political economy that alienated many of his followers.[47] Henry James, commenting in 1868 on the state of art criticism in England, makes no mention of Ruskin, but names instead P. G. Hamerton, Francis Turner Palgrave, and William Michael Rossetti as "the three principal art critics now writing in England."[48] Ruskin continued to be an influential art critic, but his energies were now divided.

The literary art critic for whom painting was one among many interests, a type represented by Hazlitt, Thackeray, Palgrave, William Rossetti, and by James himself, was a characteristic figure on the art scene before the emergence, towards the end of the century, of the modern, specialized art critic, most notably, D. S. MacColl and Roger Fry.[49] Perhaps more important, however, because of their larger readership, were the authors of the many unsigned art columns in newspapers and periodicals, those Leighton referred to by the epithet "penny-a-liners."[50] Many of these were thought to be disappointed painters, living confirmation of Disraeli's characterization of critics as "men who have failed in literature and art";[51] others were journalists whose first significant exposure to art might have resulted from an editor's assignment to the "art beat." On this group's general lack of knowledge about art, we have the authoritative testimony of one who made his living for a number of years during the eighties and nineties as a critic of literature, theater, music, and painting. George Bernard Shaw wrote that editors "sent their worst and wordiest reporters to the galleries, the theatre, and the opera, reserving their best for political meetings and the criminal courts"[52]—confirming an observation made by Edward Poynter that "as a rule English art-critics start on their career by criticising the Exhibitions, and trust to time and chance hints for learning something about art."[53] Shaw even blamed himself for writing the kind of art criticism that he later termed "idiotic."

I was capable of looking at a picture then, and, if it displeased me, immediately considering whether the figures formed a pyramid, so that, if they did not, I could prove the picture defective because the composition was wrong. And if I saw a picture of a man foreshortened at me in such a way that I could see nothing but the soles of his feet and his eyes looking out between his toes, I marveled at it and almost revered the painter.[54]

If heavy use of such formalistic criteria of excellence in painting made him an unusual art writer in the 1880s, Shaw was nonetheless typical of the critics of the day in his hostile attitude towards the Royal Academy, which he considered to be an institution blocking needed changes in art, an upholder of stale conventions, among which the most deplorable were "studio-lit landscape" and "second hand classicism"; he even gave up a very desirable newspaper position when the proprietor "insisted on interpolating over my signature ecstatic little raptures about minor Academy pictures by painters who invited her to tea at their studios."[55] Many other proprietors and editors would have sided with Shaw and against his employer on this issue; articles in newspapers and journals were effective catalysts in stimulating the frequent parliamentary denunciations and investigations of the Academy, by giving wide publicity to the complaints of outsider-artists. R.A.'s often blamed journalists for Parliament's distrust of their institution. Thus Frith told the members of the 1863 commission that its appointment was the result of the efforts of "a little clique of painters who have contrived to get possession of the public ear through a portion of the press."[56]

Some journalist-critics opposed the Academy on philosophical grounds; sympathetic with the ideals of utilitarian reformers, they looked upon it as a relic of the days of George III, when artists were few in number and needed the encouragement of royal sponsorship. Tom Taylor, editor of *Punch*, art critic for the *Times*, and president of the Wandsworth Common Liberal Club, represented this trend of thought. Taylor held that the enormous growth in the ranks of painters (which was unaccompanied by a corresponding widening of the Academy's membership) combined with the favoritism shown by Academicians in electing as new members practitioners of an easily accessible, popular type of art, meant that the Academy no longer represented, as it once had, the strength of the English school. Taylor told the commissioners of 1863, in words that carry the full weight of a Liberal's deepest convictions, that the initials *R.A.* conferred an unmerited and unfair position of privilege in the picture trade; many in the "ignorant class of buyers," he said, felt safer buying an inferior work with those reassuring initials than a work of greater merit that lacked them: "If both those men had 'R.A.' after their names, the chances are that those

buyers would prefer the good man's work to the bad man's work, but with the limited number of R.A.'s, as at present, the good man's work is passed over because he has not got those letters after his name."[57]

Reviews of the annual exhibitions had appeared regularly in the press since the early days of the Academy,[58] but it was not until 1871 that a separate viewing day, the Wednesday before public opening, was set aside for the convenience of reporters who had been obliged, up to that time, to make their notes on the formidable numbers of paintings (sometimes close to two thousand) in the midst of crowds of viewers. Critics responded to the belated Academic arrangements for Press Day with little gratitude, looking upon it much as the outsiders looked upon the Soirée, as a gift offered in a grudging and insulting spirit. They complained that the special press tickets, limited to use on Private View and Press days, were distributed only to newspaper editors; individual critics, even those whose lively and enthusiastic commentaries on the exhibitions were known to have encouraged attendance in previous years, had to buy their tickets like ordinary patrons. The wording of the Press Day ticket was considered an affront by at least one influential art writer. "Directors of other institutions," wrote M. H. Spielmann, editor of the *Magazine of Art,* "'request the pleasure' of the critic's attendance, [whereas] the Academy curtly directs its porter to "admit the representative of such and such a paper on the Press and private view days.' Empty words, no doubt," Spielmann added, "yet a straw showing how blows the Academic wind vis-à-vis the Press." One further sign of Academic discourtesy was seen in the unavailability of food and drink, for the refreshment room, open to shilling visitors during regular viewing hours, was closed on Press Day. The journalist, given the task of writing pithy descriptions and more considered judgments on what must have seemed like miles of canvases, could not even renew his or her spirits with a cup of tea without leaving the building.[59]

How is it that the Academy was able to maintain its privileged position for so long in the face of such deep and well-publicized opposition? Not even the harshest detractor of the Academy could deny that both the institution and its exhibition were surrounded by an aura of social prestige. None who sought to share in that pleasurable and advantageous ambiance could afford altogether to ignore the special events seen in their greatest glory in the commodious quarters of Burlington House, into which the Academy moved in 1869.

Attention was called each year to the special relationship between the Royal Academy and the Crown by the Royal Private View, when the queen, accompanied by members of her family with attending ladies and gentle-

men, was escorted around the exhibition by the president, the secretary, and members of the Academy's governing Council.[60] The occasion had more than ritualistic significance; signs of royal interest in a painting soon became public knowledge, thus giving impetus to the progress of the fortunate artist's career. Such favor might be shown by particular attention given a picture, as when Victoria, at the exhibition of 1858, departed from the usual procedure of looking at the paintings in the order suggested in the catalogue and instead walked straight up to *Derby Day*. The reaction expressed by one of the royal children to the picture, proudly related by Frith, must have been repeated in numerous conversations:

"Oh, mamma, I never saw so many people together before!"
"Nonsense!" said the queen. "You have often seen many more."
"But not in a picture, mamma."[61]

Sometimes, royal admiration of a picture would be publicized by its temporary absence from the exhibition, as when, for several days, visitors to the 1875 exhibition found hanging in the place of Elizabeth Thompson's *Roll Call* a placard that read: "This picture has been temporarily removed by command of Her Majesty." The queen, at whose request the picture had earlier been brought to Buckingham Palace for more leisurely examination, had this time asked that it be sent to Windsor so that the visiting czar of Russia might see it.[62]

The most impressive form of royal approval was, of course, outright purchase. Frith's *Ramsgate Sands* and the equally famous *Roll Call* had both been sold before being hung at the Academy, but after some negotiations on her behalf, the queen succeeded in adding them to her collection. One of the most celebrated royal purchases was that of the work of an unknown young man making his debut in 1855. One can imagine the excitement and exhilaration experienced by Frederic Leighton, still in Rome when he received this brief note, personally written by the president of the Royal Academy:

Sir Charles Eastlake presents his compliments to Mr. Frederic Leighton and has the pleasure to acquaint him that the Queen has today been pleased to express her intention of being the possessor of his picture of Cimabue's Procession. Sir Charles Eastlake, according to Mr. Leighton's communication to the Secretary, named the price of 600 guineas to Her Majesty.[63]

Immediately following the annual royal visit came the Private View, the first major social event that was an official exhibition function. The most prominent members of "fashionable art-loving society" were invited; beginning in 1852, members of the press also attended. Hosts and hostesses

were grateful to R.A.'s and A.R.A.'s who could provide them with tickets, for the failure to attend the Private View was a major setback to anyone with ambitions to rise high in the fashionable world and even marked one, in the judgment of the Fildes family, a social flop.[64] An invitation allowed its fortunate recipient the opportunity to get a close look at the most dazzling members of high society and of cultural and governmental affairs. The notable Academy visitors depicted in Frith's painting *The Private View at the Royal Academy, 1881* included Lady Lonsdale, the archbishop of York, Lord Coleridge, Lily Langtry, Anthony Trollope, John Bright, Gladstone, Thomas Huxley, Robert Browning, Ellen Terry, Henry Irving, and Oscar Wilde.

For many people, wrote the *Pall Mall Gazette* in 1894, Private View Day at the Royal Academy was one of the most important days of the year: "It gives not a few Nobodies an opportunity of rubbing shoulders for a brief space with a very considerable number of Somebodies." Cards of admission, the *Gazette* said, were sought with "feverish eagerness" by friends and acquaintances of members of the Academy; the press list, extensive and ever-widening though it was, failed to satisfy the demands made upon it.

In 1870, John Everett Millais (who had been an Academician for six years) jotted down some light-hearted verses which convey some sense of the spirit of the occasion:

First Monday in May
Is the opening day
Of the great R.A.,
When the public go.
But the thing to do
Is the private view,
Select and few—
For the Swells, you know.

Elbow and push
Your way through the crush
To the porter in plush
At the top of the stair.
A catalogue he
Will deliver to thee,
With bended knee
And graceful air.
Then make for the room
(Through a dismal gloom)

To the left of the door;
And, once you're inside,
Go on with the tide.
Observe the Skyed,
For you'll see little more.

All round you a patter
Of commonplace chatter,
Occasional smatter
And cant about Art;
Archbishops and Dooks,
Dilettantes and Snooks,
And Beauty who looks
Especially Smart.
Every step you will greet
Friends who say "What a treat!"
As they stand on your feet
In the hullabaloo.[65]

The high-society cachet of the Private View was only part of the event, although it was no doubt the main attraction to many of those not involved

in the art trade. For artists, this opportunity to mingle with the elite was combined with the promise of commercial advantage. The "smart and privileged crowd in frock-coats and bustles and waists," whose unofficial consensus chose one work as Picture of the Year,[66] was conferring a distinction of marketable value. A painter's reputation might be materially assisted by relationships with writers for the press, and such contacts could be carefully nurtured at the Private View. Millais, at the height of his success, could afford to joke about the private viewers' ignorance of art but knew as well as anyone what use might be made of the occasion. In 1859, a difficult year in his career, he had written to his wife, "Tomorrow is the private view. I have given my tickets to John [L]eech and his wife. He knows all the Press men, *and is respected by all,* so his opinion will be taken and carry weight."[67]

Finally, Private View Day was an important time for picture sales. Solomon Hart remembered one Private View during which a conversation with his fellow painter, Sir William Allen, was interrupted by a call to Allen from the Duke of Wellington, who had been carefully examining Allen's painting, *The Battle of Waterloo.* Allen returned to Hart with a joyful expression. "'Egad!' he exclaimed, 'he has just bought my picture.'"[68] Sometimes, paintings bought before exhibition changed hands at the Private View, and the price increase would greatly enhance the artist's reputation. New commissions, too, were given; William Agnew, for example, expressing his regret at having missed purchase of the sensational *Roll Call,* asked the artist if she would paint another picture for him on a similar theme.[69] Agnew was a preeminent figure among the art dealers, a group that accounted for many of the sales made at the Private View. Richard Redgrave remembered being startled when, having arrived early at the 1859 Private View, he found the dealers already there in force: "They were all waiting at the door at ten o'clock, and, on entering, I soon found what a business they make out of the Academy."[70]

It is easy to understand why outsider-artists placed their exclusion from the Private View high on their list of grievances against the Academy. Their pictures contributed to the success of the exhibition; what right had Academicians to keep to themselves the social and commercial advantages of this important function? William Laidlay once traveled home from Paris just before the opening of the exhibition, in the company of an elderly gentleman whose social prominence or activities as an art patron had procured him a ticket to the Private View and an invitation to the Academy Banquet. Laidlay, who had exhibited at the Academy every year during the preceding ten years (and who had still not been informed of the acceptance or rejection of his current entries), had received neither. Equally as

bad as this exclusion was the insidiousness of the Academy's tacit offer of conditional inclusion; Laidlay explained that a select group of outsiders might attend the Private View if they cultivated the friendship of Academicians and accepted, without complaint or criticism, the Academy's own definition of its rights and privileges:

Also it appears to me rather hard that no outsiders ever get a ticket to the private views—except as a favour from some R.A.—especially when you recollect who really attended these private views, and that outsiders contribute largely to the show. But this is but another instance of the patronage of Academicians, and the necessity which outsiders are under—for with regard to the Academy they have no rights—to stand well with them if they desire to obtain anything.[71]

The Duke of Wellington and others of the highest social ranks were to have one more opportunity to render homage to art before the exhibition was opened to ordinary shilling-ticket purchasers. On the Saturday evening preceding the general opening, the Royal Academy Banquet was given, for a public even more exclusive than that of the Private View, the Banquet being an affair for males only. So important was this sex restriction that the near-election of Elizabeth Thompson to Academy membership in 1875 precipitated the enactment of a number of male-supremacy statutes, including one specifying that if a woman were to be elected, she would be denied the right to attend the Banquet.[72] Such an impressive loss of Academic dignity as that contained in this outburst of masculine hysteria indicates that the Banquet was more than just an opulent evening of toasts and feasting. Some account of the evolution of this very important event is necessary to an understanding of its nature and functions.

The annual Banquet, which began in the earliest days of the Royal Academy as a festive dinner held in the exhibition room after the pictures had been hung, was thoughtfully shaped by Sir Joshua Reynolds into an instrument to further one of the central aims of his career: the social elevation of painting to the status of a liberal profession. It was Reynolds's decision, agreed to by the Academic Council, that members give up their individual preferences in the issuance of invitations to these dinners; the guest list was to be an official one, and was to be drawn up so that the company would be "as select as possible." A rule passed by the Council gave permanence to Reynolds's dictate, limiting invitations "to persons high in rank or official situation, to those distinguished for superior talent, and to patrons of the art."[73]

A comparison of the account of the formative days of the Banquet contained in the memoirs of a contemporary of Reynolds, the painter Joseph Farington, with that given by William Sandby in 1862 and G. D. Leslie in

1914 shows that the Banquet remained remarkably faithful to the form set for it by Reynolds. Decorum declined seriously during the years of the Regency, when heavy drinking (even among this select company) caused many guests to end their evening on the floor, where some remained until servants arrived to take them home.[74] By 1851, when Prince Albert graced the banquet by his presence and speech making, such behavior was a thing of the unreformed past. The prince consort's active participation in that year gave the Banquet a quasi-public character; thereafter, a *Times* reporter was invited and the guest list and speeches received press coverage. When Sandby published his history of the Academy, the number of Banquet guests had been set at 140; if any of these declined the invitation or were unable to attend, their places were to remain unfilled. Sandby insisted that the Banquet was not a public dinner—to have conceived it as such would have placed constraints upon the Academicians' choice of guests; he listed the regular recipients of invitations as "the Cabinet Ministers, the great officers of the State and of the Royal household, the heads of the Church, the Army, Navy, Law, and Civic authority . . . and generally the leading members of 'the Opposition' to the Ministry then in power." All new invitations were decided on by the Council.[75]

G. D. Leslie's description of the Banquet in its early twentieth-century form records few changes; the guest list had been enlarged to two hundred, with the addition of representatives "of the Universities, of the Colleges of Medicine and Surgery, of the Presidents of all the various societies and institutions of science and art, of the heads of departments in the British Museum, and last, but by no means least, the names also of the most brilliant leaders in the paths of Literature, the Drama, and Music." Members voted on each invitation, with two black balls exercising a veto. Like Sandby, Leslie carefully pointed out that the event was not a public one, but by this time the years of detailed press coverage required him to concede that the Banquet was only "nominally private."[76]

The inclusion of drama and music as important areas from which Banquet guests were to be regularly drawn reflected significant improvements in the social status of both those arts. Representatives of literature, although not accorded a separate category in Sandby's list, had long attended the Banquets (Frith mentions Dickens, Thackeray, and the poet Samuel Rogers as guests),[77] a practice in keeping with the wishes of Reynolds, who had made his literary friends Goldsmith and Johnson honorary members of the Academy.[78] It is significant that those concerned with the "elevation" of the sister arts of music and the drama should have ascribed great importance to the recognition of their cultural worth by an

institution of painters, sculptors, and architects. There is no doubt that Banquet invitations and dedicatory toasts were looked upon by prominent musicians and actors as providing valuable assistance to their efforts to raise the social standing of their own professions. Leighton, who enjoyed the theater and passionately loved music, used his great influence as Academy president to bring those arts within the glow of prestige cast by the Banquet. Squire Bancroft, knighted in 1897 in recognition of a long career dedicated to improving the respectability of the stage and acting profession, wrote to the *Times* soon after Leighton's death that "no actor should ever forget that it was while Leighton was President that he and the council first allowed the Cinderella of the arts, 'The Drama,' to be toasted at their great banquets."[79] Sir Arthur Sullivan's obituary tribute to Leighton dwelt also upon his generous use of the instrument of the Banquet. Leighton had corrected the Academy's previous neglect of the art of music by inviting representatives of "the hitherto tabooed art" to the very first Banquet over which he presided; starting in 1891, he had caused music to be included "for the first time in the annals of the Academy" in the official list of toasts, and had personally given a gracious tribute to music, for which Sullivan expressed deep gratitude.[80]

The Royal Academy Banquet was a well-ordered ceremony held to celebrate the opening of the new exhibition and to reaffirm the importance and dignity of the parent institution. The effort to win for art the prestige of the official sanction of government leaders by their presence and speech making was understandable but ultimately exposed the Academy and its dinner to well-deserved ridicule. Such speakers as the Prince of Wales, the duke of Cambridge, and the first lord of the Admiralty praised art by fitting it clumsily into expressions of concern for the subject they clearly believed to be far more important: the advancement of national and colonial interests. "You may say," wrote the *Pall Mall Gazette* in its tongue-in-cheek account of the 1886 Banquet,

that on this day Art is at home, and Royalty and the Army and Navy, letters and science, the Corporation of London, politics and the Church, drop in and pat her haloed head, and explain how valuable each of themselves must be to her. . . . It is much to be wished that the Academy should publish an official précis of the most pregnant aphorisms delivered each year, for it is a heavy task disinterring them from a whole page of the *Times*. But since the Academy thus neglects its duty, we must strive to pluck and present to our readers a posy of choicest flowers. Art, as the Duke of Cambridge urged, is to be encouraged, partly because artists would, in case of need, serve as soldiers, and partly because at the Academy dinner one meets so many people whom one wishes to meet. Lord Spencer, who dealt with art from the naval point of view, was not so hardy as to suggest that a naval conscrip-

tion would be enthusiastically met by what he so happily calls "the artists who adorn these walls with their beautiful works." However, he pointed out that at least two pictures in this year's exhibition deal with the Navy. . . . Sir Robert Ball, in the name of science found yet another justification of Art. The larger mammals, he pointed out, are disappearing with the most frightful rapidity. By the aid of the Academy their forms will be preserved for the edification of future students. . . . The Bishop of Peterborough—quite unintentionally, we are sure—struck a slightly jarring note when he said that the artist's picture is not what he meant it to be. Then with a final authoritative declaration from the President that there are many kinds of pictures in this year's Academy the great symposium came to a close.[81]

The *Pall Mall*'s words came at a time when the morale of the Academy had reached the lowest point in its century-and-a-quarter history. The Banquet had not ceased to attract the greatest in the land, but the dispirited quality of speeches and their heavy concentration on matters of politics and empire give evidence of the extent to which the Academy's challengers the Grosvenor and New galleries, the New English Art Club, the schools of art both in England and in Paris that were drawing the most talented young painters of the day away from the Academy's own schools—had weakened its authority and prestige. Lord Herschell, the lord high chancellor, who had dwelt, in his speech at the 1886 Banquet, on the power of the paintings surrounding the diners to lift their spirits "into a purer and nobler atmosphere,"[82] in 1893 expressed sentiments which reflected not only the Academy's lessened status but also a radically altered climate of opinion that questioned whether such institutions as academies should exist at all, whether popular paintings of the sort so prominent at the Academy's exhibitions were worthy to be considered as art, and whether the high prices recently paid to living artists had not reflected false aesthetic values:

If we were to form our opinions from the views expressed in passages we may read frequently in the Press, . . . I think we should conclude that there were three marks of a real artist in the present day. The first is that his pictures should never appear on the walls of the Academy (laughter); the second is that there should be very few people capable of either appreciating them or understanding them (renewed laughter); and the third is that those who produce works of art should receive very small remuneration for doing so (great laughter).[83]

"No longer," wrote the *Pall Mall Gazette* in its report of this Banquet, "secure and drowsy over their wine do the gods enjoy their worship undisturbed."[84]

Even though its proceedings invited parody—it would be easy enough to mistake the *Times*'s verbatim reports for the *Pall Mall Gazette*'s satires—male critics had fewer words of derision for the Banquet than for other

Academy functions; perhaps the reason was that Sir Joshua's aim, to raise art's social status by bringing the aristocracies of birth and accomplishment to a ceremonial dinner in honor of painters and their work, was seen as working to the advantage of all artists, outsiders as well as Academicians. Furthermore, during the last quarter of the century, many painters who were made uneasy by the rapidly increasing female representation in the Academy's schools and exhibitions cherished the exclusively male composition of the Academy and its Banquet. William Laidlay, whose comments on the Academy were seldom less than scathing, confined his remarks on the Banquet to the observation that although the presence of well-known patrons makes it, in a way, a business affair, very few have a word to say in criticism of the event "because it is for males only, and is liberally conducted."[85] There were, however, periodic grumbles concerning the business aspect of the Banquet. "The Royal Academy," wrote the *Art Journal* in 1858, "chooses, under a formula, for its guests, at the one annual banquet which it gives, those only who are most likely to pay for the dinner—the picture-buyer, and persons 'in elevated situations,' or 'of high rank,'"[86] a criticism that sounds suspiciously like that of a disappointed would-be guest. Millais's son included in his biography of his father a letter, written in 1856, that reveals an aspect of the Banquet seldom spoken of: the use of invitations to encourage Academy-approved patronage choices and to deter others. An important group of R.A.'s, jealously opposed to Millais, had made unsuccessful attempts to obstruct the progress of his career by this means:

So determined are they to insult every man who chooses to purchase my works, that this year they have done the same with Miller as they did with Arden, when he bought *The Order of Release*. For the first time they have not sent him an invitation to the dinner, at which he smiles, knowing the reason. Anyhow, it is rather a triumph for us, as these wretched, ungentlemanly dealings only tend to reveal the truth.[87]

The most telling criticism of the Banquet that could be made by a painter was that it had failed to accomplish the goals set for it by Reynolds. Such was the implication of a statement made by one of the century's most eminent Academicians. Sir Edwin Landseer, in testimony before the 1863 Royal Academy commission, asserted that the continuous series of investigations to which the Academy was subject—"Every generation of 20 years there is an inquiry of this sort"—was proof that its many contributions to the art life of the country had never received proper and full recognition.

"With regard to the Academy not being respected," asked Lord Elcho, a vehement opponent of the institution, "do the names of the persons who are at the annual dinner collected round the festive board of the Academy look as if there were any want of respect entertained towards that body by the magnates of the day?" "I believe," answered Landseer, "that the magnates of the day think it a very agreeable dinner."[88]

Viewers of the Royal Academy Exhibitions

On the Monday following the Banquet, the general public, its interest having been stimulated by several months of reports on artists' doings and pictures in progress and by the accounts of Press and Private View days, began to line up at the turnstile and to throng the exhibition rooms. The exhibition of 1879, the first one held during Leighton's seventeen-year presidency, drew 391,197 visitors. Over 115,000 catalogues were sold, and the Academy made a profit of £20,814. That was the peak year of exhibition attendance. Although figures never again reached that height, they remained very high for the last two decades of the century, averaging 355,000 per year.[89]

The first and most important fact, then, about this general art public is its impressive size and the diversity of social levels and motivations represented. The topmost social layer included many Private View guests. With carriages to drive them to the entrance, with season tickets to eliminate the necessity of waiting in line, they could easily spare the time to see pictures previously overlooked, to reexperience particular favorites and "be seen."[90] The lowest social rung of this great art public included a sprinkling of servants; some may have been given shillings expressly for the purpose of an Academy visit by employers anxious to ensure an edifying use of free time, while a small number perhaps had their interest sparked by contact with (or service as) artists' models. The bulk of this art public may be described as "middle class," a term used here in its widest dimensions. Included among these shilling visitors were the "hard-working professional men" who, according to Lady Eastlake, formed the social ingredient that gave London its special character.[91] There were numerous craftsmen and tradesmen in this city of small-scale production,[92] and there were many members of the labor aristocracy, a group which, in income as well as aspiration, overlapped with the lower middle class—many school teachers came out of its ranks.[93] New to the experience of viewing paintings, these groups would naturally have been drawn to those that told a story; they must have swelled the crowds that caused protective rails to be required for six of Frith's pictures.

But in all of these groups, it was the women, especially those of the servant-keeping classes, who had the most time available for art gallery visits; from the wives of skilled laborers on up the social scale, women did not generally work except under the pressure of dire necessity.[94] The numerical growth of this leisured group was truly astonishing. During the 1850s and 1860s, the middle classes accounted for a disproportionately large part of the general population increase, with the greatest growth in numbers occurring among the lower middle classes; there was also a considerable movement up the middle-class income scale during these two decades. And while it was men's earning power that allowed these social transformations to take place, women's adaptability in acquiring and polishing appropriate social skills played a major role in determining the rapidity of the change.

Some degree of familiarity with the contemporary art scene could strengthen the efforts of these upwardly mobile families to redefine social status. Charles Waldstein, writing in 1893, commented on the great change that had been effected in England during the generation preceding his own: "The middle classes in the country and in the towns, and even large portions of the laboring classes, have in every direction manifested their desire for the acquisition of the higher fruits of culture, and have made heard their claim to share in the birthright which previously had been assigned but to the few." Waldstein's general approval of the trend towards a wider dissemination of "culture" is tempered by his remark that it had been so strong as to overshoot its proper mark, landing "in the district that lies beyond the boundaries of sincerity and moderation, the sphere of the grotesque and ridiculous."[95] Far too often, art was sought less for its own intrinsic rewards than as an instrument in the quest for gentility. Such affectation has always delighted the satirists; the *Pall Mall Gazette*'s "Hints on Visiting the Academy, Addressed to a Young Lady," published in the issue of 9 May 1894, is worth quoting at some length. Its purposely exaggerated advice provides a sketch of some of the skills that were considered essential to a socially successful gallery visit. As the Academy exhibition was one event of the London social season that was an essential experience for all who wished to gain or to maintain status,[96] the article concentrates upon a visit to Burlington House.

My Dear Candidata—

Among the more difficult social performances they will exact from you this spring is the visit to the picture gallery. It is now almost unavoidable, since without it one is unable to participate in the artistic topics which at this season almost entirely supersede theatrical affairs in polite conversation. If, for instance, a young

man asks you if you have been to the New Gallery or the Academy, and you answer "No," what further opening has he? and you look so foolish. . . .

Still, it must be admitted that to tramp through the Academy and see all the yards and yards of pictures is heavy work, and a few hints towards lightening the labour may not be unwelcome. . . . Here is a rule that will halve your trouble. The pictures that are at or below the level of your head are the only pictures you need notice. They are said to be "on the line." Not only does looking at the others strain the eyes, and add to your labour, but it shows that you are unfamiliar with the unwritten code of the display. Then, again, it is not usual to notice any picture less than four feet by two. There is one little room of small pictures, very tedious and quite unprofitable, which you may safely skip. . . .

Now, coming to particular points. Look out for and do not fail to score off anything you have already seen on Picture Sunday. Say, "It looks better here"—or worse—it does not matter. Or say you certainly think he did some more to the background on Varnishing Day. A knowledge of an artist that warrants the use of his Christian name is a decided social advantage. "Here is Willie" say, getting as far away as possible from the rest of your people and then calling to them. But do not say you are so glad he has "got in." People are "hung" not "put into" the Academy, and besides, it makes your Willie seem a rather inferior artist to rejoice at all over his success. . . .

Any man who is not an R.A. or A.R.A. in the catalogue you should admire, if you admire him at all, with discretion. He may be quite a low person. . . . Find something rather weak in any feminine work; it is a perfectly safe discovery, and besides, it will flatter the vanity of your escort. . . .

As a general criticism it is safe to observe that the Academy is really not so good as last year. No Academy ever is as good as last year. Say you are disappointed, and that there is such a superabundance of mediocre work. Save that up for the courtyard and with that concluding piece of advice, and the best wishes for your enjoyment, believe me, dear Candidata, your affectionate Aunt,

Jane Crabtree [97]

It would be wrong to imply that the motivation behind Candidata's visit to the Academy was typical. People came to the exhibition for a variety of reasons, among them curiosity, a desire for novelty and entertainment, and the anticipation of the enjoyment of seeing the new work of painters, both famous and unknown. Some came as members of the group that Bruce Watson, in his analysis of visitors to the famous New York Armory exhibition of 1913, calls the "recreational" art public—people for whom art viewing provides a convenient form of using leisure for social interaction.[98] Still others came because they enjoyed a particular type of picture— amusing anecdotes, sporting scenes and depictions of animals, portrayals of fashionable beauties, landscapes both awe-inspiring and pastoral. The sheer size of the exhibition guaranteed that a visitor would find numerous examples of a favorite branch of art. For example, the art critic Frank

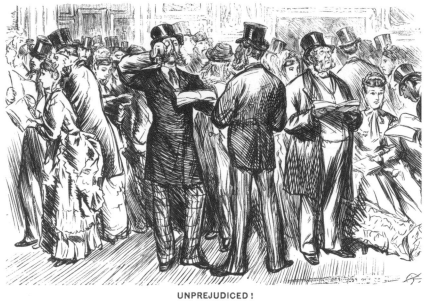

UNPREJUDICED !

Swell (at the R. A. Exhibition). "Haw! 've you any Idea–w what Fellaw's Pictu-ars we're to Admi-are this Ye-ar !!!?"

34. Charles Keene, "Unprejudiced!" (*Punch,* 13 May 1871). The theme of this cartoon, the importance of voicing socially approved opinions at the Royal Academy exhibition, was endlessly repeated with numerous variations in *Punch* and other journals. The cartoon also calls attention to the great power of the critics, whose notice (or failure to notice) provided essential cues to visitors like this "unprejudiced swell."

Rutter enjoyed telling the story of the uncle who took him on yearly visits to the Academy during the 1880s. A timber merchant, his uncle was interested only in wooded landscapes; when he found one to his liking, he would stand before it and say, "Ah! that's grand timber: just ready for felling."[99]

Painters delighted in exchanging similar anecdotes to illustrate the lack of aesthetic sophistication of much of the exhibition public. "The fact of its being 'the thing' to go to the Academy Exhibition," remarked Frith, "takes great numbers there who care for art as much as they know about it, and that is nothing at all." He relates a conversation overheard in front of a picture by Thomas Faed, *His Only Pair,* which shows a small boy sitting on a table, dangling his naked legs and sucking an orange, while his mother mended his trousers.

Two female visitors to the exhibition were in front of the picture. One held the catalogue, and in reply to her friend's inquiry "What is the subject?" replied:
"*His Only Pair.*"
"Pear?" said the connoisseur. "It looks more like an orange." [100]

Painters had mixed feelings towards this unsophisticated segment of the Academy's art public. This was especially true during the heyday of the engraved reproduction and of high payments for copyright. Ordinary gallery visitors became indirect patrons of the artist through their purchases of engraved versions of paintings, and the popularity of these had a major effect upon a painter's future bargaining power with dealers. Even after the peak years of engraving sales had passed, public attention to a picture would attract comment in the press and help to boost a painter's reputation. Thus the artist who wished to establish and maintain a name had, to some extent, to court the approval of portions of the public for whose taste he had little respect.

Elizabeth Thompson is an interesting example of an artist who felt both flattered and repelled by popularity at the Academy. As a child, she had daydreamed of success at the Academy exhibition, envisioning one of her pictures as marked out by a brass bar "a la Frith's *Derby Day.*" When her great day of triumph came in 1874, it prompted these reflections: "It is a curious condition of the mind between gratitude for the appreciation of one's work by those who know, and the uncomfortable sense of an exaggerated popularity with the crowd." So intense was public interest in this painter that her aunt came upon a photograph of her on a fruit-seller's cart in Chelsea, among some bananas. [101]

If admission to the Royal Academy's exhibition had been limited to persons of taste, the institution's resources would have been severely limited in consequence. This was the opinion expressed by the *Art Journal* in 1882, to which was added the trenchant observation that "the shilling of the uncultivated Philistine and of the aesthetic devotee are equal in value for all practical purposes." [102] The need for income to pay for ongoing Academy expenses—support of the schools, the upkeep of its facilities, and pensions to families of disabled and deceased artists—was certainly one reason for the shilling admission charge. But the charge had another function of at least equal importance, that of providing a "social floor" to assure a minimum of respectability to the Academy's general visiting public.

The imposition of a charge to keep out "improper persons" had been established with the very first Academy exhibition in 1769, the catalogue for which includes this statement:

As the present exhibition is a part of the institution of an Academy supported by royal munificence, the public may naturally expect the liberty of being admitted without expenses. The Academicians, therefore, think it necessary to declare that this was very much their desire, but that they have not been able to suggest any other means, than that of receiving money for admittance, to prevent the room from being filled with improper persons, to the entire exclusion of those for whom the exhibition is apparently intended.[103]

The admission charge was carefully maintained despite repeated attacks throughout the Victorian era; the Academy's detractors held that an institution in receipt of indirect government subsidy (the use of public buildings) had an obligation to admit the public free of charge at least part of the time. The occupation by the Academy of one wing of the new National Gallery building, into which it had moved in 1836 after a fifty-seven-year period of residence in Somerset House in rooms originally given by George III, provided a tool of parliamentary leverage to the Radical Joseph Hume, whose 1844 resolution, "praying Her Majesty to withdraw her royal favour from the Royal Academy, . . . and . . . entreating that it might be ejected from the apartments assigned to it in Trafalgar Square," was only narrowly defeated. The president of the Academy, Martin Archer Shee, defended the institution, stating that it had simply given up one residence provided by the king for another and that the public had therefore no new claim upon it; unlike the British Museum and other public institutions, the Academy was self-supporting. He argued that control of the composition of the exhibition public by means of the shilling admission charge was essential. Paintings could not be protected from injury if the public were allowed to enter freely; no compensation would be made for losses; there would be crowding, and miniatures were sure to be stolen.[104]

In 1863, members of Parliament again expressed their unhappiness with the Academy's restrictive visiting arrangements. The report of the commission of that year, whose purpose it was to suggest measures that would render the Academy "more useful in promoting and developing public taste," suggested several changes designed to bring about a broadening of its exhibition public. It recommended that the hidden charge that doubled the entry fee, the price of the catalogue—a necessary aid in an enormous exhibition which gave the viewer no other guide as to painter and title—be made truly optional by exhibiting all works with the artist's name (and possibly with the picture's title) on the frame. The commissioners thought it likely that more people would visit the exhibition if they could avoid the expense of buying a work "whose tendency has been to increase in size"; such arrangements were already in use in the National

Gallery and the principal art galleries of the Continent. The commission's report also recommended the adoption of a variable entrance fee which would retain the customary shilling as the regular rate but raise it on Mondays and abolish it altogether on Saturdays; the higher Monday charge would provide a more pleasant visit to persons of advanced years or poor health who would be enabled to avoid the crowding present on the other days, and would be a boon to art lovers wishing to study the exhibition with care, while the open admission on Saturday, "when happily many classes of workmen have half-holiday," would give pleasure and the impetus for improved taste to this important group.

The Academy did not act on the commission's recommendations for a variable fee structure and was continuously attacked for its intransigence on this issue and for its unwillingness to lengthen visiting hours. (The Sunday Society, whose tireless efforts during the last quarter of the century finally resulted, in 1896, in Parliament's decision to open museums and public galleries on Sundays, repeatedly urged the Academy to open its doors on one or two Sundays during the exhibition's three-month duration.) In 1894, several members of the House of Commons voted against a grant for the maintenance of Burlington House, the Academy's home since 1869, on the grounds that this institution that held, rent free, "one of the largest buildings erected upon the finest site in Europe," never opened its exhibition without an admission charge: "If the public could not get any return for all the money they spent, the House would have to refuse to grant any more money."[105]

Why was the Academy so rigidly unbending in its unwillingness to suspend its admission charge even for a small portion of its viewing hours? Were fears of thefts and vandalism justified? There is good evidence to suggest that they were not. In 1843, the exhibition of cartoon drawings for the frescoes that were to decorate the new Houses of Parliament attracted twenty to thirty thousand viewers each day; a shilling had been charged during the first two weeks, but admission was gratis (except for Saturdays) for the remainder of the two-month exhibition. Although no dress code had been adopted as a condition of entry, the exhibition was crowded, as the *Times* noted with evident relief, "with the most respectably dressed people." The London Art Union's annual show of pictures chosen by its prize winners is the other important example of an art exhibition open without charge to the public; perhaps the commissioners who decided to hold the cartoon exhibition in Westminster Hall had the example of the Art Union in mind, for by 1843 its show was a regularly established and popular occasion; in that year it attracted over 147,000 visitors. "I believe,"

George Godwin, founder and honorary secretary of the Art Union, proudly told the Select Committee on Art Union Laws in 1866, "we were principally instrumental in proving that the ordinary public of England might be admitted without limitation to see works of art in galleries without doing any damage."[106]

The National Gallery: Implications of Free Admission

The Academy's insistence upon the continuous maintenance of the shilling entrance fee and its refusal to grant even the most minor compromise at a time of its own declining prestige suggest that this was less a question open to pragmatic examination than an emotionally charged matter of principle. The majority of Academicians considered it crucial to maintain, at *all* times, an environment of uncompromised respectability in their crowded exhibition rooms. The precedent of an open art exhibition that Academicians found most relevant to their situation was neither the one-time-only display of cartoons at Westminster nor the annual show of Art Union prizes, a celebration (so upper-class detractors charged) of the taste of guinea-paying lottery winners that never aimed for the high social tone cultivated by the Royal Academy.[107] The example that shaped the thoughts of Academicians on the question of gratis admission was that of the National Gallery. During the fifties and sixties the nation's two great art institutions were connected not only by joint occupancy but also by common leadership, for Sir Charles Eastlake was, from 1855 until his death in January of 1866, both president of the Royal Academy and director of the National Gallery.[108] The question of the composition, both actual and optimal, of the National Gallery's art public was a central concern of the various governmental inquiries held during those years to consider how the gallery's pressing need for additional space could best be met. The steady growth of the nation's collection of paintings meant that joint tenancy with the Academy could not long continue. Many witnesses urged that the relocation of the gallery to the suburbs would be beneficial to paintings that were deteriorating in the smoky pollution of central London. But what would be the effect of such a move on the gallery's visitors? Who were the people who frequented it, and was this the art public that could best benefit by viewing a great painting collection?

Sir Robert Peel, whose deep interest in art—his magnificent collection of seventeenth-century Flemish and Dutch pictures forms the nucleus of the National Gallery's collection of paintings of that period—made him an active and influential member of the gallery's Board of Trustees,[109] had no

doubt expressed an enthusiasm widely shared when the site for the gallery was first proposed. The centrality of the location had seemed to him ideal; persons of diverse classes, drawn from all sectors of London commerce, would meet there in a spirit of mutual good will. But just a decade and a half after the nation's art treasures had been established in Trafalgar Square, a Select Committee of Parliament spent four months interviewing witnesses on the problems of the National Gallery and issued a report of over a thousand pages, recommending the abandonment of its quarters to the Royal Academy and the building of a new National Gallery at Kensington.[110] What were the reasons seen as justifying such an expensive change of plan?

Of the two major factors causing dissatisfaction with the site, air pollution due to the nearby burning of coal, and the gathering there of visitors looked upon as undesirable, it was the second that generated bitter disagreement and angry responses.[111] The early 1850s, when the first National Gallery commissions met, was a time of strong middle- and upper-class anxiety concerning the working classes. The geographical segregation of the social classes, which intensified during the late twenties with increased middle-class migration to the suburbs (a movement encouraged by the appearance of low-fare omnibuses in the forties) led to a sense of social estrangement and fear, especially at times when tensions were high: "There was anxiety about cholera, about Chartism and the Revolutions of 1848, about the inrush of Irish immigrants and the deteriorating condition of artisans threatened by the expansion of the 'dishonourable' and sweated trades."[112]

The disquieting presence in central London of a criminal underclass and of large numbers of the chronically unemployed and unemployable—the subtitle of Henry Mayhew's *London Labour and the London Poor,* first published in 1851, was *The Condition and Earnings of Those That Will Work, Cannot Work, and Will Not Work*—created a difficult problem for those called upon to determine the future of the National Gallery. Many of the committee's witnesses would have agreed with the opinion expressed by Mayhew in the first volume of his great study that "to cultivate the sense of the beautiful is necessarily to inculcate a detestation of the sensual."[113] Thus Frederick Hurlstone, president of the Society of British Artists, advocated the Sunday opening of the National Gallery so as "to afford a more refined description of amusement than the mere sensual amusements of the people in general, to which, were they denied this, of course they would be compelled to resort."[114]

But agreement as to the existence of a public obligation to provide refin-

ing influences for lives that normally encountered all too few, was accompanied by uncertainty and frequent disagreement as to whether the actual public that visited the National Gallery coincided with its optimal public, that which would benefit the most by contact with high art.[115] If respectable workers, most of whom lived a bus ride's distance to the south or to the east of the gallery, could visit it easily only on holidays, then a move to the suburbs (particularly if the gallery were open on Sundays) might still be acceptable.[116] Did they not enjoy holiday excursions with their families to Hampton Court and the Crystal Palace? Had they not gone in large numbers to visit the Great Exhibition on its shilling days? Would they not benefit by a day spent at Kensington on the borders of Hyde Park, whose pure and fresh air had designated it one of the lungs of London? As for those to whom a trip there would be an inconvenience—the disreputable poor that crowded the streets of central London—one witness commented that their room would be preferable to their company.[117] It was, in fact, "their room" that many of the witnesses and commissioners desired. Why did they come to the National Gallery, and what was it that made their presence not merely irritating, but obnoxious and even intolerable?

Some of the visitors, those referred to as "idlers" and "mere loungers," simply came to get in out of the rain, causing not only crowding, but the caking of the mud tracked in on their shoes that when it dried, turned into dust and settled on the pictures.[118] Others, it was charged, came in search of a playground for their children: mothers had been seen breast-feeding their infants while their older children were allowed to roam; parents had been observed using the gallery as a convenient place to teach little children to walk. In testimony before the 1850 Select Committee on the National Gallery, the keeper of the gallery, Thomas Uwins, had said that children's accidents were always visible on the floor, particularly on days when the band of the regiment quartered just behind the gallery played; the music attracted large numbers of people who then wandered inside. Uwins added that still other people used the gallery as a comfortable place for a picnic, frequently leaving behind them remnants of bread, cheese, and orange peel.

I saw some people, who seemed to be country people, who had a basket of provisions, and who drew their chairs round and sat down, and seemed to make themselves very comfortable; they had meat and drink; and when I suggested to them the impropriety of such a proceeding in such a place, they were very good-humoured, and a lady offered me a glass of gin, and wished me to partake of what they had provided; I represented to them that those things could not be tolerated.[119]

Asked whether the presence of police could not keep order, Uwins replied that it would take a posse of policemen to enforce regulations so blithely disregarded by such large numbers of people.

Sir Charles Eastlake had told the 1850 committee that many art lovers, expecially ladies, avoided the National Gallery because of the crowds, and suggested that a day be established when admission was charged so as "to give persons who now never visit it an opportunity of seeing the pictures."[120] Other witnesses suggested a variety of methods to keep out undesirables. Requiring entrants to write their names on a register was an idea brought up several times but generally rejected, as the system, once in use at the British Museum, was found to result in irritating delays. Mandatory purchase of a catalogue was another possibility, and there was some interest in establishing a nearby ticket office, where those who wished to visit the gallery would first have to go.[121] Several witnesses agreed with the opinion expressed by the respected painter and art administrator, William Dyce,[122] that, compared with other European art collections, England's was far too accessible:

I should be very sorry to appear to doubt the advantage which the generality of people derive from seeing works of art; but I think an extreme view of it is taken in this country which is not warranted by the example of other countries, where they admit the common people less frequently to galleries than we do; and if it is found that the admission of great crowds of people is really injurious to works of art, it becomes a question whether some restriction ought not to be imposed.[123]

Dyce's use of the word *injurious* is significant; in the last quarter of the nineteenth century, the desire of middle-class wives and daughters for social exclusiveness would be a sufficient cause for their avoidance of the National Gallery, but during the fifties and sixties there was real fear of harm. The word *cholera* must have been present in the minds of everyone who lived through the terrible epidemics of 1849, 1855, and 1866. The disease took its severest toll among the poor; it was, as the *Economist* had noted in 1849, "a disease of society"[124] and was associated with crowding and dirt—and with "noxious effluvia," then thought of as floating in the air, the "miasmata" that were believed to cause disease.[125] Again and again, witnesses expressed their revulsion at the necessity of viewing art in the presence of crowds of lower-class people, whose dirty clothes and foul breath and perspiration were said to be causing chemical injury to the pictures, and, by implication, potential harm to the health of more respectable visitors. It was reported that a greasy deposit not present in London's private art collections was characteristically found on the surface of

National Gallery pictures. "That deposit seems to proceed very much from the class of persons who visit the National Gallery. . . . More copious emanations and exhalations would arise from their clothing than from that of other persons who went decently dressed, and for the real purpose of seeing the pictures." [126]

One witness spoke of the "peculiar odour" that permeated the gallery, "as any one will discover who goes in late in the day; I think Carlyle said something about a Museum headache, which he attributed to some mephitic change in the air of the room, by the breath of the crowds in it." [127] The great Michael Faraday, a member of several of the National Gallery commissions, had confirmed the suggestions made by others that the "organic miasmata" which arose from the perspiration of the crowds were causing rapid deterioration of the paintings. [128] One posthumous opinion on the question of the gallery's location was conveyed to the 1853 committee by a letter Sir Robert Peel had written shortly before his death in July 1850. The art-loving prime minister, who had once celebrated the establishment of the National Gallery in the very center of London as conducive to social harmony, had later experienced a radical change of heart.

I have my misgivings as to the fitness of the present site for a collection of very valuable pictures, combined with unrestricted access, and the unlimited right to enter the National Gallery, not merely for the purpose of seeing the pictures, but of lounging and taking shelter from the weather; to attempt to draw distinctions between the objects for which admission was sought, or to limit the right of admission on certain days, might be impossible; but the impossibility is rather an argument against placing the pictures in the greatest thoroughfare of London, the greatest confluence of the idle and unwashed. [129]

The report of the 1853 committee recommended the abandonment of the Trafalgar Square building and the construction of a new National Gallery at Kensington Gore; that this was not done, writes Philip Hendy, "is reason to be grateful to the national conservatism and unwillingness to devote funds to artistic ends." [130] The gallery's space problems were alleviated by the removal of the Royal Academy to its new headquarters in 1869, the enlargement of its facilities in 1876 and 1887, and the opening of the Tate Gallery in 1897. [131] In 1880, a new arrangement was made to accommodate the advocates of paying days at the National Gallery; for a fee of sixpence, visitors were allowed in on the two days of the week formerly set aside as artists' copying days. [132] As the century neared its close, the working class had itself become more "respectable"; [133] George Augustus Sala noted with satisfaction, in 1894, that the National Gallery was now

visited by intensely interested and appropriately conducted working-class families.[134]

It is certain that, during the fifties and sixties, a substantial portion of those who climbed the stairs on the east side of the Trafalgar Square building that led to the Royal Academy seldom set foot on the steps on the west side that led to the National Gallery. But despite the changes in working-class demeanor that so impressed Sala and others, the Academy remained unwilling to set aside times for gratis admission. When Leslie published his defense of the Royal Academy in 1914, the charge for admission to its annual exhibition remained what it had been for 145 years, one shilling. It is safe to hazard the guess that this long-attacked and fervently-defended admission policy expressed the still-persisting conviction of most Academicians that pecuniary and social advantages were thereby maximized.

The Formation of a New Art Public: The Grosvenor Gallery

In 1877, an event occurred which permanently affected the English art scene, bringing some spirits to heights of exhilaration and excitement, while causing others to draw back with alarm and revulsion. It was the opening of the famous Grosvenor Gallery, and it had a profound effect not so much on the composition of preexisting art publics—for Academy attendance continued to be de rigueur—as on the strength of their allegiances, their aesthetic self-identifications. One of those who disapproved of the new gallery was Elizabeth Thompson. "I felt myself getting more and more annoyed while perambulating those rooms," she wrote of her visit to the Grosvenor, expressing a reaction that would have been shared by many who enjoyed her Academy-hung realism, "and to such a point of exasperation was I impelled that I fairly fled and, breathing the honest air of Bond Street, took a hansom to my studio."[135] "To a large majority of the crowd who will soon be thronging the Academy," wrote the *Times* on 1 May 1877, "such pictures as these [on the walls of the Grosvenor] seem unaccountable freaks of individual eccentricity, or the strange and unwholesome fruits of hopeless wanderings in the mazes of mysticism and mediaevalism. On the other hand a devoted if small minority holds devoutly that there is no artistic salvation out of the pale of this school."

The paintings exhibited at the Grosvenor never represented a unified artistic philosophy—the range of genres and styles included neoclassical works by Watts, Leighton, and Poynter, examples of Burne-Jones's medievalism, Whistler's evocative *Nocturnes*, and realistic portraits by such

artists as the German Ferdinand Heilbuth and the French Alphonse Legros (the latter, long settled in England, had become Slade professor at University College, London, in the year preceding the Grosvenor's opening). Still, the works hung at the Grosvenor were closely connected, as the *Times*'s critic observed, "by virtue of their high aims and their appeal rather to the sympathies of the 'fit tho' few' than of the multitude."[136] Thus, from the very first, the Grosvenor was distinguished from the Royal Academy both by the appeal of its art and by its public, which derived from the most elite segments of the Academy's publics.

The Grosvenor was not, like the Royal Academy, a corporate body with a long and complex history, but a proprietary institution that in its brief existence reflected the plans and ideals of two people whose subsequent estrangement was the primary cause of the gallery's demise. An account of the character of this gallery may therefore properly begin with an account of Sir Coutts and Lady Lindsay.

Sir Coutts Lindsay had been an army man before deciding to devote himself entirely to art. By 1875 this wealthy baronet—the handsomest man in London, Whistler called him—had exhibited at least ten pictures at Royal Academy exhibitions and thus had first-hand experience of the problems faced by outsider-artists; most of the Grosvenor's innovations were in fact formulated as conscious alternatives to Academy practices. Sir Coutts was not, however, solely an art reformer, but also a would-be reformer of artists, who had urged the Royal Academy commission of 1863 that a test of general education be required as a condition of admission into the Academy's schools; such a measure, he had said, would "raise the character of art, as a man's view of art depends upon his education." When confronted by the question that such a plan naturally suggested to those who had lived during the lifetime of Turner—would not such a test have kept the greatest English artist from attending the schools?—Sir Coutts's answer was unequivocal: the poorly educated Turner would have been a far greater man had he been forced to acquire a better education.[137] The gentleman-artist would pay but scant homage to the artist who was no gentleman.

Blanche Fitzroy, who had married Sir Coutts Lindsay in 1864, was the daughter of Henry Fitzroy, M.P., and Hannah Meyer, daughter of Nathan Meyer Rothschild and sister of Baron Lionel de Rothschild. An amateur artist like her husband, Lady Lindsay was also a gifted musician; she composed, played the violin, and was a good enough pianist to accompany the violinists Joachim and Madame Neruda. She loved Italy and Italian painting and dressed (or draped) herself "aesthetically" long before the

35. George Du Maurier, "À Fortiori" (*Punch*, 31 May 1879). The opening of the Grosvenor Gallery in 1877 recognized and strengthened currents in art and taste that we know as the Aesthetic movement. Adherents of this movement identified Frith as one of those most guilty of catering to the crude philistinism of an undiscriminating art public. In the father's comments, the cartoonist may also be reflecting signs of the softening of the demand for contemporary paintings.

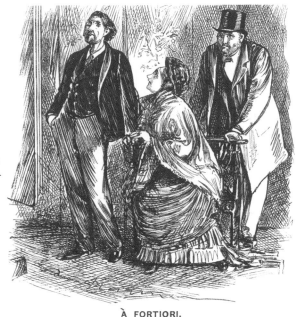

À FORTIORI.

Philistine Father. "WHY THE DICKENS DON'T YOU PAINT SOMETHING LIKE FRITH'S 'DERBY DAY'—SOMETHING EVERYBODY CAN UNDERSTAND, AND SOMEBODY BUY?"

Young Genius. "EVERYBODY UNDERSTAND, INDEED! ART IS FOR THE FEW, FATHER, AND THE HIGHER THE ART, OF COURSE THE FEWER THE FEW. THE HIGHEST ART OF ALL IS FOR ONE. THAT ART IS MINE. THAT ONE IS—MYSELF!"

Fond Mamma. "THERE SPEAKS MY OWN BRAVE BOY!"

style came into fashion. Her closest friends came from the worlds of art and literature; among these were Arnold, Browning, Watts, Burne-Jones, and Leighton.[138]

Adolph Tomars has written in his *Introduction to the Sociology of Art* that power, leisure, and luxury are elements of high rank that encourage aesthetic cultivation, while the combination of leisured cultivation with the amateur practice of art tends to favor the development of an art of complexity and purism, an art whose content shuns mundane concerns and which is susceptible to the influence of an art-for-art's-sake bias.[139] The Lindsays and their establishment exemplify Tomars's generalization. Luxury, taste, refinement, wealth, the longing for a beauty that turned its back on nineteenth-century industrial England, either transmuting its reality (as in Whistler's poetic cityscapes) or evoking images of ages long past—such were the characteristics of the Grosvenor and of the art most typically associated with it. Here is a description by one contemporary, a young artist when the gallery opened:

It suggested the interior of some old Venetian palace, and the pictures, hung well apart from each other against dim rich brocades and amongst fine pieces of antique furniture, showed to unusual advantage. I can well remember the wonder and delight of my first visit. One wall was iridescent with the plumage of Burne-Jones' angels, one mysteriously blue with Whistler's nocturnes, one deeply glowing with the great figures of Watts, one softly radiant with the faint, flower-tinted harmonies of Albert Moore.[140]

Aristocratic taste and luxury certainly gave the Grosvenor its characteristic tone, but the gallery would never have achieved its important position in the cultural life of the late 1870s and 1880s if it had represented the ethos solely of that social class whose economic strength and political power were steeply declining. The Grosvenor Gallery should be viewed not only as an attempt to restore the leadership of aristocratic taste in matters of art, but also as an example of a new form of middle-class culture, based upon the increasing convergence of the way of life and aspirations of a portion of the middle class (particularly its professional segment) with the style of life and outlook of the aristocracy. This crystallization of new social trends could not have been accomplished by the Lindsays alone; their collaboration with the two codirectors of the gallery, Joseph Comyns Carr and Charles Hallé, may be regarded as symbolic of the Grosvenor's fusion of upper-class refinement and claims to aesthetic preeminence with middle-class social aspirations.

Hallé, son of the famous German-born pianist and conductor Sir Charles Hallé (the Manchester orchestra he founded in 1857 still bears his name),[141] was a fifth-rate painter of romantic appearance and upper-class predilections. After studying painting for a while in France with his father's friend Victor Mottez, a pupil of Ingres, Hallé lived in Italy, where he socialized with a circle of English aristocrats and took part in a duel. Illustrative of Hallé's strong sense of identification with aristocratic manners was his advice given in *Notes from a Painter's Life,* a book of reminiscences published in 1909, that Englishmen going abroad into "society" learn to handle weapons, as "it is impossible to avoid the chance of having to fight."[142] Hallé, whose reputation was that of a witty and charming man always in financial straits,[143] was (until the start of his career as manager of the Grosvenor) a member of what Thorsten Veblen has termed the spurious leisure class, a class composed of people living economically precarious lives but "morally unable to stoop to gainful pursuits."[144] An artist and would-be gentleman, Hallé, like Sir Coutts Lindsay, had firsthand experience of the inadequacies of the Royal Academy exhibitions. As one who had long played the role of the artist as the "spiritual version of the

gentleman,"[145] Hallé was ideally suited to serve as an intermediary be-
tween the Grosvenor's painters and the aristocratic segment of its public.

Unlike Hallé, whose social background may be called ambiguous (lack-
ing his father's gifts, he was unable to find a permanently secure place in
the aristocracies of birth, wealth, or talent), Joseph Comyns Carr, jour-
nalist and playwright, had a clear sense of social identity. Born in 1849, the
seventh of ten children of a London businessman of modest means, Carr
was sent to a school "designed for boys of the middle classes, of whom
I was one" to prepare for a commercial career.[146] At the age of sixteen, he
was apprenticed to a stockbroker, but was unhappy with the work. Al-
though he realized that his natural bent was towards writing, the need for
a practical goal led him to choose law. After studying at London Univer-
sity, Carr began his new career, but this too proved to be a false start; the
heavy expenses of starting a law practice had to be met by income from
the articles he was writing. Once he decided to marry in 1873, it had be-
come clear that journalism rather than law would become his means of
livelihood.[147]

A series of articles that Carr wrote for the *Pall Mall Gazette* on the need
for Royal Academy reform attracted the attention of Sir Coutts Lindsay
and Charles Hallé, who were then making plans for a new art gallery. Carr
and his wife were invited to learn more of these plans at a shooting party at
the Lindsays' estate in Scotland, a party which included people prominent
in literature and art, and in high society.[148] Socializing with this illustrious
company was a new experience for Carr, who dealt with his sense of social
rawness by making fun of himself as "one of the lower-middle class" little
used to the ways of the great.[149] The self-consciousness, and probably the
self-mockery, concerning his social origins, disappeared with further ac-
quaintance with high society, and Carr became a popular figure as a gal-
lery manager, playwright, art critic, and public speaker; he remained,
however, one who "lacked the means to gratify his cultured tastes."[150]

Here, then, was the quartet that set the tone for the Grosvenor: two aris-
tocratic art amateurs and two young men of middle-class origin who lived
by their wits. Of the latter, one was an impecunious would-be aristocrat,
the other a charming and enterprising freelance writer. How did the
Grosvenor reflect the character of this partnership? In adapting the stan-
dard shilling admission (a fact carefully included by the *Times* in its pre-
view article on the gallery), the managers of the Grosvenor were accepting
the same economic boundaries as for the Academy's art audience; its pub-
lic was to be made more exclusive not by means of a financial barrier, but
by a choice of art that would proscribe the popular and the vulgar. The

Times noted with interest one important innovation: a *limited* number of season tickets was to be issued that would admit the bearer and a guest any day of the week, including Sunday. Two significant differences from Academy practice were contained in this plan: the exclusiveness attached to season ticket purchase and the promise of Sunday viewing.[151] The Academy was never open on Sunday, and season tickets to its shows were sold as a matter of profit and convenience and in unlimited numbers. The choice of Sunday as the most exclusive day for visiting the Grosvenor reflects some of the same influences analyzed in the discussion of Show Sunday: the weakening hold of religion, particularly in the higher social classes, and the extent to which art had absorbed some of the spiritual dedication once directed towards religious practices.

It was by means of the famous Sunday afternoon parties at the Grosvenor that Lady Lindsay made her unique contribution both to the gallery and to London's social life. The guest lists encompassed a wide social range, "from H.R.H. Edward, Prince of Wales, down to the queerest little characters from the third floor backs of Battersea." Invitations to these receptions and to the Grosvenor's private views, wrote Mrs. Carr, "were eagerly sought by all classes of Society." Socially, the Grosvenor, brilliant with the glamour of fashion, "quite eclipsed the Academy." Its social tone was qualitatively different from that created by the elite functions at Burlington House. The Academy's Private View Day and Banquet were one-time-only annual events, given by member-artists to certain select social groups invited to pay homage to art and to lend to the Academy an atmosphere of social distinction. Altogether different was the situation at the Grosvenor, which was founded through its proprietors' high status and connections and which incorporated as an essential ingredient of its functioning the deliberate and continuous mingling of the publics of art and of society. The line between these two publics was deliberately blurred by the Lindsays and their two codirectors; socialites and painters were to be considered, all, as guests of the Grosvenor. It was an important part of the Lindsays' "mission" to establish a closer link between artists and "the representatives of cultivated society"; in the opinion of Joseph Comyns Carr, the famous Sunday afternoons served this purpose well, providing the occasion for the forming of many new and valued friendships.[152]

It is significant that an informal reception or party, rather than a more ritualized event like the Academy's Banquet, was the symbol of the Grosvenor's success. Much of the new gallery's appeal—to shilling visitors, season-ticket holders, and painters—derived, in fact, from a special version of lavish upper-class hospitality. It was, as the *Times* noted, Sir Coutts

Lindsay's object to build a public gallery in which pictures and sculptures could be seen just as they are in the rooms and halls of private houses, surrounded with the appropriate adornment of harmoniously decorated walls and furniture. The comfort of visitors was carefully considered in the planning of the Grosvenor; chairs were provided in all the rooms so that visitors could move them and sit before pictures of particular interest—a striking contrast to the arrangements at the Academy, where heavy sofas were immovably fixed in the center of the exhibition rooms.[153]

In keeping with the atmosphere of upper-class hospitality was the treatment of exhibitors. Artists were "invited" to show at the Grosvenor; an invitation to this select exhibition was considered a great compliment and was usually preceded by one to dine with the Lindsays.[154] The *Times* informed its readers that Sir Coutts Lindsay was particularly interested in showing artists whose work was too "ascetic" to be at home at the Academy; he believed that painters of such sensitive fiber should be treated with "indulgence and consideration."[155] There was to be no demeaning process of submitting works (among thousands of others) to be judged by a harried and not always disinterested jury, no anxious period of waiting to hear if one's pictures had been accepted, rejected, or put into the limbo of "doubtfuls," no worry of finding one's pictures hung so high as to be barely visible. Once invited to exhibit, the artist was free to choose the pictures he wished to show and to indicate how much hanging space he would need. The paintings were attractively spaced—in sharp contrast to the cluttered Academy walls—and the works of each artist were to be grouped together: "Thus is avoided the jar produced by juxtaposition of incongruous pictures, while the large amount of wall space in proportion to the pictures gives rest to the eye and mind."[156]

The Grosvenor Gallery may be considered as representing a stage in the evolution of the painting exhibition. The Royal Academy's frame-to-frame show has been characterized as an obsolete relic of eighteenth-century art exhibitions that mirrored the attitudes of patrons who displayed their own collections so as to evoke wonder and admiration[157]—not only at the extent and value of their treasures, but also at the patrons' great wealth and cultivation. This form of picture exhibition changed very slowly; the desire and economic need of large numbers of artists to exhibit at the most prestigious shows—in England, that of the Royal Academy—kept the crowded, miscellaneous form of exhibition alive long after it had ceased to be regarded as aesthetically satisfactory. Romanticism's cult of personal, individual genius insisted, eventually, on very different exhibition arrangements to be ordered not by the pride of the patron, but by the rights

of the artist. This newer type of exhibition invited the viewer not to admire the taste and wealth of a patron, but to experience the depth and power of an artist's imagination. A show limited to the work of a single artist could best fulfil this exhibition ideal,[158] but economic considerations and the large numbers of would-be exhibitors limited the feasibility of exclusive showings. The Grosvenor, with its respectful treatment of artists and its aesthetic hanging of their paintings, was certainly a major step in advance of the Royal Academy and a far closer approximation to the kind of exhibition that artists wanted.

From the very first, however, the new establishment had its detractors. There were critical comments about the hanging of "amateur efforts"[159] (including pictures painted by Sir Coutts and by Hallé),[160] and complaints that the visual heaviness of the opulent decor interfered with concentration on the paintings. Ruskin, in the same article in which he denounced Whistler's contribution to the Grosvenor's opening exhibition, expressed irritation with the gallery's furnishings; its upholstery, he wrote, is "grievously injurious" to the best pictures, "while its glitter as unjustly veils the vulgarity of the worst."[161] Particularly significant testimony as to how far short the Lindsays' establishment fell of painters' ideals was later given by the major Grosvenor artist, Edward Burne-Jones. The costly crimson hangings, he said, "suck the colour" out of pictures, and the bright tables cause distracting reflections in the glass that covers some of the canvases. Burne-Jones felt strongly that sumptuous fittings had no place in a picture gallery, which should be plain, well proportionied, and well lighted, perhaps with white-washed walls. An architect should design such a gallery only with the help of a painter and should aim for "a kind of sublimated barn," in which the welfare of the paintings takes precedence over all other considerations.[162]

The close association of the Grosvenor Gallery with interior decoration and "aesthetic" dress—Whistler and the Pre-Raphaelites were, of course, important influences in both—the crucial position of Blanche Lindsay in the financing of the gallery and in the management of its social affairs, the prominence of Rossetti-inspired, mystical idealizations of femininity in the exhibition rooms, the inclusion of women at the Grosvenor banquets—indeed, Sir Coutts had announced at the opening dinner a curtailment of toasts which, "there being so many ladies present, are better fitted for their companions"[163]—all these factors point to an extremely significant characteristic of the Grosvenor, one which distinguished it from the Royal Academy just as much as did its innovative hanging arrangements. Louise Jopling provides an example of this differentiation in the form of a letter

she received from a man who had commissioned her to paint his wife's portrait:

Dear Mrs. Jopling:

I cannot tell you how surprised and indignant I am to hear from my wife today that you intend to send her portrait to the Grosvenor, and that you have not sent it to the Academy. I thought it was quite understood between us that it should go to the Academy, or not be exhibited at all. I think you might have asked my permission before deciding at the last moment to send the portrait to the Grosvenor, and I consider I have been treated with very scant courtesy, in not being informed of your change of plans. . . .

The pretty wife, writes the artist (clearly amused at her sitter's duplicity), had wanted her portrait at the Grosvenor![164] What is the significance and what are the social correlates of this close identification of the Grosvenor with the female presence?

The 1870s have been described as a period of great concern for proper social forms and rituals,[165] a concern that reflected a much-increased fluidity in the composition of London's fashionable elite. The incomes of many landowners fell steeply beginning in the late seventies. The growing insecurity of the land-based wealth of much of the aristocracy (whose members made their annual migrations to London in time for the opening of the Academy and Grosvenor exhibitions at the start of the "season") led members of that class to be more open to (and even desirous of) association with groups representing newly acquired commercial and industrial wealth.[166] At the same time, members of London's new "urban gentry"[167] of professionals were consolidating a way of life which, formed in a spirit of social emulation of the upper classes and fueled by the heady prosperity of the fifties and sixties, entailed a pattern of heavy expenditures. Those who could afford to (and doubtless many who could not) lived in elegant homes, entertained lavishly, purchased carriages that were a public declaration of high status, hired a large staff of servants, and sent their sons to public schools for an education that, it was hoped, would ensure continuance of this recently acquired status. It may be that the need to tighten budgets, felt during the altered economic circumstances of the seventies and eighties, increased the importance of avenues of social emulation that were relatively inexpensive. The minimal cost of a series of Grosvenor visits could enhance efforts to eliminate residual philistinism by purifying taste and by providing opportunities for a close and socially useful acquaintance with the aesthetic preferences of those of high social rank.

Status-conscious wives had an important role to play in pursuing activities that put the stamp of legitimacy upon gains in social mobility, for the

male portion of this new London gentry was occupied, and frequently heavily so, with work. But many of their wives had ample time for visiting galleries, perhaps during the course of the rounds of social calls and luncheons and teas that shaped the lives of middle- and upper-class women.[168] The women of these social classes, unburdened by domestic chores that were performed by the army of servants that grew to astonishing size in nineteenth-century England,[169] were free to perform in a higher sphere. Those who had been born into families of means or of social ambitions had probably been educated specifically for that sphere, that is, for a leisured life that would provide the appropriate setting for such feminine accomplishments as music, drawing, dancing, and French.[170] P. G. Hamerton, art critic and editor, reccunts a conversation he had in the late fifties with a wealthy banker whose daughter he wished to marry. The banker, whom Hamerton greatly admired for his thoughtfulness and intellectual honesty, attempted to dissuade him from pursuing the match. "Our young ladies," he said, referring to those of the upper-middle classes, "do nothing of the least use, and require to be first expensively educated, and afterwards expensively amused."[171]

Women of this background, and others recently entered into the class that provided its daughters with similarly genteel educations and aspirations, must have accounted for a substantial portion of the Grosvenor's public. (Included among them were present and former students in London's art schools.) The professional men who were their husbands represented a group that had dramatically altered its self-image during the third quarter of the nineteenth century. (The professions, wrote one eminent lawyer in 1857, "form the head of the great English middle class.")[172] Pride at being in the forefront of the useful, industrious, and productive classes, and even something of the antiaristocratic savor of the Reform Bill and Anti-Corn Law movements remained important components of professional identity throughout the 1850s. But by the time of the Grosvenor's birth two decades later, the viewpoint had changed. The insistent striving after gentility gained momentum during the fifties and sixties and could be seen in the middle-class abandonment of the city's poor for the more gentrified living of the suburbs and in the increasing urban middle-class support for the Conservative party. This meant that the upper reaches of the middle classes were now turning towards the aristocracy, eager to assimilate its social graces and elevated tastes. Professional men, hardpressed as ever by work and responsibilities during the Grosvenor's decade of existence, could enjoy the vicarious cultivation available to them by means of the participation of their wives and daughters.

Refinement, nobility, sanctity, elegance, a tendency towards conventionalization—these characteristics, as Tomars has pointed out, are of central importance to the quasi-religious aura that surrounds a social elite and forms the core of its artistic preferences.[173] All of these words have been used in descriptions of the art most closely associated with the Grosvenor, but the first has seemed particularly fitting in conveying the dominant impression of the paintings of Burne-Jones. In the opinion of one chronicler of the eighties, the major flaw in that artist's beautiful illustrations of classical myths, medieval legends, and Scandinavian sagas, was over-refinement:

Surely, in his devotion to refinement, he has refined too far! In the intent of showing us the virginal he has given us the leanness of middle-aged maidenhood. These are heavy-eyed, heavy-lidden maidens, moreover, as though they had shed tears for sin of which we feel convinced that they are not guilty; they express a humility or a bashfulness, by an inability to hold their necks straight upon their shoulders; it is as though their necks were without bone and sinew. His men, his very Vikings and heroes of classic story, have the like negative characteristics. He has put away from them all fleshiness. . . . They are fine-drawn to the point of emaciation; they would all be the better for what is vulgarly called "a full meal." We have to recognise that it is done in noble aspiration to show us all that is highest and most spiritual in humanity. It is a lofty aim that he has placed before him. His error surely has been in going too far in the one direction in seeking it.[174]

Responding to the same qualities, Quentin Bell has described the world of Burne-Jones's paintings as "irreproachably lady-like," a world of beauty and high ideals that is the pictorial representation of a seemly social ideal: "It was to this that the cultivated classes of Manchester aspired—a lovely pensive existence amidst Italianate scenery peopled by graceful persons, . . . intense, serious and in every sense of the word, gentle."[175]

It would be very wrong, however, to imply that the main constituent of the Grosvenor's appeal lay in its celebration of gentility and refinement. Even a critic as convinced of the ubiquity of English philistinism as was Roger Fry had to admit that those who identified with the Aesthetic movement experienced a genuine passion for beauty. England during the 1860s and 1870s, wrote Fry long afterwards, was "given over to art to an extent which we find it hard to understand."[176]

It was beauty of a special kind that particularly entranced the Grosvenor's art public, beauty with strongly religious content and overtones. Beauty, said Watts, a major Grosvenor exhibitor, is the face of God; to make acquaintance with it is to cultivate religious feeling.[177] Words like *cult, devotion, fervor, acolyte, ascetic,* were frequently used in describing both the

figures in the gallery's pictures and those who came to see them. The Rossetti-inspired second stage of Pre-Raphaelitism, has appropriately been called an atheological religion.[178] The cast-off past of family prayers and Sunday restrictions—one thinks of Ruskin's evangelical mother turning the family's pictures to the wall each Sunday—placed its mark upon the cult of beauty. Pre-Raphaelitism was characterized by Roger Fry as a highly Protestant form of religion, in which salvation could be attained by transcending the world of getting and spending and by opening one's soul to the high and ennobling influences of art.[179] The "intensity" that was the outward mark of the novice aesthete—a look memorialized by Du Maurier in *Punch*—was the sign of grace received.[180]

But not even the very temple of Aestheticism could turn its back for long on the world of getting and spending. The building of the Grosvenor had entailed enormous expense; Sir Coutts Lindsay had responded to the legal challenges of nearby residents to the gallery's plan by buying up most of the houses on the block, raising his initial investment to about one hundred thousand pounds, far more than had been allocated.[181] Whether or not there was truth to Hallé's charge that the Grosvenor's restaurant had "swallowed up" the profits made by the gallery,[182] it was true that the losses had kept increasing, especially after 1882, when the Lindsays separated and Lady Blanche withdrew her funds from the enterprise.[183] In 1884, a business manager was hired who (two years later) leased the gallery to what Hallé called a "smoking, drinking and comic-song-singing" club;[184] restaurant advertisements were now hung in the entrance hall of the gallery, and Burne-Jones protested these new arrangements in a letter to Sir Coutts Lindsay.[185]

In 1887, Carr and Hallé decided to end their decade-long involvement with the Grosvenor. They opened their own exhibition rooms in a place they called the New Gallery. Burne-Jones and most of the other artists associated with the Grosvenor went with them, and the New Gallery became the new center of Aestheticism. By this time, however, the movement had lost much of its heady excitement, and the New Gallery never developed the mystique that had been such a memorable feature of its predecessor. It continued to attract interest, however, because Watts and Burne-Jones exhibited there. The career of the New Gallery ended in 1898 with the death of Burne-Jones.[186]

Interviewed in 1887 about the dispute with Carr and Hallé, Sir Coutts Lindsay reluctantly told the reporter for the *Pall Mall Gazette* that this was altogether a private matter and of no conceivable public interest:

"Well, but in its bare outline, master and paid servants—I do not mean this in an offensive sense—could not agree on matters of administration: why should the servants any more than the master trouble the world about it? I cannot see their motive. . . .

"As regards Mr. Burne-Jones, I have conversed with him on the subject and have always found him on the non-commercial side. 'Money?' he says; 'what do you want with money when you have to do with art?' Theoretically beautiful, but impracticable; for money, as you must know, is an absolute necessity. Mr. Burne-Jones!" added Sir Coutts, with a pleasant smile, "for whom I have been nicknamed 'greenery-yallery.' And I assure you that I am not at all 'greenery-yallery' either in feeling or anything else."[187]

The days when living painters and their works could arouse enormous numbers of people to a high pitch of excitement were ending. The deaths of Burne-Jones, Millais, Watts, and Leighton, which occurred within a few years of Queen Victoria's, were correctly interpreted as signifying the end of an era. Those who had denounced the establishment of the Grosvenor as revolutionary proved correct.[188] The unity of the art world had been shattered, and the process would be carried to its logical conclusion in the next century. In 1907 Walter Crane could note that cliques and small groups of artists were the order of the day.[189] The splintering of the art world into unstable movements and factions (together with the emphasis on formal concerns over thematic content) has served increasingly to remove the painter from the mainstream of ordinary life. Much of the painting of our own times has developed in accordance with the course that Whistler prescribed and in keeping with his characterization of art as selfishly preoccupied with its own perfection,[190] "the worst aristocrat of all."[191] Thus Whistler's celebrated farthing, awarded to him as damages in the suit against Ruskin and defiantly worn on his watch-chain, presaged an art world very different from that which had prevailed during the reign of Queen Victoria.

Notes

Chapter 1. Introduction

1. John Everett Millais is the Victorian artist most frequently singled out as a case of great talent turned to mediocrity. At a large retrospective exhibition of his works held at the Grosvenor Gallery in 1886, Millais told a friend about the anguish he felt in viewing his own early works. "In looking at my earliest pictures," he said, "I have been overcome with chagrin that I so far failed in my maturity to fulfill the forecast of my youth" (William Gaunt, *The Pre-Raphaelite Dream* [New York, 1966], 199). Quentin Bell has characterized a number of gifted Victorian painters, including the eminent Edward Poynter, as victims of their period (Quentin Bell, *Victorian Artists* [London, 1967], 51). According to Bell, a number of the remarkably talented artists of the 1890s followed the same path as Millais. Of William Orpen, Ambrose McEvoy, Augustus John, and others: "It is in a way shocking to discover how good they once were" (ibid., 83).

2. Eric Newton, *British Painting* (Edinburgh, 1945), 9. The author was Slade professor at Oxford in 1959 and 1960.

3. "I do not think that paintings more displeasing to the eye have ever been produced. It is hard to imagine more crude effects, more exaggerated and violent colouring, more extreme and glaring dissonances, a falser and more abrupt commingling of tones" (Hippolyte Taine, *Notes on England* [1872; reprint, New York, 1974], 335).

4. Adelaide Sartoris, *A Week in a French Country-house* (London, 1867), 100. Mrs. Sartoris was a sister of the actress Fanny Kemble.

5. M. S. Watts, *George Frederic Watts: The Annals of an Artist's Life*, 3 vols. (London, 1912), 3:25.

6. Hippolyte Taine, *Lectures on Art*, trans. J. Durand (New York, 1889), 218.

7. Ibid., 219.

8. Kenneth Clark, "Art and Society," *Harper's Magazine*, August 1961, 79.

9. Lady Eastlake's comment on the British art public is quoted in A. Paul Oppé, "Art," in G. M. Young, ed., *Early Victorian England: 1830–1865*, 2 vols. (1934; reprint, London, 1951), 2:140.

10. Ibid., 147; quoted in Campbell Lennie, *Landseer* (London, 1976), 126.

11. Sir Joshua Reynolds, *Discourses on Art* (London, 1969), 247–248. Reynolds's lectures were delivered to Royal Academy students between 1769 and 1790; this edition is based on the 1797 edition of Reynolds's *Works*.

12. *Parliamentary Papers: Report of the Select Committee on Art Union Laws*, 1866, no. 332.

13. Harrison C. White and Cynthia A. White, *Canvases and Careers: Institutional Change in the French Painting World* (New York, 1965), 31; see also Thomas E. Crow, *Painters and Public Life in Eighteenth-Century Paris* (New Haven, 1985), 11–15.

14. Lady Eastlake, in Sir Charles Lock Eastlake, *Contributions to the Literature of the Fine Arts, with a Memoir Compiled by Lady Eastlake* (London, 1870), 147.

15. "Anecdotes from the history of past ages, chosen rather from the costume of the

actors than from the idea which they embody, studies of humble life, and reminiscences of juvenile innocence divide with landscape almost the whole attention of our rising artists" (*Times*, 7 May 1855).

16. "The painters who have applied themselves more particularly to low and vulgar characters," wrote Sir Joshua Reynolds, "and who express with precision the various shades of passion, as they are exhibited by vulgar minds, (such as we see in the works of Hogarth,) deserve great praise; but as their genius has been employed on low and confined subjects, the praise which we give must be as limited as its object" (*Discourses on Art*, 51).

17. From David Garrick's epitaph for Hogarth; quoted in Richard Muther, *The History of Modern Painting*, 2 vols. (London, 1907), 1:16.

18. "Art Publications," *Art Journal* 40 (1878): 176.

19. Ruskin rated Millais's *Rescue* above Leighton's *Cimabue* because of its appeal to a higher order of emotion (Emilie Isabel Barrington, *The Life, Letters, and Work of Frederic Baron Leighton of Stretton*, 2 vols. [New York, 1906], 1:235); Timothy Hilton, *The Pre-Raphaelites* (London, 1970), 140; "We fixed upon this name [the Hogarth Club] to do homage to the stalwart founder of modern English art," wrote William Holman Hunt (*Pre-Raphaelitism and the Pre-Raphaelite Brotherhood*, rev. ed., 2 vols. [New York, 1914], 2:142–143).

20. Richard Redgrave, *The Sheepshanks Gallery* (London, 1870), 4.

21. "Annual Report of the Director of the National Gallery to the Treasury for the Year 1885. Presented to Parliament, 1886," *Quarterly Review* 163 (1886): 415–416.

22. Alfred Lys Baldry, "Marcus Stone," *Art Journal* 58 (1896): 5.

23. Walter Pater, *The Renaissance* (1873; reprint, New York, 1959), 94.

24. Frank Rutter, *Art in My Time* (London, 1933), 26–27.

25. Virginia Woolf, *The Captain's Death Bed* (London, 1950), 49.

26. See Werner Hofmann, *The Earthly Paradise: Art in the Nineteenth Century*, trans. Brian Battershaw (New York, 1961), 363–364.

27. Quoted in Penelope Fitzgerald, *Edward Burne-Jones: A Biography* (London, 1975), 36, 135.

28. Cited in Max Friedländer, *On Art and Connoisseurship*, trans. Tancred Borenius (Boston, 1960), 139–140. "The art of the nineteenth century is essentially an artist's art. It is free from tradition and therefore has no hold in anything outside itself which could act as a restraining influence. Since they are judged by their inward consistency, its creations must submit to a very strict differentiating analysis—an analysis of uncompromising harshness, that rejects the idea of a moderately good performance, which so long as style existed provided style with a kind of testing ground. The line dividing weak art from strong, the line between dead formula and living expression, between patchwork that is empty of life and true creation of form, was now drawn in with a ruthlessness that was wholly new" (Hofmann, *Earthly Paradise*, 116).

29. The following are noteworthy examples of studies published since the mid-1970s: Kenneth Bendiner, *An Introduction to Victorian Painting* (New Haven, 1975); Wilfrid Blunt, *"England's Michelangelo": A Biography of George Frederic Watts, O.M., R.A.* (London, 1975); Susan P. Casteras and Ronald Parkinson, eds., *Richard Redgrave: 1804–1888* (New Haven, 1988); Susan Casteras, *The Substance and the Shadow: Im-*

ages of Victorian Womanhood (exhibition catalogue, Yale Center for British Art, New Haven, 1982); Fitzgerald, *Burne-Jones;* Richard Ormond and Léonée Ormond, *Lord Leighton* (New Haven, 1975); Rosemary Treble, *Great Victorian Pictures: Their Paths to Fame* (exhibition catalogue, Royal Academy of Arts, London, 1978); Julian Treuherz, ed., *Hard Times: Social Realism in Victorian Art* (London, 1987); Paul Usherwood and Jenny Spencer-Smith, *Lady Butler, Battle Artist: 1846–1933* (London, 1987); Christopher Wood, *Victorian Panorama: Paintings of Victorian Life* (London, 1976).

30. "The much envied prosperity of England," wrote T.S.R. Boase, "was in the period between the Crimean War and 1914 to be discounted by a not unmerited continental contempt for English taste and visual accomplishment" (*English Art: 1800–1870* [Oxford, 1959], 319). Kenneth Clark characterized the same period as one which saw "the consolidation of a Philistinism unequalled since the Roman Republic" ("Art and Society," 79). For a more appreciative view, see Robert Rosenblum, "British Art and the Continent, 1760–1860," in Allen Staley and Frederick Cummings, *Romantic Art in Britain* (Philadelphia, 1968).

31. F. G. Stephens, *Artists at Home* (New York, 1884) provides an interesting set of photographs, several of which are reproduced in this volume.

32. John Guille Millais, *The Life and Letters of Sir John Everett Millais,* 2 vols. (New York, 1899), 2:93–94, 159.

33. See Gerald Reitlinger, *The Economics of Taste: The Rise and Fall of the Picture Market, 1760–1960* (New York, 1961). Reitlinger places the "golden age of the living painter" between 1860 and 1914, but his interest is with the very famous only. When one regards the wider group of artists, it is clear that prosperity began and ended far earlier.

34. Sidney C. Hutchison, *The History of the Royal Academy in London: 1768–1968* (London, 1968), 139.

35. *Times,* 27 November 1878. (Reports on the Whistler-Ruskin trial were published in the *Times* on 26 and 27 November.)

Chapter 2. Gentlemen of the Brush

1. John Steegman, "Sir Francis Grant, P.R.A.: The Artist in High Society," *Apollo,* June 1964, 479–484.

2. Richard Redgrave and Samuel Redgrave, *A Century of British Painters,* ed. Ruthven Todd (1866; reprint, London, 1947), 359; Clara Erskine, Clement Waters and Laurence Hutton, *Artists of the Nineteenth Century and Their Works,* rev. ed., 2 vols. (1894; reprint, New York, 1969), 1:310.

3. Lord Melbourne had sat to Grant for his portrait in 1838; this commission had very likely brought Grant to the queen's attention. Steegman quotes from the diary of the queen; the entries between April and October 1839 recorded her impressions of the artist and his work (Steegman, "Sir Francis Grant," 484).

4. William Makepeace Thackeray, *The Newcomes,* 2 vols (New York, 1899), 1:264. (Published as volumes 9 and 10 of the *Complete Works of William M. Thackeray;* New York, 1899.)

5. Steegman, "Sir Francis Grant," 484; the comment was contained in a letter from the queen to John Russell.

6. Edward Burne-Jones, "Essay on *The Newcomes,*" *Oxford and Cambridge Magazine,* 1856, 56–57.

7. From a letter written to a cousin in October 1855, quoted in Fitzgerald, *Burne-Jones,* 38–39.

8. Paul Thompson, *The Work of William Morris* (London, 1967), 2.

9. J. W. Mackail, *The Life of William Morris* (Oxford, 1950), 288.

10. R. K. Webb, *Modern England from the Eighteenth Century to the Present* (New York, 1969), 37.

11. Philip Gilbert Hamerton, *An Autobiography, 1834–1858, and a Memoir by His Wife, 1858–1894* (Boston, 1897), 101; 104.

12. Quoted in Rudolf Wittkower and Margaret Wittkower, *Born under Saturn: The Character and Conduct of Artists: A Documented History from Antiquity to the French Revolution* (New York, 1963), 236.

13. W. Sandby, *The History of the Royal Academy of Arts, from Its Foundation in 1768 to the Present Time,* 2 vols. (London, 1862), 1:80–81. "Sir Godfrey Kneller, the last 'Knight of the Brush' (as Walpole described Reynolds), was probably buried in his garden at Whitton, but so little is known about the occasion that even this is not certain" (Ellis Waterhouse, *Reynolds* [London, 1973], 36).

14. Frederick W. Hilles, "Walpole and the Knight of the Brush," in Warren H. Smith, ed., *Horace Walpole, Writer, Politician, and Connoisseur* (New Haven, 1967), 147, 149–157; Geoffrey Grigson, "English Painting," in Boris Ford, ed., *From Blake to Byron* (Baltimore, 1957), 259.

15. William T. Whitley, *Artists and Their Friends in England, 1700–1799,* 2 vols. (London, 1928), 1:257.

16. Frederick W. Hilles, *The Literary Career of Sir Joshua Reynolds* (Cambridge, 1936), 4–11, 106–107.

17. Quoted in Wittkower and Wittkower, *Born under Saturn,* 279.

18. S. C. Hall, *Retrospect of a Long Life: From 1815 to 1883* (New York, 1883), 429.

19. Solomon Alexander Hart, *The Reminiscences of Solomon Alex. Hart, R.A.,* ed. Alexander Brodie (London, 1882), 76.

20. *Scènes de la Vie de Bohème,* 1845, described Murger's experiences during the 1830s and early 1840s. See LouAnn Faris Culley, "Artists' Lifestyles in Nineteenth-Century France and England: The Dandy, the Bohemian, and the Realist" (Ph.D. diss., Stanford University, 1975), 158–159.

21. Quoted in F. M. Redgrave, *Richard Redgrave* (London, n.d.), 35.

22. Hart, *Reminiscences,* 16–18. "The picture of *Lady Jane Grey's Execution* remained rolled up for a period of forty years. In 1879 I gave it to my native town. It is placed in the Hall of the New Municipal Buildings" (ibid., 19).

23. Redgrave, *Richard Redgrave,* 34; Redgrave and Redgrave, *Century of British Painters,* 294; *Dictionary of National Biography,* S. V. "Redgrave, Richard," by Robert Edmund Graves. See also Hamerton, *Autobiography,* 117.

24. Quoted in Oppé, "Art," 124.

25. Related in Samuel Smiles, *Self-Help; with Illustrations of Character, Conduct, and Perseverance,* rev. ed. (Chicago, 1881), 205.

26. George Dunlop Leslie, *The Inner Life of the Royal Academy* (London, 1914), 273.

27. Smiles, *Self-Help*, 213–214.

28. W. P. Frith, *My Autobiography and Reminiscences*, 2 vols. (New York, 1888), 1:277.

29. Ford Madox Ford, *Ford Madox Brown: A Record of His Life and Work* (London, 1896), 196.

30. Ibid., 190; this passage comes from the painter's own description of the picture.

31. Ibid., 195.

32. Derrick Leon, *Ruskin: The Great Victorian* (London, 1949), 239–240; Hilton, *Pre-Raphaelites*, 159.

33. Quentin Bell, *Ruskin* (London, 1963), 85.

34. From Whistler's account of the trial, published in Robert Peters, *Victorians on Literature and Art* (New York, 1961), 273.

35. Ruskin's comments on a just price for an artist's labor are from his statement of his case, "My Own Article on Whistler," in Leon, *Ruskin: The Great Victorian*, 527–528; Burne-Jones is quoted in Whistler's version of the trial, in Peters, *Victorians*, 276.

36. *Parliamentary Papers: Report of the Commissioners Appointed to Inquire into the Present Postion of the Royal Academy in Relation to the Fine Arts*, 1863, no. 3205.

37. A. S. Hartrick, *A Painter's Pilgrimage through Fifty Years* (Cambridge, 1939), 1–3.

38. Philip Gilbert Hamerton, *Thoughts about Art*, rev. ed. (Boston, 1876), 101–102; 120–124.

39. Ernest Chesneau, *The Education of the Artist*, trans. Clara Bell (London, 1886), 75.

40. Leon, *Ruskin: The Great Victorian*, 439; 77.

41. Leslie, *Inner Life*, 58.

42. *Report of the Commissioners*, 1863.

43. The novelist is quoted in Neil Harris, *The Artist in American Society: The Formative Years, 1790–1860* (New York, 1966), 79–81.

44. Chester Harding, *My Egotistigraphy* (Cambridge, Mass., 1866), 129; 133; 117.

45. A. M. Carr-Saunders and P. A. Wilson, *The Professions* (London, 1964), 303.

46. Marie Bancroft and Squire Bancroft, *Recollections of Sixty Years* (London, 1909), 72.

47. Francis Haskell, *Patrons and Painters: A Study in the Relations between Italian Art and Society in the Age of the Baroque* (London, 1963), 17.

48. Ibid., 117; Wittkower and Wittkower, *Born under Saturn*, 276.

49. T. H. S. Escott, *Personal Forces of the Period* (London, 1898), 277. By the time of this book's publication, painting was no longer a paying business for young entrants into the profession.

50. Francis Davenant, *What Shall My Son Be?* (London, 1870); see especially pp. 152–159.

51. Francis Davenant, *Starting in Life* (London, 1881), 116.

52. "The Royal Academy Schools," *Magazine of Art* 2 (1879): 59–60.

53. Quoted in Watts, *Watts*, 3:158–159.

54. Chesneau, *Education of the Artist*, 67–69.

55. Quoted in Peters, *Victorians*, 283.

56. W. L. Burn, *The Age of Equipoise: A Study of the Mid-Victorian Generation* (New York, 1964), 257–259.

57. William Holman Hunt, "Artistic Copyright," *Nineteenth Century* 5 (1879): 424.

58. This quotation is a composite taken from two accounts of Turner given by S. C. Hall (*Retrospect*, 422–423; *A Book of Memories* [London, 1871], 461–462).

59. Jack Lindsay, *Turner* (London, 1966), 185.

60. Ibid.

61. Redgrave and Redgrave, *Century of British Painters*, 265.

62. Ibid., 269.

63. Hart, *Reminiscences*, 50–51.

64. Hart, beginning upon a commission to paint the duke of Sussex, was amazed to find that his sitter was thoroughly acquainted with his earlier struggles: "I know when you lived in Newcastle Street, Strand, over the milk shop, where you struggled all day to get bread for certain members of your family whom you supported, and when you could only afford time in the evening to pursue your studies at the Royal Academy. I am glad to find you now a member of that body . . ." (Hart, *Reminiscences*, 124).

65. Philip Gilbert Hamerton, *The Life of J. M. W. Turner, R.A.* (Boston, 1882), 8–9.

66. Ibid., 367–368; 359; 144–145; 365; 366; 384–385; 378–379.

67. Frederick Goodall, *The Reminiscences of Frederick Goodall, R.A.* (London, 1902), 1–2; Graham Reynolds, *Turner* (New York, n.d.), 67.

68. Goodall, *Reminiscences*, 45–46.

69. Ibid., 47.

70. W. J. Reader, *Professional Men: The Rise of the Professional Classes in Nineteenth-Century England* (London, 1966), 147.

71. In addition to the books by Carr-Saunders and Wilson and by Reader, the following books and articles have all been helpful to this discussion of painting as a profession: J. A. Jackson, ed., *Professions and Professionalization* (Cambridge, 1970); Elliott A. Krause, *The Sociology of Occupations* (Boston, 1971); Bernard Barber, "The Sociology of the Professions," *Daedalus* 92 (Fall 1963): 669–688; Geoffrey Millerson, *The Qualifying Associations: A Study in Professionalization* (London, 1964); Sheldon Rothblatt, *The Revolution of the Dons: Cambridge and Society in Victorian England* (New York, 1968); Philip Elliott, *The Sociology of the Professions* (London, 1972); Eliot Freidson, *Professional Powers: A Study of the Institutionalization of Formal Knowledge* (Chicago, 1986).

72. While the military is often included among the professions, some analysts consider its nineteenth-century status as more aristocratic than professional; see Reader, *Professional Men*, 74.

73. Grigson, "English Painting," 259.

74. "Minor Topics of the Month," *Art Journal* 25 (1863): 58.

75. J. Reynolds, *Discourses on Art*, 150–151.

76. Stuart Macdonald, in *The History and Philosophy of Art Education*, identifies the years between 1800 and 1860 as the period when egregiously low standards and slack administration characterized the Royal Academy. Macdonald believes that standards were high at other times, especially under the presidencies of Reynolds and Leighton ([New York, 1970], 62–63). Other judgments have been far harsher. The late-Victorian

Academy has continued to be criticized for unfair treatment of "outsider" artists and for turning its back on new currents in the art world. For example, the critic D. S. MacColl wrote in 1893 that "the Academy School has been so poorly conducted that its pupils have to go elsewhere to unlearn what they have been taught" and criticized the Academy's annual exhibitions as "a bazaar in which attention is called to the cheapest and most meretricious" ("Exhibition," *Studio* 1(1893): 51. T. S. R. Boase identified a "growing breach between the Academy and much that was progressive in the arts" during the late Victorian period: "In its new galleries at Burlington House . . . the Academy began a career of more partisan selection and less certain authority" (*English Art*, 297). (The Academy moved to Burlington House in 1869.)

77. See Charles Eastlake's *Materials for the History of Oil Painting,* cited by Whitley, *Artists and Their Friends,* 1:330, 336; and William Holman Hunt, "The Present System of Obtaining Materials in Use by Artist Painters, As Compared with That of the Old Masters," *Journal of the Society of Arts,* 23 April 1880, 487. An American painter named Rand invented the collapsible tin tube; the invention was adopted by English color merchants Winsor and Newton in 1841 to contain their paints (Maurice Grosser, *The Painter's Eye* [New York, 1951], 72).

78. Grosser, *Painter's Eye,* 138, 143.

79. Hunt, "Present System," 487, 489, 492.

80. Ibid., 522.

81. See the Redgraves' account of Turner's work on Varnishing Days: "At these times, such was his love of colour that any rich tint on a brother painter's palette so tempted him that he would jokingly remove a large portion of it to his own, and immediately apply it to his picture, irrespective of the medium with which it was made up. From our own palette he has whisked off, on more occasions than one, a luscious knob of orange vermilion, or ultra-marine, tempered with copal, and at once used it on a picture he was at work upon with a mastic maglyph. Such a practice, productive of no mischief at the moment, would break up a picture when the harder drier began to act on that which was of a less contractile nature" (Redgrave and Redgrave, *Century of British Painters,* 255–256). Just after Turner's death in 1851, his fellow Academicians, meeting at his house before the funeral procession, were astonished to find "pictures flapping from their frames, covered with fallen plaster" (Boase, *English Art*, 275).

82. "Minor Topics of the Month: Painters' Morality," *Art Journal* 19 (1857): 384. A later example of charge of a painter's lack of ethics in the use of materials was given by C. J. Holmes; the painter in question was Charles Conder. "For nearly an hour on one occasion, he held me with a talk on the technique of painting on leather, detailed with a dreamy charm which rendered every moment enchanting. . . . He laid particular stress on the need for probity in the art, for the use of the most permanent materials, speaking with such apparent conviction that I was completely hypnotized, and could not believe for years that he himself was utterly unscrupulous in his own methods. It is something to have seen the superb early products of that genius, before the pigments had faded to mere dull stains, and the material beneath them had rotted away. No succeeding generation will understand our admiration for the exquisite symphonies in colour which Conder produced during the middle 'nineties.' Their fame was written in aniline dye" (C. J. Holmes, *Self and Partners (Mostly Self)* [New York, 1936], 170).

83. See C. F. Taeusch, "Professional Ethics," in *Encyclopedia of the Social Sciences* (New York, 1937).

84. Quoted in Goodall, *Reminiscences*, 211–212.

85. Ford, *Brown*, 208; 78. Frederick Goodall was the son of Edward Goodall, an engraver who worked for Turner.

86. J. Reynolds, *Discourses on Art*, 81–82.

87. *Parliamentary Papers: Report of the Select Committee on Art Unions*, 1845, no. 612.

88. Oswald Doughty, *Dante Gabriel Rossetti: A Victorian Romantic* (New Haven, 1949), 311.

89. F. Redgrave, *Richard Redgrave*, 43; Millais, *Millais*, 1:360.

90. Ford, *Brown*, 234.

91. W. P. Frith, *Autobiography*, 1:222.

92. A. M. Reynolds, *The Life and Work of Frank Holl* (London, 1912), 130.

93. Goodall, *Reminiscences*, 383; the appendix includes a list of works and names of patrons.

94. *Report of the Commissioners*, 1863.

95. "It would be difficult to convey an idea of the enormous number of forgeries of modern pictures that are in circulation, and it is high time to arrest the progress of a most iniquitous, but a most profitable, trade. If we can bring home the offence to the artists who *make* these copies, or imitations, we shall certainly print their names— without their aid the dealers could do nothing" ("The Picture-Dealers at the Old Bailey," *Art Journal* 19 [1857]: 382–383).

96. "'Is the Camera the Friend or Foe of Art?' 1. By the Editor. 2. By Several Eminent Artists," *Studio* 1 (1893): 100.

97. Sickert's later practice was not consistent with the views expressed here. In the 1920s, for example, he painted a series of theater pictures based upon photographs taken under his direction (Robert Emmons, *The Life and Opinions of Walter Richard Sickert* [London, 1941], 213).

98. "'Friend or Foe of Art?'" 100; George Moore, *Modern Painting* (New York, 1894), 181–183.

99. See *National Observer*, issues for March and April 1891; Sickert's letter appeared on 28 March. See also E. R. Pennell and J. Pennell, *The Life of James McNeill Whistler*, 5th ed., rev. (Philadelphia, 1911), 282.

100. Reader, *Professional Men*, 71.

101. Ibid., 51–53; Elliott, *Sociology of the Professions*, 39–41.

102. *Report of the Comissioners*, 1863.

103. Ibid. Blaine suggested maintaining the division between A.R.A. and R.A., reserving the full distinction for the most eminent artists, with the major increase in the numbers of Associates.

104. Ibid.

105. "The market for modern work was in great measure spoiled by the artists themselves. In the good days money was most plentiful, modern pictures were looked upon as 'investments,' and in consequence all the artists raised their prices in a most foolish way" (J. E. F. Panton, *Leaves from a Life* [New York, 1908], 122). "It is possible that the

prosperity enjoyed by artists during those thirty years had regrettable results—it led to an inflation of prices. Artists were no longer content to live the simple, happy lives the pursuit of their Art afforded; they built palaces and entertained. . . . An artist, every hour of whose day has been passed in pleasurable excitement—an excitement so keen that he is never happy when away from it, ought to be content with that, and leave the pleasures of wealth to those less fortunate in their manner of obtaining it" (C. E. Hallé, *Notes from a Painter's Life* [London, 1909], 182–183).

106. Rossetti is quoted in Fitzgerald, *Burne-Jones*, 118; Doughty, *Rossetti*, 547.

107. Davenant, *Starting in Life*, 124; Mrs. Russell Barrington, *G. F. Watts· Reminiscences* (New York, 1905), 110.

108. Holmes, *Self and Partners*, 199.

109. W. Wilkie Collins, *Memoirs of the Life of William Collins, Esq., R.A.*, 2 vols. (London, 1848), 2:6–10.

110. Hart, *Reminiscences*, 75.

111. Milllais, *Millais*, 1:340–341; 346.

112. Laura Knight, *The Magic of a Line: The Autobiography of Laura Knight, D.B.E., R.A.* (London, 1965), 139–140; the picture was painted about 1906.

113. The queen paid six hundred pounds for *Cimabue* (*Times*, 7 May 1855).

114. Quoted in Ford, *Brown*, 368.

115. Barrington, *Leighton*, 2:380.

116. T. H. S. Escott, *England: Her People, Polity, and Pursuits* (New York, 1880), 320.

117. Ellis Waterhouse, *Painting in Britain: 1530–1790* (London, 1953), 118.

118. Quoted in Derek Hudson, *Sir Joshua Reynolds* (London, 1958), 94.

119. "Many indications of this feeling will occur to those who read his life" (Redgrave and Redgrave, *Century of British Painters*, 263); G. Reynolds, *Turner*, 122.

120. Peter Laslett, *The World We Have Lost*, 2d ed. (New York, 1971), 43. The career of art administrator was one professional way of declaring service to society. Since it entailed a serious loss of time for painting, this career choice often interfered with the full development of an artist's talents.

121. Quoted in F. Redgrave, *Richard Redgrave*, 305–306; 307.

122. Watts, *Watts*, 1:3–4; Barrington, *Watts*, 27; Watts, *Watts*, 1:5.

123. Fitzgerald, *Burne-Jones*, 206–207.

124. The baronetcy, a kind of hereditary knighthood, had been established in 1611 by King James I. The baronet occupied a position between the knight and the baron, and each successive male heir bore the right to the title *Sir* (Laslett, *World We Have Lost*, 200; Anthony Sampson, *Anatomy of Britain Today* [New York, 1965], 13).

125. Blunt, "*England's Michelangelo*," 152–153; Millais, *Millais*, 2:174.

126. Watts, *Watts*, 2:240.

127. Ronald Chapman, *The Laurel and the Thorn: A Study of G. F. Watts* (London, 1945), 98; Watts, *Watts*, 2:3.

128. Quoted in J. Saxon Mills, *Life and Letters of Sir Hubert Herkomer, C.V.O., R.A.: A Study in Struggle and Success* (London, 1923), 281.

129. Redgrave and Redgrave, *Century of British Painters*, 83; Whitley, *Artists and Their Friends*, 2:217.

130. Millais, *Millais*, 2:174; 178.

131. Fitzgerald, *Burne-Jones*, 251.

132. Reader, *Professional Men*, 150.

133. Millais, *Millais*, 2:181.

134. Goodall, *Reminiscences*, 207.

135. Leslie, *Inner Life*, 133.

136. Quoted in Lindsay, *Turner*, 161.

137. The dealer who commissioned Millais's *Ferdinand Lured by Ariel* in 1849 for one hundred pounds refused to accept the picture when it was completed, a bitter disappointment to the young artist (Millais, *Millais*, 1:82; Hamerton, *Thoughts about Art*, 328).

138. Mills, *Herkomer*, 313.

139. Richard Ormond, *John Singer Sargent* (London, 1970), 56.

140. "It appears that Rhodes knew that he had gone too far and made several attempts to arrange another meeting with Gilbert, but with no result" (Edwin A. Ward, *Recollections of a Savage* [London, 1923], 255).

141. Quoted in Haskell, *Patrons and Painters*, 11.

142. Letter from Watts to Herkomer, 2 November 1896, in Mills, *Herkomer*, 245.

143. "In the face of bad times, of fashion turning the purchasers from the living to the dead, I feel a certain grim satisfaction in this resolve" (Hubert von Herkomer, *The Herkomers*, 2 vols. [London, 1910–1911], 2:174). It is interesting to find that the grand, noble gesture by an artist of freely giving away his work was anticipated in ancient Greece by artists who tried in this way to overcome the social prejudice that placed them with manual workers. "Thus the painter Polygnotus is said to have decorated the painted colonnade at Athens free of charge and Zeuxis, who could afford it at the end of his career, reputedly gave pictures away, declaring—so the tradition goes—that they were priceless" (Wittkower and Wittkower, *Born under Saturn*, 4).

144. Mary Clive, *The Day of Reckoning* (London, 1964), 47–49.

145. Jacques-Emile Blanche, *Portraits of a Lifetime*, trans. Walter Clement (New York, 1938), 154.

146. Ormond, *Sargent*, 57.

147. Kenneth Bendiner, *An Introduction to Victorian Painting* (New Haven, 1985), 118–119.

148. Ormond, *Sargent*, 78.

149. Fitzgerald, *Burne-Jones*, 164–165; Joseph Jacobs, "Sir Edward Burne-Jones," *Nineteenth Century* 46 (1899): 130.

150. D. S. MacColl, "Steer," *Art Work* 5 (Spring 1929): 21.

151. MacColl, "Exhibition," 36; 49–52.

152. William Rothenstein, *Men and Memories: Recollections, 1872–1900* (New York, 1931), 207.

153. G. M. Young, *Victorian Essays* (Oxford, 1962), 206.

3. William Powell Frith

1. W. P. Frith, *Autobiography*, 1:1–2; see also *Dictionary of National Biography*, s.v. "Frith, William Powell," by Sir Walter Armstrong.

2. W. P. Frith, *Autobiography*, 1:3–4.

3. Trevor Fawcett's *The Rise of English Provincial Art: Artists, Patrons, and Institutions Outside London, 1800–1830* (Oxford, 1974) is an excellent source of information on this subject.

4. On the societies at Leeds, see ibid., pp. 168–170; at Bradford, see p. 123.

5. W. P. Frith, *Autobiography*, 1:11.

6. Ibid., 18.

7. Ibid., 5–6.

8. Ibid., 8.

9. Ibid., 61; 70.

10. Quoted in Joseph Farington, *Memoirs of the Life of Sir Joshua Reynolds* (London, 1819), 12. Farington wrote that Reynolds shared Dr. Johnson's opinion and was an instance of its truth.

11. W. P. Frith, *Autobiography*, 2:33; 23; 1:24.

12. Ibid., 1:5.

13. Quoted in Hudson, *Reynolds*, 106.

14. W. P. Frith, *Autobiography*, 1:23–26.

15. Ibid., 35–36.

16. Ibid., 46.

17. Edwin Landseer was one of those who did not attempt to conceal his irritation; he typically arrived late when he was assigned duties as a Visitor at the Academy school and, during Frith's period as a student, spent his time reading. According to Frith, Landseer was often heard to say, "There is nothing to teach." See W. P. Frith, *Autobiography*, 1:42–44, 160.

18. Boase, *English Art*, 149.

19. Ibid, 57–58.

20. *Art Union Laws*, 1866.

21. W. P. Frith, *Autobiography*, 1:185; 183.

22. Ibid., 30.

23. Ibid., 144. On Sheepshanks, see Boase, *English Art*, 175.

24. W. P. Frith, *Autobiography*, 1:85.

25. Ibid., 99.

26. *Report of the Commissioners*, 1863.

27. Bell, *Victorian Artists*, 12.

28. Watts, *Watts*, 3:153.

29. W. P. Frith, *Autobiography*, 2:225–226.

30. *Times*, 3 May 1886.

31. Michael Holroyd, *Augustus John: A Biography* (Harmondsworth, England, 1974), 132.

32. W. P. Frith, *Autobiography*, 1:154.

33. Ibid., 84.

34. "The Private Art Collections of London. The Late Mr. David Price's, in Queen Anne Street," *Art Journal* 53 (1891): 327.

35. On the subject of the almost nostalgic representation of the present, see E. D. H. Johnson, "Victorian Artists and the Urban Milieu," in *The Victorian City*, ed. H. J. Dyos and Michael Wolff (London, 1973), 463.

36. W. P. Frith, *Autobiography*, 1:173.

37. Ibid., 175.

38. Ibid., 189–190.

39. On Jacob Bell's commission for *Derby Day,* see ibid., 192. On Frith's decision to sell engraving and exhibition rights to Gambart separately from ownership of the picture itself, see Reitlinger, *Economics of Taste,* 149–150. The quoted passage on the appearance of *Derby Day* as "picture of the year" is from A. C. Benson, *As We Were* (London, 1930), 217.

40. Benson, *As We Were,* 217.

41. W. P. Frith, *Autobiography,* 1:173.

42. Christopher Neve, "A Guilty Secret? Photography and Victorian Painting," *Country Life,* 18 June 1970, 1150–1152. Frith also used the help of the animal painter, John Frederick Herring, who did a watercolor from which two horses were copied into the right background of *Derby Day.* See the article on Frith in Staley and Cummings, *Romantic Art in Britain,* 294–295.

43. Roger Fenton's photographs of Crimean War battles, taken in 1855 and exhibited in London and Paris upon his return, gave evidence of the camera's capacity to record outdoor scenes; although Fenton's pictures could not show human action, developments during the next few years brought action photography into being (see Beaumont Newhall, *The History of Photography,* rev. ed. [New York, 1964]). Fenton, like most of the early photographers, began as a painter.

44. Neve, "A Guilty Secret?" 1152; Aaron Scharf, *Art and Photography* (Balitmore, 1969), 31.

45. Quoted in Scharf, *Art and Photography,* 125.

46. W. P. Frith, *Autobiography,* 1:202.

47. Ibid.

48. Ibid., 203–204.

49. Ibid., 285; 204.

50. "Notes on Some of the Principal Pictures Exhibited in the Rooms of the Royal Academy," 1858, in *The Works of John Ruskin,* ed. E. T. Cook and Alexander Wedderburn (London, 1904), 14:161–162.

51. "A Museum or Picture Gallery; Its Functions and Its Formation," *Art Journal* 42 (1880): 225–226.

52. W. P. Frith, *Autobiography,* 1:206–207.

53. "The Royal Academy," *Art Journal* 20 (1858): 165.

54. *Parliamentary Papers: Select Committee on Art Union Laws,* 1866, no. 332. See also Frith's defense of Hogarth and Wilkie against the "high-art men" in his article, "Crazes in Art: 'Pre-Raphaelitism' and 'Impressionism,'" *Magazine of Art* 11 (1888): 188.

55. Panton, *Leaves from a Life,* 25. The Tate Gallery was opened in 1897.

56. Walter Sickert, "The *Derby Day,*" in *A Free House!* ed. Osbert Sitwell (London, 1947), 202–204; the article is reprinted from *Burlington Magazine,* December 1922.

57. W. P. Frith, *Autobiography,* 1:229. According to other authorities, the price was even more exorbitant. Reitlinger agrees with the figure of £5,250 given in the *Times* obituary article on Frith (3 November 1909), noting that the *Art Journal* (1862) was convinced the real price was £8,750 (*Economics of Taste,* 150); Waters and Hutton give £9,000 (*Artists of the Nineteenth Century,* 274). It is obvious that considerable interest was aroused by the picture and its price.

58. On Haydon's exhibition of this picture, which brought £1,760, see Redgrave and Redgrave, *Century of British Painters*, 278.

59. Oppé, "Art," 108.

60. W. P. Frith, *Autobiography*, 1:234.

61. Arts Council of Great Britain, *Great Victorian Pictures: Their Paths to Fame* (London, 1978), 36.

62. Reitlinger, *Economics of Taste*, 148–149.

63. W. P. Frith, *Autobiography*, 2:169–170.

64. *Report of the Commissioners*, 1863.

65. Waters and Hutton, *Artists of the Nineteenth Century*, 275.

66. W. P. Frith, *Autobiography*, 1:231–234. To Roger Fry, *The Railway Station* was a distillation of the spirit of antiart, an influence so noxious that it explained, by way of reaction, the crudities of the Pre-Raphaelites: "One has to put oneself into the past to understand them at all; one has to look at Frith's *Paddington Station* [*Railway Station*]—in order to realize what an artistic Sodom and Gomorrah it was from which they fled in such precipitate haste that they seem to have brought nothing with them." Fry was criticizing the Pre-Raphaelites' use of flat, inexpressive pigment, which, he writes, no artist before Raphael would have tolerated (*Reflections on British Painting*, 109).

67. Sandby, *Royal Academy* 2:299.

68. Quoted in W. P. Frith, *Autobiography*, 1:236.

69. Ibid., 238.

70. Ibid., 201.

71. Panton, *Leaves from a Life*, 31–33.

72. "Minor Topics of the Month: The Marriage of the Prince of Wales," *Art Journal* 25 (1863): 38.

73. "Minor Topics of the Month: Mr. W. P. Frith, R.A.," *Art Journal* 25 (1863): 58.

74. Frith, *Autobiography*, 1:482. Frith added that he had been drunk only once in his life, with consequences so unpleasant that he was never led to repeat the indiscretion.

75. Ibid., 238.

76. Panton, *Leaves from a Life*, 238; Louise Jopling, *Twenty Years of My Life* (London, 1925), 33.

77. W. P. Frith, *Autobiography*, 1:350.

78. Ibid., 132; Panton, *Leaves from a Life*, 219; 79.

79. The first Mrs. Frith discovered her husband's infidelity during the time he was working on *The Railway Station*, a period when Frith spent a great deal of time with Mary Alford, who lived in the immediate vicinity of Paddington. Mrs. Frith saw him as he mailed a letter to her in which he had written that he was then in Brighton (Jeremy Maas, *The Victorian Art World in Photographs* [New York, 1984], 183; John Hadfield, *Every Picture Tells a Story: Images of Victorian Life* [New York, 1985], 60).

80. W. P. Frith, *Autobiography*, 2:174; 1:106–107.

81. In 1874, Flatow received £1,995 for the picture alone. In 1932 the *Salon d'Or* was sold for £48 6s.; it is now in the Rhode Island School of Design (Reitlinger, *Economics of Taste*, 150).

82. W. P. Frith, *Autobiography*, 1:282.

83. Ibid., 270; Reitlinger, *Economics of Taste*, 150.

84. Panton, *Leaves from a Life*, 122; Reitlinger, *Economics of Taste*, 319. Reitlinger

incorrectly gives seventy-two as Frith's age in 1896; the artist was seventy-seven in that year.

85. W. P. Frith, *Autobiography*, 2:225.

86. Ibid., 1:280.

87. *A Victorian Canvas: The Memoirs of W. P. Frith, R.A.* (London, 1957), ed. Nevile Wallis, is an edited and abridged version of Frith's memoirs.

88. Panton, *Leaves from a Life*, 128.

89. Walter Frith, "A Talk with My Father," *Cornhill Magazine* 20 (1906): 606.

90. *Times*, 3 November 1909.

Chapter 4. Herkomer, Fildes, and Holl

1. Lee M. Edwards, "Hubert von Herkomer: Sympathy for the Old and for Suffering Mankind," in Julian Treuherz, ed., *Hard Times: Social Realism in Victorian Art* (London, 1987), 119. "More than ten years ago," wrote Van Gogh in the early 1880s, "when I was in London, I used to go every week to the show windows of the printing offices of the *Graphic* and the *London News* to see the new issues. The impressions I got on the spot were so strong that, notwithstanding all that has happened to me since, the drawings are clear in my mind. . . . My enthusiasim for those things is stronger than it was even then" (Dr. V. W. Van Gogh, ed., *Vincent Van Gogh on England* [Amsterdam, 1968], 98). See also Lee MacCormick Edwards, "Hubert von Herkomer and the Modern Life Subject" (Ph.D. diss., Columbia University, 1984), 283–298.

2. For biographical information, see Mills, *Herkomer*, and Herkomer, *The Herkomers*.

3. Herkomer, *The Herkomers*, 1:41.

4. Quentin Bell, *The Schools of Design* (London, 1963), 256.

5. Hubert Herkomer, "Hubert Herkomer," in Louis Engel, *From Handel to Hallé: Biographical Sketches with Autobiographies of Professor Huxley and Professor Herkomer* (London, 1890), 159.

6. Bell, *Schools of Design*, 257; Herkomer, "Hubert Herkomer," 171. Walker's painting, in the description of Richard Redgrave, combined "a true feeling for rustic life with the grace of the antique" (*Century of British Painters*, 390). "There is no modern artist," wrote Richard Muther of Walker, "who has united in so unforced a manner actuality and fidelity to nature with the noble simplicity and quiet grandeur of the antique" (*History of Modern Painting*, 3:367).

7. An important technological advance, developed during the 1860s but not widely used until the 1880s, allowed drawings to be photographed onto the wood block. Use of this process meant that the original drawings remained intact and could be sold separately. The value of these drawings would rise if the painter became successful. (A. M. Hind, *The Graphic Arts: New and Old* [Oxford, 1921], 12).

8. Boase, *English Art*, 289.

9. See Gleeson White, *English Illustration, "The Sixties": 1855–1870* (London, 1906).

10. John Gaunt, *Chelsea* (London, 1954), 116–135; Herkomer, *The Herkomers*, 1:155.

11. "The sublime beginning of the *Graphic*," wrote Van Gogh to his brother Theo, "was something like what Dickens was as an author, what the Household Edition of his

work was as a publication" (Van Gogh, *Van Gogh*, 77). The *Illustrated London News* had been founded in 1842; according to the *Art Journal* it reached "all habitable parts of the globe where an Englishman is domiciled" (19 [1857]: 243).

12. Mills, *Herkomer*, 60.

13. L. V. Fildes, *Luke Fildes, R.A.* (London, 1968), 9; Reynolds, *Holl*, 97.

14. Herkomer, *The Herkomers*, 1: 165; 160; 215–216.

15. Mills, *Herkomer*, 68.

16. Herkomer, *The Herkomers*, 1: 184.

17. *Times*, 26 June 1873.

18. General Booth's *In Darkest England* (London, 1890) contains an exposé of the casual ward system.

19. Fildes, *Fildes*, 25–26.

20. ". . . without having received a single lesson in painting, he sent his first oil-picture (eight feet long, too!) to the Academy, and had the delight of seeing it hung on the line in the place of honour, bought for £600, and change hands on the private-view day at double the price" ("*La Zingarella*. Painted by Luke Fildes, R.A.," *Magazine of Art* 16 [1893]: 130).

21. A cartoon (from the Italian *cartone*, a big sheet of paper) is a full-sized drawing prepared so as to be transferred to a wall or onto canvas. A drawing is said to be "squared up" when it is filled with a network of squares; when numbered, these can be used as the plan for a larger version of the original drawing (Peter Murray and Linda Murray, *A Dictionary of Art and Artists*, 2d ed. [Baltimore, 1969], 76, 393). Medium is the liquid that binds powdered color together in order to make paint (ibid., 264). For Herkomer's description of the difficulties he encountered in executing this painting, see *The Herkomers*, 1: 197–199.

22. Fry, a partner in the Baker Street firm of Elliott and Fry, was a collector of Herkomer's early watercolors ("The Works of Hubert Herkomer, A.R.A.," *Art Journal* 42 [1880]: 111).

23. Mills, *Herkomer*, 87–88.

24. Ibid., 85.

25. Ibid., 80, 88.

26. See chapter 6 for Ruskin's comment on how this "Amazon's" work overcame his prejudice against women painters (from *Notes on Some of the Principal Pictures Exhibited in the Rooms of the Royal Academy*, 3d. ed. [London, 1875], 57–58).

27. Herkomer, *The Herkomers*, 1: 219.

28. The critic commented that it was a sign of bad times "that a living was not to be obtained in the accustomed directions" ("British Art at the Beginning of 1896. Some Editorial Remarks," *Art Journal* 58 [1896]: 25–27).

29. Joseph Banks, *Prosperity and Parenthood* (London, 1954), 53–67.

30. A. Ludovici, *An Artist's Life in London and Paris, 1870–1925* (London, 1926), 71.

31. *Times*, 27 November 1878.

32. *Times*, 2 May 1885.

33. Banks, *Prosperity and Parenthood*, 133.

34. "The Lay Figure at Home," *Studio* 3 (1894): xxx.

35. "House Building," wrote the critic A. L. Baldry, "became a fashion that scarcely

any rising artist with a balance at the bank could resist. He felt that he must surround himself with visible evidences of the appreciation in which he was held or there would be a danger that the public, always too ready to judge by externals, would pass him by as a failure, and prefer to him some of his more demonstrative competitors" (A. L. Baldry, *Hubert von Herkomer* [London, 1904], 102).

36. Herkomer, *The Herkomers*, 1:240.

37. Richard Norman Shaw (1831–1912) became a Royal Academician in 1878. He was a leader in the development in domestic architecture that broke away from contemporary Victorian house design and returned to Queen Anne and Georgian styles.

38. A. M. Reynolds, *Holl*, 217.

39. Fildes, *Fildes*, 41; 46; a drawing of Fildes's house is reproduced in Charles Handley-Read, *Aspects of Victorian Architecture*, vol. 6 of *The Pelican Guide to English Literature: From Dickens to Hardy* (Baltimore, 1969), 437; Fildes, *Fildes*, 142.

40. Herkomer, *The Herkomers*, 1:42.

41. The neighbor had asked Herkomer to give art lessons to his ward, and suggested that the artist open a school when he learned of Herkomer's unwillingness to teach privately.

42. Mills, *Herkomer*, 139–140.

43. Lewis Mumford, *The Brown Decades*, as quoted in Asa Briggs, *Victorian Cities* (New York, 1970), 382–383.

44. The score was later used to accompany a motion picture that Herkomer produced (Mills, *Herkomer*, 186–187; Herkomer, *The Herkomers*, 2:40–50).

45. Rothenstein, *Men and Memories*, 276.

46. The estimate of the cost of Lululaund was given by Herkomer in an affidavit and was, according to Mills, likely to be a conservative estimate (*Herkomer*, 213); Robert de la Sizeranne, *English Contemporary Art*, trans. H. M. Poynter (London, 1898), 203; Mills, *Herkomer*, 222; Edwards, "Modern Life Subject," 33.

47. Herkomer, *The Herkomers*, 2:2.

48. Mills, *Herkomer*, 101–102.

49. Herkomer, "Hubert Herkomer," 196. (*"Sie hexen"*—You have wrought magic or performed a miracle.)

50. Herkomer, *The Herkomers*, 1:239.

51. Mills, *Herkomer*, 129–131; 135–136.

52. Geoffrey Best, *Mid-Victorian Britain: 1851–1875* (New York, 1972), 90.

53. The last figure, given by Banks (*Prosperity and Parenthood*, 179), is also from the 1860s. Banks's source is an article in the *Cornhill Magazine*, "The Church as a Profession," June 1864.

54. Muther, *History of Modern Painting*, 3:386. Muther particularly admired *The Last Muster*—"There is something great in these old warriors praying at the end of their days"—and the portrait of Lorenz Herkomer, but felt that the artist did not, on the whole, deserved his great reputation.

55. Rothenstein, *Men and Memories*, 261.

56. Max J. Friedländer, *Landscape, Portrait, Still-Life: Their Origin and Development*, trans. R. F. C. Hull (New York, 1963), 232–233.

57. "I see clearly a certain cleavage asserting itself more and more in modern paint-

ing. I see, on the one hand, pictures painted by artists as servants of their customers, and on the other hand, pictures painted by artists who are the masters of their customers. . . . Livery is an honourable wear, but liberty has a savour of its own" (Walter Sickert, "New Wine," *New Age* 6 [21 April 1910]: 593).

58. Mary Fildes moved from Manchester to Chester, where she became proprietor of an inn. The artist's own parents were "in a small way," his father employed by the Port Authority of Liverpool. For reasons never divulged to him, Luke Fildes was taken away from home by his grandmother, who adopted him when he was eleven years old (Fildes, *Fildes*, 2).

59. The article in the *Graphic*, which was illustrated by the drawing on which Fildes based his Academy picture, stated that all the people shown in the picture were admitted to the casual ward after the sketch had been made ("Houseless and Hungry," *Graphic*, 4 December 1869, 9–10). The *Times* concluded its review of Fildes's painting with judicious praise of the artist's abilities: "Still, whatever we may think of the groundwork of the picture, there is no contesting the effectiveness of its working out, which shows in the painter a power hitherto unsuspected, such as is often revealed by the transition from conventional themes to those which have some breath of real life in them, even though it be life so shiftless and sordid, and only in the very slightest degree truly pathetic, as is this which Mr. Fildes has here so strikingly depicted" (26 May 1874).

60. "Our Living Artists. Luke Fildes, A.R.A.," *Magazine of Art* 3 (1880): 52.

61. Fildes, *Fildes*, 121.

62. Ibid., 118.

63. Treuherz, *Hard Times*, 87.

64. Fildes, *Fildes*, 203.

65. Quoted in Edward Ward, *Recollections of a Savage* (London, 1923), 224.

66. Fildes, *Fildes*, 146.

67. A. M. Reynolds, *Holl*, 113. As a boy, Holl had convinced his father to buy him a red ball he had admired in a toy shop. Unfortunately, this innocently acquired plaything become a source of guilt and psychological torment when his mother told him that he had been wicked to request such an expensive luxury (ibid., 12–13).

68. Ibid., 20; 21; 44.

69. Ibid., 62.

70. Ibid., 48–49; 84–87.

71. Ibid., 97–109; 144; 153–154; 168.

72. Ibid., 135–138; 207–211.

73. Ibid., 197–199.

74. Ibid., 314.

75. Ibid., 308–309.

76. Holl's daughter wrote, "It is not too much to say that my father threw his life away by his utter inability to rest from work" (ibid., 321).

77. Mills, who had access to Herkomer's correspondence, wrote that the crisis of conscience Herkomer experienced at the time of his father's death was based on guilt at his abandonment of subject painting in favor of the more remunerative work of portraiture, and on the fear that portrait painting was degenerating in his hands into a "mechanic art," so that success in it might mean his artistic undoing (*Herkomer*, 181).

78. Herkomer, *The Herkomers*, 2:33.

79. "I now gave my whole time to portraits, and my artistic friends commenced their cry of shame! . . . Just because portrait painting secures a more certain income than can be expected from subject painting, painters of the latter class of art are able to accuse portrait painters of turning their thoughts only to money-making . . ." (Herkomer, "Hubert Herkomer," 203).

80. Ibid., 203–204; Herkomer, *The Herkomers*, 2:33–37.

81. *Times*, 1 April 1914.

82. W. L. Courtney, *Hubert Herkomer: His Life and Work* (London, 1892), 16.

83. Herkomer, *The Herkomers*, 2:224.

84. Ibid., 64.

85. Quoted in Mills, *Herkomer*, 273.

86. "The Royal Academy," *Graphic*, 2 May 1891, 486; "The Royal Academy," *Athenaeum*, 2 May 1891, 641; *Times*, 11 May 1891. The *Art Journal*, too, was troubled by the large size of the picture: "In his large diploma work, *On Strike*, Mr. Hubert Herkomer makes the capital mistake of working out on a scale fully equal to that of life a subject which in no way calls for such treatment" ("The Summer Exhibitions at Home and Abroad. III—The Royal Academy and the New Gallery," 43[1891]: 197).

87. Herkomer's unusual citizenship—he was renaturalized British after having assumed German citizenship before his third marriage—was clarified by a legal opinion: He was German while in Germany and British while in areas of British jurisdiction (Herkomer, *The Herkomers*, 2:22–24).

88. John Lavery, *The Life of a Painter* (London, 1940), 65.

89. Quoted in Mills, *Herkomer*, 268–269.

90. Ibid., 279–280.

91. Mills, *Herkomer*, 279–280.

92. Ibid., 310–311; 311–312; 177–178.

93. Hubert von Herkomer, "Drawing and Engraving on Wood," *Art Journal* 44 (1882): 167.

94. W. P. Frith, *Autobiography*, 1:370.

95. Frances A. Kemble, *Records of a Girlhood* (London, n.d.), 5.

5. *Painting and the Independent Woman*

1. "The Society of Female Artists," *English Woman's Journal* 1 (1858): 205. This article discusses the second annual exhibition held by the Society of Female Artists and includes a discussion of how this show furthered the "self-help" goals of the organization. For consistency, the original name of the society is used throughout this book when discussing later periods; however, it should be noted that several name changes occured, as well as changes in management and philosophy. The society was renamed the Society of Lady Artists in 1872 and the Society of Women Artists in 1899 (see Charlotte Yeldham, *Women Artists in Nineteenth-Century France and England*, 2 vols. [New York, 1984], 1:88–95).

2. On Emily Mary Osborn, see the profile of the artist by James Dafforne in the *Art Journal* ("British Artists: Their Style and Character," 26 [1864]: 261–263), which in-

cludes an engraving of *Nameless and Friendless;* see also Yeldham, *Women Artists,* 1:309–311.

3. According to G. M. Young, Mrs. Grote "sat with her red stockings higher than her head, [and had] discomfited a dinner-party by saying 'disembowelled' quite bold and plain" (*Early Victorian England,* 2 vols. [Oxford, 1934], 2:414–415).

4. According to prevailing law, husbands assumed legal possession or control of all property that belonged to their wives at the time of marriage and to all property and income that their wives subsequently received (Lee Holcombe, "Victorian Wives and Property: Reform of the Married Women's Property Law, 1857–1882," in *A Widening Sphere,* ed. Martha Vicinus [Bloomington, 1977], 3–28).

5. Harold Perkin, *The Origins of Modern English Society* (London, 1969), 160.

6. Clara Thomas, *Love and Work Enough* (Toronto, 1967), 209. On Bodichon, see Sheila R. Herstein, *A Mid-Victorian Feminist, Barbara Leigh Smith Bodichon* (New Haven, 1985), and on her work as an artist, see John Crabbe, "An Artist Divided," *Apollo,* May 1981, 311–313.

7. Thomas, *Love and Work Enough,* 209.

8. On Greg's analysis, see Helene E. Roberts, "Marriage, Redundancy, or Sin: The Painter's View of Women in the First Twenty-Five Years of Victoria's Reign," in *Suffer and Be Still: Women in the Victorian Age,* ed. Martha Vicinus (Bloomington, 1974), 57. On the increase of "surplus women" between 1851 and 1871, see J. A. Banks, *Victorian Values: Secularism and the Size of Families* (London, 1981), 36.

9. Holcombe, "Victorian Wives," 10.

10. The essay was published in Dinah Mulock, *A Woman's Thoughts about Women* (London, 1858); the quotation appears on p. 58.

11. Biographical details on Mulock come from Sally Mitchell's fine study, *Dinah Mulock Craik* (Boston, 1983). For Hunt's remembrance of Tom Mulock, see Hunt, *Pre-Raphaelitism,* 1:105. The nineteenth-century author is hereafter referred to as Dinah Mulock, the name under which she first gained wide popularity.

12. John Cordy Jeaffreson, "Female Artists and Art-Schools of England," *Art Pictorial and Industrial* 1, no. 1 (August 1870): 25–30.

13. Jeremy Maas, *Gambart: Prince of the Victorian Art World* (London, 1975), 73–75. Maas provides an interesting description of the art dealer's cultivation of the Bonheur legend. Arthur Fish, in his 1905 study of Henrietta Rae, brought up the example of those unusual female artists who, like Rosa Bonheur, were known for "disowning, or at least disregarding" their sex. Such women, wrote Fish in 1905, "are so few that the artist named stands alone as having attained distinction" (*Henrietta Rae (Mrs. Ernest Normand)* [London, 1905], 13).

14. "That women artists' work seems to have sold much more easily within the Art Unions than on the open market is an indication that much women's work was priced relatively low and appealed to the small buyer rather than the more pretentious and self-conscious patron" (Pamela Gerrish Nunn, *Victorian Women Artists* [London, 1987], 42).

15. F. A. Hayek, *John Stuart Mill and Harriet Taylor* (Chicago, 1951), 122.

16. "Society of Female Artists," 208.

17. Thomas, *Love and Work Enough,* 208–209.

18. The artist G. A. Storey recounted Anna Jameson's conversation with his friend Leslie as follows:

They were talking of the advisability of admitting lady students to the Royal Academy schools. Leslie seemed to think there were certain objections to the proposal.

"What objections, Mr. Leslie?"

"I don't think it advisable for young men and women to study together."

"Why not?"

"I don't think it would be convenient; besides, the parents of the girls might object."

"Why should they?"

"It is difficult to explain."

"What is the difficulty?"

"The girls, for instance, could not draw from the life model."

"Why not?"

And so on; Mrs. Jameson getting the better of the argument with her constantly-recurring "Why not?" and with not a little merriment at Leslie's expense (G. A. Storey, *Sketches from Memory* [London, 1899], 82–83).

Born in 1835, George Dunlop Leslie, son of the Academician Charles Robert Leslie, had entered the Royal Academy schools in 1854. The conversation must have taken place in the late 1850s.

19. Queen's College, an institution of secondary education, accepted as students women and girls over the age of twelve (John Lawson and Harold Silver, *A Social History of Education in England* [London, 1973], 306).

20. "If I cannot help the cause myself," wrote Maurice, "I may do it some service by connecting with it the name of a lady who conferred great benefits upon her generation, whose memory all who knew her even slightly would wish to cherish, and who cannot be more effectually, gratefully remembered than by any services rendered to this Institution" (F. D. Maurice, "Female School of Art; Mrs. Jameson," *Macmillan's Magazine* 2 [1860]: 227–235).

21. "We have had the most distressing and painful cases of daughters of professional men, whose fathers have died prematurely; the young women having been brought up in great comfort, but from their fathers leaving no provision for them are entirely dependent on their own exertions" (Quoted in Anthea Callen, *Angel in the Studio: Women in the Arts and Crafts Movement, 1870–1914* [London, 1979], 36).

22. Ibid., 29–30. In the words of one angry father, the building that housed the Female School stood "in a bevy of gin palaces, old-clothes shops, pawnbrokers, etc., and with numerous ramifying alleys, leading to purlieus of contagion and infamy. Even by day, the loiterers on the pavement are equivocal, and at night the locality is one replete with pollution" (ibid., 32); see also Bell, *Schools of Design* 137–138.

23. Cole justified this action by asserting that the improvement of the design of English goods required the art education of all social classes; it was not enough to teach artisans who were "the servants of manufacturers, who themselves are the servants of the public" ("Practical Art," *Athenaeum*, 27 November 1852, 1304).

24. The committee supporting the school's continued existence responded that the other art schools in London were inadequate substitutes; only the main School of Design in South Kensington offered full-time instruction in a wide range of subjects, and most of the students of the Female School lived at too great a distance to travel there. The 1860 committee succeeded in raising private funds to support the school, which

was established in Queen's Square, Bloomsbury. In 1862 it received Victoria's patronage and became known as the Royal Female School of Art (Yeldham, *Women Artists,* 1:13–16; Bell, *Schools of Design,* 136–138).

25. Quoted in M. Jeanne Petersen, "The Victorian Governess," in Vicinus, *Suffer and Be Still,* 18.

26. Best, *Mid-Victorian Britain,* 77.

27. Janet Murray, *Strong-Minded Women and Other Lost Voices from Nineteenth-Century England* (New York, 1982), 313; excerpt reprinted from F. D. Maurice's *Lectures to Ladies on Practical Subjects,* 1857.

28. Thomas Purnell, "Woman and Art: The Female School of Design," *Art Journal* 23 (1861): 107–108.

29. Yeldham, *Women Artists,* 1:19.

30. Ibid., 1:21–22; see also Christopher Neve's articles on Heatherley's ("London Art School in Search of a Home: Heatherley's—I," *Country Life,* 17 August 1978, 448–450; "A Question of Survival: Heatherley's School of Art—II," 31 August 1978, 570–571).

31. Ellen C. Clayton, *English Female Artists,* 2 vols. (London, 1876), 2:146–151.

32. Patricia Thompson, *The Victorian Heroine: A Changing Ideal* (London, 1956), 39.

33. G. D. Hargreaves, introduction to *The Tenant of Wildfell Hall* by Anne Brontë (1848; reprint, Harmondsworth, England, 1979), 7.

34. [Dinah Mulock], *Olive* (London, n.d.); the title page and cover of this edition attribute authorship to the writer of *John Halifax, Gentleman,* Mulock's most popular work of fiction, which was published in 1856. In reissuing *Olive,* the publisher clearly decided to profit from the tremendous popularity of the later novel. Mulock's reputation as a serious novelist was established very early in her career. Featured as "The Author of *Olive,*" she was the subject of a seven-page article in 1851 in *Colburn's New Monthly Magazine,* and G. H. Lewes referred to her as a novelist of "considerable power" in an article on women novelists that appeared in the *Westminster Review* in 1852 (Mitchell, *Dinah Mulock Craik,* 117–118).

35. [Dinah Mulock], *Cola Monti: A Tale for Boys,* rev. ed. (London, 1866); first published in 1849.

36. See Preface of Mitchell's *Dinah Mulock Craik.*

37. Not until she turned twenty-one (in 1847) was Mulock able to inherit her share of her mother's trust. The annual income it provided, forty pounds, was less than half the minimum required for a middle-class standard of living. In the light of Dinah Mulock's later advocacy of legislation to protect the rights of married women to their own income and property, it is significant that her father, Thomas Mulock, had tried repeatedly (and unsuccessfully) to break the trust arrangement that protected his wife's family legacy for inheritance by her children (ibid., 6–9).

38. Mulock, *Woman's Thoughts,* 42, 34; 288, 2.

39. Ibid., 63, 5, 24.

40. *A Brave Lady* was serialized in *Macmillan's Magazine* in 1869 and 1870 (Mitchell, *Dinah Mulock Craik,* 69–73).

41. Mulock, *Woman's Thoughts,* 39.

42. Ibid., 50–51.

43. This is the conclusion reached by Pamela Gerrish Nunn in *Canvassing: Recollections by Six Victorian Women Artists* (London, 1986), 20.

44. Herstein, *Mid-Victorian Feminist*, 78–79.

45. "Of the accepted fine arts, painting [in the Great Exhibition] was limited to one or two examples of works in special processes, such as 'Miller's silica colours'" (Boase, *English Art*, 266).

46. Bell, *Schools of Design*, 244–246. The new Department of Practical Art was "to have superintendence over the various Schools of Design throughout the country, and be connected with other self-supporting institutions which aim to advance education in Art." ("Schools of Design," *Athenaeum*, 28 February 1852, 257–258).

47. Quoted in Jerome Hamilton Buckley, *The Victorian Temper: A Study in Literary Culture* (New York, 1951), 124.

48. Quoted in Walter E. Houghton, *The Victorian Frame of Mind: 1830–1870* (New Haven, 1957), 242.

49. Ibid., 251–256.

50. Carlyle held that work provided the vehicle for the development of natural talents and the criterion for measuring the advance towards human perfection. See Houghton's discussion (ibid., 249).

51. According to Pamela Gerrish Nunn, the Female School was partially (and temporarily) moved to South Kensington in 1852, and was then reestablished in Gower Street. In 1861, not long after F. D. Maurice added his voice to those seeking support for the institution, it was moved to Queen Square in Bloomsbury. The school came under Victoria's patronage in 1862 and was henceforth known as the Royal Female School of Art. (*Victorian Women Artists*, 49).

52. Peter T. Cominos, "Innocent Femina Sensualis in Unconscious Conflict," in Vicinus, *Suffer and Be Still*, 166.

53. Ray Strachey, *The Cause* (1928; reprint, London, 1979), 189.

54. Nunn, *Victorian Women Artists*, 112.

6. *Progress and Obstacles*

1. Like Osborn, a number of the other artists signed the petition with initials instead of given names. Perhaps their example gave Laura Herford the idea of applying to the Academy schools using this form as a strategy. The full petition follows:

Sir,—We appeal to you to use your influence, as an artist and a member of the Royal Academy, in favour of a proposal to open the Schools of that institution to women. We request your attentive consideration of the reasons which have originated this proposal. When the Academy was established in 1769, women artists were rare; no provision was therefore required for their Art-education. Since that time, however, the general advance of education and liberal opinions has produced a great change in that particular; no less than one hundred and twenty ladies have exhibited their works in the Royal Academy alone, during the last three years, and the profession must be considered as fairly open to women. It thus becomes of the greatest importance that they should have the best means of study placed within their reach; especially that they should be enabled to gain a thorough knowledge of *Drawing* in all its branches, for it is in this quality that their works are invariably found deficient. It is generally acknowledged that study from the Antique and from Nature, under the direction of qualified masters, forms the best education for the artist; this education is

given in the Royal Academy to young men, and it is given gratuitously. The difficulty and expense of obtaining good instruction oblige many women artists to enter upon their profession without adequate preparatory study, and thus prevent their attaining the position for which their talents might qualify them. It is in order to remove this great disadvantage, that we ask the members of the Royal Academy to provide accommodation in their Schools for properly qualified Female Students, and we feel assured that the gentlemen composing that body will not grudge the expenditure required to afford to women artists the same opportunities as far as practicable by which they have themselves so greatly profited. We are, Sir, your obedient servants, . . ." ("The Royal Academy," *Athenaeum*, 30 April 1859, 581).

2. Nunn, *Victorian Women Artists*, 56.

3. Yeldham, *Women Artists*, 1:34–38.

4. Dinah Mulock, *About Money and Other Things: A Gift-Book* (New York, 1887), 196–197. Social prejudice against women who studied art in Paris lasted long past the time of Mulock's essay. Lady Kathleen Kennet, a former Slade student who went to Paris for further study at the turn of the century, wrote: "In the first years of the twentieth century to say that a lass, perhaps not out of her teens, had gone prancing off to Paris to study art was to say that she had gone irretrievably to hell" (Yeldham, *Women Artists*, 1:37).

5. Mitchell, *Dinah Mulock Craik*, 17.

6. Mulock, *About Money*, 197.

7. Ibid., 191–192.

8. Ward, *Memories of Ninety Years*, 124; 22, 52–53.

9. In response to the prediction that she would become a second Burne-Jones, the young artist had replied, "No, the first Edna Waugh"; the account of her career at the Slade and the quotation are from Holroyd, *August John*, 81.

10. Nunn, *Victorian Women Artists*, 152.

11. Nunn, *Canvassing*, 174.

12. Ward, *Memories of Ninety Years*, 59.

13. Her daughter Estella, who wrote about her mother's career in a volume of reminiscences (see note 18), was born five years later; Estella Starr Canziani also became an artist; portions of her book are reprinted in Nunn, *Canvassing*.

14. Nunn, *Canvassing*, 177–178; two letters are combined in this quotation.

15. Holcombe, "Victorian Wives," 22–23.

16. Mulock, *About Money*, 15–16.

17. Nunn, *Canvassing*, 181.

18. Estella Canziani, *Round about Three Palace Green* (London, 1938), 72.

19. Starr's speech is included in her book, *Women in Professions: Being the Professional Section of the International Congress of Women* (London, 1900), 86. Estella Canziani remembered her mother's careful rehearsals for this speech—she even took elocution lessons to prepare for it (Nunn, *Canvassing*, 187).

20. Martha Vicinus, *Independent Women: Work and Community for Single Women: 1850–1920* (Chicago, 1985), 5.

21. "Woman, and Her Chance as an Artist," *Magazine of Art* 11 (1888): xxv–xxvi.

22. "Women at the Royal Academy Schools," *Magazine of Art* 12 (February 1889): xvii.

23. On women as a "refining influence" at the Academy schools, see H. S. Marks, *Pen and Pencil Sketches,* 2 vols. (London, 1894), 1:225; Leslie, *Inner Life,* 48, 54.

24. Mrs. Fenwick-Miller, "The Ladies' Column," *Illustrated London News,* 31 January 1891, 160.

25. Clayton, *English Female Artists,* 2:250.

26. Banks, *Prosperity and Parenthood,* 84–85; Perkin, *Modern English Society,* 418. Patricia Branca cautions against the tendency to extend the image of the leisured Victorian woman to income groups living far below upper-middle class income levels ("Image and Reality: The Myth of the Idle Victorian Woman," in Mary Hartman and Lois W. Banner, eds., *Clio's Consciousness Raised: New Perspectives on the History of Women* [New York, 1974], 179–189. M. Jeanne Peterson holds that the stereotype of genteel Victorian women as poorly educated girls and dependent, self-effacing wives derives from an uncritical acceptance of the polemics of Victorian reformers (and of such rebellious children of Victorians as Virginia Woolf) and also from the tendency of scholars to apply to gentlewomen data that apply only to lower-middle-class women who frequently aspired to higher social status (*Family, Love, and Work in the Lives of Victorian Gentlewomen* [Bloomington, 1989], ix–x).

27. Nunn, *Victorian Women Artists,* 39.

28. Callen, *Angel in the Studio,* 59–70.

29. Quoted in Murray, *Strong-Minded Women,* 320. "Artistic work" presumably meant work in the applied arts or handicrafts.

30. Nunn, *Canvassing,* 181.

31. Ray Strachey, in her 1928 study of the women's movement in England, characterized the late 1880s and 1890s as a retrogressive period for women (*The Cause* [London, 1928], 284; cited by Rita McWilliams-Tullberg, "Women and Degrees at Cambridge University, 1862–1897," in Vicinus, *Widening Sphere,* 135). Rita McWilliams-Tullberg's research has supported Strachey's observation: "The Victorian middle-class woman in financial difficulties was scarcely employable because she lacked training and qualifications. After training, one occupation was opened to her: teaching. . . . In a recent study of the reception of female graduates into business and industry, Michael Sanderson reports only insignificant numbers of women [university] graduates taking jobs there before World War I" (McWilliams-Tullberg, "Women and Degrees," 144). In *Independent Women* Vicinus writes: "In spite of the large increase in professional jobs for women during the second half of the nineteenth century, the numbers of women employed in such work remained small. . . . A breakdown of the major occupations in 1901 for what might be called "career women," those over forty-five, reveals that slightly over 12 percent of them were in middle-class jobs. . . . If we add government positions and commerce to the professions, we have a figure of 12.3 percent of unmarried women over forty-five in jobs requiring special training. . . . In these circumstances the continued refusal of upper-class parents to train their daughters for a life other than marriage is understandable" (pp. 27–28).

32. Maas, *Gambart,* 70–71.

33. Nunn, *Victorian Women Artists,* 175, 184.

34. Ibid., 174–175.

35. Mulock, *Woman's Thoughts,* 52.

36. Bessie Rayner Parkes Belloc, *Essays on Woman's Work* (London, 1866), 122–123.

37. "Our Daughters," *Graphic*, 7 May 1870, 543.

38. "It had . . . become customary for young couples to expect that they should start married life at the level of living which their parents had reached, and it was accepted as right and proper that a man should not marry until he had a reasonable prospect of maintaining such a level" (J. A. Banks and Olive Banks, *Feminism and Family Planning in Victorian England* [New York, 1964], 76).

39. Frederick Wedmore, "The Responsibility of Painting," *Studio* 3 (1894): 12.

40. Tessa Mackenzie, *The Art Schools of London, 1895: A Description of the Principal Art Schools in the London District* (London, 1895).

41. Ibid., 11, 24–25.

42. Gertrude Massey, *Kings, Commoners, and Me* (London, 1934), 13.

43. Hubert von Herkomer, *My School and My Gospel* (New York, 1908), 68; Ward, *Memories of Ninety Years*, 196.

44. "After spending twelve months sharing the model in the same class as the men students, separate class-rooms for men and women were built during the summer holidays. This meant that only on three evenings would we work together; and that all my other time was to be spent alone with the ladies. A student learns so much from one better than himself. In our class I was the only serious worker. To most of the other girls, art was no more than one accomplishment among other forms of higher schooling—before taking [one's] place in society as a lady. Even Mr. Wilson Foster did not spend the same time and energy of criticism in our class-room as he used to do before men and women were separated" (Knight, *Magic of a Line*, 77).

45. The *English Woman's Journal*, in its review of the second Society of Female Artists exhibition in May of 1858, expressed pleasure at the participation of many well-known women artists. But several prominent names were missing, and the journal urged these painters of the importance of their future support of the society: "The Society should be gallantly supported by those very painters in whose behalf it was *not* instituted, and who might gracefully quit 'the line' in Trafalgar Square, to adorn these walls. There is a triple virtue in 'A long pull, and a strong pull, and a pull all together'" ("The Society of Female Artists," *English Woman's Journal* 1 (1858): 206–207); "The Exhibition of the Society of Female Artists," *Art Journal* 28 (1866): 56.

46. Clayton, *English Female Artists*, 2:142–143.

47. Anna Lea Merritt, "A Letter to Artists: Especially Women Artists," *Lippincott's Monthly Magazine* 65 (1900): 463.

48. Ibid., 464.

49. Charlotte Streifer Rubinstein, *American Women Artists from Early Indian Times to the Present* (New York, 1982), 112–113; see also *Dictionary of American Biography*, s.v. "Merritt, Anna Lea," by William Howe Downes.

50. Anna Lea Merritt, *Love Locked Out: The Memoirs of Anna Lea Merritt with a Checklist of Her Works*, ed. Galina Gorokhoff (Boston [1980]), 99.

51. Merritt, "Letter to Artists," 467; her allegorical painting, *Love Locked Out*, had been purchased by the Chantrey Fund and became a part of the Tate Gallery's collection.

52. Fenwick-Miller, "The Ladies' Column," 160.

53. *Times*, 20 May 1885.

54. *Times*, 20–28 May 1885. The term "dress improver" was used in 1849 and in the

1880s as a "refined" term for the bustle (C. Willett Cunnington, Phillis Cunnington, and Charles Beard, *A Dictionary of English Costume* [Philadelphia, 1960]).

55. The artist's training in life study is thus directly comparable to "the cutting up of cadavers by medical students, . . . the probing of inner secrets by the psychiatrist, [and] the examination of the body by the doctor" (J. A. Jackson, "Professions and Professionalization: Editorial Introduction," in J. A. Jackson, ed., *Professions and Professionalization* ([London, 1970], 7).

56. The picture was an 1857 commission to paint "Napoleon the Third Being Invested with the Order of the Garter" (Ward, *Memories of Ninety Years*, 71).

57. Nunn, *Victorian Women Artists*, 152.

58. Yeldham, *Women Artists*, 1:31.

59. Ibid. See also the account of a life class attended by Henrietta Rae and several other women in the evening, following attendance in classes at the Royal Academy schools (Fish, *Henrietta Rae*, 26).

60. Edward Poynter, *Ten Lectures on Art* (London, 1880), 107.

61. Ibid., 111–112.

62. Although sexual attitudes changed during the 1880s and 1890s, the change did not signify relaxation of mores, but rather "the application of female sexual standards to all of society. . . . The women and men of the late nineteenth century were never so Victorian as when they insisted upon radical economic and social change within the context of stern Victorian sexual mores" (Vicinus, "Introduction: The Perfect Victorian Lady," in Vicinus, *Suffer and Be Still*, xv).

63. Private schools, too, may have modified their life class policies for similar reasons. It is striking that Heatherley's School of Art, long known for its encouragement of women students, is listed in Tessa Mackenzie's 1895 guide book as offering evening classes for both sexes at reduced rates, "the Costume model posing for three days a week, and the Figure model (*for men only*) on the alternate three days" (*Art Schools of London*, 47).

64. Massey, *Kings, Commoners, and Me*, 3–4.

65. Randolph Schwabe, as quoted in Holroyd, *Augustus John*, 58; Schwabe's article originally appeared in the *Burlington Magazine* in 1943.

66. Ibid.

67. Mackenzie, *Art Schools of London*, 79.

68. *Times*, 22 May 1885; letter signed "Senex."

69. Caroline Norton, *Lost and Saved* (Philadelphia, 1863), 327–331. The author's famous court case against her husband had provided inspiration to the feminist movement of the mid 1850s.

70. Kathryn Moore Heleniak, *William Mulready* (New Haven, 1980), 158. Stuart Macdonald writes that Ruskin "was embarrassed by the problem of the nude model and preferred to ignore it, hoping that his admonitions about pagan and infidel classic art, and his references to the 'dark carnality of Michelangelo,' would discourage drawing from the nude" (*The History and Philosophy of Art Education* [New York, 1970], 175).

71. Frank Davis, *Victorian Patrons of the Arts* (London, 1963), 18–19.

72. Quoted in Heleniak, *William Mulready*, 158. Perhaps Mulready's comments, recorded during the 1840s or 1850s, constituted a veiled confession of guilt. In a conversa-

tion with a fellow artist, Holman Hunt reported that Mulready "at 70 has seduced a young model who sits for the head and has a child by her; or rather she by him" (*The Diary of Ford Madox Brown,* ed. Virginia Surtees [New Haven, 1981], 189).

73. Jan Marsh, *The Pre-Raphaelite Sisterhood* (New York, 1985), 161. Annie Miller refused to accede to Hunt's urgings that she give up modeling and find some more respectable form of employment (Diana Holman Hunt, *My Grandfather, His Wives and Loves* [New York, 1969], 198).

74. W. P. Frith, *Autobiography,* 1:42. According to Charles Booth, the regular pay for models "whether for face or figure" was 7s. for a full day, including two meals, and 3s. 6d. or 5s. for half a day. The far higher rate of pay at the Academy, 54s. a week, only lasted for about a month, since each visiting Academician chose his own model (Booth, ed., *Life and Labour of the People in London,* 9 vols. [London, 1892–1903], 8:133).

75. Herstein, *Mid-Victorian Feminist,* 100.

76. Ward, *Memories of Ninety Years,* 284.

77. Quoted in Watts, *Watts,* 2:41–43.

78. John Galsworthy, *Fraternity* (New York, 1919), 9, 16; first published in 1909.

79. Marsh, *Pre-Raphaelite Sisterhood,* 33.

80. Booth, *Life and Labour,* 8:133.

81. Clayton, *English Female Artists,* 2:83.

82. Nunn, *Canvassing,* 180.

83. Fish, *Henrietta Rae,* 36; 102.

84. Galsworth, *Fraternity,* 43.

85. Susan Chitty, *Gwen John: 1876–1939* (London, 1981), 62; 77. Gwen John modeled for the sculptor Rodin and for a number of artists. "She was always ashamed of being a model and, in obedience to Rodin, never let her concierge know her profession but always let it be understood that she was a sort of artist" (p. 77).

86. Ward, *Memories of Ninety Years,* 72–73.

87. Elizabeth Thompson Butler, *An Autobiography* (London, 1922), 1–3, 43–46, 146. Three years after her great Academy triumph, Thompson's remarkable talents were eclipsed by the demands of marriage to an autocratic army officer and by responsibilities to a growing family that eventually included six children. Although she continued to paint when domestic duties allowed, her career was effectively at an end by 1881 (Paul Usherwood, "Elizabeth Thompson Butler: The Consequences of Marriage," *Woman's Art Journal,* Spring/Summer 1988, 30–34). For Ruskin's review in his *Academy Notes* for 1875, see E. T. Cook and Alexander Wedderburn, eds., *The Works of John Ruskin* (London, 1904), 14:308–309.

88. Clayton wrote that the appearance of Elizabeth Thompson's *Roll Call* was followed by "a volley of controversies," and that she was "admired, envied, extolled, spitefully or critically depreciated" (*English Female Artists,* 2:140).

89. Nunn, *Canvassing,* 175.

90. Canziani, *Round about Three Palace Green,* 42. This passage is interesting for conveying Starr's clear, albeit youthful, self-definition as a professional, in contrast to the comical lady amateurs who might have stepped out of the pages of *Punch.*

91. Jopling, *Twenty Years,* 26–33. Jopling enjoyed speculating as to whether the writer had seriously expected an answer (ibid., 86–87).

92. "The true genius of the sex," wrote C. J. Holmes in a typical expression of that sentiment included in his 1899 article, "Women as Painters," "is observant, tasteful, and teachable but not creative. . . .

In choice of subject [women] will do well not to forget the sympathies of their sex, and to avoid aiming at the heroic, the complicated, or the grandiose. If the painting of flowers and still-life is found unsatisfying or unprofitable, the portraiture of women, children, or animals will provide a wider field for their labour. . . .

The modern fashion of teaching girls a little of everything has doubtless improved the mental average of the sex. Painting, however, is not a career for average minds, and cannot therefore be judged by the rules that apply to them. Is not this the mistake that our elaborate system of Art-teaching has made?" (*The Dome* 3 [1899]: 2–9).

93. Fish, *Henrietta Rae*, 13.
94. Galsworthy, *Fraternity*, 46.
95. Nina Hamnet, *Laughing Torso* (New York, 1932), 17–19.

7. Art Publics in Late-Victorian England

1. Fildes, *Fildes*, 60.
2. W. P. Frith, *Autobiography*, 1:195.
3. Fildes, *Fildes*, 60.
4. The plural form *art publics* is used to underscore the point made by sociologists of art that the heterogeneous crowds that visit a large art exhibition do not constitute a true group, and that analysis must begin by identifying the distant subgroupings included within the amorphous body of art participants. The following articles have been particularly helpful in formulating the analyses of art publics in this chapter: Bruce Watson, "On the Nature of Art Publics," *International Social Science Journal* 20, no. 4 (1968): 667–680; B. Rosenberg and N. Fliegel, "The Artist and His Publics: The Ambiguity of Success," in Milton Albrecht, James H. Barnett, and Mason Griff, eds., *The Sociology of Art and Literature* (New York, 1970), 499–517.
5. The seasonal designation differentiated it from the Royal Academy's Winter Exhibition, usually of old masters, but sometimes of recently deceased British artists, held from 1869 (Hutchison, *Royal Academy*, 88; 129–131).
6. Millais, *Millais*, 1:444.
7. W. P. Frith, *Autobiography*, 1:90.
8. "Under date of April 3, I find: 'Many visitors. On the whole feel the picture is thought successful; cannot tell—it may be the reverse'" (W. P. Frith, *Autobiography*, 1:179).
9. Walter Frith, "A Talk with My Father," *Cornhill Magazine*, n.s. 20(1906): 601.
10. Herkomer, "Hubert Herkomer," 191–192.
11. Jopling, *Twenty Years*, 32.
12. Ward, *Memories of Ninety Years*, 113.
13. Millais, *Millais*, 2:316.
14. Fildes, *Fildes*, 86; "Art Notes," *Art Journal* 43(1881): 158.
15. Herkomer, "Hubert Herkomer," 191–192; W. P. Frith, *Autobiography*, 2:289–290.
16. Ludovici, *Artist's Life*, 86.

17. Charles A. Yount, *The Reaction against Ruskin in Art Criticism: Art and Morality* (Chicago, 1941), 114–115.

18. Charles Waldstein, *The Work of John Ruskin: Its Influence upon Modern Thought and Life* (New York, 1893), 32, 38–40. Waldstein (1856–1927) was an American, educated at Columbia College and at Heidelberg, who at the age of twenty-four was invited to lecture at Cambridge in classical archaeology. In 1894 he was elected a fellow of King's College and in 1899 was naturalized a British subject. During World War I he wrote on national ideals and in April 1918 changed the spelling of his name. See obituary article, "Sir Charles Walston," *Times*, 23 March 1927.

19. Quoted in Yount, *Reaction against Ruskin*, 96.

20. Virginia Woolf, *Roger Fry* (New York, 1940), 57–65; 52.

21. Quentin Bell, *The Life, Work, and Influence of Roger Fry* (London, 1966), 7.

22. Roger Fry, *Vision and Design* (New York, 1966), 22.

23. Ibid.

24. However different his later opinions, Fry during the 1880s was a fervent admirer of two artists beloved of Show Sunday viewers, Watts and Leighton (*Letters of Roger Fry*, ed. Denys Sutton, 2 vols. [New York, 1972], 1:113–114, 117).

25. On artists as participants in art publics, see Rosenberg and Fliegel, "Artist and His Publics," in Albrecht, Barnett, and Griff, *Sociology of Art*, 499–517, and Leo Steinberg, "Contemporary Art and the Plight of Its Public," ibid., 518–524.

26. Oppé, "Art," 133–134; 132.

27. Jopling, *Twenty Years*, 62.

28. Leslie, *Inner Life*, 138.

29. "Minor Topics of the Month," *Art Journal* 19 (1857): 65; "Varnishing Day and Private View Day at the Royal Academy," *Art Journal* 44(1882): 106–107.

30. W. P. Frith, *Autobiography*, 1:92–93.

31. Hart, *Reminiscences*, 52–53.

32. Quoted in Redgrave and Redgrave, *Century of British Painters*, 264; Sandby, *Royal Academy*, 2:239–240; "Varnishing Days," 106.

33. Redgrave and Redgrave, *Century of British Painters*, 264–265. It is interesting to compare the Redgraves' comments with those of Roger Fry: "The French artist never quite loses hold of the thread of tradition. However vehement his pursuit of new aims, he takes over what his predecessors have handed to him as part of the material of his new formula, whereas we in England, with our ingrained habits of Protestantism and non-conformity, the moment we find ourselves out of sympathy with our immediate past, go off on a tangent, or revert to some imagined pristine purity" (Fry, *Letters*, 1:300).

34. At first, only a small group of nonmember artists was invited to varnish, made up of those whose pictures the Council (the Academy's governing body) thought would particularly benefit; with the acquisition of larger facilities in 1869, the privilege was made general ("Varnishing Day," 108).

35. Ibid.

36. Ibid.

37. The term *the line* originally referred to a projecting ledge eight feet from the floor; a picture was said to be hung *on the line* when the top of its frame was level with this ledge. Unless the picture was very small, this was considered the best height for comfortable viewing (Leslie, *Inner Life*, 75).

38. Frith told the Royal Commission of 1863 that the Hanging Committee preferred to put a bad picture in a very bad place rather than to put a good picture in that place. In his opinion, it was less of an injury to the painter of an accepted picture to send it back than to hang it at the top of the room (*Report of the Commissioners*, 1863).

39. W. P. Frith, *Autobiography*, 1:307–308.

40. "I have known painters come from Scotland or France, having received no word of their picture, only to learn in the entrance-hall of Burlington House, from the proof copy of the catalogue, that it had been turned out. And recollect that this does not happen to merely one or two artists, or at an exceptional time, but it occurs every year to a number of persons" (W. J. Laidlay, *The Royal Academy: Its Uses and Abuses* [London, 1898], 158).

41. Hallé, *Painter's Life*, 52. Years afterward, Hallé, as comanager of the Grosvenor Gallery, sought to create an exhibition in which painters would be treated with consideration and dignity.

42. Leslie, *Inner Life*, 125–127; Sandby, *Royal Academy* 2:233; Herkomer, *The Herkomers*, 1:134.

43. Laidlay, *Royal Academy*, 159.

44. Ibid., 159–160.

45. Barrington, *Leighton*, 1:109.

46. Leon, *Ruskin: The Great Victorian*, 261–262.

47. Ruskin argued against the economic theories of Ricardo and Mill and held that the miseries caused by modern capitalism were not inevitable. His 1860 treatise was published in the *Cornhill Magazine* and later appeared under the title *Unto This Last*. "The *Saturday Review*, the voice of cultured and educated England in the mid-nineteenth century, undoubtedly voiced the opinion of its readers when it declared that Ruskin was 'weeping and bawling,' throwing out 'constant eruptions of windy hysterics' and writing 'in a scream on serious subjects which should be handled in the grave and quiet tone which educated men and women ought to employ.'" The reaction was so hostile that Thackeray, editor of the *Cornhill*, had to cancel the fourth installment of the work (Bell, *Ruskin*, 43–44).

48. Henry James, *The Painter's Eye* (Cambridge, Mass., 1956), 36–37.

49. Ruskin was the first English writer to use art criticism as a major prose form within which he discussed philosophical and moral issues. Henry James objected to Ruskin for treating art not as a "garden of delight," but as a "sort of assize court in perpetual session" (Bell, *Ruskin*, 112–113).

50. Leighton, disappointed at the critical response to his major Academy painting of 1856, wrote to a friend, "With God's will, I will one day stride over the necks of the penny-a-liners, that they may not have the triumph of having bawled me down before I have had time to be heard" (Barrington, *Leighton*, 1:246).

51. Benjamin Disraeli, *Lothair* (London, 1927), 367; first published in 1870. Oppé writes that critics on newspapers were generally thought to be disappointed painters ("Art," 120).

52. *Shaw: An Autobiography, 1856–1898*, comp. Stanley Weintraub (New York, 1969), 177.

53. Poynter, *Ten Lectures on Art*, 218.

54. *Shaw: An Autobiography,* 174.

55. Ibid., 174, 178.

56. *Report of the Commissioners,* 1863.

57. Ibid.

58. Waterhouse, *Reynolds,* 23; Whitley, *Artists and Their Friends,* 1:211.

59. Laidlay, *Royal Academy,* 160–161.

60. Leslie, *Inner Life,* 115. The *Art Journal,* commenting on the Royal and the Private views, was unsure of just when royalty's viewing day became separate from that of "fashionable, art-loving society" ("Varnishing Day," 108).

61. W. P. Frith, *Autobiography,* 1:201.

62. Butler, *Autobiography,* 110, 116.

63. The letter is reproduced in Barrington, *Leighton,* 1, following p. 194.

64. Fildes, *Fildes,* 70.

65. Millais, *Millais,* 2:239. His poem concludes with a jibe at his fellow R.A.'s:

Now turn to the right—	The gems of the year
The big rooms in light	Are supposed to be here;
Where the members invite	But the critics will sneer
Great people to dine.	At the notion, I guess.
Railway station of Smirke's,	Albeit for size
Where they hang their own works,	They must gain the prize,
Reserving (the Turks)	In spite of the wise
To themselves all the Line.	Myrmidons of the Press.

66. E. F. Benson, *As We Were* (London, 1930), 217–218.

67. Millais, *Millais,* 1:343. "Meech" in this quotation is, no doubt, a misprint for "Leech."

68. Hart, *Reminiscences,* 121–122.

69. Butler, *Autobiography,* 109.

70. F. Redgrave, *Richard Redgrave,* 212.

71. Laidlay, *Royal Academy,* 158; 160.

72. Leslie, *Inner Life,* 223; Jopling, *Twenty Years,* 69.

73. Farington, *Reynolds,* 74–75.

74 Leslie, *Inner Life,* 228.

75. Sandby, *Royal Academy,* 2:232–233; 364.

76. Leslie, *Inner Life,* 234.

77. At one banquet, Thackeray, returning thanks for the toast to literature, spoke of his early desire to become a painter, and of his disappointment when Dickens turned down sketches he had prepared as book illustrations (Frith, *Autobiography,* 1:87).

78. "It was with a view to improve the liberal character of the Society, that he [Reynolds] suggested the idea of admitting in its body certain honorary members, eminent for their learning; who, while they added grace to the Institution, received from it an honour worthy of their distinguished talents.

"Accordingly soon after the Royal Academy was established, His Majesty was graciously pleased to nominate Dr. Johnson professor of ancient literature; Dr. Goldsmith professor of ancient history, and Richard Dalton, Esq. His Majesty's librarian, antiquary

to the Society. Dr. Franklin, the Greek professor at Cambridge, was also appointed chaplain to the Academy. To these, who were the first honorary members of the Institution, many names of great celebrity have succeeded" (Farington, *Reynolds*, 73–74).

79. *Times*, 4 February 1896.

80. *Times*, 3 February 1896.

81. *Pall Mall Gazette*, 7 May 1894.

82. *Times*, 3 May 1886.

83. *Times*, 1 May 1893.

84. *Pall Mall Gazette*, 1 May 1893.

85. Laidlay, *Royal Academy*, 160.

86. "The Royal Academy," *Art Journal* 20(1858): 134.

87. Millais, *Millais*, 1:297.

88. *Report of the Commissioners*, 1863.

89. Hutchison, *Royal Academy*, 138.

90. "I managed the Private View, and have been again since, so am better able to tell you about the pictures" (*Journals and Correspondence of Lady Eastlake*, ed. Charles Eastlake Smith, 2 vols. [London, 1895], 2:248).

91. Lady Eastlake's characterization of London as a city "mainly composed of hardworking professional men" is found in "The Englishwoman at School," *Quarterly Review* 146 (1878): 56.

92. Gareth Stedman Jones, *Outcast London* (Oxford, 1971), 27–29, 239.

93. E. J. Hobsbawm has written of the "shading-over of the aristocracy of labour into other strata." Skilled labor aristocrats, who were sometimes considered as belonging to the lower middle class, had a status superior to that of many white-collar workers (*Labouring Men: Studies in the History of Labour* [New York, 1964], 273–274). Those holding positions in the highest ranks of labor were described by Charles Booth as "the non-commissioned officers of the industrial army. . . . Their services are very valuable, and their pay enables them to live reasonably comfortable lives, and provide adequately for old age. . . . Their sons take places as clerks, and their daughters get employment in first-class shops or places of business" (*Life and Labour* 1:53).

94. "If the wives work at all," Booth wrote of the labor aristocracy, "they either keep a shop, or employ girls at laundry work or at dressmaking" (ibid.). Low wage rates and the glut of the labor supply "stamped women's work with taint of poverty and loss of status" (Jones, *Outcast London*, 83–84).

95. Waldstein, *Work of John Ruskin*, 12.

96. The London social season lasted for three to five months; at its widest limits, it began in April, just before the Academy's opening, and closed in August with the conclusion of the exhibition (Leonore Davidoff, *The Best Circles: Society, Etiquette, and the Season* [London, 1973], 86).

97. The New Gallery was the successor to the Grosvenor.

98. Bruce Watson, "Art Publics," 669.

99. Rutter, *Art in My time*, 25.

100. W. P. Frith, *Autobiography*, 1:291.

101. Butler, *Autobiography*, 113.

102. "Varnishing Day," 108.

103. John Pye, *Patronage of British Art: An Historical Sketch* (1845; facsimile reprint, London, 1970), 172–173.

104. Sandby, *Royal Academy*, 1:117; 109; see pp. 98–109 for an account of the wave of parliamentary investigation and criticism of the Academy.

105. "Art in Parliament: The Royal Academy," *Year's Art*, 1895, 56–57. The Royal Academy had left its half of the National Gallery building with an agreement that Parliament would maintain the exterior of its new headquarters.

106. C. Eastlake, *Fine Arts*, 173; the *Times* is quoted by Boase (*English Art*, 210); Art Union Prize–winners were allowed to choose their pictures from one of the five leading galleries in London—the Royal Academy, the Old and New Societies of Painters in Water-Colours, the British Institution, and the Society of British Artists (Anthony King, "George Godwin and the Art Union of London: 1837–1911," *Victorian Studies* 8, no. 2 [December 1964]: 104). King describes the Art Union of London as part of the movement of the 1830s to open galleries and other institutions to the public; Godwin had founded it with the help of Edward Edwards, a pamphleteer interested in university reform, and later one of the founders of public libraries in England (ibid., 103–104).

107. Lady Eastlake expressed the disdain felt by many refined, upper-class people towards art unions: "These Art Unions are equally as unsatisfactory to those who encourage them as to those they encourage. A man pays a guinea for the sake of suffering Art? Not a bit of it; but merely for the sake of a cheap picture and a cheap mode of excitement. It is a lottery with no blanks." These comments are part of a journal entry dated 18 February 1843 (*Journals and Correspondence*, 1:52–53).

108. Charles Eastlake had been keeper of the National Gallery between 1843 and 1847 and was elected president of the Royal Academy in 1850, after the death of Martin Archer Shee.

109. Philip Hendy, *Art Treasures of the National Gallery* (London, 1967), 14–16.

110. Peel became a trustee in 1827, three years after the founding of the National Gallery and became the dominant influence in its administration (ibid.); *Parliamentary Papers: Report from the Select Committee on the National Gallery*, 1852–1853, no. 867; that committee was "not the last but the most searching of the long series of such Parliamentary committees of inquiry which punctuate the history of the Gallery" (Hendy, *National Gallery*, 18).

111. Sir Richard Westmacott, who was in charge of caring for the sculpture at the British Museum, told the committee that if the National Gallery's paintings were not promptly taken from London's smoky center, there would soon be few paintings left that were worth looking at. "As a penalty for remaining in Trafalgar Square," wrote Philip Hendy in 1967, "the pictures had to be glazed, and to remain glazed for nearly a century. Many of them are glazed still, but in the meantime the air and the inhabitants of London have grown cleaner round them" (*National Gallery*, 19).

112. Gareth Stedman Jones, "Working-Class Culture and Working-Class Politics in London, 1870–1900; Notes on the Remaking of a Working Class," *Journal of Social History* 7, no. 4 (Summer 1974): 467.

113. Henry Mayhew described the entertainment of the penny theaters ("penny gaffs") frequented by the poorest classes of Londoners as contributing to their sen-

suality and immorality (*London Labour and the London Poor,* 3 vols. [London, 1861], 1:42–45).

114. This must have been an extremely influential justification for Sunday openings of museums and galleries. It was said that "the Sabbatarians by their efforts gladdened the hearts and filled the pockets of every brewer, distiller, and publican in the kingdom. . . . The leading police magistrates were all in favour of Sunday opening of museums and galleries. The head of the police in Birmingham, Major Bond, was happily able to report that the art galleries had been opened in that . . . city since 1872 with the greatest success in weaning the poorer classes from the public house" (A.C.R. Carter, *Let Me Tell You* [London, 1940], 259).

115. The fact that subject was considered so nearly all-important in works of art led naturally to the conclusion that those lacking in literary education would be unable to appreciate high art because of their ignorance of thematic material taken from history and mythology.

116. The 1852–1853 Select Committee received strong disagreement on this point in testimony from the artist George Foggo, who said that he had consulted with working men in different parts of the city on the question of a new site for the National Gallery and found them opposed to the idea; he believed that the increased exertion and expense that would be required for a trip outside the central city would discourage many working-class families from visiting the collection (*Committee on the National Gallery,* 1852–1853). In 1844, Foggo and his elder brother James had published a catalogue of the pictures in the National Gallery; this was the first attempt to help members of the public develop their knowledge and appreciation of the collection (*Dictionary of National Biography,* s.v. "Foggo, George," by Lionel Cust).

117. R. Ford, in his testimony before the Select Committee, suggested that the necessity of a trip to the gallery would function as a test. He favored a location "near the Parks with a pretty walk to it that would be calculated to prepare the mind of people for the contemplation of such things [i.e., fine paintings]" (ibid.).

118. It was pointed out that Madrid's art gallery was closed on wet days for this reason (ibid.).

119. *Parliamentary Papers: Report of the Select Committee on the National Gallery,* 1850, no. 612. Uwins had succeeded Eastlake as keeper in 1847.

120. Eastlake observed that the proposed move to Kensington would reduce the number of visitors "of one class," but those prevented from going to the gallery "because of the crowded state of it, from the class of persons who go there at all times," would increase in number (ibid.).

121. This system was already in use at a few public painting exhibitions, for which tickets had to be obtained at the shops of designated print-sellers.

122. Dyce had a long and eminent career in art education, first as superintendent of the Government School of Design, then as professor at King's College, London. He was one of the recipients of commissions to decorate the new Houses of Parliament.

123. *Committee on the National Gallery,* 1852–1853. Several witnesses pointed out to the committees of 1850 and 1853 that the general public was admitted to two of the major European museums, the Louvre and the Prado, exclusively on Sunday; foreign visitors could visit on any day, by showing their passports. Lady Eastlake wrote from

Bruges in 1861: "I have long heard the provincial French museums puffed in England, and the gifts of private individuals and of the Emperor, and the liberality with which these places are opened to the public . . . ; but it is only by seeing the real thing that we get at the truth. The public of such a place as Douai are only admitted to their *musée* for two hours in the week (on a Sunday); anyone wanting to visit the pictures at any other time must pay. . . . I shall mistrust all I hear of the superior sense and liberality of France and other foreign governments in these matters. Here, in Bruges, fine old pictures by Memling and other native masters are perishing, because the government is not even liberal enough to warm the rooms they are kept in during their always inclement winters" (*Journals and Correspondence*, 2: 160–161).

124. Briggs, *Victorian Cities*, 375.

125. Edwin Chadwick's great *Report on the Sanitary Condition of the Labouring Population of Great Britain* of 1842, based on the miasmatic theory of disease, had led to the passage of the first Public Health Act, in 1848 (Perkin, *Modern English Society*, 170–171).

126. The report came from Mr. Seguier, who was in charge of cleaning and restoring the gallery's pictures (*Committee on the National Gallery*, 1852–1853).

127. According to the theory of "epidemic atmosphere," of which Chadwick was a fervent proponent, smell meant disease (Francis Sheppard, *London, 1808–1870: The Infernal Wen* [Berkeley, 1971], 265).

128. Faraday said that the Trafalgar Square site was maximally exposed to inorganic fumes from chimneys and organic miasma from crowds (*Committee on the National Gallery*, 1850).

129. *Committee on the National Gallery*, 1852–1853; the letter was dated 28 May 1850.

130. Hendy, *National Gallery*, 18–19.

131. The Tate was officially an annex of the National Gallery until it received independent status by means of parliamentary legislation in 1955 (ibid., 24).

132. Ibid., 21. A limited number of artists continued to receive permission to copy on those days.

133. "Old haunts of crime, vice and disease were demolished and their inhabitants scattered. . . . By the end of Victoria's reign, gin palaces had virtually disappeared. The social and economic functions of the pub had been reduced; drinking hours had been restricted and children had been excluded from the bar. Cockfighting, bearbaiting, and ratting had all but died out. Gambling had been driven off the streets. . . . Evangelical disapproval had hastened the disappearance of tea gardens, free-and-easies and judge-and-jury clubs. Public executions at Newgate had ceased in 1868. Southwark, St. Bartholemew and the other great London fairs had been abolished. . . . Four regular bank holidays had been instituted in 1871 and a growing number of parks, museums, exhibitions, public libraries and mechanic's institutes promoted a more improving or innocuous use of leisure time" (Jones, "Working-Class Culture," 470).

134. "I . . . delight to record that the halls of the National Gallery this particular Saturday afternoon were full; and that large numbers of the visitors were of the working class, and were not stolidly tramping from gallery to gallery, just glancing with listless gaze at the glorious works of art on the walls; but that they were steadily passing from room to

room and scanning long and lovingly the marvellous collection of paintings which have grown up in Trafalgar Square from the nucleus of the Angerstein Gallery of thirty-eight pictures, purchased in 1824 by the Government" (George Augustus Sala, *London up to Date* [London, 1894], 168). Sala reflects, in *London up to Date*, on the many changes that had taken place in London during his lifetime.

135. Butler, *Autobiography,* 186.

136. *Times,* 1 May 1877.

137. Sir Coutts Lindsay, in *Report of the Commissioners,* 1863.

138. See the characterization of Blanche Lindsay in G. W. E. Russell, *Half-Lengths* (London, 1913).

139. "The elite . . . come to regard their utilitarian functions in society merely as accessory and the cultivation of luxury as paramount. . . . The emphasis on the arts as a luxury and diversion divorced from the occupations and activities of daily life . . . tends to emphasize form at the expense of subject matter and function, while the refinement of cultivation in aesthetic taste tends similarly to treat art as an end in itself divorced from mundane preoccupations" (Adolph Tomars, *Introduction to the Sociology of Art* [Mexico City, 1940], 171).

140. W. Graham Robertson, *Time Was* (London, 1931), 47.

141. The musician Karl (later Charles) Hallé had lived for a number of years in Paris and was a friend of Chopin and of the painter Ingres. He came to England during the Revolution of 1848 (see *Life and Letters of Sir Charles Hallé,* ed. C. E. Hallé and Marie Hallé [London, 1896], 32–33; 78–79; 92).

142. C. E. Hallé, *Notes from a Painter's Life* (London, 1909), 63.

143. Ward, *Recollections of a Savage,* 49.

144. "Abstention from labour is the conventional evidence of wealth and is therefore the conventional mark of social standing" (Thorsten Veblen, *The Portable Veblen,* ed. Max Lerner [New York, 1948], 88–89).

145. The description of the artist as "spiritual version of the gentleman" was used by César Graña to describe Baudelaire (*Modernity and Its Discontents* [New York, 1964], 154).

146. The school, Bruce Castle School in Tottenham, which was run by members of the famous Hill family, prohibited corporal punishment and favored modern studies to prepare students for commercial careers (J. Comyns Carr, *Some Eminent Victorians* [London, 1908], 6–9).

147. Ibid., 57–58.

148. Prince Leopold and Arthur Sullivan were among the guests. Mrs. Carr described the party as the prototype of the famous Sunday parties later held at the Grosvenor Gallery (Mrs. J. Comyns Carr, *Stray Memories by His Wife* [London, 1920], 77).

149. Ibid.

150. Ward, *Recollections of a Savage,* 48.

151. On the Sunday opening and the limited number of season tickets see the *Times,* 12 March 1877.

152. Ward, *Recollections of a Savage,* 49; Carr, *Stray Memories,* 78; Mrs. Jopling wrote that Lady Lindsay's Sunday receptions made the Grosvenor one of the most fashionable resorts of the London season (*Twenty Years,* 116); Ward, *Recollections of a Savage,* 49; Carr, *Some Eminent Victorians,* 266–267.

153. *Times*, 12 March 1877.

154. Jopling, *Twenty Years*, 116; Pennell and Pennell, *Whistler*, 152.

155. *Times*, 12 March 1877.

156. *Times*, 1 March 1877.

157. César Graña, "The Private Lives of Public Museums," *Trans-Action* 4 (April 1967): 20–25.

158. Ibid.

159. Walter Crane, *An Artist's Reminiscences*, 2d ed. (London, 1907), 323.

160. Years later, Hallé wrote that his resignation from the Grosvenor had been a serious blow to his economic security not only because of the salary loss, but also because the gallery had served as a market for the sale of his pictures (*Painter's Life*, 159). "Sir Coutts Lindsay," wrote Henry James, "is himself a very clever painter, and I see no warrant for the ill-natured intimation which I heard put forth somewhere, that he built the Grosvenor Gallery in order to have a place to exhibit his own productions" (*Painter's Eye*, 139).

161. Quoted in Georgiana Burne-Jones, *Memorials of Edward Burne-Jones*, 2 vols. (New York, 1904), 2:77. The Pennells heard numerous complaints about the Grosvenor's overly heavy decoration. In their judgment, the sumptuous background was "disastrous to the pictures" (*Whistler*, 153).

162. G. Burne-Jones, *Burne-Jones* 2:78–79.

163. See Barrie Bullen, "The Palace of Art: Sir Coutts Lindsay and the Grosvenor Gallery," *Apollo* 102 (November 1975): 352–357; *Times*, 10 March 1877.

164. Jopling, *Twenty Years*, 284–285.

165. Davidoff, *Best Circles*, 56.

166. On the widening of "Society," see ibid., 59–61. Marriages between aristocratic daughters and families of new wealth were becoming increasingly common (F. M. L. Thompson, *English Landed Society in the Nineteenth Century* [London, 1963]), 303. See also the same author's *The Rise of Respectable Society: A Social History of Victorian Britain, 1830–1900* (Cambridge, Mass., 1988), 105–106; 108.

167. Jones, *Outcast London*, 269–270.

168. Davidoff, *Best Circles*, 41–49.

169. "The ratio of domestic servants to population reached its peak at nearly one in six of the occupied population between 1871 and 1891" (Perkin, *Modern English Society*, 418).

170. Lady Eastlake felt that the poor quality of education offered by girls' boarding schools was a reflection of "parental anxiety to keep a girl feminine, and fitted for the home sphere" with the still deeper motivation of satisfying the preferences of future suitors. "A large array of subjects may be now kept in the school repertory, but all the young girl is encouraged to learn are a few accomplishments, which, it may be added, are never accomplished" ("Englishwoman at School," 48). The curriculum at these schools was shaped to fit a leisured, ornamental ideal. The goal was to help a girl attract a husband who could afford to provide her with a leisured life (Joyce S. Pedersen, "Schoolmistresses and Headmistresses: Elites and Education in Nineteenth-Century England," *Journal of British Studies* 15 [1975]: 144); see also John Lawson and Harold Silver, *A Social History of Education in England* (London, 1973), 341.

171. Hamerton, *Autobiography*, 204–205.

172. Reader, *Professional Men*, 1.

173. Tomars, *Sociology of Art*, 188.

174. Horace G. Hutchinson, *Portraits of the Eighties* (London, 1920), 232–233.

175. Bell, *Victorian Artists*, 68.

176. "It was perhaps a moment," Fry added, "when the provincialism of English culture was almost justified by the concentrated effort which it made towards creation, even if the results that emerged now seem to us scarcely adequate" ("Mrs. Cameron's Photographs," in *Victorian Photographs of Famous Men and Fair Women by Julia Margaret Cameron* [London, 1926], 10).

177. Watts, *Watts*, 1:71.

178. Bell, *Victorian Artists*, 67.

179. Fry, "Mrs. Cameron's Photographs," 10.

180. Those who embraced Aestheticism as a fad, exaggerating the outward signs of the movement, made satire irresistible, as in Gilbert and Sullivan's operetta *Patience*, which appeared in 1881. The painter Graham Robertson believed it was this development that prematurely ended the movement in the 1880s "amidst peals of mocking laughter" (Robertson, *Time Was*, 67–68).

181. Hallé, *Painter's Life*, 102.

182. According to Hallé, Sir Coutts never had confidence in the gallery's economic viability and had built the restaurant on the floor below as insurance (ibid.).

183. Bullen, "Palace of Art," 357. In 1887, Sir Coutts estimated the financial loss from the gallery at £200,000 (*Pall Mall Gazette*, 3 November 1887).

184. Bullen, "Palace of Art," 357; quoted from a letter Hallé wrote to the critic F. G. Stephens.

185. "Grosvenor 'Split'"; Bullen, "Palace of Art," 357.

186. Carr, *Some Eminent Victorians*, 132.

187. *Pall Mall Gazette*, 3 November 1887.

188. Leighton had called it "unpatriotic" (Hallé, *Painter's Life*, 144).

189. Crane, *Artist's Reminiscences*, 297.

190. James Abbott McNeill Whistler, *The Gentle Art of Making Enemies* (1890; reprint, New York, 1967), 136.

191. "A Chat with Mr. Whistler," *Studio* 4 (1894): 118.

For Further Reading

Altick, Richard D. *Victorian People and Ideas*. New York, 1973.

Arts Council of Great Britain. *Great Victorian Pictures: Their Paths to Fame*. Edited by Rosemary Treble. London, 1978.

Aslin, Elizabeth. *The Aesthetic Movement*. New York, 1969.

Bell, Quentin. *Victorian Artists*, London. 1967

Bendiner, Kenneth. *An Introduction to Victorian Painting*. New Haven, 1975.

Best, Geoffrey. *Mid-Victorian Britain: 1851–1875*. New York, 1972.

Boase, T.S.R. *English Art: 1800–1870*. Oxford, 1959.

Blunt, Wilfred. *"England's Michelangelo": A Biography of George Frederic Watts, O.M., R.A.* London, 1975.

Buckley, Jerome Hamilton. *The Victorian Temper: A Study in Literary Culture*. New York, 1951.

Burn, W. L. *The Age of Equipoise: A Study of the Mid-Victorian Generation*. New York, 1964.

Callen, Anthea. *Angel in the Studio: Women in the Arts and Crafts Movement, 1870–1914*. London, 1979.

Casteras, Susan P. *The Substance and the Shadow: Images of Victorian Womanhood*. Exhibition catalogue, Yale Center for British Art. New Haven, 1975.

Casteras, Susan P., and Ronald Parkinson, eds. *Richard Redgrave: 1804–1888*. New Haven, 1988.

Denvir, Bernard. *The Early Nineteenth Century: Art, Design and Society, 1789–1852*. A Documentary History of Taste in Britain. London, 1984.

——. *The Late Victorians: Art, Design and Society, 1852–1910*. A Documentary History of Taste in Britain. London, 1984.

Fitzgerald, Penelope. *Edward Burne-Jones: A Biography*. London, 1975.

Gaunt, William. *The Pre-Raphaelite Dream*. New York, 1966.

——. *The Restless Century*. London, 1972.

Greer, Germaine. *The Obstacle Race*. London, 1979.

Hadfield, John. *Every Picture Tells a Story*. New York, 1985.

Herstein, Sheila R. *A Mid-Victorian Feminist, Barbara Leigh Smith Bodichon*. New Haven, 1985.

Hilton, T. *The Pre-Raphaelites*. London, 1970.

Houghton, Walter E. *The Victorian Frame of Mind*. New Haven, 1957.

Maas, Jeremy. *The Victorian Art World in Photographs*. New York, 1984.

——. *Victorian Painters*. London, 1969.

Macdonald, Stuart. *The History and Philosophy of Art Education*. New York, 1970.

Nunn, Pamela Gerrish. *Canvassing: Recollections by Six Victorian Women Artists*. London, 1986.

——. *Victorian Women Artists*. London, 1987.

Olmsted, John Charles. *Victorian Painting: Essays and Reviews*. Vol. 1, *1832–1848*. Vol. 2, *1849–1860*. New York, 1983.

Ormond, Richard. *John Singer Sargent*. London, 1970.

Perkin, Harold. *The Origins of Modern English Society*. London, 1969.

Peters, Robert. *Victorians on Literature and Art*. New York, 1961.

Reader, W. J. *Life in Victorian England*. London, 1964.

——. *Professional Men: The Rise of the Professional Classes in Nineteenth-Century England*. London, 1966.

Redgrave, Richard, and Samuel Redgrave. *A Century of British Painters*. 1866. Reprint, edited by Ruthven Todd. London, 1947.

Reitlinger, Gerald. *The Economics of Taste: The Rise and Fall of the Picture Market, 1760–1960*. New York, 1961.

Treuherz, Julian, ed. *Hard Times: Social Realism in Victorian Art* (with contributions by Susan P. Casteras, Lee M. Edwards, Peter Keating, and Louis van Tilborgh). London, 1987.

Usherwood, Paul, and Jenny Spencer-Smith. *Lady Butler, Battle Artist: 1846–1933*. London, 1987.

Vicinus, Martha, ed. *A Widening Sphere*. Bloomington, 1977.

——, ed. *Suffer and Be Still: Women in the Victorian Age*. Bloomington, 1974.

Webb, R. K. *Modern England from the Eighteenth Century to the Present*. New York, 1969.

Wittkower, Rudolf, and Margaret Wittkower. *Born under Saturn. The Character and Conduct of Artists: A Documented History from Antiquity to the French Revolution*. New York, 1963.

Wood, Christopher. *Victorian Panorama: Paintings of Victorian Life*.London, 1976.

——. *Olympian Dreamers: Victorian Classical Painters, 1860–1914*. London, 1983.

Yeldham, Charlotte. *Women Artists in Nineteenth-Century France and England*. 2 vols. New York, 1984.

Index

Note: Page references to black-and-white illustrations are in italics.